strong hearts, inspired minds

21 Artists
Who are Mothers
Tell Their Stories

Rowanberry Books
Portland, Oregon

by Anne Mavor
photographs by Christine Eagon

Library of Congress Catalog Card Number: 96-92485
ISBN: 0-9653724-0-5

Publisher's Cataloging in Publication (prepared by Quality Books, Inc.)

Mavor, Anne (Anne H.)
 Strong hearts, inspired minds : 21 artists who are mothers tell their stories / by Anne Mavor ; photographs by Christine Eagon.
 p. cm.

 1. Motherhood and the arts. 2. Women artists—United States—Interviews. 3. Arts, Modern—20th century—United States. I. Title.

 NX180.M68M38 1996 700'.85'2
 QBI96-40188

Printed in the United States of America

Cover photograph: Anne Mavor and son Rowan Karas in 1993 by Christine Eagon

To my mother
Mary Hartwell Mavor
who taught me the importance of art
—A.M.

To my daughter Cara
—C.E.

This book accompanies the traveling exhibit
"Strong Hearts, Inspired Minds:
21 Artists who are Mothers Tell Their Stories."

For information about booking the exhibit write:
Strong Hearts, Inspired Minds, P.O. Box 5644
Vancouver, WA 98668

To order copies of the book send $24.95
plus $4.00 (postage and handling) to:
Rowanberry Books, P.O. Box 80637, Portland, OR 97280

Contents

Introduction

The year I turned thirty-six I went from being a single woman living on my own, doing performance art and making wood sculpture, to a married mother of a baby boy, trying to get some sleep. It was quite a shock. But the biggest shock was that I was suddenly alone. I hardly knew any married people, let alone other mothers of infants. I couldn't stay up late anymore and my artist friends dropped away. I felt insane, frantic and depressed. And what about my artwork? It was sporadic at best and very difficult to do. What had been my lifeblood—my art, was just not accessible. I was adrift in the sea of new motherhood with no rescue ship in sight. How could this be?

I wasn't buying that crap about my child being my best creation, either. Rowan was and is, of course, beautiful and smart and funny and amazing, as all kids are, but he cannot satisfy my artistic urge. He cannot be my voice to the world. He has his own voice. The best gift I could give him would be to use my voice to the fullest. I had to find a way to combine motherhood with artmaking. I didn't want him to grow up telling people, "Yes, my mother used to be an artist before she had me, but she stopped and could never get going again. I guess it wasn't that important to her." As Rowan would say, "Yucko!"

One day, during a particularly trying day with my then two year old son, I had a tremendous desire to know what other women in my situation were doing and thinking. I wanted to hear their stories, their successes and failures, their ideas, everything down to the last gory detail. I wanted to know how they did it and I needed to know that I wasn't the only one struggling to strike a balance between two demanding offspring: my art and my child.

So I decided to write a book. If I was craving this information, thousands of others must be, too. We needed to know that the lives for which we yearn are possible, because for all of us, life without creative expression is unimaginable.

Ironically, the way artists and mothers function in society is incredibly similar. It is high time that the myth of artists being solitary, irresponsible, self indulgent, childish, crazy, elitist, starving/rich, childless and mostly male was blasted out of the water. Artists, like mothers, besides being excellent business people, are hard working, resourceful, versatile and disciplined. They have to be all those things to have figured out how to do their art or parent successfully in this unsupportive society. The minimal governmental support for the arts is quickly disappearing, especially for alternative and courageous art forms. Arts education is shrinking as well. Parents of small children are left to scramble for childcare. Single mothers with limited resources are fast losing welfare as a safety net. Artists and mothers living amidst this culture that undervalues both artmaking and child rearing are the sole

visionaries for the future. I am amazed that anybody willingly becomes an artist or a parent anymore.

But both roles are chosen for love and cannot be easily cast aside. In addition, they are crucial to the functioning of our society. If artists and parents suddenly stopped doing their unpaid jobs, the world as we know it would fall apart. No one would be bringing new people or new ideas into the world, nurturing and loving them until they could stand on their own. To say that joy could be a scarce commodity would not be too rash. Certainly, both roles combine a hearty mixture of labor, pain and joy. Taken together, they lead one on a path not taken by the weak-hearted.

If the truth be told, the real, bottom-line, secret reason I decided to embark on this enormous project? I wanted friends again. I wanted to get to know women all over the country like and unlike me. I wanted to be included in the world again, except I wanted all of me to be included—mother, wife and artist. I wanted to find out how to live an integrated life so that no part of me would ever be left behind.

In choosing the women for this book, I used two main criteria. First, they must be serious artists and second, they must have been artists before, during and after raising their children. I wanted to look at what happens when artmaking and motherhood are simultaneous rather than sequential. These artists are examples of women who did not give up. I also wanted a wide range of lives: age, ethnic background, class, medium, marital status, level of recognition, sexual identity, number of children.

I invited photographer Christine Eagon to collaborate with me.

Photographs that showed the relationships between the artists and their children were important to include. Since Chris is a mother, too, the project became a personal journey for her as well. Over three and a half years we traveled together to each artist's home, where I conducted an interview, Chris a photo session.

I have written this book as if you, the reader, is perched on my shoulder seeing what I see and experiencing what I experience: the hesitations, the pride, the moments of embarrassment, joy, surprise, and the growth of my relationship with each woman.

The information compiled in this book raises the question, "What is a good mother?" Is a good mother one who serves everyone else and gets the leftovers? Or one who makes sure she is well fed along with the others, no matter what? The consensus among the women I interviewed was the latter, but it was not achieved without inner and outer struggles. Most of these women had no trouble coming up with examples of how they are terrible mothers. We are bombarded every day with reports of how our mothering is lacking. What is more valuable is hearing and telling how we are great mothers.

I asked a lot of questions about the artists' own mothers, many of whom had dreams of their own but gave them up to raise a family. In spite of that, almost every artist spoke glowingly of her mother's intelligence and strength. Most importantly, these stories about the artists' mothers are startling glimpses into the past, revealing the clear need for feminist movement.

Support. Help. Community. Simple things, yet not in abundance. The women I interviewed who were able to go further in their careers clearly had more support of all kinds—emotional, financial, artistic. I

was both disappointed and gratified at the enormous role husbands and partners play as primary support. Disappointed because I'd hoped to see the women use a broader base of support—friends and/or family. Gratified because these (mostly) men are taking equal responsibility for their children. Those artists/mothers, mostly single moms, who lacked sufficient help were more easily deluged and tempted to give up. But no one really had enough support.

There were some generational differences. Those over fifty remembered experiencing more discrimination from art communities or teachers. The younger women denied being treated differently as a result of being either female or mothers.

I was puzzled, since conditions haven't changed significantly for women artists in the last thirty years. Blatant discrimination is no longer fashionable in art schools and universities, yet it continues in more subtle forms, strong enough to make talented young women artists flounder and question their abilities. In 1990, Artists Equity Association reported that in juried exhibitions, which are judged blindly, without foreknowledge of gender, race, etc., 43.3 percent of entries were women. In invitational exhibitions, where the artist is known to the juror, only 15.9 percent were women. Finally, although 53.1 percent of art degrees were awarded to women, female artists received only 27 percent of grants and fellowships.

In this age of assumed equality, is complaining about discrimination seen as unattractive behavior for up and coming women artists? Do we prefer to side with the male power structure and not rock the boat?

Each time I asked the difficult yet obligatory questions, "Would you ever consider leaving your children to focus on your career?" or "If you had to choose between your child and your art, what would you do?" almost all the women balked, giving passionate and explosive responses. The idea of having to choose seemed alien to most of the women, leaving me with my own questions, "Is either/or thinking just not applicable to this situation? Is that a possible 'male' model that these women refuse to accept?" Instead of succumbing to black and white thinking, the women often gave me images that showed how the many parts of their lives took turns being dominant. Spokes of a wheel. A hurdy-gurdy piping out each part of her life in turn. The petals of a flower encircling a center core.

Toward the end of each interview, I asked what goals they had for their lives and work. Most said they would just like to keep on working. A few courageous ones spoke of specific dreams or ambitions. I sensed that they were rarely, if ever, asked that question, either by themselves or by others. Unabashed ambition continues to be seen as negative for women, along with being angry, businesslike or competitive.

Visibility in the world is still a challenge for women artists. We may be able to surmount enough obstacles to create the work, but when it comes to promoting it or selling it, we stop. Sexism raises its huge head, looks down its nose at us and says, "If you were a real woman you would keep quiet and settle for whatever the culture decides to give you." When women become highly visible in our society they risk attack and criticism. Since her husband's election as president in 1992, Hillary Rodham Clinton has been barraged by negative feedback on all fronts. No wonder many women run for cover, not even

trying to let their voices be heard.

To our credit not all of us are running anymore. More and more we are letting our voices ring out. Most of the women in this book are midcareer. They have many more years ahead of them to be heard. We are making a difference in the world. No artist/mother, dying to express herself, need feel alone and hopeless anymore. A place exists for her wonderful and unique contributions.

Each of the seven chapters focuses on a different operational mode or style. While each artist's life contains aspects of all these modes, each is more involved in some than in others. The first chapter, *Pioneers,* consists of a group of women who had children in the fifties and sixties, and had to cope with a world that was openly hostile towards their choice to be both a mother and an artist. *Strivers* are a group of highly ambitious women who have arranged their lives so that they have everything they need. *Vagabonds* are artists whose work often takes them away from home. This chapter also necessarily focuses on the importance of support. The women interviewed in *Tough Choices* are united in being forced, for many different reasons, to separate from their children for varying lengths of time. *Inspired* is a look at artists whose work and lives have been enhanced and enriched by motherhood. *Revolutionaries* are women working to redefine motherhood, gender roles and where they fit in our society. Finally, *Transcenders* are those who have gone beyond the normal expectations, continuing to take risks that most of us would avoid. They make me feel that I too, can expand my circles to include ever more love and generosity.

These chapters are not meant to reduce the wide variety of lives to a few convenient catagories. By grouping them I am seeking to show similarities and highlight some of the patterns that have emerged from my research. If you find that your life does not fit neatly into this assortment, take heart, mine doesn't either. It is enough to have an array of lives before us, from which we can pick and choose, empathize with and puzzle over.

My secret goal for the book has been met. These women came to me from personal recommendations, but I did not know any of them personally before the interviews. I now count many of them as friends, all of them as inspiring.

Despite the lack of admitted ambition, these women *are* action oriented. In order to create time and energy to work, they are constantly reorganizing and rescheduling their lives. They are flexible, able to drop one thing, attend to an emergency and get back to work later. They are efficient workers; they use their limited time well. They are clear on their priorities. Any chaff is quickly cut away, leaving the essence. Many commented on how their work softened and deepened after they became mothers.

Courageous is a word I would also use to describe these women. As well as, loving and honest and hardworking. They are dead serious about their work and see it as crucial to their lives. And they are devoted mothers, every one.

What did I learn? The question I started out with, "How do they do it?" has been answered. Artists who are mothers do it any way they can, do more than they thought possible and do it in

myriad ways. I feel more competent, with the knowledge that I am one of many and am free to build my life the way I want, instead of following some fictional perfect formula. In fact, the women I interviewed who had lives that worked the best were those who made their own rules.

I also was amazed and pleased to learn that it *is* possible to be a mother and an artist and thoroughly enjoy both. While not the easiest path and not one supported by the culture, women have made art while simultaneously raising children throughout the ages. Although the vast majority, especially the few who achieved entry into the art history books such as Mary Cassatt and Georgia O'Keeffe, chose not to be mothers, some exceptions exist. These artists were often the breadwinners of the family, their husbands taking on the nurturing role. At the least, these women received encouragement from husbands, who were likely to be artists as well and, in the case of Sonia Terk-Delauney and her husband Robert Delauney, were also creative partners. If husbands proved unsupportive, the artists tended to leave the marriage, rather than stay in a situation that hindered their work. Both Artemisia Gentileschi (Italian 1593-1652/53) and Elisabeth-Louise Vigee-Lebrun (French 1755-1842) were single, both traveled with their daughters all over Europe painting portraits and became highly celebrated. We can take pride in being part of a long line of strong and stubbornly persistent artists who lived original lives. My hope is that artists/mothers can cease to be the exception, requiring super-normal energy and commitment. In my dreams, we will live in a society where creativity is as natural as breathing and where all people will be able to explore it to the fullest.

The making of this book has been a personal journey into that vast unexplored territory where motherhood and artmaking meet. As the miles and words piled up, my life changed. From the tentative beginning phone calls, through the scheduling and negotiations, to the actual time spent staring into each other's eyes, to the transcribing and editing of the interviews, each woman affected me. I would try on her life for awhile, see what worked for me and discard what didn't.

I can now navigate easily through this territory. The dangers that lurk there do not scare me anymore. I am protected by the experiences of all the women I interviewed. They live inside me, ready to come forth when needed.

Chapter One: Pioneers

The only unifying factor among these four women is the fact that they all raised children during the fifties and sixties, which was a stifling era for women. It was before the feminist art movement when male artists, critics and teachers could still be blatantly sexist toward women artists.

All of these women saw motherhood as a given, and were somewhat surprised when I asked how they chose to be mothers. It didn't seem a choice, but rather a role to follow. And on top of this expectation loomed the pressure to be the perfect mother. This was the era when the specter of June Cleaver hovered over every house. So even though they had the courage to reject that model, there was more guilt in this group of artists than in any other.

Yet once mothers, each clung tightly to her identity as an artist, much more diligently than women of later generations had to. The environment for women artists, much less mothers who were artists, was openly hostile. Male artists, teachers and critics could still say things like "to art . . . only the men have wings"—Hans Hoffman. Women had to work twice as hard as male artists just to be taken seriously. Perhaps this blatant sexism made them even more determined to succeed. All three, Bella Feldman, Susan Weil and Patti Warashina, have a fierce determination that exists in a milder form for the younger women.

A certain toughness hovers around them. This group has not and will not give up. They have seen the art market go through several incarnations, seen fads come and go, seen the feminist movement make inroads and seen it falter. They are still here and still working.

Pictured from bottom: Bella
Feldman, Nina Feldman,
Ethan's wife Susan Feldman,
David Feldman (on lap),
Ethan Feldman, Arianna
Feldman, Leonard Feldman.

Bella Feldman, SCULPTOR

BELLA FELDMAN'S SCULPTURES are like she is, built of steel so they last, filled with dark humor that sneaks out the back door to run and play. They embody an animal essence, even if they are machines or giant kitchen utensils. On the day we visit her studio she is photographing a series of sculptures shaped like rocking houses. One is a giant menorah. Her work could, if one's back were turned, move on its own.

Her studio is in a big gray warehouse in Emeryville, a section of Oakland, California filled with artists' studios. At our knock, she unlocks the outer door, lets us in and we follow her down the dark hall to her studio, where we are greeted by the sounds of pounding and the hiss of a welding torch. Bella's assistants Sean and Kristen are hard at work. Bella is dressed all in black, and her grayish white curly hair flies around her head. She is beautiful with her expressive mouth and mischievous eyes. We settle at a table in the kitchen area to talk.

Although Bella has lived most of her adult life in Berkeley, California, she was born and raised in a working class tenement in the Bronx, New York. Her parents were immigrant Jews who left Poland for the United States in the 1920s. Her father arrived in 1926 and her mother and older sister joined him in 1929. Bella was born March 1, 1930. A younger sister and brother followed. Her father worked as a shoemaker and her mother stayed at home.

She now lives in Berkeley with her husband, Leonard Feldman. They have two children, Nina and Ethan, and two grandchildren. Bella teaches sculpture at the California College of Arts and Crafts in Oakland.

I get rough answers to my questions and there is an undercurrent of anger in her words. Perhaps she is saying what most of us are feeling: frustration at not getting the recognition we desire as artists. Though she is respected and known as an artist in the Bay Area, she yearns for more, and regrets the years that she didn't actively pursue her career as an artist. When she looks back at what was hardest about being a mother and artist in the years when her children were young, she recalls, "I had the false illusion that I was functioning in my career. But my studio was in my house, which was probably a mistake, considering the distractions. Anyway, I had the impression that I was working and progressing. Later I realized I was barely holding on."

While not denying her tough experiences and desire for more recognition, I want to acknowledge what she *has* done, which is quite a lot. She combated blatent sex discrimination, isolation and her own limitations. During her children's younger years she taught part-time to pay for childcare so she could work on her art. This was something almost unheard of in the fifties. But she was grateful for the discipline it provided. She smiles as she muses, "There is nothing like laying out

money to focus your mind."

Bella's daughter, Nina Feldman, gives me another side of the story the next day. "I'm really proud that she's a famous artist, but she doesn't seem to recognize how far she's come. I guess that's the perfectionist in her. If I were just to talk to her, I would think she had been a total failure as an artist in terms of the public. I think the fact that she is still climbing up, even as a woman in her sixties, is really amazing. I'm proud of her."

In 1970 Bella had to wage a campaign to keep her job at California College of Arts and Crafts, where she has taught since the sixties. When Leonard's work took the family to Uganda for two years, Bella took a leave of absence from CCAC and taught at the Fine Arts School in Uganda. But "when I returned to the United States, I found that my teaching position was in grave jeopardy. A new chairman had been hired in the sculpture department, and he made presumptions about me as a woman, that I lacked serious talent and teaching ability. He didn't know me or my work at all.

"It was then I realized that the period of time when I thought I was working, I had been just keeping my hand in. That was when I should have been going full force establishing my reputation by having many exhibitions and teaching full-time. I would not have been so vulnerable. Of course, then I probably couldn't have raised the kids, either. So I dug in my heels and fought to stay at that college. I did some research, and found that for a hundred miles around, there was no woman teaching sculpture at eleven universities and three or four private colleges. So I was able to take my case to Equal Opportunities and win."

This was a turning point for both Bella and the school. Her voice intensifies and her sense of outrage is apparent. "I got no support for that battle from the administration," she says, "but it really galvanized me. Before this, the women teachers in the school had not really related to each other. We were about fifteen percent, which is more than most schools at that time. I did bring them together and get their support and I did fight it, and we did change things. The women's studies program, which still exists, came out of that."

Before this experience, Bella had been "pretty timid" but "became much more assertive and ready to fight." She chuckles and adds, "Adversity is kind of useful. In fact, I use this experience as an example for women who are afraid to fight, for fear of being stigmatized. Once I resisted I became very visible on campus and visibility means strength to most people. So shortly after I won the case, I was elected by the faculty to be graduate director. I went from someone who was barely hanging on to a job as a lecturer to becoming graduate director as well as tenured faculty."

Bella is possessed of incredible drive. She laughingly attributes this to the fact that she, as well as her three sisters, "have been extremely busy trying to avoid becoming like our mother." Bella's mother suffered from severe paranoia and lived an isolated and unfulfilled life. Bella puts her mother's life into a larger context, what she calls Jewish paranoia. "The theory is that there is a genetic streak of paranoia caused by thousands of years of persecution. Those that fled at the first sign of trouble went on to reproduce while the nonparanoid would perish. There are varying degrees of it but my mother had it quite severely. In her case it was useful because it made her want to get out of Poland.

And of course in 1936 or '37, Hitler moved in and many of my relations were killed."

Bella tells more of her mother's story. "She was extremely beautiful, which is one of the reasons my father married her without a dowry. She was orphaned when she was seven years old. In the stetl (these little towns in Poland), people barely survived and lived hand to mouth. If you had parents, you could go to any town where you had a distant relative and they would take you in. But if you were an orphan, nobody looked after you. So at seven, she and her sixteen year old brother were put out on the streets. He managed to get himself apprenticed to a banker and found a cellar to sleep in. My mother was out in the streets until a kind woman took her in, where she functioned as a child surrogate, but also as a maid. She was given some education and could read and write in Yiddish, but when she got to be an adolescent, men started pursuing her and so the family put her out again. She wandered as a homeless, orphan child during World War I, eating from the fields. So you could understand why she would be paranoid. I've spent a number of years in therapy with my therapist telling me I should get angry at my mother. I really couldn't." Bella starts to cry, then apologizes for the tears and stops.

I ask Bella if she was close to her mother. She describes a painful relationship with her usual frankness. "I was her favorite daughter and she talked to me all the time. But I can't say I was close to her, because she had a very limited and distorted picture of life. She was always saying some neighbor insulted her, and I had to listen to her stories. I discounted most of them, but still I was affected by them. She was invasively curious about my life. So in order to create a separate life I

would also distort the truth. I would gossip entertainingly about my friends' romances, just to keep her out of my own life. I felt a responsibility to keep her connected to me because she had so little.

"In some ways I was her mother. My mother could manage babies, but once they started to have personalities, she couldn't cope. So my older sister mothered me, and I mothered my younger sister, who was three and a half years younger than I. When my longed for younger brother was born, my mother got sick. She had pneumonia three times that one year. So now I truly mothered. She pulled me out of school and at twelve I had an infant to take care of. For most of the first year of my brother's life I received no schooling."

Bella's father seems to have been the stabilizing factor in the family even though he was working most of the time. "As a child, I adored him. My mother hit us a lot and he was gentle. He would allow us to fondle his head and he'd tell us stories. But he was not the decision maker of the family. My mother dominated the family. When she was in a good mood, she could be extremely charming. But as she grew older she got more and more bitter and reclusive. She had no interests, except her family and tales she would concoct about the ill treatment she imagined receiving. But he outlived her. Now he occasionally says, 'You know, your mother tried to turn the children against me but she didn't succeed.'

"My father tells stories of World War I, when he got along well with the German soldiers because he could communicate with them in Yiddish, whereas the Poles couldn't. My grandmother was a kind of Mother Courage character during World War I. You know the Brecht play, *Mother Courage*? [ed. note. A play by Bertold Brecht about an old

woman who traveled with a cart selling goods throughout the countryside in Sweden during the Thirty Years Wars.] That's what she did to keep her family alive during the war. She'd take what was plentiful in one village and put packs on her children's backs and at night they walked through the woods to another village and would sell to the soldiers or to the other villagers. It was all kind of contraband. My father keeps telling me these stories with great gusto. It was a great adventure for him."

I am intrigued. The image of her grandmother using the available resources is not unlike Bella making art out of junk metal. Bella agrees. "I do see a connection. Her name was the same name as mine. She also used to go into the woods to gather up mushrooms and strawberries and sell them. She cooked for people. And I like to cook and I *love* to gather wild things. I was thinking about her just yesterday when I had my grandkids with me. We found mushrooms and I started talking about it."

As Bella tells me these stories I can easily see those individuals and landscapes hovering around her as she works on her giant sculptures that are so alive. As a child, her imagination was the way out of her harsh family life. "I escaped into reading. My older sister's greatest gift to me was introducing me to the public library. I'd come home with a stack of five or six books and hide with them under the bed. I did a lot of imaginative play. We didn't have any dolls, but I'd construct shoeboxes for castles and houses. Sometimes I look at my sculpture and see the shoeboxes that influenced them."

Her art education started with a friendship outside the family, given that "there was not a picture on our wall, except one of Lenin, which disappeared when I was about six. And a picture of my parents when they came to this country. It was absolutely bare, except for what you needed to live.

"When I was about eleven and a half, I made very good friends with a girl who was in many ways a child prodigy. Her parents were better educated. She played piano, drew well and she sang. Her sister was an art major in college. I made her home my home and began to draw with her and do things with her."

Bella was also able to take advantage of the special high schools within the New York Public School system. "When I was in junior high, they came around and asked if anybody wanted to apply to the High School of Music and Art. So my friend and I decided we would and we went for this test. The first serious drawings I did were for that test. We both got in, but her parents, being more protective, wouldn't let her go to school in Harlem, which was where the school was located. I went on to become an artist, and she didn't.

"Once I was at the High School of Music and Art, I found myself in the midst of the children of the intelligentsia of New York. I was in way over my head, coming from the background that I did. My best friend was the painter Ben Shahn's daughter, who had studied with Moses Sawyer since she was a little kid. She knew everything. I knew nothing. So I tagged around after her in adoration, picking up as much as I could, most of the time having terrible stomach aches, because I was so tense about keeping up to her intellectual level. She was an important mentor for me in high school and helped me form my tastes and direction."

Given that Bella comes from a working class family and her parents

were uneducated and had little support for or knowledge of the arts, I am curious as to how she thought she could have become an artist. "I was in a high school where most parents sent their kids on to college. My friends were smart and they were all going. I identified with them. Fortunately, city colleges in New York were free. So it was a question of just supporting myself. I still don't really know how I did it, because I worked five nights a week and all day Saturday at a department store. How I did my homework, God only knows. I majored in early childhood at that point because it prepared me for a job, though I continued to go to art museums."

Bella married Leonard Feldman when she was eighteen and a junior in college. They moved to California after her graduation where she taught kindergarten and Leonard started a lifelong pattern of total support of Bella's artwork. "He was always there and he was always supportive. He never felt competitive. He took great pride and still does in everything I do. It's rare. Leon is not an artist. He's in math education. He's really not a visual person at all. He's learned a lot just from hanging around me."

Nina comments, "What's great about my dad is that he gets interested in all the things she's interested in. She enlivens his life. He's an amazing person that way. She's made his life much more exciting than it ever would have been if he's married someone else. So they make this perfect couple."

After marrying, Leonard soon encouraged Bella to go back to art school. But Bella didn't feel she could leave a paying job, so she studied art during the summer. Later, a miscarriage during the eighth month of pregnancy impelled her to realize how important her art was. "It was

my first brush with death and death always makes you think about what your priorities are. It was at that point I decided I would go to art school full-time and not return to teaching kindergarten."

Bella always wanted to have children and was heartbroken over the first miscarriage. Another one followed and she doubted whether she could have children. Yet, she confesses, "I did it in all innocence. I didn't realize the sacrifices it would entail. They really were wonderful, but relentless in terms of energy consumed. When I tell my students it's very hard for a woman to be an artist and have children, I say it very seriously. Even if you have assistance, the sheer number of details that you have to keep in mind definitely interferes with the wholehearted concentration you need to be able to go through the long haul and develop a personal body of work."

When Nina was born, Bella was able to take her to school with her where other people would amuse and distract her while Bella worked. Bella went to California College of Arts and Crafts, which at that time had only three hundred students and had a relaxed atmosphere. She also employed babysitters.

"When my son came along twenty months later, it was too much. I tried staying home, but soon I realized that I would probably go crazy. I didn't really have a choice. And again, my husband, unlike many, was really supportive. We didn't have the money, but we scraped and I continued to go to school. I didn't go for a degree, I already had a BA. I just took courses."

In 1972 Bella went for a graduate degree, even though she had already been teaching for years. When she started working at CCAC it was common for teachers to be hired soley on the strength of their

work and exhibition list. But in the early seventies, policies changed, prompting Bella to get a graduate degree, which turned out to be a wise choice in more ways than one. "I had worked in a very isolated position as a mother. I caution my women students about the need to keep a peer group. I could have developed a lot faster if I had had people to interact with. And when I went back to school for my graduate degree, I found these people. I went initially only to get the degree to cover my ass and it turned out to be an important educational experience."

Later, Leonard's job took the family from Berkeley to Palo Alto, a suburban city, where Bella taught mosaics and sculpture classes in her garage. She was pretty alone. "I felt very isolated, because these women were nice enough and pleasant enough, but I was the big shot, and I knew I wasn't a big shot. I did see that the suburbs were deadly, the way they isolate women." This isolation proved too hard for Bella and she convinced the family to move back to Berkeley.

Growing up, Nina and Ethan had mixed feelings about having an artist mother, ranging from pride and admiration to embarrassment and shame. When Nina was five or six and living in Palo Alto she remembers feeling embarrassed when her mother was teaching housewives mosaics. "I had a very strong idea of what was feminine. And what my mother did when she got into welding was not feminine. Maybe I was getting these vibes from other people in Palo Alto which was pretty conservative. The garage door would be open, so she could get some air, she'd have her blow torch and her goggles and a big dirty lab coat on. I remember just wishing that she would look like the mom in the *Dennis the Menace* cartoon with the little apron and the high heels and the permed hair and the lipstick."

Bella remembers, "When my son was about eighteen or nineteen, he told me he had been terribly ashamed when he was younger. Why wasn't I a group mother like his best friend's, you know, a class mother and make cookies? And there I was visible to all the neighbors doing this weird thing. When they got to be adolescents, I became a source of pride, particularly to my daughter. They would march their friends passed me while I worked and say, 'Look at my mother, she's so cool.'"

Bella denies having been affected as an artist by her children. With the unabashed discrimination against women artists, especially mothers, it makes sense that she would try to separate her artwork from her children as much as possible. She states adamantly, "I don't think it was affected at all. My own childhood influenced me. For example, reading fairy tales was fascinating to me. It moved me toward the surrealism of my early work, which has been modified and formalized over the years. There is still a surrealist underpinning to much of my work. My interest in archaeology, time, my own anxiety. These are the large issues that have shaped my work."

Then she reconsiders and offers, "Of course my love for my children increased my anxiety. When the children were small, I was extremely anxious for their survival. Nuclear testing was happening all the time and I really wasn't sure I would see my children to adulthood. That nuclear anxiety affected what I did for years. It still shows in the kind of ironic war machines that I do now." She pauses and then admits, "I'm anxious for the world again now that I have grandkids. One's kin makes issues more visceral."

Bella is ecstatic about her grandchildren. But she is glad not to be

responsible for their growth and the emotional baggage that goes along with it. "I can just have fun with them. My daughter-in-law is a wonderful mother. Her kids love her, but I asked the little five year old one day, 'If you were a teenager, what would you wish?' She said, 'I would wish for a car so I could get away from my mother.' She loves her mother! But there it is, already as a germ. It's that fact that you have to socialize them and keep them in line. I think living in an extended family is better, where that task is shared, and all the hard feelings that mothering engenders is not just focused on the mother."

She reflects on her own motherhood. "It was very good that I studied early childhood development because it made me a better mother than my mother. My mother was fearful, we couldn't try things. I absorbed those fears, but I learned through this training, not to stop my children from doing things."

Bella's face brightens, "Children always teach you to see the world fresh. Of course, when they become teenagers, they are really off on their own. But we traveled together in Africa and in Europe. What did I learn from the kids? Well, I love them. Love is an important teacher. But I learned more from my students, in terms of ideas, than from my specific family." She explains why. "As a teacher you have things to offer and you're sort of parental but you don't have the the parental emotional baggage. You're readier to listen to them. It's just a much easier interaction."

Bella loves teaching. It is a source of inspiration and community for her. "It's been a two-way street. I've been really helpful to people and I've learned a lot from them. I've had good male students and I have strong friendships with them, but I feel I'm most valuable to women students. For those who are thinking about marriage, I'm someone who is married and has kids and has done the work and they see it happening. Also, having gone through all the stuff that I did when I was young, I can recognize the pattern of selfeffacement, the willingness to let the guys speak first or speak for them. The wanting to do tiny work, not really because they are interested in intimacy, but because they don't think they deserve much space. I went through that so I can spot it and talk about it in a way that few of their teachers can, even if they are women teachers. I think women who are teaching now who are in their forties perhaps are not so aware of that particular struggle as I am. They didn't face it in as obvious a form."

I ask Bella if she had hidden from the art world the fact that she was a mother earlier in her career. Her eyes suddenly flash as she answers angrily, "No I foolishly didn't."

While fighting for her job upon her return from Africa, She had had to address the faculty assembly about someone's criticism of her not "having quite the prominence that he was expecting. I made reference to the fact that I *had* been exhibiting, and I'd also been raising two children. I put it as a point of pride. I then saw people turn around and titter and realized I had said exactly the wrong thing. This was regarded as an unprofessional moment. I had done all this and raised two children, too and it went over like a lead balloon. Subsequently, I have heard women say that they don't mention their children if they have them. I think that's pretty awful. I think that I was right in putting it as a point of pride. It's a really difficult thing to do."

When I inquire if she believes attitudes have changed toward artists with children, she answers vehemently, "No, I don't. I don't

think it's changed. It's true that it is really a struggle, and many women artists succumb to it when they decide to have children and just give up. It is really hard."

Bella says she has never considered leaving her family for her artwork, but adds, "I can certainly understand women doing it. When you get passionate about your work and if you feel that your husband and other members of your family could carry on . . ."

Even though Bella has never left and clearly never intended to do so, Nina recalls moments when her mother, out of frustration, would suggest leaving the family. "Oh she used to threaten it all the time. I'm not sure she meant it. It was very upsetting. She would say it in the total heat of argument when I was a teenager and we were having all sorts of mother daughter problems. She'd say, 'I can't stand this. You're driving me crazy, I'm leaving.'"

The history of Bella's work reveals her constant struggle to succeed as an artist in a male dominated medium. As she talks, she warms to the subject. "When I started studying sculpture, CCAC was a small school. The sculpture department was a one room Victorian building. There was a graduate student there, Fran Moyer, who worked in steel. I was just fascinated to see a woman using this serious tough material. Fran Moyer showed me that a woman could work with steel. So I learned to do it.

"It is a very malleable material and takes the kind of small motor skills that women are very good at and is really very much like sewing. It's a forgiving material in the sense that you can make mistakes and correct them easily. It's certainly cheaper than bronze casting. It really intrigued me that women could do this so well. If you work large scale, you do need hoists. But men should also use hoists to lift.

"I worked in steel for quite a number of years with an old oxy-acetylene tank. Then I got interested in more, let's say, female shapes, round billowing shapes. But I couldn't forge those kind of shapes. It hadn't yet occured to me that you don't have to make them, you could find them. So for some years I left welding and worked in other materials. I've worked in cast and fabricated media: resin, aluminum, wood, steel, bronze and cast paper."

By 1985, Bella was back working in steel. While getting ready for a show she realized she needed help. This was another turning point in Bella's work. "I put out word that I needed an assistant and Kristen turned up," she says grinning. Kristen "is a much better technician than me, just has welding in her fingertips. And we were a congenial team. I was able to work much faster, and design more because she was so quick at executing. In addition, that isolation I've spoken of so often was gone. I had somebody to discuss the work with. I'm convinced that artmaking is not a solitary thing. One needs some solitary time, but you also need a lot of interaction and discussion. And Kristen and I were able to do this."

Finding colleagues and an artistic community is a recurring theme throughout Bella's career. She yearns for interaction with other artists. "In New York, artists really talk a lot. I've been here for many years, but I'm basically a New Yorker. I think better when I talk and it's very useful to give and take criticism. In the Bay Area it's very bad form to talk about your work. Originally I had a little solitary studio by my house and I was isolated. I finally got ambitous enough to rent in this building which is full of artists to talk to. They come by and say hi,

but nobody talks about your work.

"I talk a lot with my graduate students about how important it is to keep your peer groups and keep the interaction. But they report back that a quality of politeness tends to creep in which stifles a free exchange. They are afraid to say something that might alienate someone. I encourage them to talk in my classes and hope it will become a necessity."

This brings up the issue of perceived scarcity of opportunities in the art world. Is there a fear that we might slip and share a secret? Bella nods and adds that there is "also the feeling that you're not doing as well as you should. You are comparing yourself, instead of feeling some kind of comradeship. I don't expect it will change in my lifetime. But I do have the graduate students and former graduate students and that's good. I can encourage them and talk about their work. I don't feel superior to them. I think people can make good art at any level, so I'm quite willing to accept a student as a peer. I don't feel that I'm necessarily any better. I have much to learn from them."

Bella's advice to women who want to combine motherhood with art comes directly from her own regrets. "After I made the commitment to being an artist, my husband and I decided that since he could earn more money, I would essentially take care of the household. I would earn the extra art money." Emphatically she resounds, "That was a mistake. We should have somehow divided our careers. He should have worked less and been more of a family participant and I should have worked more. It was a decision that seemed to be very practical. But it was costly. It kept me back professionally. I wasn't taken seriously and as a result, I didn't take myself as seriously as I

should have. If I had it to do all over again, that's the change I'd make. I just didn't know any better at the time. I was very bold to actually hire somebody to come in. That was considered very radical given our limited income. Hopefully the future will allow for more of that flex-time."

Either way she looks at it, Bella doesn't perceive herself winning. On the one hand, she regrets the time she didn't work hard at her art. On the other, she regrets her willfull ambition. "I was too preoccupied with my own issues," she says. "I was engaged in the fight for my job at CCAC. It filled my head and dinner table conversation. [My children] felt that I was not sufficiently interested in them. And that was probably true."

Perhaps there isn't anything to win, just the opportunity to become more and more who she is: an artist who is living a full and passionate life. Bella snaps into the present. "I have a strong connection with my grandkids," she says, and her mouth widens into an impish grin. "I had a show recently and they were all there. At the opening while I was chatting with people my five year old granddaughter held my hand while chanting softly, 'She's mine, she's all mine.'" Bella has a bemused expression on her face as she reflects, "Maybe the grandkids aren't that different than my own children. Perhaps the problem my children had with me as they were growing up was the fact that I wasn't sufficiently 'all' theirs." She shakes her head slowly, "It's probably not possible for an artist to be that kind of mother or grandmother."

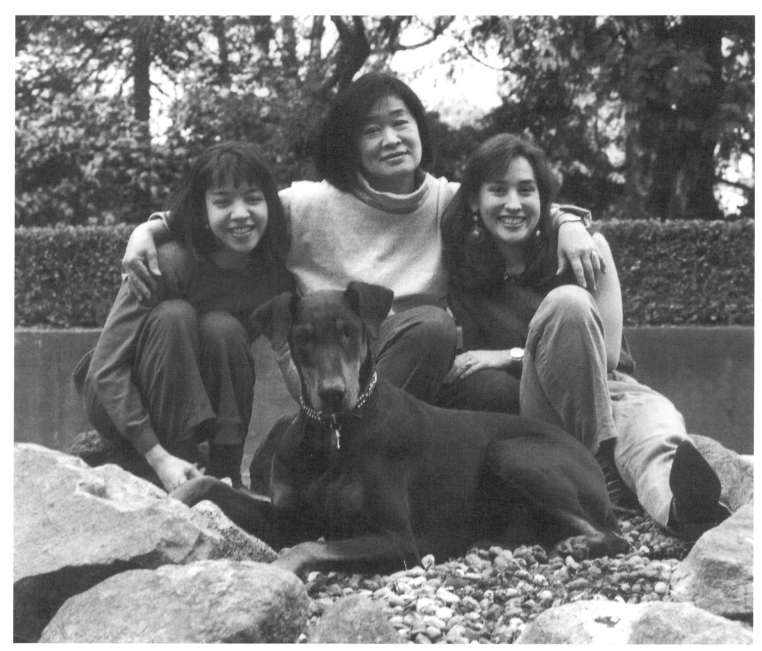

Pictured from left:
Lisa Bauer, Patti
Warashina, Gretchen
Bauer. In front: Kirow

Patti Warashina, CERAMIC SCULPTOR

PATTI WARASHINA'S studio and living quarters, overlooking one of Seattle's many harbors, looms up behind the cute pink cottage in front like a large and very forward distant cousin who gives big handshakes and hugs that leave you gasping for air. It is huge and gray and industrial. The first floor houses Patti's studio, the second floor is where her husband Bob Sperry works and the top floor apartment is where they live and entertain. They have a glorious view. For the interview we meet in the pink cottage where Patti's office is.

Patti is third generation Japanese on her mother's side, born March 16, 1940 in Spokane, a city in eastern Washington. Her father emigrated from Japan when he was seventeen, earned money by working in a saw mill and then sent himself through school, eventually graduating from dental school. He had an arranged marriage with Patti's mother, who was second generation Japanese or Neisei, born in this country. In 1951, when Patti was eleven and in the seventh grade, her father died at fifty-two of stomach cancer, leaving Patti's mother to support three children. Patti is the youngest. Her sister is eight years older and her brother two years older.

When I ask Patti about her class background, she hedges, since the answer is complicated by racism. "When I was young, the Japanese American community kept to themselves. Until I was in grade eight, my brother and I were the only minorities in the school. Our family was middle class in means, but I never felt a part of the mainstream middle class."

Patti graduated in 1964 with an MFA in ceramics and jewelry from the University of Washington, where she now teaches. She has taught art at the college level for thirty years and has exhibited her ceramic sculpture here and abroad. Patti's work ranges from the intimate to the monumental. It is narrative, usually figurative and speaks with a sharp wit. She has two daughters by her first husband Fred Bauer. Gretchen is twenty-nine and Lisa is twenty-eight. Both were later adopted by her second husband, fellow ceramacist Robert Sperry.

While we talk I have a mixture of feelings ranging from respect for her unwavering commitment to her work and making it visible in the world to admiration for her ability to do so in the face of single parenthood and academic pressures to frustration because she is not more open about her feelings. But later, as I'm transcribing our conversation, I see clearly that for Patti her salvation lays, as she repeatedly explains, in "just doing it."

Patti glitters like a highly polished gem, quick talking, fast moving, impenetrable and strong. Like a bulldozer, it seems that nothing can stop her. Indeed, two things strike me most about Patti Warashina. First, that her mother was and still is, a huge, even heroic figure in her life. And second, that they both live by the same motto, in Japanese

called, Shigata Ganai "If something should happen, make the best of it."

Patti retains a solid Japanese core, despite being born in the United States and raised during and after WWII, when anti-Japanese sentiment ran rampant, causing her family to Americanize almost instantly.

Living in Spokane, Patti and her immediate family were not forced to move to internment camps, like the Japanese Americans living nearer the Pacific Ocean, but they were closely monitored by the government. Patti's father was searched both at his office and at home, since he was an elder in the community. "About four or five FBI men spent several hours at the house searching for contraband, or anything linking my parents to spying for the Japanese government. In Spokane, the government froze all Japanese bank accounts for three or four months after Pearl Harbor. My mother couldn't touch the thousand dollars she had in her account. My dad's office rent couldn't be paid. Fortunately, the Jewish landlord was very kind and allowed him to stay, but dad was not allowed to charge or bill his patients as he was considered an 'enemy alien' because he was from Japan.

"My mom had twenty-five dollars cash when the accounts were frozen. She spent five dollars for fifty gallons of stove oil, to last one winter month with the temperature set at fifty-nine degrees. I was one and a half, my brother three and a half and my sister nine. There was no welfare program to turn to so we ate very sparingly from the canning that Mom put up from the garden. Luckily we had some corned beef and Spam put away from the war rationing. My mother still gets very upset about this time."

Resourcefulness reached into Patti's playtime, as well, since toys were scarce. "I had a homemade tent on the porch that I anchored down with rocks that I carried around all the time. When I was about ten or eleven, the neighborhood children would play kick the can or hide and seek at night. We liked to peek into neighborhood windows. I remember getting baby chicks for Easter and raising them in a chicken coop and pen, until one day a neighbor dog killed four or five hens. Dad suggested we not waste them and had Mom cook them." Patti stops and grins. "No one ate that evening except my dad."

Patti describes herself as a good student who studied hard. But she doesn't take credit for that. "It was programmed into me from very early," she says, "which was typical of Japanese families. My mother used to say, 'It doesn't matter how poor you are, as long as you have clean clothes and feed the children well. If you have a good education they can take your possessions away from you, but they can't take away your knowledge.'"

References to Patti's mother sneak into our conversation constantly. I want to know more about her. Patti is happy to talk about her mother, possibly happier than talking about herself. "Publicly, she is a shy, rather retiring Japanese woman, who doesn't push herself forward. She had a solid high school education and enjoyed school. If my mother had the opportunity for higher education she would probably have chosen an artistic field. She has incredible dexterity and loves to keep her hands busy, as well as, a visual mind. She is also romantic and loves beautiful objects and surroundings. She used to love to read about King Arthur and the Round Table, Greek myths and fables and would recite a few lines of poetry when the feeling struck her. She also took ceramic classes at the Y when I was young. She sculpted beautiful roses

on mirror and brush sets, frames and earrings. She made a very detailed wax chess set of knights in robes holding swords, two inches high. She had hoped to eventually cast them in gold scraps from Dad's office. She always had some project to challenge her curiosity.

"She's a very ethical person. She never says anything bad about anybody. Many older Japanese people are like that. After the war, they never complained. I often wonder if this detachment is related to Zen Buddhism, which is so much a part of the earlier Japanese culture. Like yin and yang, you get the negative as well as the positive. And when you get the negative part, you just get through it.

"She is also very resourceful. Never wasting anything and always making things to improve her condition. She also learned to save what money she could and invested in the stock market to help with our education and her retirement. Her involvement in the Japanese Methodist Church also helped her to overcome problems."

When Patti's father died, that resourcefulness was sorely tested. "I remember my mom crying for what seemed like three years." Patti says. "I watched her change from a forty-two year old housewife with a high school education and no job training, into a breadwinner for three children. It really affected me. After Dad died, she sold the dental office and a year or two later started working in the display department at JC Penny's. She worked there for sixteen years and really loved the people she worked with. After that she worked for the Department of Social and Health Services for five years doing interviews, which was grueling work."

As Patti describes her mother's life now, her voice gets louder and faster. "She's very compulsive. She works hard all the time. Her house in Spokane sits on three city lots. The whole thing is covered with a lawn and flower beds and a big vegetable garden in the back. She's eighty-five. For a long time she mowed it herself. Now she has someone come and do it. She does all the gardening herself. The place is immaculate with large trees and beautifully pruned topiary.

"She makes me laugh. Last year I was staring at her and she said, 'What are you staring at?' I said, 'Well, you just blow me away. How do you do it?'

"She used to walk five miles a day, now she's down to three. She gets up at the crack of dawn, 3:30 in the summertime. I told her she shouldn't do that because it's dangerous to go out that early. She said, 'Well, it's cool then.' So I said, 'Tomorrow, wake me up and I'll go with you.' So she tried to rouse me but I didn't wake up. At 9:00 I woke up and found she had gone on her walk, come back and was canning fruit. She's really amazing, but she never complains. She just does it."

I am amazed but not surprised. I have come to the conclusion that women, in general, are overworked. "She really does work hard," I say.

"Yeah," Patti agrees, "I feel slow compared to her."

"What did you get from her?" I ask.

"Probably my compulsiveness," Patti answers laughing, rocking back precariously on her stool. "Resourcefulness, but I'm not as resourceful as she is. I learned about independence from her. She couldn't rely on anybody, because she was a widow. So she learned to fix things around the house herself. She still climbs up and changes the storm windows herself. She was on a ladder up on the roof last year. I got a lot of education just watching her treat things in a nonchalant

manner. She tries things and if it doesn't work, then she will call somebody. She showed me how to survive."

Those survival skills, learned at her mother's knee, were put to good use once Patti became a mother. She had her first daughter, Gretchen, at age twenty-four, and eleven months later Lisa arrived. During this period she was maintaining a career as a college professor. Then, when the girls were three and four years old, she became a single mother.

In a way, this was business as usual for Patti. She didn't grow up thinking about motherhood, but somehow assumed she would have children. "In those days, if you were not married by the time you left college, there was something wrong. Right out of graduate school, I married Fred Bauer, my former husband. We applied together for a full-time teaching position to share. So the fall after we graduated we taught at Wisconsin State University at Platteville. I had Gretchen while teaching, but I was back at work after one week out. It didn't seem to affect me physically too much. We lived just a few blocks from school and my mother-in-law Helen Bauer came to help us. She was really great to us."

"Did you think about how having a baby would affect your work at all? Were you concerned?" I ask.

"I had to get back to my job," she explains patiently, "as I didn't want to appear uninterested in my classes. Also I was young and I had a lot of energy. It just became a part of my life. I accepted it and it wasn't a big deal. Having two made me feel less guilty when I left them together with the baby sitter."

This pressure intensified after the divorce, when Fred moved to California, leaving Patti as essentially the only parent. Her shoulders tense as she remembers. "I had to be pretty organized in order to carry on with the career. I remember writing lists of things I had to do every day. I worried all the time about the baby sitter. I had to make sure she would be there when the kids came home. What if she got delayed or got the wrong bus?"

Patti also was able to impress upon her daughters the importance of her work and enlisted them to help her. "When the girls were very small, we had some very serious talks. I told them how important it was that I get my art work done and teach, so that I could support them. I think they took these conversations very seriously, as they were very dependable and responsible. They came home on time, locked the door, etc. They were 'latch key kids.' Although it was a difficult time for them, it eventually made them into very responsible adults.

"My biggest worry was when the kids got ill. Lisa had allergies and asthma attacks. The kids were brave though, and I was very fortunate to be living close to work. They also had each other to depend on. Actually, the three of us became very close because of our circumstances."

But feelings had to come out somewhere. "We used to argue Saturday mornings about getting the chores done. The house would be falling apart by the weekend and we were too." Patti solved this problem by initiating a 'neutral session' after they had finished cleaning. "The three of us would sit down and tell each other what and who was bugging us during that week. It was a way of being able to vent any hostilities without holding any grudges. Sometimes we'd cry, but generally we ended up laughing our apologies to each other.

"I do feel guilty that I didn't spend a lot of free time with the girls. We couldn't sit around and relax. At Christmas time, we'd make cookies, but there wasn't a hell of a lot of time to do that sort of thing on an ongoing basis, since I was trying to keep a career going too. I wasn't a 'mother.' But I think the kids turned out pretty well, in spite of it all. The hardest thing was just getting it organized and keeping it all together. I used to say to myself that all I had to do was keep my chin above water."

"But you were also good at that," I remind her.

"No, I wasn't," she answers shaking her head. "It was plain survival. I just had to do it.

"I know that there's a lot of things you *were* great at," I insist.

She finally relents, "All I can say is that I earned a living and made sure we were all fed and safe. And I kept my career up."

Patti pauses and adds, "The girls loved animals. In the beginning I didn't want the responsibility of a dog, so I purchased a pet black and white rat named Hagatha. They made a leash and used to walk it in the neighborhood. As they grew older we got a German Shepherd, rabbits, pigeons, gerbils, tropical fish, lizards and adopted a baby robin that became imprinted on the family. The girls were very good with animals and were responsible enough to care for them. So I guess my tolerance of animals may have qualified me for good mother status."

Patti's weekdays were spent at the university teaching and going to meetings. In the evenings she would come home, cook dinner and supervise her children's homework. "When the kids were really small I used to put them down to bed at eight o'clock. I said, okay, after 8:00, it's my time. I had an aquarium and I put the bubbler and the tank light on and let them read in bed. It became a night light with the fish going back and forth. It was the greatest thing I could ever have done. It was an instant baby sitter and made nighttime a pleasant experience.

"After 8:00 was my time and I would do desk work, get organized for the next day and go down to the studio. Night was the most peaceful time to work in the studio, with no interruptions and I could work until three a.m. I'm a night person anyway, even now. I can go two or three nights with four hours and the next night I'll crash about eleven o'clock. I'm an insomniac of sorts, and I used to feel guilty about it but my mother and sister are the same way. Now I've come to accept it and think of it as a way to extend my day.

"It sounds like a rather rhythmic routine, but in actuality I would go to the studio every spare moment. A half-hour here, half-hour there. My studio was always in a basement so I could just go downstairs to fire the kiln and yet be at home with the children. When the kids were small I took them down to the studio and let them play."

Despite her protestations of having merely survived, Patti's primary motivation for being an artist has never been monetary. In fact, the joy and excitement she got from her artistic work gave her the energy she needed to cope with her responsibilities. "There really wasn't that much time to think," she says laughing. "I didn't have time to do anything outside the kids and the work. So the artwork itself was primary. It gave me all sorts of inspiration. If I felt like things were happening with the work, I was excited. It's really a joy when something comes alive. If it's not working then I get really frustrated, so I try another alternative. Solving aesthetic problems in the studio became an energizer in itself and seemed to lead on to the next idea to be solved."

But, as is common for many in the arts, she didn't plan to be an artist. "Being an artist was not encouraged because it was a hard way to make any money. So it wasn't even considered. I just figured, 'Well, I'll get married, go into dental hygiene or lab technology like my sister.' When I was in grade school I used to like to draw on my own. And in high school I would draw fashion figures and clothes. Also I was selected to do murals when I was a kid. But I never thought of art as a career.

"In fact, in Spokane we didn't know what the word meant. I remember the first artist I ever met in Spokane was when I was in high school on a double date. Ed Huneky's father was a lawyer and his mother was a painter. I remember walking into their house and seeing an easel with a canvas on it. I thought, 'Wow.' I had heard about commercial art but being an artist was way beyond my comprehension."

Like her older sister, who became a dental hygienist, Patti chose a science major in college. On a whim, she took an art class as an elective. "I had never taken an art class before and it was just great. So I just kept taking them. One day I was walking down the hall and I looked into the ceramics room and God, it looked like fun. Mud all over. I thought, 'I have another elective, I'll take that.' Well, after that I never left. Finally, my junior year, my advisor said, 'Pat, why don't you switch majors and get out of this science thing? You love this, you're here all the time.'

"And I was. We weren't supposed to be in the art school after hours so I used to sneak in the window to get into the ceramics studio on the weekends. I'd leave the window ajar and jump from the lockers into the studio. When I heard the clinking of keys I would hide in my locker. The campus police would come in and the potter's wheel was still spinning, the place was a mess and the lights were on. They probably figured I had gone elsewhere. Eventually I got to know the grads and police well and they would let me in."

After graduating, Patti was offered a teaching assistantship by the director of the art school. Patti was surprised, since the administration usually hired men. But she accepted and taught her first class. "I was scared. The first day I walked in the class and told them my name, the class number and the tools to bring and then dismissed them. That first class lasted five minutes." After graduate school, she was asked to stay on an additional year, but she and Fred had already accepted a job in Wisconsin.

After Patti obtained her MFA and began earning her living by making and teaching art, she was still hesitant to call herself an artist. "I really didn't know I was an artist. I didn't even know what an artist was. I remember there was a time when I said, 'I think I'm an artist.' There's a certain need that artists have, it's like food. I tell the students at school that you know you are an artist when you need to do it. And when you feel frustrated if you can't, that's a good key, too. Art becomes part of your daily routine."

Fortunately Patti got a lot of support from her mother who, after Patti made the decision to be an artist, was solidly behind her daughter and even offered to help her through graduate school. "She has always pretty much let me do what I wanted," Patti says. "I feel the same way with my kids. If you can find something you like to do, great. You've found a place you fit."

Additional support came from Patti's professors in college who

became her mentors. "One woman in particular, Ruth Pennington, was highly regarded, nationally, in jewelry. She was innovative in her field at that time. People would usually buy the findings [pin backs, earring wires, hinges, latches, etc.] but Ruth made everything so that the design would be unified. And she would also use common things, like agates she would find in Puget Sound. She made fabulous jewelry, really gutsy looking stuff.

"She was also highly respected by the other faculty, but she was a very tough woman and scary. The male faculty wase scared of her, too. But looking at her I could see the possibility that I could do something. She was very good to me, too. When I finally dropped out of jewelry, she was disappointed.

"From the very beginning, my teachers encouraged me to exhibit. And I got a prize in the first show I ever entered. My professor said, 'Pat, don't get a big head because you're going to get thrown out of the next one.' And sure enough, I did. It's like a lottery, it depends on who's jurying the show. Rejection is part of being an artist.

"I've had some wonderful dealers to work with, colleagues at school and wonderful students, as well as my husband Bob. Although we work independently of each other, Bob understands the pitfalls of being an artist and a teacher. He is very sympathetic and supportive. And I have an assistant who works with me in the studio now. I hire him fifteen hours a week. It's fantastic."

"How do you think the art world saw you as a mother and an artist? Did you have children tagging along behind you?" I ask.

Patti shakes her head. "I didn't have to make that many appearances because I exhibited nationally and shipped my work out a lot. I put the work in a box, put a stamp on it and it was gone. When I did go and give lectures, I would never take the children. I don't really know what people thought, but I wasn't accepted as one of the guys, you know. If you're a painter and a guy, you might be down at the tavern every night. But it wasn't that kind of thing for me. I don't really know how I was affected. I didn't have time to think about it. I was just trying to get through the week."

When she did travel, Patti had baby sitters stay with Gretchen and Lisa. "It was hard. I had a list of twenty baby sitters. My favorites were at the top. For awhile I had a live-in baby sitter Sally Tilman who was a painter and an art student. She stayed with us and lived downstairs in our house. It worked out pretty well."

I am struck by Patti's almost brutal practicality. Her sense of survival is a voice that speaks first and more loudly than anything else. She places her feet firmly on the floor and leans forward. "When you teach in a college or university, it's publish or perish. And in the visual arts, if you don't exhibit, you're out of a job. They can get rid of you as fast as they can hire you.

"After I got divorced, I didn't want to lose my independence. There was no way I was going to rely on some guy to take care of me. I didn't trust it. So I always wanted to keep my thing going. Bob and I have been together over twenty years now, but if it didn't work out, that's okay. I can survive. I'm like my mother that way.

"Also, I've always liked to work. I've always liked being an artist. I'm very frustrated when I'm not working. So it was a combination of things. I couldn't just be a mother. There was no other way, financially, unless I was independently wealthy."

Yet she claims nothing takes precedence over anything else. "Bob and I laugh about it. He says, 'Pat, you always give equal importance to everything. You have to have priorities. You can only do so much in your life.' But I just make these lists and go through them kind of blindly.

"But I think you are talking about something deeper. If something happened to my kids or Bob, that would be the worst thing that would happen. The artwork can go. I don't care about it. A lot of artmaking is just problem solving. It's like working on a puzzle."

Patti's current relationship with her daughters is almost sisterly. During the photo session, taken at the Seattle Arboretum, a favorite hangout, they giggle and chatter together like school girls. As a relatively young mother, Patti seems to have grown up with her daughters. "They were really important to my work, especially when they were young, because of the imagery. I work very narratively and I've also worked with the figure. And I like to work with images that are absurd and surreal.

"I remember one piece called 'Ketchup Kiss' that I made during the Beatles era. It was a handbuilt piece about three feet high. And it had this mouth on it. When I was ready to ship it off, I said, 'Hey Lisa, what does this look like to you?' She said, 'ketchup kiss,' and went running out of the room.

"Actually, I was one of the most popular mothers on the block. When the kids were small, I was making these thirty inch cars and their friends would come over and say, 'Did your mom make that?' So it was easy to impress them."

That attention to the visual world rubbed off. Gretchen, who is interested in fashion design, teaches pattern making at Seattle Community College. Lisa started college majoring in international studies, but she later switched to art. She now produces and sells hand painted clothing at her own store. Both Gretchen and Lisa continue their childhood pattern of being supportive of their mother's work.

"There is so much to learn in ceramics it's endless." Patti speaks of the future. "I am continually learning something new. And I mean not only technically, but intellectually, too. I'm always looking for the next best piece. Right now, part of my work involves painting and I'm not a painter. But I have a painting show scheduled a year from now down in Texas. So it's a challenge. It's exciting to see if I can do it or not. Like a mind game that I play with myself.

"My mother said to me, 'Patti, when are you going to retire?' I said, 'Artists don't retire, Mom. You are always an artist. It's like food.'.'" Patti grins at me and says, "But I could retire from the university meetings."

Her ideal life? "To not worry about my family," she says. "Otherwise I'm very happy. I've been lucky. As long as everybody's okay and healthy. That's all you can ask for. I've had a really interesting life. I don't know what else I could ask for."

Her advice is simple. "You can only go by your own instincts," she relates. "I think it is very possible to be a mother and have a career. It's very fulfilling. If you find something you really like to do, go for it. It doesn't leave a lot of time for contemplation. There is just so much to do. You just have to be very stubborn and be able to take rejection. If you sit and think about how hard it is, it scares you. I think you just do it."

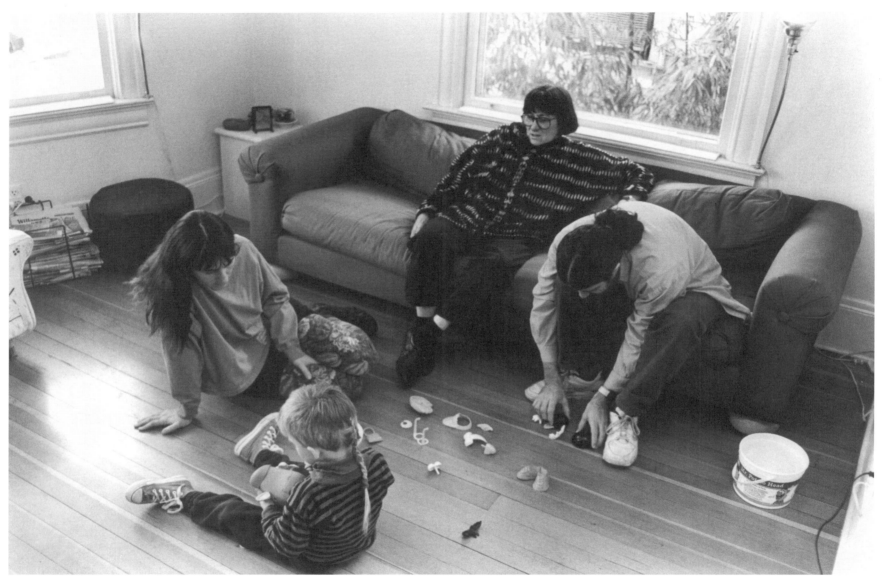

Pictured from left: Sara Kirschenbaum, Sara's son, Sage Bedell, Susan Weil, Christopher Rauschenberg

Susan Weil, *PAINTER*

AS I ENTER the sparsely furnished and immaculately clean apartment on the top floor of a bright blue house in Portland, Oregon, I am greeted by Bernie Kirschenbaum, Susan Weil's husband, and Christopher Rauschenber, her son. They are rushing out to construct Bernie's installation piece at a local gallery. The apartment belongs to Chris. Susan is seated at the dining room table surrounded by tissues. She has a terrible cold. I am nervous and shy. I realized later, after hearing about her life, that Susan was probably just as shy.

Susan Weil lives and breathes art. Talking about her children is the only thing that even comes close to rivaling art as a topic of conversation. She became an artist during an exciting and geographically focused part of art history. In New York City in the fifties and sixties, abstract expressionism bloomed amidst the total redefining of painting and Susan Weil was in the middle of it. As a result, she counts as her contemporaries and friends the major movers and shakers of that time. She certainly fits the stereotype of a New York artist who came of age during the fifties: black clothes, black hair, pale face, intense concentration and blunt responses to questions.

Her artwork includes paintings, prints and drawings and illustrations for limited edition books. She has exhibited extensively in Europe and the United States during her long and full career. Her work is as much about the material from which it is made with as it is about the subject matter, which involves with nature.

Susan now lives in New York City with her husband, sculptor and installation artist Bernie Kirschenbaum. They have a daughter Sara Kirschenbaum, thirty-five, who also lives in Portland. Susan's son Chris, forty-three, is from her first marriage to artist Robert Rauschenberg. Almost a year after I spoke with Susan, I got together with Sara and Chris to get their perspectives. Sara is an artist who also has worked for nuclear disarmament and advocated for the homeless. She has a son Sage who is four and an infant daughte, Annie Dove born in the year between interviews, whom she brought to the interview. Chris is a photographer who cofounded Blue Sky Gallery in Portland. They are living testimony to the strength of their mother's life as a creative person.

Susan was born at home on March 31, 1930 on 2nd Avenue in Manhattan. Her mother's family was Episcopalian and of Scottish and English descent and her father was Jewish, though neither of her parents were religious. Susan's father was a writer who worked at home. When Susan was eleven and her brother was thirteen, they were both burned and he died. She spent many years in the hospital recovering. After the incident her parents adopted two younger children.

Susan grew up surrounded by nature. During the school year they lived on a farm and in the summer they moved to an island. "Well, I had a very funny growing up," she says smiling. "I think it was wonder-

ful. The island was a little one family island in Long Island Sound off Connecticut. My mother was a licensed lobster woman, so she would lobster and set fish nets in the summer. It was unusual."

It was also isolated. Living on the farm, which was far away from the town where they went to school, Susan and her brother weren't able to sustain friendships with schoolmates. And in the summer, they were the only children on the island. "So when I was little I felt quite shy with other kids," she adds quietly.

Creativity ran rampant throughout her childhood, mostly initiated by her mother. "We loved making things, drawing and making collages and inventing games. When we'd go to the island, my mother would allow us to take one toy. She wanted us to rely on our own creativity and invent our own toys. And be really interactive with the natural environment. So that's what we did. I remember it being very hard each summer to look at my dolls and things and think I could only take one. I felt really bad about all the ones that got left behind."

Susan's mother came from a family in which it was "important to do things correctly and be part of their community," but she did not fit in. "My mother was a completely wild person," Susan says with pride and amazement. "She had a marvelous sense of humor. My father was the more affectionate and nurturing parent. And as I told you, he was home all the time. So it was a very different growing up than most people my age had. Most people my age didn't have fathers around very much.

"But," Susan explains, "I really had two childhoods, because before the time my brother and I were burned, we had this kind of idyllic growing up. Afterwards things were very tough and my parents became very different people. They were in depression. When my younger siblings came into the family, they only knew the parents I had after I was eleven."

Unable to cope with the loss of Susan's brother, her parents quickly adopted two children. "But it really was a completely wild thing for them to do," Susan says, shaking her head. "They hadn't emotionally recovered and they were in their forties, older than was really comfortable with little tiny kids. But the clock ticks away and you can't just say, we'll spend five years coping with this and then we'll have little kids. It was wartime and there were a lot of babies needing homes."

Susan's mother was an intensely creative person, and chose to funnel her creativity into activites with the children. But as Susan's eyes meet mine I feel her sadness through her cold. "Before my mother married, she was writing and drawing and painting and so on. But because my father was also a writer, she just quit. Like that was his turf. She'd find other ways to do creative things. We put on puppet shows of Wagner's Ring Cycle together with all the cousins. Each year we would do another piece of the Ring. She built the stage and the puppets, with all of us helping. But she was never the directly creative person she had been before she married.

"It gave me funny messages as a girl child because the thing that was natural for her to do, she didn't do, because that was his area. After he died she was very ill, but she began suddenly trying to write a play. She worked on this play just endlessly in the last two or three years of her life. I have ninety-nine forms of that play put away and I would really like to figure out how to pull it together."

Susan took the lesson of her mother's frustrated creativity to heart.

It was as if she made a promise to herself, that whatever she did, she would make sure she had the time and space to make art. Susan didn't define herself as an artist, though, until high school. Before that art was just how she lived. "I thought that all kids made things and drew and so forth. My father was always encouraging me to write. He thought I wrote very well. I liked to write, but I didn't feel that was my vocation. Then when I was in high school, I found my way to painting and I just knew that was what I was going to do and set about doing it."

The breakthrough experience came her second year, while in a class taught by Aaron Kurson. "The first day I felt timid. I put up a piece of paper and began to make a drawing. It was very little and in the middle of the page and fussy. I remember it was of a little boy and girl with balloons. I suppose I was thinking of my brother and myself. And then Aaron came and said, 'I want you to try something for me.' He gave me a charcoal and said, 'Feel the edges of the paper, so you know how big it is, and close your eyes and draw so your drawing touches all four edges.' I drew a rooster and it was just so freeing and exciting to me. From then on, the day of art class was my favorite day of the week."

Susan speaks with assurance, as if once she's decided something, that's it. And for her it always has been so. "I was ready to be a painter immediately," she explains. "I wanted to get right down to it. But my father was intent on my going to college. So I began looking at schools that had good art departments, like Bennington and Bard. I heard about Black Mountain College through my art teacher in high school. I then went to see it and just loved that place. I said, 'I'm not even going to think about the other schools. This is where I'm going to school.'

"But first, in the summer after high school, I went to art school in Paris. There I met Christopher's father, Bob Rauschenberg, who was going to the same art school. He was there on the GI Bill. We were also staying at the same pension, by chance, and going to the same drawing class and French class. So we could not have missed each other if we tried. And when he knew I was going to Black Mountain, he decided to go to Black Mountain, too.

"At Black Mountain we studied with Joseph Albers. And that was a very curious experience for me, because Albers had a very rigid way of teaching. From Albers' point of view there was only one way to draw and only one way to study. He thought the important thing about being an art student was that you were a student and nothing you did had any value, you just had to learn. For me, it was a real adjustment. And also I was still a bit adolescent in my thinking so I was wrestling with this man in my head and wishing I could be back in a situation more like my high school, which was very free. Afterwards, I realized I had learned a lot from Albers. But at the time it was a struggle.

"And after that I went to the Art Students League in New York. There I studied with Vytlacil and Kantor, who were very good teachers. It was just enough after the war that the schools were full of ex-GIs on the GI Bill. So it was a different kind of environment than anything I'd known. I met a lot of people who have since really made their way in the art world very well."

While at Black Mountain, she and Bob got married. Susan was twenty and their son Christopher was born when she was twenty-one. Motherhood was a natural step for Susan, since she "had a big hand"

in raising her little brother and sister. "My parents were really wonderful because they expected me to fully participate in everything. They didn't coddle me as a child with special needs, ever. I had to pull my own weight. It was very good for me, because I was disabled at that time and going through these constant operations, grafting and so on."

In 1951, being married and having a baby at twenty-one was normal. I ask her if it was a choice. "Yes," she answers, though her expression clearly says, "Of course, why wouldn't it be?" I am put in my place. In an attempt to lose my generational blinders and understand the full situation I ask, "Did you think about how your son would affect your artwork?"

"I had this idea that I could manage anything and everything," she says simply and quietly. "In my life, I had already coped with a very great deal. It didn't seem that it would really be a problem. But shortly after that, Bob and I divorced and then I was a single mother. That was a little bit harder. When Christopher was real small, Bob wasn't even in New York with us, so I really was bringing him up by myself at that point. Bob went back to Black Mountain to teach and he traveled around. For a lot of Christopher's growing up, he was in New York, but he was very focused on his art life. He saw Christopher regularly, but I really took the responsibility for Chris. They are very close now, real good buddies. But I had the daily responsibility."

Fortunately, she had her parents to lean on, as well as her younger sister, who by then was a teenager. They provided a larger family context for her and Chris. And she and Chris also spent summers on the island with her parents.

Susan has happy memories of those early years with Chris. "In many ways I really didn't feel very grown up yet. And we had a lot of fun together. We did a lot of projects and made things together. And I guess that reflected the younger years of my own childhood. Christopher had his first camera when he was four or five. He was taking pictures and printing and developing pictures then. I have pictures of him as a little boy with a camera around his neck. So now I love it that he's a photographer. We really enjoyed each other and my house was always full of kids."

In those early years it was hard for Susan to get her work done. Before he was two, she had her studio at home and would work at night when he was asleep. When he turned two she got an outside studio and put Christopher into nursery school, which was very early for that time period. While he was in school, Susan painted in her studio and ignored housework. Their day together started when she picked him up from school at three p.m.

When Christopher was about six, Susan was introduced to Bernie by her friend, artist Dorothea Rockburne. Needing a studio to paint in while spending summers on the island, Susan was looking for an architect. Bernie was an architect and former partner of Buckminster Fuller, though by that time he had decided to be an artist. So together, they built the first geodesic dome house. Susan grins. "Of course Bernie designed himself into it and we got married and had Sara. But I still didn't have a studio on the island. We lived there summers and weekends. Bernie would have liked more children, but two was all I felt I could juggle. Or wanted to."

As she speaks about motherhood and her children, Susan has an enviable sense of ease. "I have always had good friendships with my

children," she explains. "First of all, Chris is just the most generous, warm, amiable person. Everybody tells me that. I'm not just saying that as a mother. He's nonjudgemental about people. So he was a very easy kid. He's also very lively minded and loves to do things and make things. He's just a remarkable person. So as a little boy, he was the same remarkable person.

"Sara also is a very good and generous and warm person. But she's a little more complex. She challenges herself all the time. Adolescence is harder for daughters, because of the mother/daughter thing.

"I listened. Because of the physical difficulties I had as a child, I was able to fine tune my responses to other people. I think all children who go through really traumatic illness do this fast growing up. They take a lot of responsibility for their own needs and are more tuned in to what's going on around them. That's a gift, because when you have kids, you can be more attuned to their needs and also make yours clear.

"I was very easy going on one level, but I kept boundaries very clear. It's important with kids that they learn to consider other people around them as well as themselves. Childhood often times is this kind of selfish time, but it doesn't have to be. Children really appreciate having real responsibilities. I took care of my little brother and sister from age twelve to eighteen, and to me it was a real thing, not a play thing. I had a real role in the family. They needed me and I helped them. It's very important to kids to not just be receiving, but to be giving.

When I ask her to tell me how she is a terrible mother, Susan looks at me blankly. "I'm not sure," she says after a pause. "I'm content. I'm a very easy going person. I'm disorganized and I'm messy. But that doesn't really matter."

I ask laughingly, "How did you decide that it was okay to have a messy house?"

"Just priorities. If I had clear time in my full energy part of the day, I was going to do my work. I picked up the pieces when Christopher would take a nap or whenever, run the vacuum, wash a dish. Our house has always been a bit chaotic. It doesn't bother me."

Susan describes the early years, when the kids were small as "the years of divided focus." Although she was always making work, she let go of trying to show professionally in a gallery setting, outside of group shows. Her first important show coincided with Sara turning seven and being in school.

Susan takes another tissue and sits up in her chair. "I'm having a second round with this divided focus, because my father-in-law is ninety-eight and very needy right now. Three or four days a week Bernie and I need to be there and have supper with him. He goes to bed very early so we have to leave the studio by three to be at his house by five. It reminds me of when the alarm clock in your mind goes off and it's near three p.m. and you need to pick up your kid from school. It's always in your mind."

I ask her to remember what it was like to be an artist and a mother in those early days. Susan takes a moment to consider. "I realize more from a distance. It was a tough time within the art world to have kids. People just didn't take us seriously. But when I was living in it, I didn't perceive it like that. Also, the kids were a big part of my life, making my life very different from other artists who didn't have children.

"Both Chris and Sara grew up going to and participating in happenings and being a part of things. So it brought a richness to their

childhoods. They didn't always love being dragged to galleries all the time. But every once in awhile they really responded. I find that children of artists are more visually aware than other kids. They grow up seeing their parents responding to the world in a certain way. It's a gift to kids."

Both Sara and Christopher agree. They credit their mother, as well as their respective fathers, for giving them the freedom to create joyfully. "I had this experience with Mom and Bernie going somewhere on the bus," Chris says with a smile. "This woman got on and paid her fare and Bernie leaned over to Mom and went, 'Rubens.' And Mom nodded. I didn't know what Rubens looked like at that point, but I could tell they did. And that they had basically transported themselves back into the museum. I was probably ten or twelve. It was like, wow, it turned the whole world into a giant museum, where there are great things to see. I continue to believe that you see more interesting and exciting things on your way to the museum than you probably will see when you get there, if you remember to pay attention."

Sara adds, "It was a really blessed childhood. I remember a lot of people, grown up people, coming up to me and saying, 'I am so jealous that you got to have Susan as your mother.' She's amazing and so attentive to children. And the whole environment was art. More than everyday we'd have some kind of project and we were always making collage books and playhouses and games and theater. It's completely my way of operating now as a person."

Sara also noticed the struggles, perhaps because she is female and identified with her mother so strongly. "There was pain around it," she says bluntly. "Both my mother and father really suffer from the bad things about the art world. It's not like having parents who are bus drivers or scientists or politicians. Well, maybe it is more like being a politician. Like right now I have two careers. I'm an artist and I'm an administrator. And I can see that it would be really easy to be an administrator. You work hard, so you move ahead, get paid more, get more responsibility. But moving forward as an artist is so much more tricky and difficult and painful. It is still going on with my parents' battles with getting an appropriate dealer who will advocate for them. We are in a society that doesn't honor art. You have to circumnavigate around all these barriers that society has put up."

But during the fifties and sixties, New York was an exciting place for artists. Susan glows when she remembers. "It was fantastic. It was such an explosive time in the art world after Bob and I left Black Mountain and moved to New York. DeKooning was there and Klein and Rothko and the abstract expressionists. It was just thrilling. I would walk into a gallery and confront these paintings. Everything that we knew about painting was gone, replaced by something else. I was very privileged, because I did get to know those people."

In the sixties, Susan's foray into the art world coincided with the beginnings of the feminist movement. She became involved with New York Professional Women Artists, an organization that addressed some of the sexist attitudes toward women artists. "We would speak and point out that there were either no women artists or one or two token women at any given gallery or museum. We had all the statistics. And the dealers, writers and collectors all had prejudices about women. They thought that with women art is a hobby, but with men, it's a profession. They were particularly prejudiced against women with families.

So that was something to deal with."

Susan sits back and dabs at her nose again. "But," she explains, "as I say, I withdrew from professional activity for quite a long time. Once I began showing, I was showing rather regularly. But New York is a very difficult and competitive city for artists. I really love making work, but I don't like dealing with that part of it."

I decide to push her on this and ask, "Are there any specific examples of how you were treated as a woman artist and mother during that time?"

"I was shy about confronting that issue," she answers. "I was careful of myself, and I didn't put myself into positions of being pushed away. It was particularly tough for me since many of the artists that I grew up with in art school became very important artists. One can't help but note that it was the men and not the women who were in school with me who became well known. With the exception of Dorothea Rockburne, who now shows in top galleries and museums.

"When I used to be on these panels about women in the arts, I found that one of the problems was women's own attitudes. We took on some of the prejudice ourselves. We didn't have the same expectations for ourselves that men did because of how we were brought up. We regarded our role differently. It is really sad."

She brightens, as she reminds herself, "Actually, I've had a very exciting professional life. I've shown a great deal in Europe and have enjoyed it very much. It's just the politics of it. And the way people push themselves, I just can't do that. Whatever happens for me, has to happen because of people responding to my work. I can't do an ad campaign for myself."

Like most women of her era and even now, there is a strong aversion to selfpromotion. I am curious if Chris and Sara had noticed a difference between their mother and Chris' father in how they approached the business side of art. Putting it plainly, I say to them, "Here is an example of a woman who had primary responsibility for a child, while her ex-husband was out making a huge name for himself. I don't know the whole story, but . . ."

Chris jumps in. "I'm not sure I do either. As a child, the inequities of the art world ladder were not apparent to me. In retrospect, my tendency is to say, oh gee, here she is, stuck with ninety-nine point nine percent of the childcare and responsibilities, I got in the way. I don't know if that's right. Not that she would be sorry that I was around. Even now, it's more difficult to be a woman in the art world than a man. And I'm sure, in the fifties that was absolutely true. If you look at the artists of that generation, they seem to be men, by and large.

"Certainly she was able to get into her studio, but she was not able to go around to the openings and do the social aspect of it. One would like to think that isn't important, that you just concentrate on making the work. But unfortunately, the fact that you do really good work does not mean the world will beat a path to your door. I see that all the time. You have to put as much energy into promoting your work as you do in making it."

Sara was "extremely aware of it." Being younger than her brother, she witnessed Susan when she was more actively pushing her work. "I remember particularly agonizing with my mother when dealers would come to her studio. It was always a very painful thing. She'd come back and say, they didn't show up, or they showed up two hours late and

didn't look at anything. I had superstitions about stepping on a crack and breaking my mother's back, that kind of thing. And the threat, always, was if I didn't do this superstitious thing, my mother wouldn't be successful in her career.

"When I was ten, I remember being really mortified one time when a dealer came to her studio to look at her things. She was spray painting on Plexiglas at the time and I had done a little piece, basically copying her. And the dealer bought my work. I remember feeling so awful that I had collaborated in this terrible disrespectful act. But I was supposed to be happy, I got my five or ten dollars."

Having children affected Susan's work indirectly, by helping her reach beyond her own experience and isolation. Susan sits up in her chair and her voice rings with conviction. "You can get very wrapped up in yourself when you're inventing worlds, which is what artists do. I think it's real important that our world expand past our own ego needs and our own vision. Raising a kid is such a heavy responsibility. We have such an enormous influence and input on the life of this child, that it balances the solitariness of our work journey." Dually, she feels strongly about making sure her own artistic needs are met and encouraging her children to respect those needs. "If your children have a sense that you are being good to yourself, they'll feel better. If you're a sacrificing mother, it's not good for the children."

Susan's eyes suddenly dance. "I feel better about myself because I feel great about my kids. The thing that makes me joyful about Christopher is that he really likes himself and he's also good to everybody else. Parenting has given me a generosity and very deep relationships that are like no other.

"There are other days when I think, well, if I hadn't had kids, I could have really been concentrating on my work and could have made this step and that step. I could have been like the men who didn't take the responsibility for their children, just shoved all their energy into their work." She stops and says impatiently, "But I can't ever know. I can't go to that place."

And she doesn't particularly want to either. Her family continues to be a rich source of support and joy for her. "We are interinvolved with each other's work," she says proudly. "We are all creative people. Sara had her first exhibition here in Portland this past year. And she's always been drawing and painting and writing and making things. Talk about full energy, she's got a kid just three and she's working and growing and everything. She was always in my studio, always interested in what I was doing. And Christopher, as I say, was taking photographs, drawing and inventing games since he was tiny. Christopher had his mid-career retrospective at the museum here in Portland, was it two years ago? I flew here for it, his father flew here for it. And Chris has often flown to Europe for Bernie's shows and mine. We're always paying attention to each others' work."

Until twelve years ago, teaching had been Susan's main source of money. But since, both she and Bernie have earned money in various ways. Although Bernie was trained as an architect, once he decided to become a sculptor, he only worked part-time as an architect. For the last eight years, he has taken on the main support role. He has been a professor of sculpture at the Art Academy in Sweden. Susan commuted back and forth from Sweden to New York. They have also both had Guggenheim and National Endowment for the Arts grants.

One of Susan's goals at this stage in her career is to establish a regular gallery connection in New York, which she has already in Europe. But her primary goal is to keep doing the work and seeing where it takes her. "I've been working for forty-some years, so it doesn't feel like I'm going from this spot to that spot. It's just always working."

She is motivated by curiosity and sheer excitement in the artistic process. "A painting is a process like a chain," she grins, "where one painting describes to you what it wants to happen in the next one. It's very hard to stop working for awhile because then it's hard to get back into it. I've been in a bad period for that right now, because of Bernie's father. I get mixed up if I'm not working off of the last work. When my work is going through a really big change it's extremely confusing. I have to be really quiet with myself and climb back into it very slowly. But my work is always kind of shifting. Just when I think I know what I'm doing, I don't. Often that's the most interesting time in my work, because it's the most free time. I'm not going on what I already know. I'm struggling."

In talking with Chris and Sara, I hear praise for their mother over and over. And gratefulness. "My whole career as a photographer comes from my mother," says Chris. "She would take me walking around the neighborhood photographing. The dark room was in my room because I had the least windows. When I was going to bed, these brown jars would appear in the bathroom and I knew it would be a good night to read under the covers for awhile. Mom would come in and get everything set up and I would say, 'Oh, can I print one of my pictures?' She'd laugh and say, 'Oh, you're asleep.'

I ask Sara, who now has two small children, "What kind of a role model has your mother been?"

Sara has been pacing around the room, but she stops her pacing and adjusts the wrapping that holds her tiny daughter. "It's those two sides of her. In a way she is the most empowered person that I know of. She is completely joyous in her creating. She just celebrated ten years of writing a poem every day and then doing artwork with that poem. She's just incredible. And then, also the role model of holding back in terms of the politics of the art world. I'm an artist, but I haven't put it center stage, partially because I've had to earn a living, but I think I was also scared to tackle it, because I saw the way it treated her so badly."

"Well, your life is not done yet." I say. "Where do you see yourself going?"

"I struggle with it. As an artist I'm going all these different directions. I'm a writer and I do oil paintings and life drawing and a little photography. I want to give it center stage, but I have to push myself. My mother, she just does it. No matter what happens in her life, there is no drawing her away from it. I hope to capture some of that tenacity and focus. And that feels like the next step. It's interesting that I don't feel impeded by my children. I think well, now I've had a boy and a girl and I'm ready for a new stage in my life. I'm ready to hunker down on my art. It's nice that I feel that way, instead of, now I've got two young kids, I've got to put off my life for awhile."

"Do you think you got that attitude from your mom?"

"Maybe. I felt guilty that I held her back from spending more time in the studio, but there's nothing going to stop her from her work. Our mother is incredibly energetic. I don't remember her saying, 'I'm so

tired.' That's not her style. I'm impressed at how well she got around the childcare. When we were as young as my kids are, she found a way to be working in her studio probably twenty or thirty hours a week. Nothing has gotten in the way of our mother doing artwork."

Chapter Two: Strivers

It is no accident that everyone in this chapter was raised middle class, that particular part of the population who believes if you try harder, reach higher and look better, you will be rewarded by success. Each woman has clear goals, is articulate about the whys and wherefores of her choices and confident about her ability to function in the world. These women have negotiated the muddy waters of motherhood in the same straightforward businesslike manner in which they have steered a course through their art careers. They are in charge of their lives.

Each of these women has considered education as crucial; all have masters degrees and two have gone on to seek PhDs. All earn their living through art related jobs. Two of them, Linda Vallejo and Martha Wilson, founded and now run their own arts organizations.

Organization is another hallmark of this group. Linda Vallejo carries this to a fine art. Once she decides on a plan, she doesn't stray from it. Her life is cleanly partitioned. Though the different parts may affect each other deeply, they are also quite separate worlds filled with different people and concerns. Opal Palmer Adisa's schedule is organized in a more informal way that flexes according to her children, yet she is plainly in control.

All of these women returned to work almost immediately after childbirth and have used paid childcare generously and without excessive guilt. No cabin fever for them! They rushed back into the world, where they could continue to be players, rather than to isolate as at-home mothers. After all, their career goals were waiting. They are nothing if not ambitious, and do not hesitate to promote themselves at any opportunity.

Creating community, family and connection to others is also crucial to them. Martha Wilson, who is without parents, has built a vibrant nonprofit business that gives her an important community in New York City. Opal Palmer Adisa lives far away from her family in Jamaica but has joyfully plunged into the Oakland community. And Linda Vallejo, who repeatedly calls herself a lonely child, has assembled a rock solid family, cultural and spiritual life around her. All have known what it is like to go it alone and all have worked consistently to create a nurturing environment to allow them to do their best work.

They are not overwhelmed by motherhood. They take it in stride in the same competent take-charge manner they take everything else. It is significant that their own mothers, who served as powerful models, were and are strong and supportive characters. Two of the artists in this chapter—Opal Palmer Adisa and Linda Vallejo—fully expected to become mothers and worked towards that goal. The third, Martha Wilson, accidentally became pregnant after watching her biological clock tick away for many years and welcomed her son. But being a mother is, in fact, integral to each one's sense of self.

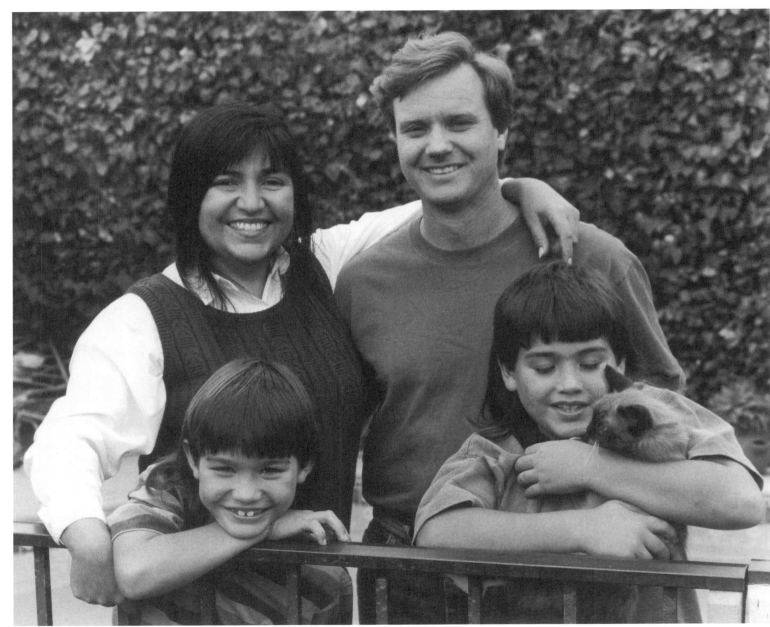

Clockwise:
Linda Vallejo,
Ron Dillaway,
Robin Dillaway,
Paul Dillaway

Linda Vallejo, PAINTER

AFTER WANDERING AROUND the industrial area of downtown Los Angeles, Chris and I finally find Galleria Las Americas, the gallery owned by Linda Vallejo, which represents contemporary Latin American and Chicano fine artists. Ever the business woman, she immediately gives us a tour. "Isn't this beautiful, wonderful, powerful." The enthusiasm and dedication, especially for her own work, is direct and unabashed.

Linda has worked in printmaking and sculpture, but now focuses on painting. She shows us painting after painting of large, luminous faces of women surrounded by butterflies and other symbols. Her work is highly symbolic and ranges from womanhood to harsh visions of urban life. It has a directness and clarity about it that defies misinterpretation.

Born December 2, 1951, Linda Vallejo is the oldest child of Adam Cavazos Vallejo and Helen Muños Vallejo. A brother and sister followed. Her father was in the Air Force so, though born in East Los Angeles, Linda spent her childhood traveling all over the United States and Europe. She currently lives in Long Beach, California with her husband Ron Dillaway and sons Robin, ten and Paul, eight.

Linda identifies herself as an indigenous Chicana. Her father's family has been in California for five generations, while her mother's family emmigrated more recently from Mexico. Linda tells me, "My favorite thing about being Chicana and Mexican is that I'm an Indian." For the last fifteen years she, along with her sons and husband, has been practicing Indigenous American religion.

We sit at a small table overlooking downtown Los Angeles. From time to time the small portable phone at Linda's elbow rings and she answers it briefly and efficiently. She calls attention proudly to her black wool suit, a recent birthday present from her father. In addition to the gallery, Linda works as a consultant and grant writer for non-profit organizations. She also teaches grant writing and personal management workshops.

Linda speaks in a direct, machine gun fashion. Information, opinions and feelings spill out at a relentless pace. Here is someone who is entirely clear about where she has come from and where she is going. I love her high expectations for herself and determined willingness to work for her goals. Giving up is not in her vocabulary.

Because of her military upbringing and the fact that she traveled so much as a child, Linda grew up separated from her Chicana culture. It wasn't until her twenties that she discovered it. I ask her what it was like to travel so much. She laughs and answers. "You take a Chicana, turn her inside out and upside down and flip her around a little bit, and that's what happened to me. I've been pressured into being myself all my life, because I've never had a group to cling to. We were always

moving so much, I developed a character that Ethel Merman would enjoy. A sort of Rock of Gibraltar. And every now and then it cracks, too. But the travel was incredible. I saw the Roman ruins, I visited France, I visited Portugal. I studied theater in London. I went to high school at a private boarding school in Madrid, Spain. I did the preppy thing, almost."

The early sixties found Linda in Montgomery, Alabama when the schools were being integrated for the first time. She was there to witness all the riots and killings and bombings. It was an experience that affected her deeply. I ask where she, as a Mexican American, fit in. "I didn't," she says sadly. "I couldn't go in the black bathroom. And if I went into the white bathroom, I was afraid that someone would . . . A lot of people thought that I was Creole. Or Puerto Rican. Or Cuban. They didn't really know about Mexicans in that part of the country. I had white friends who knew that I wasn't black, but I never dated. And that hurt."

Loneliness is a constant theme in Linda's life. She brings it up frequently during our conversation as a reason for her life choices. "I studied a great deal. Spent a lot of time alone. My parents were really big on doing well in school. I had already decided to go to college when I was seven years old and to become an artist. I was unhappy as a young girl. It was too much loneliness for me. That's why I got married and had to have children. I just couldn't be alone in a studio for the rest of my life. It would have killed me."

Her experience growing up in a military environment overshadowed much of her childhood. She learned organizational and speaking skills, but the life was harsh. "We were independent, because we had to be.

My father was a diplomat for many years, so we had to be well dressed and prepared. I learned how to speak well, because I was always being asked questions by diplomatic individuals. I was on cue quite a lot. It's really not a lot of fun being a military child. The most exciting thing, really, was the travel."

Linda's father, who retired as a colonel, was in the military for twenty-eight years. He started out as a pilot, but for the last ten years of his career was a diplomat. Subsequently he earned a law degree and now has his own law firm. "My mother was the consummate diplomat's wife," Linda adds. "We were surrounded by a lot of love and a lot of interests. But there was a lot of pressure, too. There still is. My dad loves it." Linda chuckles. "That's why he's a lawyer. He loves that stuff."

"Did your mom love it, too?" I ask.

"Apparently." Linda laughs again. She enjoys her parents. "Imagine her, coming from a poor, farm worker background, wearing cocktail dresses, getting to go to diplomats' parties and hanging out with the Prince of Spain. It has been like a Cinderella story for my mom. I have photos of her in the most fabulous gowns. She's always been a looker. She's real young, only sixty-three. So is my dad. When I go out with my parents, people think they are my brother and sister."

Linda has nothing but praise and admiration for her mother. "You can tell that she nurtured me and protected me a lot as a woman, because of the courage that I have today. Everything grows around her. She treats her plants and her children with the same kind of loving touch. I had the patent leather shoes and the handmade dresses. I was the first granddaughter on both sides, so I was pampered pretty terribly.

"The children love to be with her, because she's cackly kind of funny. We sit around and just cut jokes and laugh all the time. She's incredible. And she's suffered her own illnesses in her own time. The one thing about my mom that I admire is, when the shit flies, my mother just stands up and beams."

"Like what?" I ask.

"She had cancer." Linda replies abruptly. "They did a mastectomy on my mom three years ago now. But she saved everybody, nobody saved her. It was because of her attitude about her physical being and about her health."

"What *was* her attitude?"

"She took charge. She made all of her own decisions regarding her healthcare. She didn't become super weak and then afterwards blame everybody, because they didn't make the right decisions. My father just said, 'Helen, it's your life, you have to do what you have to do.' And she just did it in the most beautiful way.

"She has a great sense of humor about it. She had the mastectomy within forty-eight hours of the test and the next day, when everybody was in the hospital ready to start crying, my mother was sitting on the bed, cracking jokes. Boob jokes. I knew she had her private moments, but she wasn't doing the selfpity thing. And she never did. It's been very amazing. I'm very, very proud of my mother. She has a lot of resilience.

"If you really needed somebody to be there for you, my mom would be there. That's how come my dad made it as far as he did." Linda smiles as she adds, "You know what they say, behind every really great man, is a better woman."

I nod. "I believe that one."

"The men need the women to stand behind them or else they just topple. In the Native American Indian tradition, the women always stand behind the men. Everybody thinks it's because they are sub-servient. It's not the truth. It's because the guys are supposed to take the first shot. But the women are in the back literally holding them up. In all the ceremonies, the women stand behind the men for that reason. It's the power of the women behind the men that allows them to do what they do."

"Who helps the women?" I wonder.

"God, Mother Earth. The women are born with strengths that men just don't have. Statistically, there are more male babies born, but more male babies die. Giving birth can be compared to being shot." Linda tips her head back and roars. "Women's pain tolerance is twice as high as men's. That's why women live longer. Why do women go through birth, bleeding every month and live longer than guys? Because they're stronger."

"Hmmm." I pause here. I need to think about that.

Linda has consciously wanted to be an artist since the age of seven. She has strong memories of making art at age three or four while at preschool in Germany. "Can you imagine?" she hoots. "Who did preschool in the fifties? Me. I remember we did fingerpaints on an egg for Easter and I was extremely happy. I'm still painting.

"I won my first awards for art when I was six years old and my work was put up on the bulletin board. I was writing little stories and pictures at that time and I did the plays in my neighborhood. I was also always asked to do art for people when I was very small. When I

was in high school, I was writing music and playing the guitar. I wrote my first song when I was twelve." She stops here and explains matter-of-factly, "But I gave up music to paint. I wanted to be a mommy. You can't do everything."

After high school in Spain, she returned to Southern California to be with her family. She received a bachelor's degree from Whittier College, then took a two year break before graduate school. In her typically rigorous style, she said to herself at the time, "If you don't produce a portfolio when you get out of undergraduate school, you don't deserve to go to graduate school to study art. I want to see what you do." She then produced a series of linoleum monoprints and etchings that gained her acceptance at California State University at Long Beach. "It was a good and inexpensive school that I could afford to put myself through. I modeled in art classes and did factory work and worked at Self Help Graphics as an art instructor to get my MFA in lithography. I did really well in school."

Linda pauses in her narrative to add, "I haven't painted for about six weeks but you'd think I hadn't painted for six months, the way I'm agitated and upset. But if I don't paint, the loneliness takes over. Being a physical human being is difficult for me. I'm much more spirit than I am body and it's hard. So I fill it with the massive portfolios of work and the two businesses."

Growing up so separate from people, her models were the great artists in the museums she visited. They affected her deeply. "I got to see the Louvre and the Prado and all the museums. I got to see all the Italian art. I got to see the Sistine Chapel before I was graduated from high school. That poetic artistic soul is not just something that belongs to dead people. I really get upset about that. We have all the feelings that Van Gogh or Picasso or any one of the ones that you want to mention had. That's what we have in common. The artist's soul is a big elastic thing."

Her extended family was also a source of inspiration. "My great grandmother and my grandmother and my mother were very important to me in terms of resilience and truth of character. Hard working, optimistic, always willing to give me what I needed to be able to feel good about what I was doing with my life.

"Yet I wasn't surrounded by women of color. I was the only Mexican in my junior high school. The only other Chicano in my high school was a boy and he dated all the blond cheerleaders. I didn't even know what it was to be Chicano or to be a woman of color until I came back to the United States when I was twenty-five years old. And I found out about this fabulous culture that I was a part of."

"Even when you were in college in Whittier you didn't know?" I ask.

"I had no sense of it at all." Linda explains, "I was an artist. I dressed like an artist, looked like an artist. I was in the theater department all the time. Painting, too. I was either writing music for the plays or writing the plays or doing the props for the plays or acting in the plays. My whole life was art, art, art."

Nowadays Linda is well connected to the Chicano art movement. "We understand the same language. We understand what the aesthetic means, what the lifestyle means, what the commitment means. It's been seventeen years, so people call me Vetarana now. Old timer." Linda laughs long and hard. "The other day someone introduced me as one

of the high priestesses of the Chicano art movement. I paid a big price for that intro and it meant a lot when she said it. Now I'm a Chicana in Native American ceremonial. I've just had my fifth year anniversary of conducting Native American ceremonials in women's prisons."

"Can you be more specific about which Native American tradition you are following? Is it secret?" I ask.

"No, no," she assures me, "it's not secret. It's just somewhat difficult to explain. But I'll try. My family and I have been adopted by Sioux, Navajo and California Indian people. The Sioux is the largest tribe in the United States right now. We participate in Bear Dance ceremonials, Sun Dance ceremonials and sweatlodge ceremonial. And although I conduct the sweatlodge ceremony in a lodge that is built according to the Sioux traditions, I am welcomed as a Chicana to pour water. I use the California Indian songs, Sioux songs and personal songs that have been given to me to conduct the ceremonial."

I ask how she first met her husband and she answers, "I was so incredibly independent, kind of a big mouth, always doing what I wanted to do. I really didn't know whether I would find a man that would marry me and make a family with me. But my husband is an exceptional human being. I lucked out. I picked him up at the LA airport. 'Hey, you're cute, do you want to have a cup of coffee?'"

She was twenty-one and a hippie. "It turned out that we were getting on the same plane going to the same place. We dated over Christmas and we've been together ever since. Twenty-one years later, here we are.

"Ron's a very different person than I am. What we actually have in common is the home front, where the children are raised and the way the house is. The way we were brought up was very much the same. We are also developing a spiritual relationship now, but it's taken many years. I've always felt it's been a plus that he hasn't been a heavily spiritual Christian white guy, because I probably would have had a lot of trouble bringing Native American Indian thought and philosophy into my house."

Her voice becomes strained when she speaks about her struggle to have children. "I knew I was infertile since I was fifteen because I never had regular cycles like other girls did. And that fed into my fear of not ever meeting a man, being married and having children. I thought, 'What man's going to marry me if I can't have children and make a family?' I thought for a long time that I would end up single, living in New York in a loft, producing a lot of art, traveling back and forth to Europe and Mexico." Linda chortles as she adds, "And raising a lot of good hell, which I'm completely capable of, believe me!"

She then continues. "I went through major surgery and then lost two babies. I finally got my first son when I was thirty-two. And even then, the maternal instinct didn't hit me immediately. The night after the baby was born, I told them, 'Please, I need to sleep tonight, just keep the baby in the nursery and feed him with the bottle tonight.' It was thirty-six hours of labor and then a C-section. I was wiped out. At 2:00 in the morning, they brought the big pram with the babies all crying for their mommies. And I started bawling like the biggest baby you ever saw. I can still cry today, thinking about how I felt.

"At that moment it hit me that I could be a mom and I would be a good mom. For seventeen years, it appeared as if I wasn't going to get any children. And I was afraid that if I didn't get them, I probably

wouldn't end up married. I would just go off and do my thing. As you can see, I'm doing it anyway. The only thing that really keeps me anchored is the fact that I go home every night and make dinner and take care of homework and wash babies and do Christmas.

"At one point, very early in my marriage, I was separated from my husband for about seven months. I was doing the infertility thing and I reached a point where I just couldn't suffer anymore. I got an apartment which was basically one huge studio. You know how that is. Your bed is somewhere underneath the canvases. Your telephone is someplace. I looked at the walls and I said, 'I can't live like this, this is too lonely. I will go mad.' I went home."

Linda's journey to motherhood is symbolically documented in her work. She describes in detail what happened. "Before I had the kids, I took prints from my masters degree and folded them up into geometric shapes. Then I covered them with Plexiglas boxes and plastic. The work looked like abstractions of the inner body. One of my friends said it was about my infertility. Like a uterus and fallopian tubes that were covered with plastic film. And that is exactly what my insides looked like at the time. Everything was there, but with cobwebs inside my body. I then had surgery to clean it up. It didn't really dawn on me until later that I was creating inner vision with this outer work.

"I then did sculptural works out of wood which were about being born from the earth and being a woman and giving birth. The figures seemed to be breaking out of the wood. A friend said, 'There's a lot of pain in those sculpture pieces, Linda. I can't decide if they're being eaten alive by the wood, or whether they are actually emerging.' And I said, 'Well, that's because there's change.' It was me breaking into who I

was as a woman." Linda nods and leans toward me. "A lot of people don't know the real meaning of that work, because I don't share about my history and infertility."

It was during this wood sculpture period (1979-1980) that Linda was finally able to conceive. She had her first pregnancy in 1980, but lost the baby. In 1984 she gave birth to her first son.

During this period she also started her involvement in the Native American spiritual work. "I had begun sun dancing. Sun dancing is an amazing ritual that takes place over four days and three nights, where you don't drink or eat. You stand in the sun all day and dance with several hundred people. I think the dance healed me so that I could become a mother. It centered me spiritually.

"And then I did this whole series of paintings of beautiful, beautiful images of women in different erotic poses, poses of what might be considered mature womanhood. So the child thing and the spiritual thing and the family thing are completely interlaced."

Linda pauses and explains, "I don't like cathartic work, even though some of my work is specifically personal and very cathartic. I would rather take personal catharsis and turn it into language which connects me to other people. I want to have community. I want to have relationships with people. I'm not going to become Frida Kahlo. She became very myopic and and pretty much buried herself in those images of selfpity. I decided to work towards transcendence and transformation."

But as a mother, Linda is securely grounded in the material world. "I'm real good at telling my kids the truth," she says proudly. "One time we were driving down the street and we saw a homeless guy, who

had obviously had a hit of something because his eyes were bopping in his head. At the stoplight I said, 'Boys, check this guy out. Don't stare, don't point, but check this guy out, see his eyes? He's probably just gotten some heroin or some crack cocaine at one of the alleys around here. And that's what it looks like.'

"I also give them responsibilities and a lot of freedom, because I trust that their knowledge protects them. I'm big on education and they're both at the top of their classes. They both have access to making money. We have a point system at the house for chores and art and music and studying math. Three points are a dollar. They can set goals and buy things for themselves. They both have savings accounts.

"I also think that giving them a spiritual core has been very important. Robin and Paul oftentimes will conduct ceremony with me. One will sit on my right, one will sit on my left. I take them into women's leadership circles. They see me in leadership and see that women have leadership responsibilities and it's important to respect women. I'm hoping that rubs off. I think it is very special for any child to be involved in the spiritual choice of their family. Family and spirit is where all the strength comes from. You can do anything you want from there on out."

Linda's biggest challenge as a mother is her lack of patience. "I have a bad temper, but I try real hard to be honest about it. I apologize for my fits immediately after and explain things. One day Robin said to me, 'You know, Mom, you're really too hard on yourself.' So I know that they're not afraid of the rage. Everybody carries something. I carry anger. I never hit my children, but I do abuse them with my voice. Right around PMS time, man, I just hit the ceiling and pick a fight.

They don't last too long, though. That's the good thing."

Linda knows all about support. She knows how much she needs and what kind. And she figures out how to get it. "My maid has been with us seven years." Linda talks even faster. "She's also my baby sitter. She's a Mexican woman who comes to my home. She's my confidante and very close friend. We got her papers, we got her dental care, we got her a gynecologist. Without her, I couldn't possibly do what I do. She's very ill right now and I miss her desperately. That's another reason why I'm agitated lately. I don't have the help, the backup that I need.

"My mom takes my children, but we don't live close enough for her to have them all the time. Most of my girlfriends are so busy with their own children that I don't get backup from them. LA is so spread out that your best girlfriend lives thirty miles away. In my old neighborhood, I had a wonderful woman named Marge, who lived across the street and took care of Robin every day when he was a little baby. And I had someone cleaning my house, so I could really grow and do things and come and go as I needed to and still be able to be a mom."

Linda sighs. "I wish I had more support. If all of my best friends and my sister and everybody could all live in one neighborhood, it would be fabulous. I worry about my children in the urban center so I don't tend to leave them around. I would think even in the rural areas it would be pretty difficult.

"My husband is the strongest support for me being a mother. He does the schlepping with the baseball and the basketball. He takes Paul to his horseback riding lesson and helps me with the children and cooks for them when I can't be there. It's unfortunately down to the nuclear family. There isn't much extended family around anymore.

That's why I insist on being married with children. I would never want to be single with children. I can't imagine the isolation. You'd literally have to live in the same neighborhood as some of your relatives to be able to get the backup you would need."

Linda is also proud of the artistic support she gets that enables her to do all that she does. "How many artists do you know own a gallery and still have it after four years? I get support from the Latin American community, because I'm not just an artist trying to make money and be famous, I also have a family. The heart and soul of the buying clientele are my people in the indigenous Chicana community, people who I sweat with and dance in ceremonial with and pour water for and teach their children. That's how this thing thrives and how it really pulses. Hundreds of people support me in this.

"Artists support me too. Last month an artist sent me a check and said, 'Gee, Linda, we know how hard you're working and dammit, you deserve to make a living, too.' The gallery business is really very difficult. There's some money, but nothing that really matters. And he took pity on me. Can you imagine?"

Her children and husband also tell her honestly what they think of her work. "Oh, they like some, they don't like others. They'll come into the studio and say, 'That one is not done, is it? I think it really needs some blue over here.' Yeah, the kids are great, they do their own paintings. They are very good, especially my little one. And they know that, contrary to what people might think, we could take these paintings here and burn them right now and it really wouldn't affect me very much."

I look closely to make sure she is serious. She is. "Why is that?"

"Because the paintings are not me," she explains. "They are not my children, my religion, my body or my mind. The paintings are paint on paper. And I can create millions more."

"So it's the doing." I comment.

"It's the doing for me," she agrees. "It's being an artist and producing that means everything to me. When it was really tough times and I was trying to save money, I produced two one-woman shows out of a studio in my house for two consecutive years. I did it as a way to prove to myself that I can work anywhere. To people who say to me that they can't produce because of this or that I say, 'That's baloney. You can produce anywhere if you want to.' I produced forty in five months, including twenty major paintings, between nine and one in the morning, on a little rickety easel in the corner of my den. My children were there and saw all the processes."

Linda grins when she thinks about how her artwork will affect her sons. "Oh God, I won't know for another twenty years. People say, 'Are you teaching your kids art?' I go, 'No, believe me, by the time they are teenagers, they'll hate the fact that I'm an artist.' They'll say, 'Well gee, Mom, if you hadn't been an artist, I could have had that electric car when I was sixteen.'

"I'm not going to teach them anything. They'll watch me struggle, they'll know the whole thing. And people go, 'Do you want your children to be artists?' I say, 'No, I don't.' If they have to be artists, then I will help them. I will teach them marketing, I'll teach them everything to help them make it through. But if I have a choice, I'd like the little one to be a veterinarian because that's what he wants to be. The big one wants to make money so I told him flat out, 'You want money?

There ain't no money in art. Be a collector.' I've already started their collections for them. I'd like them to support art and artists. There's a million of us. We need every collector we can get, even if he is only nine years old."

Would she ever consider leaving her family? Linda answers me seriously. "Well, I was separated from my husband early on. But at this time, no. I wouldn't even consider it. Being without my children would just devastate me. You could destroy all my art and I could make it. You could take my spiritual work away from me and I think I could make it. You could take my business away from me and I probably would throw a party. If you took my husband away from me I would be very sad, I doubt I would marry again, but I would make it. But if you took my kids from me, I just don't think I could make it. I'd probably paint devastated art about that forever. Horrifying thought."

Throughout the interview I have been impressed by Linda's ability to orchestrate all the parts of her life. I ask how she does it. She answers immediately. "My philosophy has been that if you combine the spiritual, the psychological, the physical and the creative together, into a strong group of four, you can have a whole life and actually accomplish something. If I let the spiritual go completely and just did the art and the business and the family, I wouldn't be complete. If I let the art go and did the family, the spiritual and the money, I still wouldn't be complete. And on and on around the circle. Each one has to be given a certain amount of attention. I've built a philosophy that makes me the closest to a whole human being that I can become." She smiles broadly and adds, "I don't think in little strands of hair, I think in full heads of hair."

"It sounds like all of those things nurture you," I comment.

"Yes," she says with satisfaction, and adds adamantly, "I'm not the kind of person who keeps running. I'm very willing to say, 'My kids are sick and I can't be there today.' I don't stay out late very often and I'm not the selfsacrificing type. You'll very rarely see me ill because of it. Money isn't worth it. Nothin's worth it. Not even ceremony is worth it. Your first and foremost responsibility is to take care of yourself, to heal yourself, so you can do your work. Who cares if you're different from everybody else in your community? Your spirit and philosophy are very personal. Only you know what makes it tick and what brings the rhythm. That's what life's all about. You've gotta figure it out."

When she *does* get frustrated at not having time to work on her painting, instead of getting angry, she quickly rearranges her schedule so she can resume work as soon as possible. "Like today? As soon as we leave here, I'm driving down to the studio. I've already made arrangements to stay late tonight. And I'll probably get there and just sit at the easel, looking into space, trying to reach it. You know that philosophy I was telling you about? It has a schedule that goes with it. Studio two days a week, gallery three days a week, writing grants one day a week. I'm very military like."

Linda further describes her schedule. "Right now I have a new client and my schedule is sort of topsy turvy. But once I get into the rhythm of it, I'll pick a solid day and a solid night to paint. And then I'll just do it religiously and there ain't nobody that'll stop me. Because the painting has to go on all the time. If it stops it's like being constipated for days. My spiritual work is basically one Sunday a month when I pour water in the prison. We do major ceremonial twice a year.

It's like a big family vacation. In late July, early August, I close the gallery and we go to big ceremony in Arizona."

But Linda rarely travels on business. "I usually make the price so exorbitant that they don't take me. Instead they pay me to stay in town and work while they're away. I don't travel with the gallery either. If I travel, I travel on vacation and take my family.

"I wasn't the kind of mom who took my kids all over the place either. When the kids were little, for years I didn't go to openings. 'Why don't you drag your kids along?' people would ask. Because kids aren't going to have any fun there. All there is, is liquor and chips. And there's all this noise and all these people. They're going to have enough art openings to gag on by the time they're thirty. Who needs more of that?"

This separation of business and family life is important to her. "No one has my home number. If you want to see me, you have to come to the business. And no one even knows how to reach me at my studio. The appearance is that I'm rarely at home but it's actually the opposite. I'm home quite a lot. I cook four nights a week."

She becomes angry, "People get on my back about it. They tell me the business would be stronger, my career would be stronger, all this baloney, if I was out and about a lot. And I'm like, 'You know, fame doesn't really cut it for me.' When I sell a piece, now *that* cuts it for me. Then I can go home and do Christmas." She pauses and states, "I think fame is a lie."

Linda has created a life for herself based on her own set of rules and standards for success and happiness. And by her own standards, she is exactly where she wants to be. For the future, she sees only

embellishing. "I've already made all my choices. The business is doing well. My family's built. I have a good relationship with my husband, and my children are growing. It took me seventeen years to consolidate and create this plan for my life.

"Artistically, I want to have one-woman shows every other year till the turn of the century. My dream is to have the biggest party this side of the Pecos, December the 31st, 1999. I'm going to have a beautiful, first class patio party, with awards to artists and collectors. Tickets at the door. Artists for free. Artists deserve a lot for their sacrifices."

Linda has lots of advice. It comes out of many years of thinking hard about this subject. "Make a decision for your life and stick with it, be loyal to yourself. Nurture yourself. Think ahead, and don't get caught up with the baloney about being rich and famous as an artist. It doesn't exist.

"One of the lectures I give is about the philosophical core. In the center are inspirational experiences. You know how the center of the flower has little circles and poles that stick out with the seeds on the end? Each one of those stands for a moment when you're inspired. Inspired to begin a painting, inspired to do something special with your child or with your husband. From there come all the petals which are all the things you do. The paintings and the poetry and the trips with your family.

"Never allow anything or anyone to talk you out of creating. Never allow your creativity to take a back seat, but to sit right next to you in your life. I've met a lot of women who were painters then became mothers and are no longer painters. And women who don't paint as much as they need to. I can see that they are missing something. They

have paid a price that they didn't have to pay.

"A long time ago somebody asked me a question about that and I said, 'Anybody who tells me I can't have it all can go jump in the lake. Because I'm going to have it all.' I was like, cocky, but I got tired of people saying, if you're a mother, you can't be an artist and if you're an artist, you can't be a mother.

"I was the girl who was forced to be independent because I had no one around me. But I also didn't have anybody telling me what to do or be. That's how come you end up with someone who can say, 'You know what? I'm going to be a mother and I'm going to be a wife and I'm going to have a house and I'm going to be an artist and you know something else? I'm going to own a gallery and I'm going to be spiritually and physically sound. So there!'"

Pictured from left: Teju Adisa-Farrar, Opal Palmer Adisa, Jawara Adisa-Farrar (sitting), Shola Adisa-Farrar

Opal Palmer Adisa, *WRITER & STORYTELLER*

THE FRONT DOOR to the Spanish style duplex apartment is almost hidden behind the gaggle of potted plants that congregate around it. As I stand before it, I feel a familiar twinge of anxiousness. The thought, "Will she let me into her life?" flashes through my mind as it does every time. But at my knock the door flies open. A small dark woman stands in the doorway with energy whirling around her. Her smile reaches out to envelope me as her hand grasps mine and pulls me in.

Opal Palmer Adisa was born on November 6, 1954. She has one older sister and two older half-brothers from her father's first marriage. Growing up in class conscious Jamaica, which until 1962 was a British colony, Opal is very clear about her middle class status. Her father was a chemist on a sugar plantation and her mother was executive secretary to the manager and highly respected in the community. She and her sister attended a private school and the family had a TV and a car. Her parents divorced when she was five and Opal continued to live on the sugar estate with her mother and sister. When Opal was in high school her mother temporarily moved the family to New York City, so that the girls could go to college in the United States. After graduating from Hunter College in 1975, Opal worked in Jamaica for a few years, but returned to the United States. in 1979. Opal now lives in Oakland, California with her husband Tarik and three children, Shola, nine,

Jawara, five and Teju, three. She has a PhD in Ethnic Studies and is currently head of Ethnic Studies at California College of Arts and Crafts in Oakland.

Though she lives far away from her homeland, Opal carries Jamaican culture with her in her voice and art. Each lilting word is caressed, before being sent out into the world vibrating with power. In her work, Opal seeks to give voice to people not often heard from, specifically rural women from Jamaica. She is a writer of short stories, poetry and novels. She is also a storyteller and performs regularly.

Opal lives a full life, like most of the women I have interviewed, but now she is relaxed and the interview is not rushed. The children are with Opal's sister this week, but I doubt she is much different even when they are at home. Her feet are firmly planted in the earth, drawing up limitless energy and generosity. Throughout the two hour interview I sit bathed in her light as her dancing words cascade over me.

Opal's childhood in Jamaica still surrounds her like a warm quilt. She laughs with delight as she tells me about it. "I had a very wonderful childhood, a lot of freedom in terms of being able to roam. And I had the love and protection of the community where I knew that I was special and my mother was special. We had a great big lawn in front of our house and across the road there was the cricket club, where they also played soccer. I would love to go and lay in the grass and look up

at all the wonderful shapes in the clouds. I thought a lot about trees. There was a great big tree in front of our house. In fact in one of my poems I talk about the trees that had hands like umbrellas. I had five dogs and we had rabbits and chickens. My mother always had a garden. I guess my garden is a reflection of that. She grew flowers and vegetables. I remember in the evenings, when she came home from work and was outside watering or working, I would be out there with her. I was very close to my mother. I liked to hang out with her."

Opal lived primarily with her mother and sister, but her older half-brothers would live with them periodically, even after her parents were divorced. "In Jamaica," she explains, "the whole familial thing is different. My mother was always taking in people. I remember one kid, Carol, whose mother had died, came to live with us for almost a year when she was about seventeen. She and her father were having problems. My uncle, my mother's younger half-brother, who is an artist, came to live with us for awhile when he was out of a job and trying to pursue art."

When I ask what kind of person her mother is, Opal responds in a great gush. "Oh my mother is wonderful. She is a fighter. There's a word in Jamaica called *talawa*, which is African derivative. I think it's Twé-Akon. It usually refers to a woman. The full phrase is, 'She little, but she talawa.' They always said, 'Don't mess with Miss Palmer, 'cause she talawa.' Even though my mother is small, nobody messed with her. She had a mouth and she used it rather well.

"In 1950s Jamaica, if a woman had 'a good husband' (that means a husband who was educated and making money) you didn't leave him for nothing. The fact that he might womanize, which is what my father

did, the fact that every once in a while he might go with his friends and get drunk and mean and slap you, you still didn't leave him. But my mother did. She was an exception to the rule. She was respected by both men and women, but there was always an attitude of, 'Who does she think she is? This woman who would throw away a husband for all intents and purposes. And be surviving on her own and surviving well.'

"I remember one incident when my sister and I and some other kids got into a fight with another kid and put chewing gum in her hair. They had to cut her hair and her father was very angry. He came to our house and said, 'Miss Palmer, Miss Palmer, I'm going to flog your kids even if I have to draw them out from under your bed.' Now he never went to any other parent's house, but he figured he could do that 'cause my mother was alone. And I remember my mother standing on the verandah with her hands akimbo, telling him that he should try it if he wanted to. In Jamaica we call it tracing down. 'She really traced him down with her mouth.' I remember her ending by saying 'You might think these kids don't have a father 'cause a man don't live in here, but if you have the audacity to put your hand on them you'll find out.' And I remember wondering, 'What if this man decided to take my mother's bluff?' Because it was really a bluff. But he didn't, because of her position in the community and the kind of force that she carried. I often wondered if my mother was ever afraid. She must have been. She must have been terribly frightened in many instances.

"My mother was the oldest of three kids. Her mother died when she was ten and her father's brother, who was married, didn't have any children and lived in Kingston, said he wanted to raise one of the kids. So she was, in a sense, given to him. As a result, my mother was more

educated than her other sisters, because her father got remarried and ended up having eight, ten other kids. My uncle wanted her to be a nurse and she went to nursing school for a semester but didn't like it and dropped out. Then they sent her to secretarial and business school."

Opal's models also include a woman named Miss Scott. As she tells the story, Opal's voice takes on an even more rythmic quality. "Miss Scott lived more in the interior of the island. I guess at the time she was about fifty-nine. She was six foot one and strapping, and even the dogs were afraid of her, 'cause she had this fierce look. It's wrong to say she looked like a man, you could tell she was a woman, but she had the strength and the body of a man. People in the community used to be afraid of her. They said she was an Obeah woman, which is analogous to voodoo.

"For some reason, Miss Scott had this wonderful love relationship with my mother. She honored my mother. She was not poor, because she had land. But she couldn't work the land to make money, so every once in awhile, she would come by the house and my mother would give her a little food. And whenever Miss Scott had anything, yams or plantains, she would come and give my mother some as a token of appreciation. Very few people spoke to her, but she would come around to our back door and talk to my mother.

"One of the things I admired about Miss Scott was that she walked anytime, night or day. It could be pitch dark. People here don't understand what darkness is. You have to be in the Caribbean or Africa. When we say it's pitch dark, that's literally what we mean. You put your hand in front of you and you don't see it. So Miss Scott would emerge out of this pitch darkness and the dogs would kind of growl, but then they would hobble and go away. They said she was an Obeah woman because she had had three husbands who all died. People said she gained more land, 'cause these men had land. I don't know.

"One time Miss Scott came to my mother and said she was getting married again. This would be her fourth husband. And she wanted my mother to come. She had never had a church wedding but she was going to have a church wedding and she was going to wear a white dress. And she did, she married this thirty-five year old man."

Opal emerges from her storytelling trance and says to me, "I used to say I was going to be like Miss Scott and have four husbands. She stands out as a woman who broke all the rules, in a sense very similar to my mother."

We laugh together and I ask, "What kind of rules did *you* break?"

"I was always rebellious," Opal says proudly. "I hated the fact that boys got to do more than girls. I remember one particular summer there was an alligator pond about two miles away and all the boys in the community used to go. I wanted to go too, but girls didn't do that kind of thing. But I snuck off and went to the alligator pond and almost fell in. Lost one of my shoes. But I still went. To this day, my mother doesn't know. We girls weren't supposed to go into the woods with our slingshots and go shooting birds but the boys did. So I would sneak off with them. I had big fun. I still am resentful of what boys can do and what girls can't do."

This ability to cross barriers and follow her own direction has helped her to pursue writing. She has always written, even though sup-

port for it was mimimal and racism limited her models. "I remember myself at nine, writing. Writing a lot about the superstition of Jamaica. Writing a lot about nature. My first poem was about the sound of the sea. It was published in the school magazine. But you see, I grew up when Jamaica was a colonized society. Throughout my high school, we never had any literature by anybody but Europeans, primarily English or North Americans. All the writers I knew were dead white men, for all intent and purposes. So the idea of being a writer seemed far-fetched to me.

"In fact, when I came to this country to go to school, the assumption was I was going to be a lawyer. It was always said that I could talk my way in and out of anything. It was not until I went to college, here in the United States, that I met some writers. I met this Trinidadian man LeRoy Clarke, a painter, who encouraged me to write. That was 1972, during my first year of Hunter College in Manhattan. Also, Jayne Cortez, an African American poet, was invited to the campus to read and I was just swept away by this woman too.

"It was then I decided, not only that I wanted to be a poet, but that I was *going* to be a poet. So I started to share my work and attend readings. For many years I was strictly a poet. I didn't think I could do anything else."

In 1975, after receiving an undergraduate degree in educational media she went back home to Jamaica and worked for the Ministry of Education as an education officer and a producer of radio poetry shows. It was there that she became known as a poet and connected with the dub poets who were beginning to put their poetry to the beat of Reggae music. This also lead her into performance poetry.

But she left Jamaica in frustration in 1979. "I was very idealistic, planning to help change the society. But I ran smack up against a very rigid class system where people didn't want change. I didn't feel as if I was making any significant contribution. At the time I also wanted to go to graduate school in communication, but the University of the West Indies didn't have a communications program. So that, combined with the feeling that I'd gone as far as I could go in my job, and just feeling a sense of hopelessness that the society was not changing, made me want to leave again."

Opal ended up in Oakland almost accidentally. While still living in Jamaica, she took a four week vacation to visit her mother and sister. They were living in New York, though Opal's mother was preparing to return to Jamaica. "Well, after seven days," Opal recounts, "I decided I could not take New York. I had a constant headache. It was too noisy. I knew why I never liked it. New York was not the place for me."

She had the names of two Jamaicans who lived in Oakland, friends of a friend she had just met in Jamaica. "So after seven days in New York, on impulse I called one of the persons, the woman. I said, 'I was thinking of coming to California, but I don't know anyone. If I were to come, could I stay with you?' She said, 'Oh yes, in fact, my sister just finished college in New York and is coming out here to see if she likes it. I have to work. You guys could hang out together.' The sister turned out to be my age and we are good friends now. So my mother said she would pay my plane fare and so I came."

"And you never left?" I ask.

"Well, I've gone back and forth," she explains. "But for the first two years I literally didn't leave. My mother went home and packed up

my apartment and sent some of my stuff here."

Though Opal waited until her late twenties to begin to think about having children, she always assumed she would be a mother. "It never occurred to me that I wouldn't be a mother," she says joyfully. "The Jamaican identity of a woman is very much akin to the African identity of a woman. If you're not a mother, you're somehow not a woman. Not that all women were mothers, just that they were always women who were mothering. So my mother was quite worried when I was twenty-six and there was no sound of any children. At that point I wasn't ready, I was having such a good time, enjoying my life."

When she did decide to have children, it was on her own terms. "My first daughter is not the daughter of my husband," she announces. "I was against marriage, partly because my mother was not married." Opal explains further. "My mother's sister has been married all her life. I could never understand why she would put up with her husband. Marriage seemed like a big trap for women. I had already decided that I was not going to take care of any man, that I was not going to cook and clean and wash and do all the stuff that my brothers' wives do. I had been married, in fact, just out of college and that lasted six months, because my husband wanted me to be a wife. And I wasn't prepared to be a wife. I wanted my freedom."

"When I was about twenty-seven I had a relationship with a man and we wanted to have kids. But after trying for two years and not getting pregnant, we decided to go through the fertility clinic to see if there was anything wrong. But before the end of the tests, I got pregnant. By that time we had decided to break up. I had a lot of models at that time, of women who were single mothers, divorced, college edu-

cated, artists and doing fine, so it didn't seem to me that I needed marriage."

And she didn't. Being raised in a close and safe community in Jamaica has given Opal a core belief that there is support and community available for her elsewhere. Her choice to have her first daughter as a single mother was based on this perception as well as a realistic evaluation of her own goals.

"I was here in Oakland," she explains. "I had finished my master's in creative writing and English at San Francisco State University and had a full-time job teaching at San Francisco State in the black studies and women studies department. So I was economically viable. I had been to Europe, the Caribbean and Africa, so I'd done a lot of the traveling I wanted. I'd saved money, because I'm very sensible with money, and I was determined to have a child, come what may. I was thirty when my daughter Shola was born.

"'Shola' is Yoruba, and it means joy and that's what she means to me. She came at a point in my life when I needed to be a mother. I needed to be less selfcentered. I was relatively known in the area as a writer. I was respected as a teacher, I was performing and doing storytelling. I was in a number of anthologies. It was like, hey, my professional life was going well, I needed something else in my life. So I had my Shola."

I am impressed. "What kind of help did you have?"

"Oh God," she laughs. "I had all the help in the world. Because, you see, this is a wonderful area where children are very much integrated into the society."

"Are you speaking about Oakland?"

"Yes, and the community of artists that I hang out with. I was fortunate in that they all had kids who were teenagers, so I had a built in baby sitting community. I had very wonderful friends, like Shola's god-daddy Bilal. When Shola was six months and I needed to go to a writers' conference for a weekend, he kept her for me.

"When I was in the hospital I had a very long labor, thirty-six hours, so I ended up having a C-section. I called my sister when I was going in the hospital and she flew down the next day and for the entire time I was in the hospital, I was never alone. I had a series of women around the clock to support me, Wendy, Karen, Kathy, Sala, Imani, Aida. Then my mother came up and took care of me for a month. So I had a support group of women who have helped each other and raised each other's kids, so it never was really a problem.

"When I say this to people, they think I am making it up. But it never really was a problem. One, because I wanted and needed Shola so desperately. And I had this great support group.

"Then after I had her, I was encouraged to do a PhD I was really ambivalent about it. I really wanted to pursue my writing. I was ready to write a novel. But I also was feeling, okay, now you have this child and for all intent and purposes, you are the sole provider of her. You need to put yourself in the position where you have the greatest stability and leverage. So that was what really motivated me to go back to school.

"And that is where I met my husband. He was finishing up his PhD at Berkeley and I was working on my PhD at Berkeley. I also knew I wanted other kids. In fact, my great plan was that I was going to finish my PhD and then have another child." Her eyes twinkle mis-chievously. "You see, I never worry about where the husband or man is going to come from. Well, I had my second child before I finished. Having two other children probably delayed my finishing. But I finally finished."

Opal's husband Tarik is a major source of support for her. She states frankly, "I have a very supportive spouse. I have to or I wouldn't be married."

"Did you choose him for that?" I ask.

"I picked him," she says with a wide grin. "I was very clear. I wanted a man who was going to be a good father. More than in the West Indies where a good father merely supports his children financially. It was important that I was going to marry a man who had integrity, who I perceived was going to be a good father and who was domesticated. And I have all of that. He cooks, except for Monday, when he fasts. But he cooks Tuesday through Saturday and I cook Sunday and Monday. He does as much washing and folding clothes as I do. He tends not to like to clean, so I do most of the cleaning. But that's okay, because he does most of the cooking. And he cleans the bathroom and he does most of the washing. And he's also not someone who wants to run around. He is very much interior. And he's a great father.

"In fact, what I have done with three kids, I couldn't have done as a single mother, even with a support network. People don't mind sitting one kid, but three kids become a problem. February, March, October and November are my busy months. I might be gone two, three evenings out of the week for several weeks. So that requires someone to stay home. We couldn't afford a nanny, unless we had an au pair girl or something like that."

She speaks more of Tarik. "He thinks I'm a good writer. Before we had three kids he used to do more of my reading for me. He very seldom reads anything that I've written these days. But he's very supportive of my work and he knows that my work is important to me. So at this juncture in my life, I do all that I do because I have a very supportive mate."

"I'm good at having fun with my kids," she adds. "Mostly, I laugh. That is what has kept me sane. Shola can read me very well. She looks at me and looks at me until I burst out laughing. We like the outdoors. This summer we went on a couple family outings to the Russian River and Clear Lake. We go a lot to the parks and just hang out."

Her face becomes serious for a moment. "I'm not looking forward to them growing up. This might be misunderstood, but I wish I could clone them at this age because they are at the age where they are most perfect, as far as I am concerned. Shola is eight, she's independent, but she still likes to sit on my lap and I read to her. I read a page and she reads a page. So many nights, we'll sit there, the three of us, Jaja and Teju running around, reading or whatever. And there's that sense of intimacy and family, which is very important to me.

"One of the things I insist on is sitting down to dinner every day. That was something my mother did. It was a way of us coming together and connecting. I won't be able to do it this year because I'm teaching two evenings a week. I'm really bothered by that. I've also been able to volunteer at my daughter's school. We've produced poetry books for the last two years at her class. She feels very proud that I can come in and do poetry. And I can go on field trips with my younger children's preschool."

"It's very important to me to tuck them in bed at night, to tell them stories, because I remember being told stories. To sometimes lay in bed with them. I grew up in a very physical family. My sister and I shared a room, but many nights I didn't sleep in my own bed, 'cause I was scared of noise. In Jamaica ghosts are very real to us so I was scared of duppies and the croaking lizards and all that stuff. My sister hated me to sleep with her because she said I was always throwing my body over her and hugging her. But my mother didn't mind so she came and slept with me."

Discipline remains a challenge. "My husband says I'm a paper tiger," she says roaring with laughter. "I'm not firm." It is clearly a source of amusement and something she is not worried about. "I think children should be indulged and I do indulge them. Every once in a while I get mad and scream at them, but I know it's my own fault. My son does something really obnoxious and I say, 'Jaja, I'd like you to go in your room,' and he doesn't go and I know I should be firm, but it's like, Lord, he's a child, he really wasn't malicious. So I'm terrible at discipline."

Opal leans forward and her face softens. "To say I love my kids is not even adequate. There is something about them that is absolutely miraculous and I do think they are very special kids. I think they are quite remarkable. So I'm in love. I can't describe it."

"Do you feel guilty about anything, any mistakes?" I ask.

"Oh yes," she says laughing. "I'd like to meet the mother who thinks she doesn't make mistakes. I feel most guilt ridden that I'm not as patient as I should be. I feel most guilt ridden that some nights I'm too tired to read them a book and they beg and I'm just too tired. I

feel bad that many nights I'm helping Shola with her homework and I'm just trying to get it over very quickly because I think of all the papers I have to mark.

"I don't feel that I give them enough undivided time. I'm pulled in so many different directions. And part of that is my own ambition. I want to be known as a storyteller and the only way that's going to happen is to keep performing. I want my work to be out there, so every anthology that asks me to submit, I'm busily trying to prepare stuff to send. So I'm trying to do it. I'm trying to be a good mother and obviously something falls short. There are only twenty-four hours in the day and there's only one of me."

One way she has figured out how to help herself is through working regularly with four other women writers. "We meet once a month for three hours. We did it a couple times with our kids. But the whole time it was, 'Can we get this, can we get that?' We felt it was important to deal with our writing for three hours once a month, without kids." Working as a teacher gives her the flexibility she needs to make her life work. During the summer she produces the bulk of her writing, leaving the school year for revising.

Opal has also always traveled extensively for her work. "When my daughter Shola was born, I was invited to the University of Hawaii to do a reading to celebrate my short story collection and I took her with me. I have a friend who lived in Hawaii who had a teenage daughter and she came and helped so that worked out fine. And when I went to the big island, I didn't have anybody there, but the woman I stayed with was a mother and she had a seven year old boy. So while I was reading she kept Shola for me. People have been wonderful.

"There was a conference in 1992 for Caribbean women writers that was held in Trinidad. And I took both Jaja and Shola because I was feeling guilty about leaving them. I also felt my husband needed the break. Some of it was difficult because there were times in the evening, when the women were sitting down talking, that I was never able to complete a sentence 'cause Jaja was running off somewhere and I had to go and get him. But then a lot of the women were mothers, so we picked up the conversation five minutes later.

"I'm invited to the University of Kentucky for about four days in October. I'm deciding whether or not I'm going to take Teju with me. But if I do, then Shola, who loves to travel with me is probably going to be resentful and I don't want to take all of them. So I might end up leaving them. Then I might go to Guyana in November and if I do, I probably will take them."

Curiously, she is perplexed by my question about whether there are obstacles for mothers in the writing world and answers confidently, "I meet a lot of writers who are mothers. Many of the leading, certainly African American, women writers have been single mothers. Alice Walker, Toni Morrison, Toni Cade Bambara, Pearl Cleage. The list goes on ad infinitum. And even some Native American writers who I'm familiar with like Paula Gunn Allen.

"People know I'm a mother because I'm always very up front about that. And oftentimes when they invite me, one of the things they'll ask is, 'What about childcare?' Like this conference I'm going to in Kentucky wanted people to stay over until Sunday. Well, I'm going from Wednesday to Saturday and I'm not staying over until Sunday, 'cause I'm a mother. They said they understand because a number of

other women want to go home Saturday night, too. People don't *not* invite me to conferences because they know I'm a mother."

Yet she does not hold back when she talks about how mothers are treated by society as a whole. "I hate that this society doesn't respect mothers," she says angrily, her eyes flashing. "I hate that this society doesn't credit us for being mothers. This society, in fact, does not credit parents.

"It's a tremendous amount of pressure to have a full-time job that doesn't end. My husband and I are both teachers at the college level. Shola said to us at the end of this year, 'I hate that you guys are teachers, 'cause you're always spending time on your papers.' And even Jaja, who loves books, started tearing them up because my husband and I were always in a book.

"I am much more flexible than my husband. My husband will close the office door if he's marking papers or getting ready for class. They don't bang on the door when he is working, 'cause they know that he's firm. But I go in the office and Jaja just bangs on the door. So I open the door and sometimes I let them sit in my lap while I'm writing, until they start messing with my computer. But also I have learned to write with interruptions. This novel I'm working on, when it gets done, is going to be interesting because I have written it stopping a lot."

"You seem to have been able to handle it," I say.

"Yeah. I have to," she answers and the words shoot out hard. "My children are important to me. My writing is important to me. I've no intentions of giving up my writing. I've no intentions of giving up performances. I feel that this society forces women who want children to choose.

"It's like when I was going through my PhD I had professors who had the audacity to say to me I wasn't serious about being a scholar because I was having all these children. They would make these snide remarks, 'My, aren't we productive now.' They make the assumption that if you're a mother, you're not serious about your art. I'm not going to give up my art and I'm not going to give up my children. Being a parent is very important to me. It's very important for my own development and how I see myself.

"And I'm also arrogant. I feel that I'm a good parent. I'm very conscious of wanting to produce some good sensitive people who are conscious of the world and the earth and what needs to be done with it. My parenting is a form of production. One of the poems I've written for Shola says, 'You are the best poem I've written.' She's an incredible child."

Opal considers a moment and then adds. "It's interesting that with each child, I've produced something. When Shola was born, I had a children's book out and then my short story collection came out. Six months after I had Jaja, I took and passed my orals with honors, and then finished my dissertation with Teju. I don't know what that says. They have not stopped me. Now I'm working on a novel. I've done performance all through, with all of them."

"Has your work been changed by your children?"

Opal tilts her head and, as if it is a new and wonderful thought says, "You know, I think it has gotten better. My kids make me more ready to write. A lot of times when I'm playing with them and engaged, the ideas are jelling in my head, so when I write it comes quickly, because I know I have a little time. And maybe it's age and

maybe it's that with children you get to relive what you don't remember of your own childhood in a very different way.

"I used to feel like I wasn't accomplishing anything, but I realize now, that I've accomplished a tremendous amount. Part of that has to do with being very organized, and that I don't need a lot of sleep. Most nights, when everybody in this household is asleep, I'm up. I'm at my computer between ten and one o'clock, because that's the only concentrated time that I get. My kids never seem to get into bed and settle down before 9:00 or 9:30, so most days, between 4:30, when I pick them up and 9:00, I am being a full-time mother with three kids demanding my energy."

Opal shifts in her chair. "I've learned that you don't have to have a room of your own," she says quietly, looking straight into my eyes. "It helps, but you can learn to work with interruptions. I have not done anything, including my dissertation, without constant interruptions. Yet it was a coherent body. I think it was a coherent body. Let's say my committee thought it was a coherent body.

"To be an artist and a mother in this society is very difficult, but I think it can be done. And it can be done without making your kids resent what you are. Involving them in what you do on an intimate level. Taking them to your performances or your readings. Letting them see what you're doing."

She adds to that advice, "Keep doing it. Do not surrender your creative work, because that's surrendering to death. Maybe you don't want to exert the kind of energy I'm exerting in my mothering and in my creativity, but never abandon it."

Opal is moving at a fast pace and nothing will stop her. Her grin widens and her eyes flash merrily. "I want a bestseller and I want my work to be translated into many different languages," she says. "That might sound like a cliché, but I really do. There are lots of books in my head and I'm finished with baby-making. I'm ready to write them. This novel is just a beginning of that."

Pictured: Comly Wilson and Martha Wilson

Martha Wilson, PERFORMANCE ARTIST

IT WENT LIKE THIS: I found out that Martha Wilson was going to be the featured speaker and performer for the Women's Caucus for Art regional conference in Tacoma, Washington, a mere two hours drive north from Portland. What luck! We arranged to do the interview and photo session between her arrival at 2:00 and her presentation at 6:00. My husband Dennis and son Rowan planned to come with us and entertain Comly, Martha's five year old son, while the interview took place. Would this plan come off?

We arrive in Tacoma as planned, but Martha and Comly's plane is over an hour late. We wander around the Tacoma Sheraton Hotel, nervously wondering if we will have enough time before the performance. Joyfully, we do. After a rushed photo session, I have exactly one hour to interview her. Dennis and Rowan whisk Comly away to find a park and Martha and I settle down at the table in her hotel room. My emergency rations of rice cakes come in handy. Martha is hungry and nibbles as we talk. Fortunately, Martha and Comly seem to be expert at adjusting instantly to a new time zone and city. Though tired, they overcome the fatigue. An hour after we finish, Martha is in front of an audience, performing as Tipper Gore, regaling and informing us on the subject of sexual politics and censorship in the arts.

Martha is a performance artist and also runs Franklin Furnace, a nonprofit arts organization she started in 1976 that presents perfor-mances by artists from all over the country and, until recently, archived artists' books, which are books made by artists as visual pieces. Her performances are about physical transformation through make-up and costume.

She was born in Philadelphia, Pennsylvania on December 18, 1947. Both sides of her family are a mixture of English and Welsh. Though Martha was raised middle class economically, an air of aristocratic pride wafts through the family due to the 350 year old Quaker lineage on her mother's side. Her mother was an artist and fabric designer who had attended Philadelphia College of Art. Martha's father worked as an architect. They lived in northeast Philadelphia which evolved from farmland to suburb during her childhood. Martha graduated from Wilmington College in Ohio and received an MA in English literature from Dalhousie University in Halifax, Nova Scotia. At the age of forty-one and single, Martha gave birth to her son Comly. She continues to raise him by herself. They live in Brooklyn, New York.

Martha Wilson is outspoken. Her speech is peppered with rough language and idiosyncratic phrases. The interview is awash in strong and controversial opinions. She does not apologize for her ideas or her life choices. I find her refreshing and full of thought provoking analyses of her life and the world. Fascinated by her own psyche, she talks

openly about why she is a performance artist. After many years of "shrinkage," Martha is amused by and gently tolerant of her need for attention. In fact, she laughs at herself through much of the interview. It is probably a mixture of jet lag, preperformance excitement and the real Martha but her life seems like a big game, fun, full of risky escapades and challenges.

This zest for adventure was apparent in her childhood. As with so many of the women I've interviewed, Martha too liked to play in the woods. "I had a boyfriend, Donny Motson, and we would build roads and forts and play, not exactly cowboys and Indians, but we had opposing teams and weapons." She pauses and clarifies, "We had swords." Martha stops again and finishes her bite of rice cake. "I was a tomboy for a long period of time." In her typically direct and some-what harsh way she says, "I was the athlete, my sister was the book-worm. She was a little bit younger."

"There were two of you?" I ask.

She nods. "Yup. She had brown hair and blue eyes, I had blond hair and green eyes. We just divided the world in half. And now that she lives on the West Coast and I live on the East Coast, we have con-tinued this tradition. Ironically, she's the one with the middle class lifestyle and she's infertile and I'm the one with the crazy lifestyle and I was able to conceive, so we are still dividing the pie."

Martha's relationship to her mother was as intriguing. I proceed by asking innocently, "Were you close with her?"

Martha answers by putting her experience into the context of her cultural and class background. "I believe that Anglo families have cer-tain gestural traditions. They are nonreactive and cold in appearance. I spent a lot of time in shrinkage talking about how I wasn't being looked at. And now I'm a performance artist!" Martha pronounces as an afterthought, "I was raised in a Skinner Box." [ed. note. A form of child rearing, developed by behaviorist B. F. Skinner, in which the infant is completely enclosed inside a transparent box.]

My eyes widen. "You were actually in one of those?"

She laughs, "Yeah, for two years. It was right after the war, 1947. My parents started their own design business and it failed. My father then went to work for an architectural firm. They lived on a houseboat in the Delaware River and I was born in December and it was cold, so the box was a safe place for me.

"The Skinner Box, in their minds, was the most modern form of child rearing at the time. It kept me off the floor. The baby healthy in body would be healthy in mind. You have physical freedom, but of course it's also soundproofed. And you can't crawl to your mother. You are stuck in this box. I have this picture of myself staring through it.

"My shrink suggested that not being able to go to her and get what I needed became the reason I turned into a person who, while very shy, had to become an exhibitionist to handle this dichotomy. Who knows?" Martha whoops with laughter. "I buy it totally."

"So you wouldn't say you were close with your parents at all?" I ask again not knowing where this is all leading, but sensing that it is important. "What was your relationship?"

"Cold," she answers plainly. "And also, my father may have molest-ed me. I have no memory of this at all but my sister remembers him getting into bed with me. I believe it totally. I think he fingered me when I was little, because later he came on to me when I was twenty-

one years old and thirty-one years old. So it wasn't beyond him at all.

"My mom never understood that her role was to stand in the middle and protect me. She would just look the other way and pretend like, 'This is not going on in my family.' Also he was an alcoholic and he died before he admitted it, so those sorts of codependent things were going on, except we had no language for it."

Still curious about her mother, I delve further, "What type of a person was she?"

Martha thinks a moment. "I think she was very purposeful. For example, she believed that on a farm, you need to eat, so you kill the chickens. So we had pet chickens, that later appeared on the dinner table. But when my mother told us that these were our chickens, my sister threw up and I got completely ill."

Martha pauses. "Purposeful is not the right word. I know what it is," she says after a moment, her voice rising in excitement. "If you're a Quaker, you think you are umbilically connected to God, so whatever you think is what God thinks. You have no intermediary, no priest, nobody telling you what to think. It's just you and God, right? So once she got an idea in her head, you could not persuade her, you could not negotiate, you couldn't change her mind. That was it. So my parents would have huge fights about our education and money and all the stuff you negotiate in your relationship, because she would not negotiate at all. She had her idea of what was supposed to be right, and that was it. I'm not sure I've found the word. Single minded, or something."

Martha reaches for another rice cake. Through her munches she mentions, "At one point she fell out of a cherry tree and almost died. When she recuperated she went down to the drugstore and bought a whole bunch of toys, brought them home and laid them out on the rug. I was embarrassed that my mother was playing with toys. She said, 'When you get that close to death, you figure I may as well enjoy myself. I'm here. I'm alive. So I'm going to buy toys and do whatever I want.'"

I am struck by this singular woman who gave Martha the freedom to create an original life not unlike her own. But I am missing a piece. "It seems like you are speaking about her as if she is far away," I muse. "Is that the reality of it?"

Martha takes the rice cake out of her mouth and looks at me. "She started muttering when she was in her forties. I was still in high school. We then went away to college and stayed away. She had Alzheimer's and deteriorated during this whole period. My father died in 1980. I then came back and took care of her for the summer, then Callie took her here in Olympia, Washington for the winter and we continued to trade off for the next year. We then decided we couldn't take care of her full-time and institutionalized her. She died in 1985."

Martha shifts in her chair and looks out the window at downtown Tacoma. "Yeah," she says, "I feel removed. I spend a lot of time wondering about Quakerism. Wondering about transmitting the values she transmitted to me and my sister. This occupies a lot of my screen. Maybe Quakerism is not such a great religion, because it doesn't really handle sexuality and violence, two basic human things. It just looks the other way and pretends it doesn't exist. So she is with me a lot. I'm not trying to say she's not with me. I'm still talking to her, even though she died in 1985."

Art was an integral part of Martha's childhood and something her

mother encouraged. Martha laughs, remembering. "Oh, yeah. It was part of everything. We went to Falsington Craft Center and did watercolors and painting. My mom and I did modern dance and my sister did basket weaving. It was totally part of the deal. And also art and music were still in the school curriculum, even in the public schools. Not now . . . I loved art class when I was in high school. It was great."

By the time she was ready to enter college, any idea of being an artist had faded away. "I didn't really have the guts to be," she says loudly. "In college I majored in biology but changed to English, because my father refused absolutely to send me to art school. He thought if I went to art school, I would be just a bum."

So she did the next best thing, had a boyfriend who was an artist. With a degree in English from Wilmington College she followed her boyfriend to Nova Scotia. He was going to Nova Scotia College of Art and Design while Martha attended graduate school at Dalhousie University. She spent most of her time at the art college though, where she felt more comfortable. "In 1973, when [Dalhousie] didn't accept my PhD thesis, I quit graduate school and got a job at the art college teaching English to art students. I found out about conceptual art, which is the marriage of the word and the image. Nova Scotia College of Art and Design was a very, very hot place in the seventies. They were bringing in Doug Huebler and Vito Acconci and Dan Graham and Lawrence Weiner. All the white guys, Richard Serra, Joseph Beuys. They were all coming in as residents for six weeks or even just a day.

"So I got to see this work going on. Vito Acconci did a piece in which he put his penis between his legs and took photographs of his vaginal area. Sex transformation work, which turned me on totally."

"What kind of work were *you* doing?"

She explains, "At that time I was doing performances just for the camera, not for an audience. Using make-up to deform my face and costume to change myself from a woman trying to look like a man who's in turn trying to look like a woman getting himself up in drag. Doing sex and age transformations forward and back again. Exploring whether putting on make-up is a way to actually have *more* expression rather than a way to *hide* expressions. These were all experiments for an internal sense of audience. You have to believe what I'm telling you, since there wasn't any way you could experience the work, exactly. I would take photographs of it. And I thought that was performance and at the time actually it was. But it was not called performance, it was called body art.

"And there I met Lucy Lippard who told me that this stuff that I was doing *was* art and there were women all over North America and Europe doing this kind of stuff and I shouldn't let these guys tell me that it wasn't art.

"In 1974, I split up with my boyfriend and moved to New York. When I submitted my slides to the Whitney Museum of Art, they accepted my work as a performance artist and said, 'You have a date, it's such and such at 7:00 and three hundred people are coming.' I just thought, 'What? I don't know what I'm going to do. I don't do that.' It was a horrifying realization that there were going to be other people watching me do something."

"What did you end up doing?" I ask.

"I ended up doing pieces based on the structure of *Alice in Wonderland*, looking at the characters in certain sections of the story,

using Alice and the caterpillar. I was using a video camera pointing at my face and watching myself in the monitor and then fixing the face on the monitor with black and white grease pencil to make myself into Alice and then turn it into the caterpillar, while a text was going. It was about deforming and changing features using make-up. And yet, it was a live performance with a live video feedback, so it satisfied the needs of people to stand around and watch something happening."

"Have you kept on doing similar work all these years?" I ask.

Martha chortles and nods. "It's the scariest thing that I could find. People scare me the most. It's got to go back to the Skinner Box, right? Some primal need is being addressed here, because I assure you, standing up in front of people is not something that I did when I was younger, but something I threw myself into in order to master this huge fear. Again, I think Quakerism has something to do with it. You worship in silence, you don't demonstrate your emotions, your shades are down a lot. And this is the opposite, you live or die up there. Your audience either laughs or doesn't laugh or . . ."

"Yeah," I interrupt. "Living on the edge." We smile into each other's eyes and Martha laughs some more. She loves this life she has created for herself, full of calculated gambles and fortuitous accidents. The surprise arrival of Comly was just one more turn in the river. She just hauled him on board and kept paddling.

"I never thought I would be a mother," she explains. "For a really long time I wanted to call myself an artist and feel like I had accomplished something as an artist, which I worked at doing in the seventies. And then I started Franklin Furnace, which was like having a baby. It needed constant care in the beginning. I lived in the organization and fed and watered it all day long. And this went on for some years. Then it got to be a toddler and then a teenager and I could leave and live in Brooklyn. So Franklin Furnace is my first offspring. Comly's the second and it's much easier the second time. With the first one you haven't dealt with rage and limits and all these little things you have to do.

"The clock started ticking really loudly when I turned forty. It was already ticking, I could hear it. It is the idea that you're going to be the last one. There isn't anybody after you and it's just you and this sky. My parents are both dead and it's just . . . emptiness.

"It's about hope. If you have a child, it seems to me you're saying, 'Look, the future is looking bad, but what can we do, we just have to leap into the unknown and go for it.' It's exactly the same thing as art. It's an act of faith and hope. That whole time I was pregnant, I was a mess because I didn't know if it was the right thing to do. But it was too late. I was out to here. It wasn't the right guy. I wasn't married. I had no intention of marrying this guy. None of that. I just decided that I was going to have a baby."

"Do you want to talk more about that?" I ask.

"Yes," she answers and launches into the story. "I was on a couch in the Poconos at 9:00 on June 4th, I think it was. I'm having sex with Scott, who doesn't even have a high school equivalency diploma, but who is a very nice guy, and the thought kind of went by, 'Hmmmm, I should be more careful, because I bet this is the fifteenth day after my period.' It *was* and I did get pregnant. Then the whole thing started, deciding what to do.

"The first version of what I was going to do involved my sister. In

a Quaker family, you don't own anything individually. If you have a rice cracker, it's yours, it's ours, we can have it together, but I don't own this separately from you. So my sister had been trying to have a baby for twelve years. I called her on the phone and said, 'Look, I'm having an accident, why don't we work out some open adoption thing.' This discussion went on for about three months. Then she decided it wasn't going to work for her and she would like for me to have an abortion. It was getting to the end of that period of time when an abortion would be healthy. I thought, 'Go to fucking hell! Where do you get off telling me to have an abortion? It's not your fucking baby. It's my baby.' I was forty-one years old and it hit me, this was my choice, totally. My sister and I didn't speak for some months.

"And when I told Scott I was preparing to have a baby he said, 'You're ruining my life, I hate you.' So I said, 'Oh, fuck off.' At that point I really thought I was going to have this baby all by myself and ride into the sunset and never speak to anybody again.

"Then my sister decided to adopt so the kids appeared at about the same time, which was kind of neat. And also Scott, being the biological father, wanted his son to be a heterosexual, so he showed up at the hospital with a football. And he's still there. In a way, it's a great deal because I travel a lot and Comly stays with Scott. Scott doesn't have money, but he gives me time, so that's a deal that is very good for my life and for his life. He gets time to train Comly to be a heterosexual football player and I get time to go to Miami and everything works out."

"When you found out you were pregnant, did you think about how it would affect your life as an artist?" I ask.

"I made work out of it right away," she howls. "I did a birth announcement that said he was a grant from mother nature and that the shipping weight was nine pounds, four ounces and the materials were body and soul.

"I saw this as a really big art project," she adds and her bellow rings out through the room. "One of those projects that doesn't end real soon. And like your art, you spend all your money and all your time on it and think nothing of it. So it's the same. No problem. It's not painful.

"What I think is so amazing about motherhood, which I couldn't have known before, was how much fun it is. My mother never gave me the impression that she was having fun at all. I think it doesn't look like fun. When other people look at us and we're running around after these kids and picking up socks, they're thinking, 'You like to do that? You like being a serf?' But there's something in it that's fun, that's really more joyous than it looks."

Always straightforward and practical, Martha set up her support system early. "I made it perfectly clear to all my friends that I really needed help. I had never been a mother before and there were no grandmothers or anybody else around. My board of directors gave me a lot of money and my friends gave me a ton of stuff. I had the biggest haul you've ever seen.

"I paid a friend of mine, Diane Torr, who had a five year old and a husband, a thousand dollars to move into my house and stay with me for thirty days after the birth.. They picked me up at the hospital and drove home to my house in Brooklyn. They slept on the couch, I slept in my bed, the kid was right next to me in the bassinet. And it was the

greatest sum of money I've ever spent.

"Marcel, Diane's husband, would say, 'Oh yes, that's a hunger cry.' And he would get up in the middle of the night and feed the baby. Diane kept making me drink Black and Tan, which is the Scottish way to promote lactation. Half Guinness and half regular beer. You chug this and the baby goes to sleep and you're a little bit drunk and your milk is producing like mad, it's great. It's the Scottish formula for a happy household."

Martha is the only single mother I talked to who says it is easier raising a child alone. She contradicts almost all the married women, who swear up and down that they never could make it if they were single. So much for rules. Martha doesn't even know they exist. "I don't think it's so hard," she insists. "Single parenthood is easier, because you are not arguing with somebody else about what school, you just look at your tax return. I'm not negotiating so much.

"Also, the Buddha gave me the right baby. He was easy immediately. He's very calm somehow. He recovers his emotional and physical balance right away. It's really incredible. I take him to openings, we go to performance art. He just takes it all in stride. It's no problem at all. It's not like he knows anything else, so he doesn't get rattled by our lifestyle.

"I just stick it right in with everything else. I have a pie with three big sections, Franklin Furnace, my kid and then my art. The art section has always been real small anyway, because I have to jam it in. The work section is the biggest one really. And Comly's jammed in there, too.

"I don't think I have less time. It doesn't work out like that. It's not like the Freudian theory of emotional balance sheets. You have the same time that you had before to do what's important to you. What I like about it is that it makes it clear what's important. If you don't have a kid, you can imagine that the slaughter in Bosnia is important. And it *is* important. But if you have a kid, getting a hot dog into the kid's stomach seems important, too."

Finances can present a struggle. "Stretching the money around is pretty tough, but it's always been tough. It seemed to me when I was poorer and younger and decided I had to go into shrinkage or die, I found the hundred dollars a week that it was going to cost. I have no idea how I did it on twenty thousand or whatever it was I was making at the time, but you just find the money for whatever reason. I decided I couldn't pay for private school. It's just not possible. So he's going to public school. But I did afford Washington Market School and daycare and all that other stuff. You figure it out somewhere. You don't buy something else."

I ask if she has experienced any difference in how the art world has treated her since having Comly. "Women report that, but I didn't really notice any change," she says bluntly. "See, I run an organization, so people kowtow to me all day. I don't have to worry about conforming. It was just the opposite. Women came up to me and said, 'I'm so glad you did this, because you are a model for me. You are still going to openings and performances and you have this kid.'"

Martha started Franklin Furnace soon after she moved to New York City. "I had a little money, because my boyfriend jilted me and felt guilty. So when he sold the house that we restored in Canada, he gave me five thousand. From that I had about fifteen hundred left to

start Franklin Furnace. The rest of it I spent on a hot water heater and vacuum cleaner and all that stuff. So I had some personal money in the very beginning. I also taught at Brooklyn College and then got unemployment for about a year and a half. Unemployment was a godsend. I never looked for a job, I just worked on Franklin Furnace full-time.

"In the very beginning, I hired an artist to teach me how to raise money. I was getting seventy-five dollars a week unemployment and she charged me forty dollars a day, but I needed to hire her to help me, because I didn't know how to raise money.

"Now we raise almost $400,000 a year and I get ten percent of that." Martha laughs, "Franklin Furnace now pays me a middle class wage of $40,000. This sounds like enough to live on, but it's really very tough, because I go out all the time. It's never easy, it's not like we're ever rolling in money, but it's a better job than any other job, because it's my doing. Me and my board are it. So I'm very happy with the condition that I'm in. Okay, so I have to raise this money every year, but I'm not working for somebody else, so this is good.

"I started Franklin Furnace to serve an area of art that was not being served, now known as artists' books which are really ideas masquerading as books. In 1993 the board and I decided to sell the whole collection to MOMA. The cataloging and conservation costs were absorbing almost half of the budget and the space was not fireproof and we had collected the largest stockpile of artists' books in the country. So now I have the opportunity to reinvent my job, without having to find a new one. What a deal! I am going to orient the program more toward performance art and orient my own time more toward a cable TV show about performance art.

"Lately, senators have been telling the public that performance artists, such as, Karen Finley, are obscene and what's the public to know? They never see performance art. So this show is going to put performance art out on the airwaves, on public access at first, but later maybe elsewhere, so that channel surfers may become exposed to it and some will want to know more by crawling to the dives in their local cities and towns. This will in some small way change the world."

In her work as an artist and an arts administrator, Martha travels frequently. Comly often comes with her, as he has on this trip. "When he was really little I would just take him with me and let him crawl on everything. He was a conference baby. And up until he was able to walk, I took him to work, too. Then he pulled all the press packets off the press shelves and totally destroyed it. My friend Barbara Pollack was whipping up the stairs and she slipped on the press papers and landed on her knee. I thought, 'This is a sign that liability is here. I have to get him out of here.' A little bit later I caught him with his little heel hanging over the edge of the stairwell and there was this drop right behind him." She stops and shudders. "It still scares me to think of it. So I took him out of the work place and put him in the care of a single parent, Peggy, who was recommended to me by other artists.

"His first opening was the Whitney Biennial. I just took him everywhere. What I think is real interesting is that he would look at the work and have a genuine response to it. For example, we saw Ilia Kabakov's reconstruction of a Moscow apartment building. You go in this hallway and turn left, then you go around another turn. It's a labyrinth. He started screaming. It was claustrophobic. He had to get out of it. It was supposed to be overwhelmingly claustrophobic and it

took him no time at all to figure out the nature of the work. So I like to take him to art things.

"But I didn't take him to France. I imagined him falling down stone steps there, so I left him with Scott when he was a year old and still breastfeeding. When I came back he looked at me and recognized that I had been gone. I think he hadn't quite figured it out till he saw me again. And then he realized that he hadn't been at the breast either. I'd been expressing the milk into the sink. It was so painful. But I thought I was going to stop breastfeeding. But then he started rolling on the floor and moaning, like Jean Paul Sartre, staring at the abyss. I just couldn't deal with it, so I let him breastfeed. And then the next summer, when he was two years old, it was no big deal to stop."

She seems amazingly tough, resourceful and able to adapt easily. What gives her that strength? How does she generate enough inner juice to keep going? "Well," she says slowly. "I was very worried about this. I serve three thousand artists a year. I give away stuff to my kid all day. When do I get anything for myself? I thought I was going to go through my whole life, have a kid and have a great job and die without a mate. But I found a mate actually, last December. I found an art slut like myself, who goes out and consumes art all the time and likes kids and is a fishmonger. So I'm madly in love. The whole idea that I can have some of this now is really exciting to me. I think being in love is a nice way to recharge."

I grin at her. "So that's what works for you?"

"I guess so. Right now." Martha laughs. "We'll hate each other soon enough, I'm sure."

Her advice to other women artists contmeplating motherhood stems from how she lives her own life, recklessly diving in and then figuring out the next step. "Go ahead and have the kid. Enjoy yourself and don't worry about what other people think, any of that crap. It doesn't matter at all."

She is glad that she had Comly late in her life. "Some women have kids early and it works for them. I would not have been able to put the career side together, I don't think. I waited until I was forty to have the kid. That was the brilliant move, to wait till I didn't have to establish my identity. Then I was free to have the kid or not have the kid or whatever. It was not an identity building decision."

Martha responds to my question about choosing bertween her child and art with puzzlement "You don't mean life and death?" she asks. "You mean, if I have to go to Miami and my kid got sick?"

"I mean as big as you want it to be. Life and death," I answer.

"Well," she answers patiently, humoring me "It's art all the way to the point where the kid's endangered and sick. Then everything stops and you go to the pediatrician and that's it. So that's the answer. I don't think it's an either/or thing, it's a matter of degree. Having a kid means having less torture in your life, not more. You don't have time to torture yourself anymore. You have to just get the hot dog."

Another way Martha makes the whole equation work is her relaxed attitude about parenting. I ask what she hopes Comly will learn from her. "I don't think about that very much," she says offhandedly. "I have the idea that kids are mostly biologically determined and not very much environmentally determined at all. And I sincerely don't care if he wants to be a ballet dancer. That's absolutely fine. I guess if he wants to be a drug dealer, it might be not so fine.

"One of the things I do well in my life, in my career, is present artists without comment. They bring their proposals to Franklin Furnace, we review them. I like it, I don't like it, that doesn't matter. The panel selects the work and I present the work. And I stand up for that work. If I hate it or if it gets Franklin Furnace in deep trouble with the federal government, that's fine. So I would like to give Comly also the right to be himself and not be who I want him to be. If he doesn't want to be a ballet dancer, that's okay, too. My father wanted me to be an opera singer. I even took opera lessons for awhile."

"Well, you're not far off," I say grinning at her.

"Well, that's true," she answers surprised. "Gee Dad, thank you."

Chapter Three: Vagabonds

To travel or not to travel? For these three women, the determining factor seems, at first glance, to be financial. Yet, that is hardly the whole truth. The fact is, they love to travel and they love to travel for their work. And why not? Who says that men own the right to spread themselves and their work all over the country and world? I commend these women for being able to do it.

Support is a governing factor here. Without a safety net supplied by spouses and families, their traveling lives would probably not exist. Two of them, Tish Hinojosa and Norie Sato, rely heavily on their husbands, who have chosen to put their own careers in second place, for the time being. The third, Naomi Shihab Nye, uses a combination of family, friends and community support.

They have chosen work that demands travel. Tish, who lives in Austin, Texas, says that a musician can't stay in one place "unless you want to be a lounge singer somewhere," and adds, "That's such a depressing thought." For Seattle-based public artist Norie Sato, building a reputation requires her to accept jobs all over the country. Naomi Shihab Nye contends that writers make more money from talking about writing than from selling books. So that's what she does, in the form of conferences, readings, writing residencies and other public forums which take her away from her home in San Antonio.

They see travel as having been a positive contribution to their families, and speak proudly of how their children are superlative and experienced travelers. But each one of these artists works to maintain a secure and healthy home environment. As their children grow they accompany their mothers less and less, but whenever possible, they do go along.

Traveling is a dream for many artists. Women artists with children often assume it is not an option and lay that dream aside for many years. Tish, Norie and Naomi refuse to do that.

Pictured: Naomi Shihab Nye
and Madison Cloudfeather Nye

Naomi Shihab Nye, WRITER & MUSICIAN

IT IS A BEAUTIFUL spring morning in Portland. Though she lives in San Antonio, Naomi is here for a poetry festival. We meet at a tiny house hidden behind huge green hedges and trees, where she is house sitting for writer Kim Stafford. We enter to the sounds of merriment. Naomi is just finishing up a breakfast meeting with two Portland writers. Her seven year old son Madison emerges from the bedroom. He has accompanied her on this trip, as he does on many of them. For twenty years she has worked as a visiting writer at countless campuses and institutions. Naomi is energetic, generous and resourceful. Although in a strange town, she has handily lined up childcare for Madison so we can have a couple hours to talk.

Naomi Shihab Nye is a writer of poetry, essays, songs, stories and children's books. She was born on March 12, 1952 and grew up in a middle class, ethnically varied household in St. Louis, Missouri. Her father is a Palestinian who emigrated from Jerusalem in 1951; her mother is American with a German-Swiss background. Naomi's father worked as a journalist and as an importer. Her mother, who went to art school and was a serious painter before her marriage, worked in the family business and was a Montessori teacher and a substitute teacher. Naomi has one younger brother.

In 1966, when Naomi was fourteen, the family disposed of all their belongings, sold their house and went to live in Jerusalem. Her parents had an understanding when they married that they would live in both of their cultures. But because of the Six Day War, they had to leave just one year later. Naomi has been back many times since and has drawn on that heritage for her work. She is married to photographer and attorney Michael Nye.

Naomi is a fast and fluent talker. Her spoken word retains a careful choice of terms that mark her as a writer. Her low and somewhat husky voice caresses the words as they emerge. A long dark braid of hair hangs over one shoulder, framing Naomi's quick, dark eyes. We sit at a small table by the window, looking out at a magnificent oak tree with a swing hanging from a high branch. The table is littered with breakfast remnants of coffee, tea and scones.

Naomi loves to travel and feel how large her world is, how wide her network. In addition to her constant traveling, she regularly corresponds with writers all over the world. Periodically, she accepts artist-in-residence jobs in far away places, requiring her husband and son to temporarily transplant their lives carrying their roots along with them in portable pots.

Naomi has been traveling with Madison ever since he was a baby. "I have almost always taken him with me," she says. "If I didn't have one of my parents willing to fly to the place, I would call the university or wherever I was going and say, 'Look, I'm scheduled to give this

reading and visit these classes. You've got to get me somebody to baby-sit.' That's pretty reasonable. Some writers say, 'I have to have a bottle of special vodka' or something. Getting a baby sitter should be easy. People are always happy to comply.

"So we would show up in San Francisco and they'd say, 'Well, the babysitter will be standing at this door at two p.m.' I remember one day I let him go off with this woman and suddenly it hit me I did not know her last name, I did not know her address. I knew nothing about this person he had gone with except that the coordinators knew her, loved her and she babysat. They just went off to have an afternoon together. And he was two. I started panicking before I had to give my reading. 'My God, this could be one of those horror stories you read about where your child vanishes with a stranger.' Of course it was fine, she was great, he loved her. I just got a little more particular with my list of questions after that. It has always been good."

Naomi's attitude that the world is inherently a good and support-ive place enables her to trust people. Her voice takes on a new forceful-ness as she says, "I'm not one of those parents who's highly skeptical of strangers. I detest the notion passed on to children that you don't ever *talk to* strangers. It's the stupidest thing in the world. We have to learn how to talk to strangers because the world is full of them and how could we ever gain a new friend or anything if we weren't talking to strangers? I always told Madison this from the beginning. If he had a question I didn't know the answer to and there was a woman over there who did, I'd say, 'Go talk to her. Tell her your name.' And he knows now. He's very clear on what would *not* be appropriate behavior with strangers, but he's also totally comfortable about talking to them."

But Madison has grown older and Naomi cannot take him every-where anymore. He now has his own schedule, though they have avoid-ed many activites, such as soccer or Cub Scouts, because Madison is not interested in them. Her solution to this dilemma is to take the whole family with her for longer periods. They spent a semester in Hawaii when Madison was in kindergarten. Next spring they will relo-cate to Alaska for six weeks and Madison will be a first grade exchange student. She also tries to make her trips without him as short as possi-ble.

She makes it look easy. But support is a given in Naomi's life. She expects it and creates it around her as a matter of course. In her over twenty years of traveling as a writer, she has built up a vast network of friends and writers. In addition, her parents have come forward to an impressive degree, for which she is grateful. "They have gone to more writers' conferences than I can possibly name," she says in wonder-ment. "They have flown to Alaska, gone to Egypt. My mother even went with me to Michigan in the worst snow, to take care of Madison while I worked as a writer-in-residence for a week. I feel I owe them a lot. In April I went for nine days to do the Georgia Poetry Circuit and Michael was preparing for a big show and had to be in the darkroom every day. I was really worried, 'What is going to happen to Madison?' He was in kindergarten, but he had to get picked up from school and he still had his whole afternoon before him. And my father just said, 'I'll come down and stay the whole time and take care of him.' My parents have been really wonderful about that. We don't live in the same city, but manage to see each other more in *other* cities since Madison was born."

The continuing support her parents give her now, not surprisingly, had its start in her childhood, which Naomi loved and still misses. "I loved reading. I have clear memories of the first poem I wrote at age six, the first stories that were read to me, and the first books I loved. That part of my life is very vivid and very comforting. There was something dependable about reading. You could do it by yourself, put a book away, go back to it and know where you were in the story."

Yet she was a social child and had many friends. Throughout her elementary school years, she lived in the same house. The St. Louis she grew up in was a rich and eccentric city. She considers it middle America, but "also ethnic and old world and rather haunted. To this day when I go back to St. Louis, there is something sorrowful, melancholy, yearning, nostalgic about that place."

Naomi's mother passed on to her children the importance of creative expression. "There was never any sense that art was an extra thing," Naomi says, her voice ringing with the memory. "Going to the art museum every Sunday was as much a part of our lives as I guess going to Sunday school is for some other people." They also went to the ballet and to plays and symphonies. "I was very seriously training on the violin and I was in a youth symphony. My mother was very musical and taught us both to sing and taught me the piano."

But though "very sensitive and extremely intelligent, feeding us organic food when others had barely heard of the word," Naomi's mother could get very depressed. "I remember feeling it was important to stay upbeat and responsible. She had stopped painting after her marriage and I was born less than a year later. I personally think her depression had a lot to do with giving up something she really loved in her life. She was also an incredibly devoted mother, responsive to our needs."

I am riveted to this story and press for more information. Naomi hesitates at first to tell the story of her mother's former life as an artist. But then decides it is time to examine it publicly and plunges in. "Her giving-up of her painting was an undercurrent in my thoughts, and something that still bothers me now. It was very present to me as a child that some sacrifice had been made on my behalf which I wasn't sure I wanted anybody to make. She was very devoted to us, even when she was feeling sad and we were all very conscious of her mood cycles. Now she's facing the question, 'Who am I and what do I do to make my time valuable?' That's something artists don't have to work out. We have vocations beyond jobs for pay that give us a sense of identity or presence in the world, and my mother had that at an early point in her life, but set it aside.

"One thing I have to say is that my mother was really a great painter. Her work was phenomenal. It is immediately recognized as the work of a serious, visionary artist. She had a scholarship to art school, worked with notable painters like Philip Guston and Max Beckman and was having shows when she was twenty-one in New York City. Last year I took some of her old canvases to be stretched and this archival person was shocked when I unfolded them. She said, 'Who did these?' And I told her my mother. And she said, 'She's an incredible artist. Is she still painting? Where is she?' I have to go through the same story every time. This person who gives up what they love. I've always been intrigued by this. I know a man who was a child prodigy opera singer. He gave it up as an adult because he didn't want the bur-

den of living up to himself. People say my mother could start again. But I think that's easy to say about someone else. Maybe for herself it wouldn't be easy to start it again.

"So my mother is a complicated individual. Maybe she tried to do with her marriage what I would never try to do with my marriage, let it become her reason for being and fulfillment. To me the idea of 'two becoming one' has always seemed ridiculous, impossible and slightly disgusting. I don't want to feel that way about someone else. I don't want them to feel that way about me. My mother was of the generation that had different beliefs about marriage and need and duty and responsibility. And she's still living in that.

"My father was very optimistic and seemed to us kids an easy going person. We were never spanked or treated harshly. Once my father got out a belt in frustration and showed it to us as something someone might use, then he got tears in his eyes and put it away. It wasn't always easy for my mother and father with this whole mixture of traditions. My father also harbored a certain restlessness. I think immigrants often have a sense of looking to the Old World. 'What have I left? How much have I retained? Did I make the right choices?' I think it strongly exists among Palestinians. Maybe more since they have that sense of the lost country as well. They *are* the country. And so for him there was always this sense of longing and looking off toward the horizon. And then my mother. I think of her as having been in exile from her art. The thing that she loved so much, her remarkable talent, her abiding activity before we were born. So in a way I grew up with two parents in exile."

Out of this household of mixed cultures and creative energy, emerged Naomi the writer. She speaks confidently of her beginnings. "From when I learned how to write I was always writing. It was never a thought before it was an action. I started sending things to magazines when I was seven. And it wasn't so I could prove that they were good. It was just because I had read things by other children in magazines so I thought that's what you did."

Her parents' support took the form of "warmly neutral" responses to her writing. "I admire their neutrality now," she says brightly. "When I was growing up I remember giving them things to read that I'd written. They never said, 'Oh, this is wonderful, write some *more*,' nor were they critical. They would just read it and maybe ask a question or say, 'that's interesting,' or 'oh, thank you for sharing this.' When parents are *too* enthusiastic about what their children do artistically, the children may clam up. There's a certain expectation involved. 'They think I'm really good, they want me to do more, well, I don't want to.' This can also happen with teachers. I don't want to scare my young writers off by my enthusiasm."

Naomi's models were the writers she read. As a child, she loved Margaret Wise Brown, Louisa May Alcott and Carl Sandburg and read everything she could by them. Her real life models were the strong and independent women her mother knew. "My mother knew interesting women who did eccentric things, who walked for peace, who traveled alone. I felt there were a lot of those women out there. I never for a second had a sense if you were a woman you should be following particular patterns or planning marriage. I never doubted that women had absolutely as many opportunities as men."

Motherhood entered Naomi's life with the same air of inevitability

as her writing had, but without the ease. "I used to have dreams when I was in college that I had one son. I never thought of myself as having a group of children, ever. Just one son and never a daughter. And then once I was married, I definitely wanted to have this son. But it took us a long time to have him. A real emotional roller coaster."

Naomi relates the scenario with amusement. "We went through all the tests and the doctors kept saying, 'Well, we don't know why you're not having a child. Just keep trying.' Then after seven years, he came. It was mysterious. He came in his own time, not ours."

Any doubts Naomi might have had about her choice to have a child was tempered by the long wait. "If it had happened earlier, we would not have had the same understanding of the event. In retrospect, we both feel grateful that it took so long, that we had to go through those seven grueling years of mystery and disappointment and hope. I've had many friends over the years who are in that process of wanting a child and not having one. I know that yearning. We had such an incredible prelude to having our child that we felt utterly ready. And very happy."

When Madison arrived, Naomi was only a little concerned about being able to continue as an active writer. The trust and hope that carried her through those seven years of waiting continued to serve her well. "I'd always valued solitude. And yet, having worked for many years as a writer in the schools, I also knew that great things could come out of chaos. A classroom is very chaotic with all these kids together and all their booming, ebullient energy. The fact that kids write fabulous poems in such a situation continues to be an amazement after twenty years of working in schools. So that gave me a little courage. But many

voices I cherished, like Thoreau's or Gertrude Stein's, were often people who hadn't had children. So I started reading as many things as I could by other women who had children. I looked for clues in other people's lives who had managed to do both." Naomi bends close to the tape recorder and says loudly, "And I definitely did not ever for one second, *Mom*, consider giving it up."

I smile and ask, "I wonder how many references to your mother you'll let me use in this interview?"

"Probably a lot," she answers recklessly. Her tone sobers, "I have to say that my mother, despite the fact that she gave up her art, is so much more interesting to me than people who never even tried to do anything that was creative or personal. Women who've said things like, 'When I was nineteen I thought about writing but I knew it wouldn't be good so I didn't.' I really respect the fact that my mother was so engaged in the visual world, even briefly and was so wonderful at it. I just happen to love her paintings and am greedy and would like to have more of them in the world."

Naomi found the adjustment to the new pattern of living with a child difficult, especially the first year. "I was used to working early in the morning so that I didn't feel, through the whole day, as if I was looking for time to work. But when he was waking up in the night, I didn't have enough energy to rise early. There wasn't even a sense of what's early and what's late. I was frustrated trying to find the energy or the motive to work. I felt so emotionally involved in every bit of daily life that it was hard to retain that part that stands back and observes. After the first year it hasn't been hard timewise, because I returned to getting up earlier when he had a regular sleep schedule."

Her weekdays begin at 4:30 a.m.. "I'm at my desk by 5:00 and I work till 8:00 or 9:00. When Madison is going to school he has to get up at 7:00 so I have two hours to work before he gets up, then take him to school and then usually have some time. Unless I'm working at a school myself. In the summer I can work from 5:00 to 9:00 when we're at home. You know, four hours for me is a lot. I don't really want more time in a block. I've found that I can only write well in the early mornings like that. In the afternoon if he has friends over and they're out playing, I can revise and work on things. But I don't really *start* things then. I think you always have to be paying attention to your own process. How does it work for *you*? What time can you *give yourself*? Where are you going to *claim it*? And then just stick to it. I haven't felt a big frustration about not having enough time because I found out where it was for me—early and first. So by the time other people wake up I've had that private time of being alert."

She does admit to having a lot of energy. How does she feed it? "Once I became a mother," she says with an impish grin, "I developed a mysterious ability that my German grandfather had of lying down for five minutes and waking up completely revived. I could never do that before I had a child. Now I can say to Madison, 'Okay, I'm going to take five minutes,' and he'll lie on the bed beside me and read a book or whatever. I'll close my eyes for five minutes, sleep, wake up and feel totally revived. That's helped. Taking walks or whatever things you need to do to revive yourself . . . I think mothers deserve to do that a lot. So much of our energy goes to the child. We should never feel it's frivolous to think about feeding our own energy.

"Every three or four months now I get a facial from some Australian women in Dallas. I found that this is a reviving experience. After living in Hawaii, where we were outside all the time, I developed a peculiar skin condition, as if I had been burned, a big streak down my face. I spent all this money going to doctors. They kept saying, 'This is a mystery. You'll live with this for the rest of your life.' Oh, great! So I went to an Australian facial clinic in Dallas. The women took one look at me and said, 'We can fix that.' They fixed it in one session. So I decided that these women were now integral to my life. I didn't want to get that thing again. It's not frivolous. I'm not big on martyrdom and sacrifice. I don't think that's healthy for anybody."

"How do you stop the selfsacrificing?" I ask.

"I think part of it is attending to those personal, creative and artistic needs. The mothers I really feel for are mothers who have a deep creative impulse but haven't found a medium. Lots of times they show up at readings or conferences and want to talk. They have a desperate glint in their eyes. How do you help someone ask the questions that will let them find out? Maybe we need to experiment in as many ways as possible till we find things we are really comfortable with.

"A good mother is one who makes lots of mistakes, but the child is aware of her endeavoring to be better. A good mother is one who is open with the child about how she would like things to be and can easily say she is sorry. Of course, I want to be a good mother. All the time I want to be one. I harbor these very particular regrets—doesn't everyone? Two years ago why did I not want my child to eat a doughnut in Heathrow Airport? Who cares? I look back on these moments and think how I would replay them. Some days I'm a good mother and some days I'm impatient or distracted. But I think *trying* to be a good

mother and being conscious of the process, that's important.

"I've failed in a lot of ways as a mother. Whereas I may be very patient as an artist, willing to sit around with a story or poem for years, I've found out I'm much more impatient in real life than I thought I was.

"I have a nostalgia about my son's childhood passing. I wish we could have age three back every few years or so. My favorite quote that hangs on our refrigerator is from Thailand, 'Life is so short, we must move very slowly.' I think with a child we cherish that sense of having shared time well together. I regret all the times I've raised my voice, the times I listened with half an ear. I have regrets that I sometimes had to be going to give a workshop or be preparing for a poetry reading when he wanted me to be with him instead."

Though proud of the traveling she has done with Madison, since it has "encouraged his ease about new experiences," it has not been all rosy. "He was angry at me last night," Naomi says thoughtfully. "We were outside playing and I wanted to come in to make a few phone calls about the Portland Poetry Festival tomorrow night. And he said, 'Can't we ever just have a vacation? We just have trips.' And I said, 'What's the difference?' And he said, 'Well, on a trip, somebody works. And every time we travel, you're working. Can't we have a vacation where we just play the whole time?' And that made me sad. Even though we were singing and eating raspberries, he knew that I had to make phone calls. It bothered him that I wasn't totally his. In my case, being at home so much is a little confusing to a child because you're there, but you're also working. When are you his and when are you working?"

I ask about daily support as a mother and am amazed to hear that until he was five, Madison never went to any daycare at all. Naomi explains, "I used to have a friend in our neighborhood come in for about two hours, three afternoons a week. Just so I could do some of the desk stuff, correspondence stuff which I didn't want to do in my early morning writing time. She would just play with him while I was there. And since my husband is a photographer he understands this need for time. He's been a good support when I had to go on trips."

Another source of support when she is at home is a network of other mothers who help each other by trading childcare. But always seeking more creative solutions, Naomi took that concept further. "This summer we did a thing called Hummingbird Camp, where the kids would alight at a different house every morning. I just had the kids one morning a week. Each mother had four other mornings when they could work."

As an artist, her community is huge and starts with her husband. "Sometimes I think, 'How must it be for women whose partners look askance at what they're doing as an artist?' That would really be horrible. I can't imagine what it would be like to live in a house with someone who didn't regard what I was doing with utter respect. I read him poems or stories before they're finished because he's got a great ear.

"I've always corresponded with writers whose work matters to me. When I was in college I took a playwriting class and the professor said, 'I tell you all now—writing is so solitary. If you ever read something that means a lot to you or see a play that means a lot to you, I commission you to write to the author if you can find them and let them know what it has meant to you. Don't ever think that it's foolish or

unnecessary. It is really critical that you express your response.' And so I always did that. I thought it was a wonderful idea. I've had lots of correspondences with writers over the years. Not that we write forever. You can hold those letters close in your heart for years. And yes, I do have just a voluminous correspondence especially now that I do anthologies, too. I have a huge family of writers from all over the world corresponding with me. I have mothers in Mexico writing to me about how they balance their time with their four kids and their poetry. It matters a lot to write to these people in other countries and share our experiences. The family of writers, holding one another up and respecting one another's processes."

It is important to Naomi that Madison learn the power of his voice and of using words deliberately. She has been successful. He sees writing as a natural form of expression that he can use. Naomi describes an incident. "Last week a friend of his promised to come over and play and then didn't come, forgot and went to sleep. Madison got really mad at this boy and kept calling and calling. By evening when the friend woke up, it was time for him to go to Flamenco dancing so he still couldn't come over and Madison was furious. So he said, 'I'm going to go write this all down.' And of course after he had written the whole story down he was in a great mood because he had a wonderful story to show everybody. And I said, 'I've done things like that. When I'm upset about something and I write it down, I feel better.' And he was really intrigued by that. So I think he has a sense already that *our experience is what goes into writing.* In school the teachers have said they've never had any student who felt more comfortable with reading and writing than he does. I love to know that."

She has also taught him the difference between art and life. In the past, Madison has not wanted Naomi to quote him in her work. "Of course I *always* quote him," she says smiling, "because he says such great things. There's one poem I wrote that he didn't want ever to be seen by anyone in the world again. And I said, 'I'm sorry you were involved in it, but it's not *you* anymore. Now it's *my* story. I'm not trying to reveal things about you.' I wanted him to have the sense that *he* could go off and tell a story about *me* and re-invent even his own mother. When he saw the poem actually in print, I thought he was going to have a fit, but he didn't say a word."

Madison has also affected Naomi's relationship to her own writing. "After he was born," she says excitedly, "for the first time I felt like a part of history. Before, I always felt like a floating thing in the margin of the universe. He gave me a really different sense of what it is to have a root, and of course he gave me a totally different sense of my own parents. I don't think I had that crucial sense of linkage with other people and with time before I had him. I feel his clear and penetrating voice has come to inhabit my ears, so of course that alters the voices one hears when one writes.

"A child is so immediate and so present to experience that living with one calls us to a kind of double vision—we're more deeply tuned into the details of daily life. Which for me were always important anyway. But with the child you're tuned to them in a more crucial way. It is Bath Time—almost worthy of capital letters. Bed Time. Which is your favorite Place Mat? There's no other person whose details you'll ever be as caught up in as your own child's.

"We live in a ninety year old house and before us a woman lived

here for fifty years and raised one son there. I'm very conscious of her presence and her raising that one son and now she's died and he's still living. Just that sense of ongoingness when you have a child. It's as if my context as a human being fell into focus better. I understood or cared more for *all relationships* once I had a child.

"I think you become very conscious of how much mothers have had to say and how many of them have not said it to anyone but maybe the audience of their children. The child has been the listener for all these mothers through history, through time."

I ask her straight out, "If you had to choose between the parts of your life, how would they line up?" Pain flashes across her face and she spurts out, "Child would be number one and then my work. If he were in a situation where he was not happy or life was awkward for him, *I* couldn't work."

"Where is your marriage?" I ask.

She winces again. "Certainly the marriage is caught up with the child, so it's number one there. In terms of a one-on-one ongoing romantic relationship, maybe that's the part that suffers. We have to keep reminding ourselves to take time alone together. Even a little bit helps."

And since she is willing to engage in this question with me, I press further. "Which thing would you leave if you had to?"

"Oh God," she says, laughing nervously. "Well, I'd like not to have to leave any of them. I think I'll stick close to all three of them. I have a very independent husband. He's fine when I'm not there. When he goes off to photograph in Iraq or somewhere, people always ask me, 'Aren't you worried about him?' And I say, 'No, I'm not really worried

about him.' Because I have such confidence in him and how he'll be that I don't have to sit around and worry about him. There's a real comfort, knowing a person is taken care of by himself, but I do think it's important to fan the flames and keep the relationship alive."

Naomi regards money in the same relaxed light as she does most things in her life. Both she and her husband work freelance now. "I have about a hundred thousand jobs a year. Like many artists, money is not what makes me do things. People don't make the money from publishing books. Someone once said, 'You make a lot more money talking about writing than writing.' And it's true. But I like to talk about writing so I've been able to do that a lot. I've been open to all different kinds of jobs that relate to the field of writing. Not too particular about what they are, who they're with, where they are. That's always taken care of itself. I know where I'll be one semester in advance. Because I've lived this way so long, I know all these jobs will come up. I've never really gone out soliciting jobs. One thing has always led to another so I feel comfortable with that."

She giggles as she continues. "A few years ago we got audited by the IRS and looking at my list of employers for a year, they were boggled. They said, 'We just don't understand. Why would you give this poetry reading in one place for $2,000 and give this poetry reading over there for two hundred?' The woman was so *literal* minded. She said, 'Are you just trying to get your name around?' I said, 'No, I've never thought about it in that way. That's just what they had to pay me and two hundred dollars is better than zero dollars.' And why had my husband given up his semi-lucrative law practice to be a photographer? It ended up that the IRS gave us $1,000 back after they decided we

paid them too much all these years. This woman was so troubled by us hopefully they'll never bother us again."

"Do you do housework?" I ask abruptly.

"Yes I do," she shoots back. "When Madison was born, it suddenly seemed like so much energy went to just caring for one little baby and the little house loomed larger than ever. 'God, I still have to take care of this place, too?' My husband does some, too, though. At that moment I decided I could never iron again. So I said, 'Can I find someone to iron for us?' I had heard of a woman who liked to iron and was looking for another job. So she's come and done all our ironing for the past seven years. Pure pleasure."

"Does housework ever stop you from doing your work?" I ask.

"Sure, sometimes I feel really irritated having to clean up the house. I would rather read or write than scrub a bathtub. But sometimes physical labor balances us. And I still think the tedious daily picking up is, in most households, mostly the domain of the woman. Men can be very helpful now and then, like some burst of energy to clean the house fast for guests, but on a daily, ongoing basis it seems to fall to the woman. And gardening, too, takes a lot of time which is why certain parts of our yard have gone very wild. But it's all right, I like it wild."

For other women considering living her type of life, Naomi strongly recommends having one child versus multiples of children. "I say that really seriously, and not only because of one's own time. I think population is the most critical issue on our planet and we need to think about that more. Most of us have been brought up in a world where one child was looked down upon. I have strangers all the time say rude things to me. 'Have a brother or sister for him. Don't you let him be so lonely!' And he stands there saying, 'I'm not lonely. What are they talking about?' There's a real mythology in America, probably that 'populate the frontier mentality.' They look at me as if it's my duty to have another child so this child has someone to play with. No, I think it's my duty to give this one child the best life I possibly can. One child is very portable and time together has a sweet luxury about it. Identify your own attention span, what you're going to be able to deal with best. Follow your instincts."

When I inquire about her goals as an artist, Naomi admits to being "not very ambitious in a tangible way." Instead, she feels lucky to keep writing and exploring. I wonder if she is superstitious about telling me what she really wants, for fear it won't come true. But perhaps what she says *is* the whole story. A sense of wonder and excitement about what might lie ahead surrounds her. A few years ago, she doubted this. "A writer whom I've never met but whom I have one of those correspondences with wrote to me years ago, 'After forty it's so much harder to write.' Well, this was a very ominous thing to read at the age of thirty. I worried about it for years. I'm forty-one now and I'm here to say, I think it's completely untrue. My goal would be never to feel that way about aging, that now you've passed your prime and don't have anything to say anymore. It's exactly the opposite. I have much more to say, more to explore, more to read and many more people to connect with."

Pictured from left: Norie Sato, Tomohiro Berry

Norie Sato, SCULPTOR, VIDEO & PUBLIC ARTIST

IT TOOK ALMOST a year of finagling and phone calling to arrange a time to get together with Norie Sato at her home in Seattle, Washington. As an artist who is involved with public art projects all over the country, she travels often. In fact I first met Norie at an alternative printmaking workshop she gave in Portland. She arrived in class with her son Tomo, then an infant, and her husband Ralph Berry in tow. While Norie taught the class, Ralph and Tomo went off merrily to tour Portland. When she mentioned in passing that Ralph was the childcare person, I was immediately fascinated. What was their arrangement? How did it come about? And how could I do it, too?

Their small gray house is filled with light and feels spacious and airy despite its size. Evidence of Tomo, now 3 1/2, is everywhere and Norie's prints and sculptures cover the walls and ceilings. For the interview, we adjourn to the TV room while Ralph and Tomo take a walk.

Norie Sato was born in Sendai, Japan on July 19, 1949. In 1954, the family moved to the US when Norie's father, who is a physicist, was offered a job in Pittsburgh, working for Westinghouse. He subsequently worked for Ford Motor Company Research Lab in Michigan, where Norie spent most of her childhood. She has one brother two years younger and a sister fifteen years younger. When I ask which socioeconimic class she identifies herself with, Norie is puzzled at first, then answers "Academic class." She comes from a family steeped in the sciences and tells me proudly that her maternal great-grandfather was one of Japan's earliest scientists in the western mode and well respected.

Norie, though an artist, is continuing the family tradition of scientific inquiry. Since her graduate study in art at the University of Washington, her work has been focused on memory and the relationships between mechanical and natural intelligence. Her work is consistent only in its content. She jumps freely from printmaking to glass to video, blasting away the belief that only artists who consistently work on one easily identifiable medium will succeed. Her most recent emphasis has been public art, much of which is in collaboration with other artists. For the past year she has been involved in the design of Portland's new light rail stations, as well as a project in Dallas, Texas.

Norie's speech is punctuated by bursts of laughter. Even when she is speaking of sad or troubling memories, there is a merriment bubbling behind the words. She is proud and confident when talking about her work. Her feelings about motherhood are more tenuous and uncertain. She is not assured of her ability yet, which seems normal for a first time mother of a rambunctious 3 1/2 year old. I maintain that she is a better mother than she will admit.

Her own childhood, growing up in the United States with Japanese parents, was filled with unspoken challenges. "Obviously they didn't

know about all the American traditions," she says. "We used to celebrate all the holidays, except for the really national ones, like the Fourth of July. We would have turkey on Thanksgiving, but we didn't have the American tradition of family recipes.

"Mostly, we blended in, without blending in too much. But I don't remember it being that big of an effort. It wasn't as if my parents wanted to maintain the Japanese traditions, but they didn't necessarily exclude them either. The communities where we lived were primarily white, so I had very little contact with other Japanese people when I was growing up."

Norie spoke only Japanese when she first arrived in the United States, but quickly switched over to English once she entered school. Although her parents spoke Japanese at home, she and her brother preferred English. As a result, Norie's Japanese vocabulary didn't develop beyond five or six year old language comprehension until she studied it at college.

She at first describes herself as a regular child and a good student. But no child is regular. In the school system, specialization is encouraged and that was never Norie. "I was one of these kids who was interested in everything and could never specialize in anything," she says giggling with the memory. "I just wanted to do a little of this, a little of that. I took piano for awhile and then I started getting interested in drawing and painting. Then I did synchronized swimming. But since my family was not very art oriented, I didn't get too much of that from my family, though my mother encouraged me.

"In second, third and fourth grades I liked to play out in the vacant lot, making up stories about fairies with my friends." She looks down briefly and muses, "It seems like we just did so many different things. I was also really interested in science and did science fair projects."

"Did you do well in school?" I ask.

"Yeah." Norie chortles. "I was one of those typical good students. Kind of boring." She laughs louder. "In my school, one of the privileges was making bulletin boards out in the hall and I made I don't know how many of them."

"It sounds like the start of your public art," I comment.

Norie grimaces a little. "Bulletin boards."

Norie's mother came from an academic family and went to college but soon after she graduated she married and became a homemaker. "In Japan women don't go out and work in quite the same way that Americans do," Norie explains. "The mothers are all powerful in the family, generally. So my mother did all the motherly things. Cook and clean and sew clothes. But she was not a completely traditional Japanese woman, so I was actually pretty lucky. She played piano quite a bit. That was one of her major loves. She continued her piano studies while I was growing up."

"Were you close with her?" I ask.

"Relatively close. I wouldn't say super close. But we never had any major rifts or anything like that. It has to do with how Japanese mothers and daughters interact. You know how mothers and daughters often become really good friends here in the United States? In Japan the roles are more defined. The mother is the mother and the daughter is the daughter. I had a very good relationship with my mother, but I thought of her as in a different world."

I cannot feel Norie's mother yet. There is a distance in her words. "I'm still not getting a sense of who she is," I say.

Norie laughs and tries again. "Everything she did was for the kids, really. Aside from piano and sewing, she didn't spend a lot of time doing her own interests. Her interests were our interests. She was very supportive of almost everything that I did. But on the other hand, both of my parents expected me to do well in school. So they were never surprised or impressed by my accomplishments. Ours wasn't one of those families who were super-praiseworthy."

Norie's father was the traditional Japanese father. "He would go to work and was pretty much hands-off our lives. He was there quite a bit in the evenings and weekends, but he never did much housework. However, I feel closely aligned with my father. My father used to ski in his youth and when we got to be teenagers we started skiing together. He grew up in Sapporo, which is in the northern part of Japan. Although I don't think my father would agree, I feel that being an artist is much like his being a scientist and a theoretical physicist. There are very close ties between the creative act of science and the creative act of art."

In high school, Norie took art classes at the university art museum. These classes were taught by university professors. "That was really my first touch with art concepts and the idea that you didn't just make projects that your teacher set out for you to do."

But her decision to become an artist was slow in coming. She was also interested in science, because of her family background, and in learning how to speak Japanese better. "The idea of specializing in art really hadn't occurred to me. I thought maybe I could be an interior designer or something like that. Neither the school or my parents ever said, 'Hey, you could be an artist,' because it hadn't occurred to them either. I never could decide what I wanted to do. There were too many things I was interested in. So I never thought about becoming an artist until I was in college."

Norie decided on University of Michigan, which is a big school and one where she could continue to keep her options open. She had applied to the liberal arts school, but since she wrote about her interest in art in the essay, she was accepted into the art school. "So then I had a conflict. I did some asking around and it seemed that once I was in the art school, I would be limited in the liberal arts classes I could take. So I actually transferred out of the art school and into the liberal arts school for my freshman year."

About two weeks into her freshman year, she ran into a friend from high school who was surprised that Norie was not in the art school. She encouraged Norie to transfer back to the art school, brushing away any fears Norie might have had about not being good enough and explained that Norie could take as many liberal arts courses as she wanted. Norie then proceeded to transfer back into the art school.

It took her another year to get back in. "I had to apply and present a portfolio. It was a much more difficult process to get back into the art school. But I decided, right then and there to go into art school and start focusing on that. After I transferred I never looked back. But I really had a hard time getting to that point."

Graduate school was the logical next step for Norie, since in her family graduate school was a given. "I applied to Yale and didn't quite make it. I was on the waiting list. University of Washington accepted

me. I was attracted there because of the mountains and water. I also wanted to get out of the Midwest and be in a different environment."

But first, Norie spent nine months in Japan, from July until March, immersing herself in Japanese language and culture. "We were going as a family the summer after I graduated from college, so I set it up so I could stay in Japan longer than the two or three months my family was there. And it was really great. I learned a lot of Japanese and did everything—calligraphy, wood cuts, sumi painting, cooking and aikido. I was out every minute, taking every lesson I could think of.

"On my way to Japan though, I came here to Seattle for a visit and of course it was one of those beautiful days. And the art school looked great. So I went." Norie then admits, somewhat sadly. "It was not a good decision. In the end I wasn't satisfied with the quality of the school."

"But you did it anyway," I say.

"I did it anyway," she says resignedly, but then brightens. "Actually I had a lot of really good experiences at graduate school, mostly with other students and two professors. The good ones kept me going. I should have left but I didn't."

Her major in graduate school was a combination of printmaking and video. It naturally kept her options open and invited connection with many fields, spanning conceptual art, sculpture, installation, science, geography and poetry. "My work was focused on a couple of things. One was the idea of horizons, which I think of as an abstract concept, since there is no actual tangible horizon. It's really that place where earth and sky meet, but they meet in different ways in different situations. So I took the idea of a horizon and abstracted it further

and made different contexts for it. I made horizons into three dimensional shapes. I also used the image of a canyon quite a bit, which creates a dipping horizon. And then I would take those images and put them into cylinders, giving them that kind of shape and limitation. So I was doing a lot of landscapes that had to do with the abstract concept of the space in between. This is actually something that I am still very concerned with. The space in between, the moment in between, the state in between two things. I did a series of work both in video and prints about that."

Norie is comfortable being an artist. She knows how to move in that world, knows her artistic process, knows how to reach an audience. But motherhood is still new for her. She didn't go to school to learn how to parent and hasn't had twenty years of experience behind her. She was over forty when Tomo was born. "When I was younger I didn't think I had time to be a mother. I was really busy, working and surviving. It just didn't seem an option. It wasn't something I had closed off completely, but at that moment I just knew that it wasn't going to be a part of my life."

"How did you change your mind?" I ask.

"It was the biological clock that said, now or never, so my husband and I said, 'Okay, we'll try and see if something happens. If no baby comes, we won't go through all these extraordinary things. If it happens, it happens, if it doesn't, it doesn't.'

"Ralph and I seem to have a ten year cycle. We got together in 1970. We were together for ten years before we finally decided to get married. Then we were married for ten years before we had a child. I don't know what's going to happen in the year two thousand."

Though somewhat concerned about how motherhood would affect her life as an artist, she approached it with an abundance of self knowledge. "I was relatively secure in my life choices. I knew I was an artist and this was how it was going to be. And I knew enough about how the art world worked and enough about my own work habits. When I got pregnant we were pleasantly surprised. I just continued to work. I was really lucky that my pregnancy was pretty easy and that I was able to continue working.

"I was working on one of my first big commissions. And the installation date was the baby's due date, basically. And, of course, it couldn't be changed. I was working like crazy, trying to get everything done. I was traveling a lot. During the first trimester I was teaching up in Bellingham, Washington and commuting back and forth. I was also working on a planning project for the new Denver airport. It was a four month project, two months before the birth and two months after the birth. Thankfully I didn't have to make anything, because I don't know if I would have been able to. By the time Tomo was two months old he had been to Denver twice already."

I ask her to talk about how she and Ralph have set up their family to support her work. Norie's eyes lock onto mine. "Ralph has been the reason I've been able to continue my work during the time I was pregnant and since Tomo's birth," she answers. "When I got pregnant I had a couple of commissions. And since Ralph was figuring out what to do with his life, we decided that he could help me build these commissions and we could keep the money in the family. Otherwise I would have to pay somebody else to build them. So for a number of years now, he and I have been working together on my work. We've really

been doing everything together, even raising Tomo. I have been busier since Tomo was born than before he was born. And the fact that I've been able to do as much work as I have was because Ralph was doing the childcare."

"How does that arrangement affect your marriage?" I ask.

"Tomo has worn us both out in a funny way," she says shaking her head. "You never know how hard it is to have a child until you really have one. And it probably depends on the child. Tomo is so energetic. He doesn't rest, so it's been very demanding on both of us. We've had childcare for him. And now he goes to preschool. So it's not as if we don't have time to work.

"I have been out of town quite a bit since Tomo was born, actually. The first year we would all go together. During the meetings Ralph had Tomo and they would be running around to various places. But now that Tomo is older, we just can't take him everywhere, so Ralph stays home with him." Norie pauses and looks down at her hands. "You know, it's hard to tell if it has been hard on Tomo or not."

Answering my stock question about how she is a great mother proves hard. "I don't know," she starts out. "I think I'm a failure as a mother sometimes. It's hard to assess one's own successes, but I have had to come up with creative ways to deal with the various crises that come up in a child's life. Tomo seems to have so many crises and situations where he needs help or needs something. I tell him stories and think up distractions.

"I think playing is always easiest. And being able to spend time doing things he really wants to do. The hardest is trying to get him to do what he doesn't want to do, but needs to do. The struggles have

always been getting dressed in the morning, brushing teeth, taking a bath. I try to come up with different reasons every morning for doing all those things. A nice challenge."

Then I let her talk about the terrible parts.

"I'm the worst at discipline, trying to toe the line and make him keep to the limits," she says immediately.

"Are you learning how," I ask jokingly, "or are you . . ."

"Have I given up?" she says, jumping in. This hits home for both of us and we collapse in hysterics. She continues. "I'm trying to learn how, because I know it's important. But there is so much you have to be able to put up with, in order to set the limit and stick with it. All the complaining and crying and whining. When you're at home, that's one situation, but the hardest part is being able to ignore that tantrum out there in public. And they're screaming and saying things like, 'I don't want to go with you. You're a bad mother.'

"We were shopping one day and Tomo saw something that he wanted, some weapons, and I told him he couldn't have it and we had to leave the store. He wanted to go back in so much, it looked like I was kidnapping him. He was saying, 'I don't want to go with you, don't take me away.' And people were watching me like, does this woman belong to this child or is she kidnapping him? That's when it's the hardest. Trying to pretend it's all okay."

As a somewhat new mother, her support systems are not fully in place yet. Her friends either have no children or have children significantly older, and both Ralph's and Norie's families are far away. Plus urban living is such that getting to know the parents of Tomo's schoolmates is difficult. "When we drop off our children at daycare, most of us are rushing off. We've actually gotten to know some people at his school a little, but the kids live all over the city. And there aren't that many kids in the neighborhood. I'd say we don't have much of a support network."

"What would you like?" I ask.

Her mouth curves into a soft smile. "I'd like to have some children in the neighborhood that Tomo could play with," she says. "That would probably be the nicest thing. People who live close, have similar interests, similar age kids. I'd love it if my mother lived close, too."

On the other hand, Norie has plenty of artistic support. "It's because I've lived here since 1972. I graduated in 1974 so that's twenty years that I've been working as an artist here." But being an artist is still a challange. "I think that opportunities for artists are limited here. It's such a volatile thing. One year I'm doing a lot and the next it's famine, there's nothing. But I always feel like there is something around the corner, some opportunity of some sort.

"I had really good support as both an artist and a mother in the Denver project especially. Tomo was born right in the middle of this project and when he was a month old I had to attend meetings there. He couldn't be far from me for very long because he was nursing. The meetings lasted all day long so I ended up nursing him during the meetings. The others on the design team, even the men, were really great about the whole thing.

"For some reason, I was selected to present the final report for the thirteen artists working on this project. We had just spent three days cooped up in a studio writing this report. Tomo was with me the entire time, poor baby. We never even saw the light of day that whole

time. So I had to give the report to the art steering committee of the Denver International Airport holding a two month old baby in my arms. It seemed unusual to me. But it showed that there was a lot more acceptance of motherhood and having a family. Women are becoming more prominent in the art world now and a lot of them have children. It just becomes part of the whole situation. So it hasn't hindered me much."

It has been a concern though, for both Norie and the communities that employ her. When Norie started working on the Denver project, she was eight months pregnant. Because it was a four month project, there was some thought as to whether or not she could do it, but not enough to lose the job. Tomo was only a month old when Norie when to interview for the project in Dallas. Fortunately somebody was able to take care of Tomo for the hour interview. In both instances, the amount of travel was raised as a potential problem to be solved rather than an insurmountable obstacle.

"In the art world itself, as long as you get the work done, it doesn't seem to be that much of a problem, beyond the usual prejudice against women. But I don't know if it has become worse with a child. There are differences in the types of things one can do. For instance, somebody asked me whether I would come and do a six week residency. And I thought, I can't just uproot my family. And I can't be gone for six weeks without my family."

Norie pauses to think. "I wonder if the opportunities fall off after you keep saying no. It's hard not knowing what stops opportunities from coming to you. You don't know if it's because people don't like you as an artist, or they don't like your work, or whether they are not interested in taking on a whole family. Unless some overt thing happens, related to the fact that I am a mother, I cannot tell."

It is also hard for Norie to evaluate how her work has been affected by Tomo, because ever since Tomo arrived, she has been involved in public art projects, a somewhat recent form for her. "It's difficult to say whether that's the work I wanted to do anyway, or whether Tomo's birth led to feeling a certain kind of responsibility or what.

"My work has always dealt with movement from one state to another," she explains. "I think that the whole idea of transition and looking at the past, the memory issue, has really come up a lot more because of him. When you look at a child you really see into the future. I pay attention to that more than I used to. That whole issue of the past, and what's happening in the future and being on the cusp between the present and future, has become much more a focus.

"My work habits have changed quite a bit, though. I used to work a lot in my studio and not at home very much. And I really did work all the time. Now I don't because I want to make sure I spend time with Tomo. So there are hours in the day when I just don't work anymore. I used to work all day then come home and eat dinner around 9:00 and that would be the day or I would go back to the studio sometimes.

"But now, we go and pick him up at school around 4:30, so between 4:30 and the time he goes to bed, I spend time with him. I still end up working at night, when I'm under a deadline, but I spend a lot more time working at home. I've chosen to do the computer work at home so I always have something to do here, but I can't work when he's awake, so it's kind of funny. Partly I don't want to and partly it's impossible."

"Are you saying that you actually work less hours, yet are doing more work? Is that true?" I ask.

"Well yes and no," she says slowly, bringing her eyebrows together. "I can't say I've gotten more efficient. I realize that what I can do in a certain amount of time now is different, so the timing is different.

"The last three years have been busy. It's been crazy. It's been really hard on Ralph and Tomo, too. So when I'm here, the demands Tomo places on me are much greater than if I had been a more steady presence. He makes sure that I don't get any work done while he's awake or on Saturdays. I used to never take off Saturdays. But now I don't work so much on weekends, unless I'm really under the gun."

If she had to choose between her child and her artwork Norie unhesitatingly picks her child, then tempers her answer. "I don't know that you can be an effective mother if you're prevented from doing other parts of your life. It's hard to tell what kind of mother I would be if I couldn't do my work. What I do as an artist affects my personality so much. I would have to find something else to do with my life besides childcare. You can't focus on your child one hundred percent of the time. It's not very healthy for either you or the child. And even housewives don't focus on their children one hundred percent of the time. No mother has ever focused on one child, certainly not one hundred percent of her waking hours, I don't think.

"It's so hard to be an artist actually. It would be very hard to start both being a mother and one's art career at the same time. One would have to choose at that point. I made a choice earlier in my life. I chose to focus on my work rather than being a mother. At a certain point the work becomes a habit, so that you are focused less on certain aspects of that. I really can do both things now. And don't feel that I need to choose."

Norie is in the uncommon position of being able to support herself and her family entirely from art and art related projects. She combines a number of different jobs, ranging from teaching to public art projects to selling the odd artwork. She has also worked with architects as a consultant. "I guess you could say that I make all my money from art, but not from selling my work." Norie says smiling.

"I was lucky with my project in Dallas because I didn't have to pay for any of the fabrication. I was paid a fee to do the design work and the oversight of the construction. I actually ended up doing quite a bit of the fabrication, though my fee was the same whether I did nothing or did a lot of work. The fabrication budgets and our fees were separate.

"With a lot of public art works you have a certain budget and then you have to decide how much money to spend on the project and how much your fee will be. And usually, you make less than you think because everything ends up costing more. So every project I try to learn this lesson: don't propose anything that's going to cost more than a certain percentage of the budget, say fifty to sixty percent, because it will always cost more. For some reason I've never been able to learn that lesson very well."

"Even though Ralph is working with you, you are the one bringing in the work. What is it like being the bread winner, in essence?" I ask.

"It's hard and nerve wracking actually. Right now is a very difficult time for me, because I was so busy last year I never had time to find any other projects. And now that all those projects are finishing up, I

have none coming up in the near future. So I'm in a really tenuous situation where I don't have any income and I'm trying to decide what to do. I applied for a lot of projects that I got rejected from recently. You just can't predict what it will be like.

"But I have a show coming up. And I'm relishing this opportunity to make studio work since I've been focusing on public art work for so long. I'm trying to guard my time, so I can get a body of work together. But studio work seems to cost money and doesn't really bring in money right away, anyway. Who knows? It's not easy to balance. I wake up in the middle of the night and think Aaakkkk. How are we going to do it?"

I ask how she nurtures herself. "Hmmmm . . ." she says. There is a long silence. "I'm not sure. I think I do it in different ways at different times. I really do get a lot of feedback from my work. If I can work in my studio without any big dreadful deadlines or demands, I relish it quite a bit. The demands on my time are so great, especially when I'm working on two or three projects, it becomes ludicrous in a way."

Norie relaxes as she remembers. "I like to spend time with friends and family and eat good food. I haven't been doing enough of it. It's the kind of thing that keeps me going. I like to travel quite a bit and explore new situations. I like to read books, but I hardly have time to read books actually, only on airplanes. But that's always good."

Norie is a tireless and committed artist, undaunted by the frustration of not being able to work when she wants to. This ability is coupled with her long term practice of making art. She has this advice to offer. "It's really important to do artwork even when you feel like you can't do very much. Art can happen in a lot of different ways. If you feel like you can't do art in the same way you are used to, you can change. Say you are working in some medium like welding. You just can't do it when you are nursing a baby. You could do watercolors or something like that. You need to be relatively versatile since it's frustrating otherwise."

Norie's goals reflect her stage of life. She is mid-career, a new mother, working in a relatively new art form. "What do I want to have done in ten years? I'm not sure anymore. I used to think, gee, if I could just have a show at the Whitney Museum, I would be so happy. I don't know now if that would be a goal. Could I retire after I had my show at the Whitney Museum? I don't think I could now. But I'm not sure what beyond that I would like. I think it has to do with age. You gain a certain experience and discover all the possibilities, then it expands even more and so what used to be a narrowly focusable goal is no longer one.

"The thing I don't want to get into is a rut. It's so easy to do the same thing over and over again. One of the wonderful and frustrating things about some of these public projects is that it takes a lot of research. You learn how to do something new and then it's never applicable to any other situation. So it's hard to get into a rut, which is a good thing.

"There is one thing I wouldn't mind being in a rut about: continuing to survive off my artwork in some fashion and never have to do another kind of job. But on the other hand, another job can make you grow. If something comes up that is kind of interesting, it might not be too bad to do something different.

"What's interesting about the things that I've been doing is that

they really have touched a lot of fields. For the Portland project I've also been working on a station for Tektronix, a big company in Beaverton, Oregon that makes electronic equipment. One of the ideas for that station is to make a place where technology and nature meet. The station has a lot of trees around it even though it's hemmed in by warehouses, parking lots, etc. It's still relatively natural. There are also wetlands around. I'm working with bird calls, translating them through high technology into sonograms which will be inlaid in the pavement. If you learn how to read a sonogram you might hear a bird and figure out what bird it is. And so all of a sudden, this art project is making this connection with ornithology in an interesting way. I'm not ever going to be an ornithologist, but I think it's interesting how these things can connect."

I lean back in my chair and smile at her. "You haven't changed really. You were telling me that as a child you couldn't make up your mind about what you wanted to do. Art is fortunately a type of work where you can use everything."

She nods, grinning. "You don't have to make a choice. Everything is a material for art. That's what I always try to tell students. You can use anything to make art and any idea in the world is a potential idea for art."

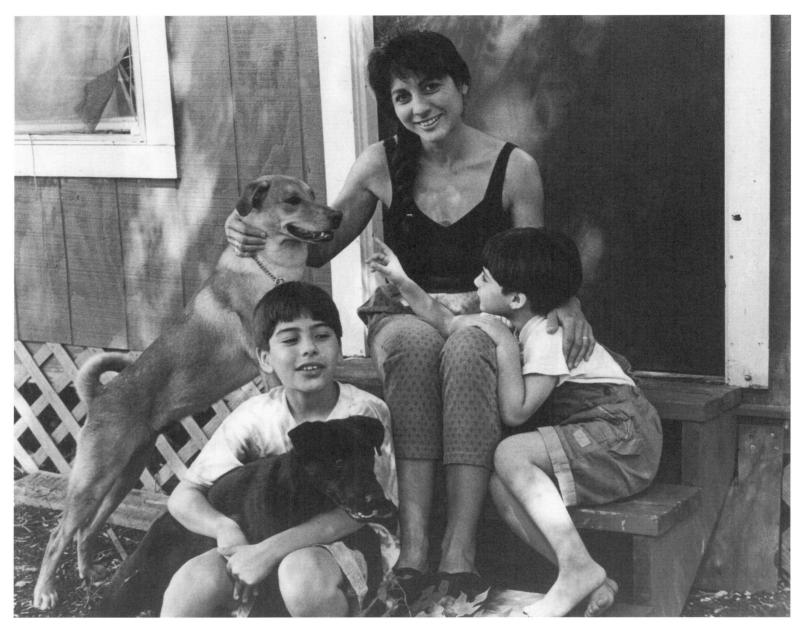

Pictured from left: Adam Barker, Tish Hinojosa, Nina Barker

Tish Hinojosa, SINGER/SONGWRITER

DESPITE THE THICK Texas heat, it is wonderfully cool in Tish Hinojosa's neighborhood of small ranch style houses nestled comfortably amid lush trees and bushes. As we drive up, a slight blond man is unloading something from a van. It is Craig Barker, Tish's husband and manager. His gentle and warm welcome is the hallmark of our entire visit.

It took over a year of letter writing and calling to arrange this meeting. Only by scheduling it during a time when singer/songwriter Tish Hinojosa was at home doing a gig with the Austin Symphony were we able to make it happen. She lives the life of a musician: constant touring, recording and promoting. After over twenty years in the business, she is finally on the brink of national recognition, although she has long been beloved in her native Texas. Her latest album *Destiny's Gate* was picked up by Warner Bros. Tish's music straddles several styles and hovers in its own place somewhere between country/folk/pop and Tex-Mex. I am a sucker for her gushy ballads about heroic families and true love and I love rocking out during the foot stomping down and dirty country numbers. She sings in both Spanish and English and blends those cultures proudly.

Tish was born December 6, 1955 in San Antonio, Texas, the youngest of thirteen children, eleven daughters and two sons. Tish's father worked as an auto mechanic and her mother was a homemaker.

Both parents came from Mexico, providing her with a traditional protective Mexican upbringing, speaking Spanish at home. She currently lives in Austin with her husband Craig Barker who is a lawyer and their children Adam, who turned ten the day before the interview, and Nina, six and a half.

Tish's career is also the family business and it seeps into every corner of their lives. The office where Craig works runs the entire length of the house and is jam packed with the tools of the trade: cardboard boxes of tapes and CDs, promotional materials and telephones. Large unmarked boxes stand in the almost empty living room. The house feels as if they just moved in or are about to move out. The focal point is the kitchen where as we enter, Tish is putting the finishing touches on a batch of salsa. She is small and lithe with big dark eyes and lots of long black hair tied in a braid. She excuses herself to go "put her face on." As we wait for Tish to join us, one of the dogs, George, pees on the bathroom rug and Craig rushes in to clean it up. Incidentally, the other dog's name is John Ringo.

When Tish sits down across from me and my tape recorder she asks me to remind her what this interview is about. Interviews are a constant in her life. I hope this one will be different. Her soft Texas twang belies her strength. As her life begins to unfold before me, I see the amount of hard work and commitment that it has taken to be

where she is now. That strength didn't appear out of thin air. Her sturdy roots go deep into the Texas soil, nurtured by her Mexican American culture. Wherever she is going, she moves forward with her whole being. There is no hesitation in her voice, only pride in her family and her work.

Tish grew up in her own time, tagging along after her older sisters and brothers. "It took me a long time to grow up. I remember being fourteen and still not doing things that other teenagers were doing. I was also a really sickly kid so I stayed home with my mother a lot and didn't have a lot of friends outside of the family." Not having many toys, she and her older sisters would invent games for them to play. "I found myself playing alone a lot so my imagination was a very vivid part of my youth. I'd play outside by myself under the trees and imagine. We also had a river that ran behind our house. My mom was of course, very busy all the time. She was usually in the kitchen. And we were all outside running around."

"It's great to have that extra childhood time." I agree.

"Yes," she says laughing, "I didn't want to let it go. It was a lot less complicated being a kid than an adult."

As a performer on the road, Tish takes risks daily. But she is not working without a safety net. That net started with her mother. Tish says lovingly, "My mother was definitely the ruler of the roost. Unfortunately, we lost her about nine years ago. As I grow older and know more about her, I realize how much strength of character it took to get as far as she got in her life. She was raised in a small town in Mexico and stopped going to school by third or fourth grade. She had very bad eyesight throughout her life, bad glaucoma and cataracts. She

came to San Antonio when she was in her mid-twenties with a two year old son looking for work. That's when she met my father whose wife had just died. She came to work for him, because he needed somebody to run his family and clean his house. He had seven kids. Somehow they found that they felt something for each other and they got together. So they had an automatic eight kids. Three or four years later they started having children together. They had five more daughters, of which I'm the youngest.

"The older kids, my father's children, who were age sixteen down to two years old, didn't like having another woman coming in. That's where her character really came into play. I'm sure she hadn't realize what she had gotten into. She had to learn by her wits, running a house, running a family. She survived through all this without being educated and also with her handicap.

"My father was basically a good hearted man but wasn't very family involved. He loved his family and he provided, but he was at work all the time. He would come home, have a few beers in the afternoon, have his supper and go to bed, basically. I think he felt somewhat alienated because he had so many daughters. He'd be on the front porch a lot of the time. I was somewhat closer to him because I would sit out on the front porch with him when I was little and help him fix the car and that kind of stuff.

"My mother was a great cook, an incredible housekeeper and really creative. Christmas and Easter were always wonderful. Our house was like the center hub for all the rest of the families. So even after my older sisters got married and went away, every Sunday was a big family day at our house. It was always that way until she died."

Tish's interest in music comes directly from her mother who had a beautiful singing voice. "When she was young, her dream had been to be a singer. She wanted to get professional training in Siltillo, the capital of her home state, Coahuila, Mexico. Obviously her dream didn't come true. My father would love to hear her sing and she would sing for us acapella. She would sing some old classics, like 'Estrellita,' and it would make everybody get misty eyed.

"My mother always had the kitchen radio on. She didn't listen to the Tejano station that played Tex-Mex stuff, we always had it tuned in to the old station that played a lot of music from Mexico, old classics and soap operas. It was real drama radio. I would sit there in the kitchen for hours with her just listening to music. I've never had vocal training of any kind but I find that when I sing, especially songs like I did last night with the symphony, I can close my eyes and fantasize being on the radio singing along with those vocalists of the thirties and forties. To me it's still play acting and the imagination of my youth."

Tish's older sister Linda who, as a teenager, was a gifted singer and prodigy, also served as a model and inspiration. "To me she was perfection," Tish says with a grin. "She was beautiful, she could sing, she was talented, she was smart. She had everything. So it's because of her, mainly. We went to a parochial school and the nuns sort of took her in. We couldn't afford things like music lessons, but they made a work study program for her. She would clean the conservatory in exchange for piano and voice lessons. By the time she was a teenager, she was already singing in musicals and training for opera. So it was really exciting for me to be six, seven and eight years old seeing my sister, who was seven years older than me, being a straight A student and having such a time. She was my parent's pride, really."

Ironically, Linda's success served as an important model for Tish, but it also hindered her. "I was really in awe of my sister. I still didn't know I could sing. I just knew I liked music a lot and I would sing along with the radio all the time." It wasn't until Linda entered the convent to become a nun that Tish began her own musical explorations. By that time she was a teenager and for the first time in her life, she was left alone. Most of her sisters were grown up and gone.

Tish's high school years coincided with the popularity of folk music. She made friends with some girls who were emulating Joan Baez and Joanie Mitchell, borrowed one of their guitars and found that guitar playing came easily. "I just found myself automatically playing along with songs that I had been singing for years already. It was a very exciting time for me. I started going to coffeehouses with all these other people who played guitars and sang. I had been introverted somewhat before, so it was sort of my coming out with music."

At that time her goals were vague, other than getting out of school which didn't interest her and making music, which did. "I imagined pursuing some form of musical career, follow in Linda Ronstadt's footsteps, be a singer, I guess. And I thought it was going to be a lot easier than it turned out. Had I known how hard the road was going to be . . . obviously I did it somehow, but it wasn't near as easy as I pictured. I knew absolutely nobody in the music business, so I had no rules or map to follow.

"I ended up staying in San Antonio several years after high school just playing in clubs. I was making money. That was nice, I could sort

of support myself. But outside of that, it was really frustrating, because career-wise I wasn't making any moves. And I didn't really know where or how to make the moves either. I never even thought of doing things like a bio or photos or that kind of thing. I got signed with a Tejano label in its early days, back in 1974, when I was a senior in high school. I recorded a few records for them in Spanish. Then I saw it was not really where I wanted to be. I was more into the American country rock sound that was happening in the seventies and not so much the bubble gum Mexican stuff."

In her early twenties, Tish moved to Taos, New Mexico on a whim, breaking away from a brief marriage, her home and family. "It was really wonderful up there. The next eight years I spent in that area were like emerging from my cocoon. I was finding my own self without family, without influences of any kind, except for just being me and young and single and turned on to music."

It was then she started to go beyond her folk roots. Always practical and needing to make a decent living, she adapted to the music scene there which was country. She also started to write songs and while in a band, met Craig. "Michael Murphy took me under his wing and let me be in his band. I sang background vocals for him and actually toured with him a little bit too. He was like a big brother which was really flattering. He would give me a lot of advice on the music business. Then I got signed with a music publishing company out in Nashville. So Craig and I moved to Nashville about 1983."

Their son Adam was born in Nashville in 1984. The first of two surprises. "The motherhood part is really strange. I never saw myself as one. I saw all my sisters being mothers. And in their eyes I was just a Bohemian, just a girl with her guitar and music traveling around. So I sort of saw myself that way, too. I loved children and I thought maybe someday, but it really wasn't a reality to me. I lived and breathed my music. And even after getting married, Craig and I talked about having children at some point, but it was always this elusive thing, like somewhere, somehow in the future this might happen.

"I was terrified when I found out I was pregnant with Adam. 'Oh no, I'm going to be a mother!' My sisters all thought it was rather humorous. And I got mothered a lot during the pregnancies and got advice from all sides. A lot of, 'I guess this means you're going to settle down now.'" Tish chuckles. "They didn't know we were going to have great traveling kids."

Tish worked well into her eighth month of that first pregnancy. At that time she and Craig were traveling around playing the college circuit. And when Nina came along, Craig was in law school so her mother-in-law came on tour to take care of Adam. "The traveling never really stopped. The constant motion of booking dates, you know, that's our survival. You really can't stay in just one place, unless you want to be like a lounge singer somewhere. That's such a depressing thought. And by then, my songwriting was beginning to take a real front seat."

Living in Nashville away from family and support made those early years of motherhood rough. "We weren't really making it. I was with a publishing company, but I wasn't being paid by them and I was just singing demos. They'd sign one or two of my songs, but I didn't write the kind of stuff that they really signed. It wasn't commercial country stuff. Craig was out waiting tables and I was with this newborn. It was

just he and I and this baby trying to survive just enough to pay the rent.

"Although I was always the babysitter in my family with all the nieces and nephews, when it came to my own it really scared me. I was really terrified of this little living and breathing thing who needed me for every little aspect of his life. It was because it wasn't expected for me to be a good mother from my family's point of view. I wanted to prove myself. I would not let him out of my sight, even to go take a shower. I'd sit him in his basket right outside the shower so I could be watching him. Or if I'd go to the studio to sing, I'd make sure I'd fed him and he would be in his basket at my feet while I was singing demos. People probably thought I was real weird or something. I felt so responsible."

But motherhood became the catalyst for a new commitment to her music. As the bond between Adam and Tish deepened, her music changed. "My song writing got stronger. I had a lot more reason to want to work really hard, because now I had to support this child and give him a life. So my focus on being a professional grew. I didn't want to go back to school. I didn't have any interest in anything else. And when it came down to how much I made by the hour, doing music, as opposed to doing anything else, like wait tables, I still did better with music. It was what I could afford to do and what I loved to do. Therefore I focused hard on moving ahead with it. And that meant constantly having my pen in hand and trying to write songs and pitching and moving and getting in touch with record companies and seeing how to advance this career.

"Every little aspect of motherhood became a source of inspiration.

I've never been a doting kind of mother, but at the same time, I really enjoy being that mother person. I just wrote a song, 'Baby Believe' that's on the last record that talks about that, what children show you about yourself that makes you like yourself more, because you realize somebody loves some quality about you that you didn't know you had."

Despite her grueling schedule and involvement in the music industry, Tish hasn't lost her openness and genuineness. When she speaks of the easy parts of mothering, her voice grows warm. "Well, I find it easy to communicate. Maybe it's because I've always been somewhat childlike myself. I've never really outgrown the wonder of childhood. I can still recall a lot of it. So I enjoy watching their imaginations and amazement. It's really hard sometimes to focus, because we get really busy with our things. Say I've got interviews or I've got this or I've got that. And Craig's in the office. So we stray off, but the kids always manage to pull me back in and remind me of how great imagination is.

"The hardest thing is trying to juggle all these different things that I still love. I've got to do five different jobs and do them all as best as I can without letting one of the balls fall. I love them all and I can do them all. But there is just not enough hours in a day to make sure Nina is learning all her letters right. And make sure that she is totally well rounded. Are her nails clean? Have I cut her toenails? Everything from grooming to paying attention to their emotional growth. You ask anybody who's a homemaker about just running a house and raising the children and there are probably not enough hours in a day just to do that. So I realize that Craig and I are challenged by his law career, my music career and all those little aspects that go along with them, especially mine because his law career really does more circle around mine.

He pays a lot more attention to being my manager than to his other legal clients."

While Tish is on the road, Craig stays home and keeps it all together. "If I were a single mother," she says, shaking her head, "I don't think any of this would be going on. It would be extremely difficult. Or somebody else would probably be raising my children for me. So it's his support in everything from running the house when I'm gone to being there when I need to break away when the kids go with us on the road. Just all around he does half of it. If I'm not doing enough, he's definitely filling in and vice versa. That's kind of a blessing."

For a moment, her face grows earnest and her voice quickens. "Whether or not he and I are getting along, we always try to keep a good balance for the children. They need that constant nurturing and growing. In this business, the only thing we can predict is that it's going to be unpredictable. Every day there are fly balls thrown at us. And we're trying to give the kids a normal life. They go to public school, they both take music lessons, they both are in sports. So we have to be those kinds of parents too, that run their kids off to the ball field three times a week. Even though it never fits into our schedule, one of us has to break away from whatever we're doing to go do their thing.

"We've really placed high value on the children and their circle of people. Adam has been at the same school since kindergarten. Even though we moved to another neighborhood, we still take him back there because that's where he formed all his early relationships. Three or four of the families are still in our network of people so when Craig and I both have to leave town for a week, our kids will actually stay at their houses. That's been important and really helpful. Our life moves so fast as it is, if it means taking a little extra time to drive them to their school in their old neighborhood so that they feel comfortable, it's worth the trouble.

"Adam and Nina have grown up in our life and in our business so they know how it works even though they don't like it sometimes. I get locked in a studio for two weeks at a time. We're paying five to seven hundred dollars a day for a studio and that means I've got to be there even if they get sick. Once both kids came down with chicken pox while I was working on a record. We just had to keep a little doctor's station in the next room with the bed. I'd do a little recording and then check on the kids."

For Tish self-nurturing comes in the form of songwriting while she is on the road. "I take my notebooks and my tape player of half-started songs that hit me while I'm in the midst of something crazy. On the road I tend to be a workaholic. If I'm not with my family and not doing housework or home related stuff, I just want to totally immerse myself in something productive musically. Whether it's interviews, going to radio stations, record stores, something related to where I'm going to play that night or writing songs. I don't think I ever turn the television on in my hotel room, except once in a blue moon when I'm just totally exhausted and want to see a little news or something."

"So you never stop?" I ask.

"I guess I don't," she says slowly. Then explains quickly, "But see, I enjoy the quiet time. I love it when I'm not being bothered. No one

calls me at the hotel. If I can sit there and have two hours of solid quiet with my thoughts and with my pen and paper, that's like heaven to me. I can read in an airplane, I can listen to a tape player in an airplane and I can watch a movie on an airplane, which we are on a lot. So the times when I'm by myself, I either do some exercise or I write. That's the me time that I spend."

We hear a car drive up. It is her sister Linda, who lives in Dallas and was at the concert last night. Tish is relaxed, even though she has a party planned for her family today.

I ask what brilliant thing she does that makes it all work so well. "I am efficient," she says proudly. But then laughs and adds, "But I still need to work on my attitude about it. I get real flustered and frustrated when I see inefficiency. I am like a dictator about it now."

Being a dictator has its good and bad sides. Tish is able to do an incredible number of things, but the stress is hard. She describes how she does it. "If I know tomorrow and the next are going to be really busy days, before I go to bed I'll make my list of everything. This is the priority, these things have to get done tomorrow. And I'll just plod through it, hell or high water, because that is what needs to get done.

"Before the kids and before my career really took off, I never used to do things like that. Nothing was ever so critical. But I've learned that if I've laid off something I really should have gotten to three days before, all of a sudden, there's ten things on this day and we should have gotten to five of those things five days ago. So this train has to be kept in constant motion to keep the ball rolling. Otherwise, we have this massive train wreck and then we have to take two or three days to clear it all out. Everything from the office to the house."

Along the way she also figured out that having somebody else clean her house was a good idea. "I don't clean my house anymore," Tish announces happily. "Somebody comes in and does it twice a week. 'Used to be just once a week, but then I realized that wasn't enough, I couldn't clean up all the spills, I couldn't make all the beds, I couldn't do all the laundry. It's got to be twice a week for me to be able to breathe and move. If I see piles of things, I just think, disorganization. It's like having a flea in my head or something. It just drives me crazy."

I am curious about what advice she would have for other women considering living a life like hers. Tish answers immediately, "If you have to think about it that way, then you shouldn't be doing it. You don't decide you're going to live that way, you just suddenly find yourself doing it. You'll sit down one day and realize what you've been doing for the last five or ten years and say, this must be what I do."

Tish's voice rises as she continues. "There are a lot of professional women out there who did not have children and I think they're missing out on something. They thought too much about making that choice. I think the nurturing that you learn from motherhood is something that helps you balance. I find it helps balance everything else in my life.

"The music business can engulf you. I've seen a lot of women who have chosen the music over establishing a relationship or having children and they seem aggressive. Something seems lost in the personality. Something about a softness, or a more human attitude that women have naturally, especially women with children because children need you and that need becomes far more important than anything else.

"If one of my children had an illness or something, I couldn't leave my career, that's what feeds our family. But definitely my child

would take precedence. If that child needs me, I would be there in a second. Even if it meant canceling six months of work dates or something. I feel really lucky about that, because I love knowing that I'm passing something on ahead, a caring. I hope I'm raising children that way. I think I am, because the kids see the struggle, they see how hard it is. They see when I screw up, too, when I just get overwhelmed. So they see my human side."

"What type of life are you aiming at?" I ask. Tish's answer takes me aback.

"Actually, I think I've already achieved it." she says, smiling. "Everything else from here on is icing on the cake. I've put out six records now that I just love. I've got more records in me, but I feel like I've said everything necessary to this point. If I died tomorrow I'd leave an interesting legacy of songs that will grow and that a lot of other people, Mexican Americans in particular, will appreciate. I've planted some really good seeds, including my family and my children and I feel very good about that. I've nurtured these two children to grow up to be caring sensitive adults."

I am amazed at this. Then I realize Tish knows something I am only learning—that it is more relaxing and fulfilling to work toward something you want in the best way you can, than to have never tried.

She goes on. "I used to be really afraid of flying. I thought, if I died, my children wouldn't know me. Or I wouldn't get all my songs recorded. We've been traveling so much, especially in the last three or four years, that I don't fear death like I used to. If it happens, I'd be kind of sorry, I guess, but at the same time I feel very good about where I am. If something happens, it will keep on growing without me.

If I'm here to see it, fine, if not, I'll enjoy seeing it from somewhere else."

Chapter Four: Tough Choices

When is it the right choice for a woman to leave her children? Though leaving one's family is tolerated and even somehow expected for men, it is forbidden for women. After infanticide and prostitution, abandoning one's children is the ultimate sin. The three women in this chapter would never say they left or abandoned their children, but all of them did, for varying lengths of time, choose their careers first. And for all of them it was a matter of survival—financial, emotional and artistic.

Writer Mare Davis chose to relinquish custody of her son Cody to her ex-husband when Cody was nine. Cody, now twenty-one, has cerebral palsy. When Margaret Dean's marriage was threatening to fall apart, she decided to leave her family and go to film school in another city in order to become more financially stable. And painter, Hung Liu, left her six year old son in China for two years while she went to graduate school in the United States.

Making such choices is the unspoken fear of most artists who are mothers, and of those artists in the throes of deciding whether to have children or not. Will I be able to be a good mother? Can I continue to do my artwork and be taken seriously as an artist? Will I have to choose? How can I choose? Why do I even have to make this choice? Men certainly don't. But the fact is that we make choices all the time. It is always a question of degree. Only in the eyes of our perfectionist vision of ourselves and other women do we seem to have only one final choice. There is never a final choice. Life is always changing.

Mare, Margaret and Hung Liu have all made choices with their children in mind as well as themselves. They were not idle decisions made on a whim. They were hard. In hearing their stories, I felt their pain, but I also saw their strength and commitment to building their lives in the way they wanted. And that, too, is what their children will see. Isn't that a better legacy to pass on than anger and disappointment at not living the life you want?

Pictured from left: Margaret Dean, Brian Gallagher, Carey Gallagher

Margaret Dean, SCREENWRITER

WE EXIT THE Santa Monica Freeway at La Cienega Boulevard heading north toward West Hollywood. Our destination is Sunset Boulevard where it cuts high across the hills on its way westward toward the Pacific Ocean. We are meeting Margaret Dean at *The Ren and Stimpy Show* [popular cartoon show on cable TV] where she works as production manager. But this is only her day job. Her real work is writing screenplays for the film industry.

When we get to *The Ren and Stimpy Show*, Margaret finds us wandering around the reception area and leads us to her office. She is tall, at least five feet ten inches and large. Her thick straight hair is cut to chin length. Her level gaze looks out from a solemn face, that nevertheless breaks easily into a laugh. As we talk, she uses her long and graceful fingers to push her hair back from her face impatiently.

Margaret sits behind a large desk covered with papers and other office paraphernalia. Since she is a single mom, meeting during work hours suits her schedule best. Even so, we are interrupted frequently, but are able to get back to our conversation easily.

Margaret Dean was born in Queens, New York on July 10, 1951 into an Irish German Catholic working class family. She is the third child and oldest daughter of six children. Her father worked as a policeman and retired as a lieutenant detective of homicide. Her mother worked at home raising the children. In this solid working class family, work was highly valued. It was basically what they did together. Margaret says unceremoniously, "We took care of the house, we went to school, we did our school work. Our motivation was getting things done. And with eight of us, there was a lot of work to do."

She is still working. "The reason I get places is that I'm willing to put the hours in. In some funny ways, my father was the initial role model for me, telling me over and over, 'Don't tell me you can't do something. Say, How can I do this?' When I talk to a lot of producers, not just in film, but producers in all walks of life, that seems to be the philosophy they all work on. So I do have a basic belief that I can pretty much do anything I want to do. I just have to figure out how to do it and work around whatever is in my way."

As a child, she was often alone, since her sisters are six and nine years younger than Margaret and her brothers would not include her in their adventures. She used television as a way to escape. "As I got older I watched it more and more and became more reclusive. I watched movies, basically. I was not interested in hanging out with my family and I would stay up late while everybody else went to bed and watch the late late show and the late, late, late show.

"I also used to play sports, but because I was a girl, I was never really encouraged. For some odd reason my mother took me to a basketball clinic for girls when I was about ten. And I just loved it. But

ketball clinic for girls when I was about ten. And I just loved it. But never again did they offer anything like that and I couldn't seem to get on the teams. But now that I'm an adult, I play in a women's league and it's still quite an obsession of mine.

"The only fun thing we did as a family was go camping. My parents would take us on long family trips, cramming eight of us into a car with tents and all our belongings. The good part was that I got traveling into my system. When I was about ten, we took a trip from New York to California. A lot of my childhood friends never left New York, but we did. I have just one brother on the East Coast, the rest of us live in California. Somehow we were given this gift of feeling free to just move and go. And that it wasn't unfathomable to actually relocate somewhere as far away as California."

I envision a solitary, serious looking child with secret ambition. Watching her mother's life may have helped that intense determination to develop. "I grew up with a lot of frustration and anger inside me that my mother wasn't going to get to do things and maybe I wouldn't get to do things either. She was very bright and selfsacrificing. She dedicated her life to her children and her husband. As a young girl, even though I was not consciously aware of it, women's liberation made perfect sense to me. I understood what it was about and how true it was and how unfair things are.

"I'm sad about the amount of sacrifice that she made, because she was an artist herself. In high school she was very gifted, got a lot of recognition and went to a special high school. But then there was a war and she met my father, fell in love and got married. She did what everybody had told her she was supposed to do. She was healthy and able to bear children with very little trouble and had six of them. So she never pursued her art.

"She read voraciously. Everyday I would come home from school at 3:00 and my mother would be sitting there with a cold cup of tea, leftover sandwiches and a book. Obviously she had been sitting there for a good period of time. But as soon as we would come in she'd quickly put it away."

I have heard this several times while interviewing for this book. I half jokingly ask Margaret if she thinks all mothers read a lot. She answers me earnestly. "It's the only thing you can do for free that you don't need childcare for. I read a lot and I'm sure if years later someone interviews my daughter, she would say, 'God, every night my mother would get into bed and read for hours.'"

"It's the only drug that won't really hurt you," I say.

"Right," she says with amusement, "it might even help. The hard part about being a mom, especially with really young kids, is that you are totally cut off from the world. Reading a book is like going somewhere else and maybe even sharing intelligence with adults."

When her children had grown, Margaret's mother went back to school to obtain a BA in art. Margaret went back to New York for her mother's graduation while pregnant with her daughter Carey, . "It was a very wonderful and proud moment because I saw her as a really different person that weekend. She was so happy and so proud and outspoken. I remember sitting there at the dinner table and watching her interrupt people. My mother never interrupts. She always just sits there and listens and speaks in turn. But she was in there arguing and really pushing herself. She just felt so good about herself.

"The next day, after the graduation, I was talking with my dad and he was saying, 'Well, you know your mom wants to get a job, but she just doesn't get it, that nobody is going to hire a woman her age.' My mother was sixty and her friends that she went to school with were probably in their forties. All these other women were sending out resumes, trying to get jobs. I realized he was right.

"To me it was an unbelievably sad moment. My mother had dedicated her life to raising her children and probably one of the things that she most wanted to do in life was work at a job. And she'll never get to do it. She will have to settle for doing the little things and never getting past decorating lunch bags and little notes and making cards for people. It brings great joy to my life, to my children's lives and to the lives of people that she's in touch with, but to me it is wasted potential."

As with all of her answers, Margaret hardly shows emotion. The visual exterior shows a calm, controlled person. That is not the whole truth. With only a little embarrasment, she says, "I live my life not really knowing where I'm going, but always ending up in a good place. I go real intuitive. Either that or I have a very powerful guardian angel. When I came down here to film school, I didn't even know what a producer did."

Margaret did not grow up thinking of herself as an artist. Her oldest brother Ed, now an architect, was the designated artist. "He was such a good draftsman that I never got a chance. I thought being an artist meant being able to draw, so I wouldn't even try. Achievement was such a big thing in my family that there was no point in trying something that I couldn't be the best at."

Instead she latched onto chemistry in junior high, and ended up majoring in it for two years at a small women's college in San Rafael, California. When she transferred to the University of California, San Diego, her major remained science. "But after about three weeks there, I just said, forget this. A) I can't compete with these people and B) I don't like these people, I don't want to work with them for the rest of my life. So I floated around for awhile trying to figure out what to do."

The turning point came the next Christmas. "My parents were very concerned that I obviously had no direction. So my dad gave me a thirty-five millimeter camera. It was like night and day. On Christmas Day I went to a park that was covered with snow and wandered around taking photographs. I actually took some pretty good ones for the first time out. My brother Ed was into photography, so we set up a darkroom over the course of a year or two. And then I started printing pictures myself and I took a photography class at school. This enabled me to finally say, 'fuck science.'"

When she announced to her parents that she wanted to take another year to study art (she had already gotten a BA in biology), her father refused to pay for it. So Margaret supported herself with a part-time job. "That extra year still stands out as one of the best years of my life. I just took painting classes and sculpture classes and performance classes and photography classes. And for the first time in my life, I was getting positive feedback from people. I was always mediocre before, and all of a sudden I was getting straight A's with very little effort. Coming from a family where your worth is based on what you can do and what you can do well, this was like the lights of heaven

were shining on me. It was the first time I ever did something that made me feel good and that I could do for hours and hours and hardly notice."

After that year, Margaret decided to stay at the art department in San Diego. "Rather than going and getting a second BA, I decided to go for the gold and try and get into graduate school. It took me two tries. I worked in a lab on campus and went on unemployment for a year, during which I just made art. It was another great year of my life. I worked on one photo piece for that whole year and that was what got me into art school.

"In graduate school, I started working in video and film and basically never picked up my still camera again other than taking great photographs of my kids. I was just so fascinated with the moving image. My still photography was always photographs and text. So to be able to have your images speak your words was easier. I hesitate to call it experimental film because to me, that stuff was never about anything except the medium. My work was not about film and video, it was about women and body images and substantive stuff."

Margaret's transition from budding scientist to visual artist to screenwriter is long and twisting. She emerged from it with an MFA from University of California, San Deigo and a masters degree from UCLA film school. She also acquired a husband and two children. After finishing graduate school at UCSD, she moved to Alabama with her new husband who was doing his medical residency in Huntsville. Luckily, it was the home of the Alabama Filmmakers Co-op, where she became involved in documentary filmmaking.

Her time in Alabama became more than a detour, it put her onto another track. "I was taken out of a young, hip, art school community and put into this little bedroom community. In my first few months there, I worked on a documentary film as a photographer, taking production stills. We hung out with this artist who was in his seventies and totally illiterate, but he made unbelievable paintings from dirt and found materials. He never used paint. It was the total opposite of art school for me where everybody was very articulate about what they were doing. Probably more articulate than their art was any good. And this guy, his art was unbelievable. Everybody was touched by it and stirred by it. But all he ever did was tell jokes and play his harmonica. It was a mind blowing experience for me." Within two years, Margaret was executive director of the film co-op.

Motherhood then came on the scene. Like most women of her generation, Margaret didn't give much thought to having children until she was ready to do it. "It's always shocking to me to hear people who are twenty-one years old talking about how they are going to get married and have kids. At that age I was so wrapped up in art school and my studies and my friends and trying to figure out who I was. The whole idea of being an adult and being responsible wasn't even in my brain. It wasn't until I met the man that I ended up marrying, that the idea of kids popped into my head. That was actually how I decided that I was in love with him. I thought, I want to have children with this man. It still stands out as a clear memory. So that's when I decided that I wanted to be a mom."

Characteristically, Margaret never considered how children might affect her art. Margaret smiles and shakes her head. "Like I said, I don't think about things. I'm embarrassed that I don't. I just get this idea of

what I want to do. When my friend Kathy was pregnant, I was spending a lot of time with her and I had a scare of thinking that I was pregnant, when all of a sudden I said, 'Yeah, I want to do this.' I didn't care how it affected my art. I just thought, 'I want to do this. And the other things will work themselves out.'"

"When I had Brian, I was the executive director of the film co-op. In Brian's first week of life, he was really sick, like he almost died sick. He was septic and for ten days we were in the hospital with him and I was pretty freaked out. On the way home I thought, this parent thing is very serious and I was taking it a little too lightly, not realizing this is a real human life and I'm the one who's responsible for it. So I tried to get out of the job at the film co-op. It was eight months before I was finally able to get them to let me go."

In 1984, they returned to California and Margaret's husband set up a practice in Watsonville, near Santa Cruz. Her daughter Carey was born soon after. The decision to have another child was very deliberate and based on an awareness of her needs as an artist. "I basically said to my husband, 'Either I have another child now or I don't have anymore children.' Brian was just turning two. I could see the light at the end of the tunnel. And I was ready to go back to work. I didn't want to start another career and then get pregnant again and have to start all over again. My career is built on momentum. I have to build it up and get it rolling and it's got to keep going. So I decided to have a second child and I had a daughter Carey.

"I actually had this experience when I was just sitting quietly for awhile . . ." Margaret pauses and says sheepishly, "I'm always embarrassed to tell this story just because some people get it and some peo-

ple don't. But I heard a voice inside of me that just said, 'I'm in here and I'm your daughter, I want to be born.' And that was it. I told you, I make these decisions like, okay, I'm on this track now and nothing takes me off until I reach my goal. I'm very directed that way."

That ability to focus and meet goals would come in handy soon. "When Carey was a year or so, I knew that she was going to get to that golden age when I could start to let go and have time for myself. What did I want to do? Somebody actually asked me, 'I get the sense that there's still a ceiling on you. What would you do if there was no limit?' Well, it was one of those things that just popped out of my mouth. I said, 'I would make big movies that lots of people could see.' That was always my frustration in art school, that the art world was so small. I wasn't interested in making work for rich people who believed what I said or if they didn't, weren't into looking at my art. I wanted to reach broad groups of people. And that's when I started thinking, 'What do I have to do to make that happen?'

"I decided at that point that I had to go to film school. I didn't need to go back into a production program, because I knew basic film production. And I didn't need to go back as an undergrad. I needed a producers' program because I needed to know how to get money to make films. And I actually managed to get one application into UCLA, before I decided it was totally pointless and I shouldn't do it anyway. I got accepted. So that's how I ended up in film school."

Getting through film school was more complicated. By the time she finished, she was divorced and living in LA as a single mom. "But I always was a single mom," she explains. "My husband was a doctor and he had a solo private practice. So I did it. It was my job. And there

were many, many times he wasn't there."

"Is that why your marriage ended?" I ask.

"No," she answers matter of factly, "I was actually okay about doing that. We couldn't communicate with each other and there was some question as to whether or not we were able to love each other. It was also my first primary relationship. I had never dated before that and there were a lot of things I didn't know. But the straw that broke the camel's back was when I came down to UCLA and finally made the decision to do something by myself.

"My perspective is that when we got married, my husband made certain promises to me. That he understood who I was, that I was an artist and this was my life's work and I was very passionate about it. When I got accepted at UCLA, my husband said to me, 'Why can't you be happy at home with the kids? And just take it as being an easy life and I'll support us and make a lot of money.' That's when I looked at him and thought, 'Who is this man that I've been married to for eight years that he could say this to me?' People who know me for five minutes know that I'm not that type of woman. I also felt like we had made a number of moves based on where he wanted to live. And it was all okay with me because I had the kids and it didn't matter where I lived too much. But it was my turn. And as soon as I made a demand or wanted something that was the end of the relationship."

"Did your children come with you when you went to film school? Where were they?" I ask.

"Initially," she explains, "they stayed with their dad. I came down in January and from January to June, my first two quarters, I rented a room in somebody's house during the week and I would fly up every weekend. My parents lived with Joe and the kids for the first three months and then we hired somebody to live with them.

"When I came back everybody was messed up. The kids were fighting with each other and being obnoxious and nasty beyond the normal fighting stuff that kids do. Obviously they were angry. And Joe was livid with me. And it took me a month of just sitting and listening to them vent about what had happened before they were normal again.

"That's when I decided that A) Joe can't handle having the kids. It's not good for him, and B) it's not good for the kids. They need to be around me. So we all decided I would take a leave of absence and that in a year we would all move down. And that's what pushed the envelope so that all of a sudden, both Joe and I realized that going to LA would be the worst thing that he could do. He was in heaven. This man will live and die in Watsonville. He's content.

"We had a big fight and he and I agreed that I should go and I should take the kids. Student housing came open and it was a two bedroom apartment. Actually it was fortunate that I did take them because in the divorce settlement I got custody of the kids because they were already here. If I had left them up there I wouldn't have them now. And I would not be a happy person."

Despite the intensity of the subject, Margaret has a twinkle in her eye. She is happy with her choice. She is living the life she wants. I am interested in knowing what it is like for her now as a mother. "The hardest thing about being a mother is that I know that I can't do the job as good as I want to. I want to be a perfect mother. I want to never yell at them. I want to be able to give them every single thing that they need and be there understanding every struggle they're in.

"On the other hand, I'm very happy with Brian and Carey and they look happy to me. Big picture wise I'm doing a fine job. But I can see all the cracks and all the places where I just can't be there for them. In the middle of the night, when Carey is sick and she's woken me up for the fourth time I can't say, 'Oh, yes dear, what do you need?' I have to say, 'WHAT? What do you want NOW?'

"There are two things I decided I was going to be sure that my children grew up knowing or having in their life. One is that they know that I love them. I grew up not knowing that and actually still don't really believe that my parents ever loved me. The other thing is that I am really good at staying in touch with them. I put a lot of time into talking to them about their feelings, letting them know how important they are as people. I'm hoping when my kids are twenty-five they will still be coming to me and saying, 'I have this problem, my girl friend is doing this . . .'"

Support, of course, is very important for single mothers. Margaret speaks warmly of what she has created for herself over the years. "My mother loves children. She lives on the East Coast, but they come out every year for months because most of my brothers and sisters live in California." She also has a housekeeper who comes in to take care of Brian and Carey during the week before she gets home from work at seven. In addition, Margaret has the support of colleagues in the film industry, which she consciously built up.

Support wasn't instant, though. "In Alabama, there was a very small community of people who were actually artists. The support there was hanging out with each other. But when I moved to Watsonville, I was alone, not only because I was having the baby, but there weren't even people I could talk to about movies. It was tough.

"So when I came to LA, I had figured out that I needed support and that was seventy-five percent of why I was going to school. I made a very conscious effort to meet as many people as I could and situate myself in the community. It was a different approach than a lot of my peers. A lot of them came to make contact with the people who were teaching the courses, who were all in the industry. But my main interest was the people who were sitting next to me in class. So now I have a very large support community here as a filmmaker and that's also why I live in LA. In LA, you go into the grocery store and there are filmmakers working there. There are people standing on line that you can have a conversation with about this movie or that movie. You drive down the street, people are making movies. Just being here supports me."

Her current support system still isn't perfect. "I think travel is impossible as a single mom. If you have a partner it can work out, or if you have family in the city. At one point, I wanted to go out of town for the weekend and for some reason I couldn't leave them with Joe. I remember talking to my friend Mary Lynn, one of my closest friends. But as soon as I asked her, her face changed and I realized that this was above and beyond what I could ask anybody except my mother or sisters. And Mary Lynn has a good relationship with my kids and she loves them."

Margaret accepts those limitations for now. As she looks to the future when her dreams of making movies will come true, she remains realistic. "I couldn't possibly be a producer now. It will be ten years before I'll be able to have the kind of lifestyle where I can travel and be someplace for three months or twenty weeks to actually produce a film.

So my filmmaking is done on paper as screenplays. My visual arts background made me a good writer. My screenplays are very visual and I know how to think that way.

"Working here at *Ren and Stimpy* is not great. It is very hard for me to do as a mom. I see my kids three hours a day, an hour in the morning and two hours in the evening. And for none of us is that enough time. The hour in the morning is the best hour. When I come home, I'm beat and I sit and watch TV with them or we read and then we go to bed. So long term, this job is to get me out of debt from going to school. But the ideal lifestyle for me, the one that I'm pushing for, is to be a screenwriter for a few years and then possibly move into being a producer. Then I'll be free of the kids."

She points out something that I have heard over and over while interviewing these women. The ability to focus well and use time efficiently. "I'm surrounded by people who are ten, fifteen, sometimes even twenty years younger than me. One of the things I noticed in school and here is that I'm a much more focused person. I can do so much with a little bit of time. I've been forced by being a mother to learn that thing of, okay, they're asleep now for who knows how long? Maybe two hours, maybe fifteen minutes. What is the best use of my time? And also, having children got me out of myself. The stuff I used to worry about as a young adult is so unimportant now. My priorities got clicked right into place. I'm not sure that would have ever happened if I didn't have kids. I feel I'm more sure about what's important, what's real."

Margaret's office mate has come back from lunch so we decide to move elsewhere. Resettled at a white metal table on a patio outside her building, we hear the traffic roaring by as we continue. Her kids Brian, now ten and Carey, eight have lived in Los Angeles for the last six years. They saw her go through film school and have witnessed her screenwriting. Has her journey affected them? "Well, there's some obvious things, like my kids have an understanding of media that a lot of other kids don't get. They know how *Ren and Stimpy* is made. They get to see all the behind-the-scenes stuff. I also hope my daughter realizes that there are endless possibilities of things that women can do. And both of them are seeing me pursue what's almost impossible. They see me week after week, year after year stay on with my dreams. And actually have some successes. It has to be a lesson. I believe that they are perceptive enough to get it.

"And I'm the ultimate cool mom," she laughs. "I work on *The Ren and Stimpy Show*. They score lots of points at school. Then, about the screenwriting, well, Brian is really into film. We go to the movies a lot and we talk about the producer and the writers. So he likes it. Carey, at this point, is not interested in film. She probably thinks it's a real pain in the ass that I work like this. She would rather have me home."

Steering back toward the hard places, I wonder aloud about how the film industry treats mothers. Margaret nods. "It's definitely an issue, but I don't think about it a lot, because I'm going to do it anyway. It's an issue for me because probably the second thing that comes out of my mouth after, 'Hi, I'm Margaret Dean,' is 'I'm a mother.' And I always say I'm a single mom. It's an important thing for people to know if they're going to know me.

"If you come in as a mother into the industry, it's very difficult. There's a lot of women who are successful who became mothers later.

But they have lots of money and they can hire somebody to take care of their kids. They are not the ones who are changing diapers and doing all the work. They're not paying the price that many people have to pay to be parents, which is lower incomes and the struggle of trying to make it on whatever you've got.

"It's also that people in the industry live a totally different lifestyle. Being in the industry is about schmoozing and partying. You are basically expected to work twenty-five hours a day. The industry is built on relationships. You have to have lunch with people. You have to have phone conversations with people. And I can't speak for hours and hours on the phone. Actually I make most of my phone calls here because my kids won't let me talk on the phone.

"And then everything moves so fast. If you meet somebody who's interested in you and wants something, they want it right away. And for me, everything takes longer than it takes for everybody else. Even though I'm a faster writer, the amount of time over months from beginning to end is longer, because I only get to work two weekends a month. Like this Christmas I have ten days to rewrite a script. And if I don't get it done, it will be two more weeks before I'll get some free time to sit down and do it. So things can pass me by."

Screenwriting, the ultimate crap shoot. Like most aspiring screenwriters, Margaret works on speculation, hoping to sell it after it is written. She grins proudly. "But my first screenplay that I wrote was sold and Leonard Nimoy is going to direct it. I am actually hoping it will go into production this year."

Her screenplays are about freaks. She currently has three scripts that are in different stages. "The one that Leonard Nimoy is doing is the story of the original Siamese twins, Cheng and Eng. The story I wrote is about their courtship and how they got married. They had twenty-two kids between the two of them and they were never separated. It's an unbelievable story. And then my second one, which is the one I am rewriting, is a reverse beauty and the beast story where the beast makes beauty human and the beast is a twelve hundred pound man. And he's a blues singer. It's not a true story except that there really was a twelve hundred pound man. Then my third story is based on a true story that my dad told me, one of his homicide stories."

It is important that her children are with her now even though it is very hard. But priorities can change. Margaret looks down briefly before answering my question about choosing art over children. "In June, Brian will finish elementary school," she says slowly. "So it's one of those transition points. And his father has been saying, 'Why don't you let him come up and live with me?' And because he's a boy, it probably would be a good thing. There are certain guy things that his dad can show him that I can't. I trust his father, but I would miss Brian terribly."

Margaret stops again and reflects, "When you asked that question I remembered an argument I used to get into with my ex-husband. He would say, 'I don't believe you would choose your family.' He was always so threatened by my decisiveness and focus on being an artist. I went round and round inside my head, 'Would I pick my family over my career?' Well, I can't quite give up my career, but I'm not willing to give up my family either. And I refused to make the choice. It doesn't have to come down to that. I can do both. And as long as it's still good for everybody, I intend to stay here being their mother. It's equally

important to me as being an artist."

I ask how she makes money. Margaret nods vigorously, glad to talk about it. "That's important. Because I learned some things. We made a decision about money that day I was driving home from the hospital with Brian after spending a week with him being sick and almost dying. I said to my husband, 'Do you think we could afford for me to stay home because I didn't have a kid for somebody else to raise?' And he said, 'Yes, I agree with you.' So at that point it set us up with the standard male/female arrangement. He earned money and I didn't. We were forced into these roles which later was one of the elements in the demise of our relationship. As far as he was concerned, I wasn't working. Even though I was, of course, doing all this stuff with the kids, doing most of the housework and at the same time, trying to be an artist and maintain some sort of hand in a career. In his mind, my career was not generating any income so therefore it didn't count. He resented that eventually, but at that stage he said, 'Yes, of course.' He had made promises that I could be an artist and he would be a doctor and would support me in my art. And it just didn't work out that way.

"The decision about going to film school was based partly on wanting to earn money. Things were getting rough enough in the marriage and I just thought I had to be prepared. I got a flash of how vulnerable I was because I had no income and was not really employable. I didn't know where I could get a job even though I had a graduate degree in art. What's that worth? If I had come right out of school and gotten a teaching job and gone on that circuit, then it might have been worth something. I was stuck in the proverbial female rut. I wanted to figure out some way I could earn a living making films.

"Once I got to school, I took out student loans right and left. My husband sent me a certain amount of money, but it was a lot lower than what he pays me now. We had a divorce settlement where I stood my ground and that got me through the rest of school, although it never paid for all of what it cost for us to live here. I went into debt, both student loans and credit cards. And now I work at *The Ren and Stimpy Show* and I get a decent wage, not to mention medical and dental coverage, so I can get my teeth fixed. And I'm paying my student loans and I'm starting to cut away at my credit cards."

"How long have you worked here?" I ask.

"A little bit more than a year. I just graduated a year and a half ago. In this town to have a job six months after film school is pretty lucky and amazing."

As we sit basking in the sun outside the huge office building that houses *The Ren and Stimpy Show*, I am reminded of a very important ingredient in this whole scenario. Margaret Dean is a hard worker, devoted mother and dedicated artist. There is not much that will stop her from reaching her goals. But what helps her keep going? How does she feed herself? "Probably not very well," she grins sheepishly. But then lists quite a bit. "Co-counseling is a big support. It's a large network of people who help me whenever I'm in emotional crisis. Weight has always been a big issue for me. About two years ago I lost about sixty pounds on a fast through a clinic. Since then I've been in maintenance. I go up there every Saturday morning and we talk about how to maintain weight loss. And then shopping and buying clothes is a big thing I do now that I have money to buy clothes. And getting my hair cut. I spend forty-five dollars to get my hair cut, which to me is a

ridiculous amount of money. Growing up working class and also Catholic has overtones of not allowing ourselves to have any kind of indulgences. It's taken me a long time to get to the point where I actually think it's okay to do them. And I go to the movies on my free days."

She is also looking for someone to clean her house once a week. "The first time I ever hired somebody, I thought, this is better than therapy. I felt a lift, like after having a really good therapy session. I walked into the house and it smelled clean. It was really funny to realize how getting real help from somebody, even if I have to pay for it, could make such a dramatic difference in my whole emotional stability."

We are nearing the end of the interview. It is time to wind up. Asking women to remember the brilliant ways they do handle their lives is important. Margaret has her answer easily at hand. "The single biggest thing was building a support network for myself. I never begrudged a second of the time I put into doing that. I have many friends who are now having babies. I have made a tremendous effort to reach out to them. Besides being their friend and wanting to socialize with them, I have taken care of their kids and they take care of mine. And my kids take care of their kids.

She has also recognized and accepted that her life is different from everybody else's. "I have to tell myself that every day so I don't get into the 'They're all out there having fun and making contacts because they go to parties and I don't and so I'm weird.' I just keep saying, 'I have this, they have that and my life is different.'

"The advice I always give everybody I meet who's branching off into being a parent is, don't do it alone. Find other people who are pregnant and hang out with them. If you're an artist, find other artists who are pregnant and hang out with them. When I was in Santa Cruz I hung out with a lot of moms who had babies the same age as my baby. But they didn't quite get who I was and I didn't feel that one hundred percent support that I actually feel now. All my parent friends are artists. They are filmmakers or directors or writers or whatever. Actually now that I'm thinking about it, they are all men, all dads. I still haven't found too many mothers. It was a big accomplishment at school to find a woman who was married.

"The other thing, just don't ever limit yourself. I tell myself that every time I think this is as far as I can go. I now have this little voice in my head who says, 'Are you sure this is all you can do?' There's a little compulsiveness in there, but there is also a healthy voice that's saying 'Be careful, you know that you always limit yourself because you're female. If you were a man, would you go further?'"

Pictured from left:
Hung Liu, Ling Chen Kelley

Hung Liu, PAINTER

AFTER TAKING A six a.m. flight from Portland, I arrive in Oakland, California at 8:30 a.m. It is pouring rain. At the airport, Hung Liu and I spend a desperate half hour looking for each other. I am tired, stressed out and nervous. I have a busy day ahead of me and a tight schedule. We finally spot each other. Hung is dressed entirely in black and silver. Black leather pants, black shoes, gray silk blouse, black wool jacket with silver animals dancing on her lapels. Her long black hair flies behind her as she walks, fast and furious. We climb into her shiny aquamarine van and speed to her studio, located near the train tracks in an industrial section of Oakland, before going to her house for the interview.

Hung Liu's paintings are predominantly of Chinese people. Her loose style—thin paint layered with drips upon drips forming the images—contrasts with the power and definition of the subject matter. She shows me one painting of a group of small children dressed in bunny suits, dancing around trying to act happy, though their long pink ears droop sadly and they are clearly in pain. Garish red and pink paint runs down their faces like a combination of tears, blood and smeared lipstick.

Hung Liu was born in 1948 in Changchung (formerly Manchuria) in northeast China, eight days after the Chinese Spring Festival, February 17, in the western calendar. She comes from a family of teachers who, as intellectuals, were persecuted during Mao's communist regime. When the Cultural Revolution occurred in 1966-69, Hung Liu was forced to leave school and was sent to the countryside for four years. Upon her return she went to Beijing Teacher's College and graduated with a degree in art education. She subsequently received a graduate degree in mural painting from Central Academy of Fine Art in Beijing. In 1984 she left her six year old son—whose father Hung Liu divorced while her son was a baby—in China with her mother and aunt and came to the United States to go to graduate school at University of California, San Diego, graduating in 1986. Hung Liu currently teaches painting at Mills College in Oakland, California. She lives with her son Ling Chen, 16 and her husband Jeff Kelley who is an art critic, writer and a part-time teacher at University of California, Berkeley.

In Hung Liu's house, perched in the steep hills overlooking Oakland, we sit at the dining room table to talk. The house is modern with high ceilings and big windows that on clear days probably have a great view of Oakland and San Francisco Bay. Today, all it looks out on is rain dripping in sheets off the roof. Hung Liu's work hangs on most of the walls. She is a warm hostess plying me with tea and cookies during the interview and feeding me egg drop soup.

While talking to Hung Liu, I am aware of the cultural and linguis-

tic canyon separating us. She is the one bridging that gap while I sit comfortably on my side. I admire her self-confidence and gutsy determination to succeed and continually challenge herself. How much of this is the ambitious and hardworking immigrant in her and how much comes from an inner drive to express herself and have that expression highly visible in the world?

Hung Liu talks fast. I have to listen carefully not to miss anything. She gets up frequently from the table to get more tea, change her clothes, answer the telephone. She is an engine on overdrive—thinking, worrying, calculating, connecting. It is no accident that during the ten years she has been in the United States, she has won two NEA painting fellowships, received numerous awards and public art commissions and shows her work all over the country.

The inner drive started early. "Because I was the only child in the family, I played with both dolls and guns," she explains. "I could also climb trees. I was given permission to do whatever I wanted to do, basically. My childhood, overall, was probably not so bad, considering all the revolutionary movements. I was fortunate to have a family to nurture me and to give me a lot of freedom. They allowed me to be more myself. I was scared many times, but I was never really a timid girl. I had a strong and positive belief in myself from childhood."

Because of the Communist Revolution, Hung Liu's mother was forced to divorce her husband, Hung Liu's father, since he was in jail as a prisoner of the state, having fought on the side of Chiang Kai-shek. Hung Liu lost all contact with him until last summer when she saw him for the first time in forty-six years, still alive in a labor camp in Nanjing.

Hung Liu was brought up in the home of her maternal grandparents. "My mom was with us, but she worked all the time. I spent a lot of time with my grandma. She probably felt bad for me, losing one of my parents so young."

As a child, one of her favorite things to do was spend time by the railroad tracks that ran near her home. "I loved to go there even when it was late. Sometimes I went with other children and sometimes by myself. The railroad was the border between the country and the city and it triggered a lot of imagination. Traveling has attracted me all my life. I counted how many cars in the train. It was all a mystery to me. So I loved to watch that." She tells me proudly, "I did a drawing once of the railroad with a bridge over it. It was a proof that I did go there a lot.

"The other thing I loved was family gatherings. Summer was my favorite time because my aunts and uncles and cousins came to visit and I could see that I belonged to a big family. I didn't have a father but I was loved by all the relatives. All my adult family members at that time were teachers. My mom taught both mathematics and biology in middle school. My grandfather taught biology in middle school. I remember the neighborhood being very close. Everybody knew everybody. If you needed somebody to take care of something you could get help and you seldom locked your door. To me it's almost like some kind of a paradise. But of course, that's how I remember it."

Hung Liu's sense of freedom and love of travel translated into more than just watching trains. When she was ten she impulsively decided to move to Beijing with her aunt. "It happened one summer after my aunt's visit," Hung Liu gleefully remembers. "Everybody was

seeing her off at the train station and I said, 'I'm going to Beijing to school.' Everybody said, 'No, you're not ready, you don't have your clothes with you or anything.' I said, 'I'm going,' and got on the train. My aunt then says, 'Well, I can buy some clothes for her.' My aunt and uncle never had children." Hung Liu pauses, takes in my look of astonishment and continues. "When I think about it today I am still amazed. Why did they let me go, not prepared, spontaneously getting on the train? I was also the only child and a girl. Beijing was a long, long way and full of unknowns. I can't remember exactly what my mother said, but she let me go. A couple of years later my mom and my grandparents joined us."

I want to know more about this mother who did not hold her strong and confident daughter back. "Were you close to your mother? Is she alive still?"

"Yes, she lives in Beijing. Would you like to see a picture?" Hung Liu runs and gets a snapshot of an intelligent looking woman elegantly dressed in red and black.

Hung Liu's voice speeds up even more as she talks about her mother. "She is a strong woman and very smart. Once she decides something, she is so determined. When she was eighteen she went to school to learn how to deliver babies. She also went to university to study math, pretty odd for a woman half a century ago. In the beginning she felt so stupid, she didn't understand a thing, but at the end of the course she was the best. All her life she wanted to be the best. She never learned art or anything but she has this natural artistic talent. In China, for many years, everybody had to wear very boring uniforms, even children. She hated that kind of uniformity, so she made clothes with a little design here and there, an animal. She also knit sweaters for me. When she was teaching biology, she made models of pigs and other animals with papier mache. She learned it just by observation.

"I have a lot of respect for her. She has an understanding of me and my mission and has helped me many times. She understands my work very well. I was surprised. Sometimes I think she will be offended by what I'm doing. Sometimes she asks me, why do you do this? And sometimes we talk. She basically understands what I'm doing. Down deep she is a rebel, so I admire her."

Even though Hung Liu loved drawing and painting when she was growing up and got lots of encouragement from her family, she never considered herself an artist. "In high school I was preparing to become a doctor because in China art is not considered a serious job or occupation. And even my mom said studying art was not serious business. She said, 'You can always do art in your spare time.' I was very good with my studies so I decided to be a doctor. I loved the idea of being a doctor and saving people's lives. Very romantic—also hard work. I needed to spend eight years in the medical school to become a surgeon.

"But then the Cultural Revolution happened and of course, I was sent to the countryside for four years. But I never stopped drawing and painting. In the countryside I mainly worked in the fields. I could draw and paint once in a while (when we had political meetings). And I did a mural for the village about a revolutionary Peking opera.

"In a way the Cultural Revolution changed everything. I realized I still loved art and I wanted to study it. So when school reopened I started in 1972 to study art at the Beijing Teacher's College. I studied art education as well, so after leaving college I could teach art in ele-

mentary and middle school."

Hung Liu's son Ling Chen, now sixteen is from a brief, arranged marriage. Did she expect to be a mother? Hung Liu guffaws and says, "Well, as a woman you always think that someday you will become a mother. But there never seemed to be the right time to have a child."

Then she explains more fully how it happened. "I was always outgoing, energetic and trying to accomplish something. I graduated from teacher's college when I was twenty-seven—in China pretty old for a woman not to be married. When I got to age twenty-nine some relatives tried to help. 'You are just too weird. Almost an old maid. And you cannot just focus on your art or your work.' So they started matchmaking. One relative found a guy who was five years older than me from an intellectual family. He studied astronomy, his mother was a teacher and father was a scientist.

"I was under the gun. There was a lot of pressure. In China people live so closely. The neighbors almost know everything. Even at work everybody said 'You are still single? Why haven't you found a man?' Everybody tried to help. It was like I had a problem. It became a public thing. Finally, I decided to do it. We met early in the year and got married in August. So it was a quick thing. We didn't know each other well. It turned out to be a failed relationship because we were so different. Not just in occupations but in our world views, philosophy and how to value friendship.

"For example, the moment we got our marriage license—which in China means legally you're married no matter if you have a ceremony—he and his mother both started to take off their masks. In China a daughter-in-law is supposed to be obedient. They said to me, 'From now on concentrate on your husband and your own family. If your friends happen to visit you, don't offer tea or cigarettes or let them in. Block the door and send them away. If you offer tea or anything, they will sit there for a long time and they will be back again. Just concentrate on your own life.' I was shocked because in my family that was never the way to treat your friends.

"He thought he was better than me because he went to a big university and I went to a teacher's college and was teaching kids. But I thought, maybe things can be worked out. All these maybes. My son was born when I was thirty. In China for thirty days after giving birth, new mothers are supposed to stay inside and rest. But before the thirty days were over we had a big argument. I left and went back to my mom's place. A year later or so I decided to divorce him and we went to court. He didn't want to give any support to the child so he didn't pay a penny. That was fine, it's not a big deal anyway in China, a few dollars a month child support then. He got remarried very soon after, I heard. But we never had contact. I basically moved back with my mom and my aunt."

The tradition of multigenerational households is strong in China. The nuclear family with its distrust of the older generation and deadly isolation is not the norm. Hung Liu's ability to take advantage of this situation saved her from the financial problems and career limitations that single mothers in the United States face. Anxious to continue to grow and further her career, when her son was a few months old, she decided to go to graduate school in China. "I could have stayed at my first job teaching art to kids. It was a stable life but I wanted to move on. So I went to graduate school at the Central Academy of Art in the

second year of my son's life and my mom and aunt took care of my son for me. In graduate school I was pretty busy, most of the time I stayed at school. So Ling Chen spent a lot of time with the two grandmas."

After finishing graduate school in China, which was the highest she could go, Hung Liu was still not satisfied. She decided to go school in the United States. "I knew there were a lot of things outside China I needed to see and experience. It was all pretty abstract, but I knew that if I went out in the world I would learn more and also be more challenged. In a way this is how I always did things. Because of a wild thought I decided to move to Beijing when I was ten and it changed my life. China is a big country and I competed with people throughout the country to go to graduate school. Only two of us got into the graduate program. So coming to the United States was a new challenge. I got accepted at the University of California, San Diego. I was offered a full scholarship. But the Chinese government didn't give me a passport for four years."

I sit up startled. "You waited four years?"

"Uh huh."

"How old was your son when you finally went?"

"Six."

"Was it hard leaving him?"

"It was very hard," she says steadily, "because even though I had been away in graduate school, I could go home anytime. If I really missed him, I could just get on the bicycle and go home. It was close enough.

"When finally I got the passport everybody in my family was happy. All the time my son knew what was going on but wouldn't say a word. But the moment I was saying good-bye he said, 'Mom, please don't go,' and started to cry. It made me so sad. Of course the separation was hard. But nobody had brought it up before. At that moment he suddenly realized that I had to go."

This is almost impossible for me to understand. My heart twists everytime I think about leaving my son for so long. How did she reach the point where it was a good choice for her? She explains patiently. "First of all, in China there was a lot of repression against the people and against women particularly. I felt, if I don't make a better future my son won't have one either. If I didn't take that step, we would be always there, suffering.

"A family can be the best of friends but it doesn't mean you have to stick together all the time. On some level we are always together. But I see the future always. He's sixteen and a half and will soon be gone to his own life. I'll always miss him but we will be always together spiritually."

Hung Liu's ability to see past the pain of the present moment and look ahead to the final benefit enabled her to move away from home at age ten, to attend graduate school in China while her son was a baby and to take the hardest step, leaving her country. She admits, "It was painful to leave him for two years. Especially at such a young age. He needed a mother very much. He already didn't have a father. But I knew I would be reunited with him as soon as I could. Also I felt he would be fine with my mom and my aunt. I couldn't trust anybody more than my mother and my aunt. Not just to feed him, to take care of his needs, but also teach him values. Of course, I would miss him, but it

was the best I could do. It was the only choice I could make. I brought him here as soon as I remarried and was ready to graduate.

"And that was hard, too, because in two years he grew up a lot. We had to readjust to that relationship. And also I had a new person in my life, my husband. But I'm glad I got him as soon as I could. He just had his sixteenth birthday and we joked that his nickname is half and half. He had lived exactly half of his life in China and the other half in United States. He is basically a healthy and good teenager. I'm very happy."

Hung Liu is not saddled with the impossible-to-meet American standard of maternal perfection. She is realistic rather than idealistic. "I don't believe there's a choice in the world that you don't have to pay a price for," she says bluntly. "You just have to make the choice. I made several choices in my life when I was young, probably unconsciously. I made that choice to leave my mother and move to Beijing when I was ten. I still don't know why. But there's a voice that gave me courage to do it.

"Now I make choices more consciously and think about pros and cons. But I still make risky choices. You cannot predict everything. Even if you don't make the greatest choice you still can gain something if you take responsibility for it. I cannot say I always made the best choices. But I made them all because of what I am and they formed who I am today. I have survived and have learned a lot and gained a lot and lost some. But it's fine."

Hung Liu did not make those choices alone. She had solid support from family and friends. "In China privacy is such a rare thing. Nobody respects it. People gossip about what you did last night, who you are with today, all kinds of things. But I could rise above this kind of criticism, by the help from family and friends. Here, it seems people pay a lot of money to talk about their problems. In China good friends help each other out. Moral support is very important."

Isolated from the rest of the world in China, Hung Liu took advantage of books as another way to get support and expand herself. As always, she takes strength from wherever she can get it. From reading European and American writers, as well as Chinese, she was able to glean a vision of the world as a nurturing place, filled with universal spiritual truths. "Even if I could not travel to the world, I could bring the world to me. Reading supported me in different ways. I had some soul mates from different cultures. It didn't matter, English or American or French or Chinese. Throughout history, if you look at it vertically or horizontally there is some kind of spirituality there. That kind of imagery or spirit is very supportive, sacred and powerful to me. Inside myself I was filled with satisfaction and strength, because of my reading. In reality my life was not that encouraging. But both were realities to me. You can create your own reality to a certain degree in your mind. It's not a fantasy because you can shape yourself spiritually.

"There is a Chinese writer Lu Shun, who died in 1936, whose books are almost like a bible to me. They are very serious social satire and criticism. He did an autopsy of Chinese society and tradition. I felt I had a great teacher and a great friend and somebody who could talk to me. I could share a lot of things with him. His books taught me how to deal with pressure. I still can remember most of the stories, the actual words."

As a mother Hung lives on her own terms. She has never let moth-

erhood stop her from pursuing her goals. Yet she *has* let Ling Chen affect her deeply. "I think he has fundamentally changed who I am," she says thoughtfully after a rare pause. "My identity is more complicated. I understand the world differently than if I never had the experience of being a mother. For example, the bunny dance painting. I did it to mourn my childhood, Chinese children and also children throughout the world who have had to put on a cute suit and were programmed to please the adults' world, to please the society. I feel very angry about that because I am a mother.

"On a daily basis I worry about his safety, his future and his food. When I am by myself I don't cook much. I just eat leftovers. Family dinners are an important ritual, not just to have something in your stomach. So he gives me permission to do this kind of thing. I spend a lot of energy taking care of him, worrying about him, but he has enriched and complicated my work."

And in exchange Ling Chen has also benefited. "He is proud of me. Especially among his friends and also at openings. I showed some of his friends my studio. It's fun to see his reaction. Being a teenage boy he is sometimes so cool. But once in awhile he says, 'Mom, I'm so proud of you. You are so famous.' I say, 'I'm not that famous.' 'Oh, you are, you are so great.'

"He knows more about art and artists. In his writing class when his teacher asked the students to list famous African Americans, Ling Chen could list a lot of African American artists. One of his classmates didn't know any famous African Americans, not even one."

Hung is proud of her son, but hesitant to claim responsibility for how well he is doing. "I said to my son, 'I really am not a good mother.

I'm learning, I've never been a mother before, you're the only one.' He's always generous, so he said, 'Mom, you're the greatest mom I could have.'

"And one day I said, 'You are my big burden sometimes. But you know what, I enjoy it.' And he was very moved. I'm happy for that. It's hard to pretend that you are a wonder woman. Everybody makes mistakes. I made a lot of stupid mistakes. And people forgive you. They are so generous. When I'm not traveling I try to cook him breakfast or dinner at home and prepare his school lunch. He says he's the one who always has fancy lunches. He is proud of that."

She adds, after thinking about it seriously, "Probably the greatest thing we have is our relationship. We can talk to each other pretty honestly. I yell at him, of course. I sometimes get mad. But overall, we can be honest with each other, share a lot of things. We don't hide our feelings. That is very important for me. I don't have to pretend I'm the best mother in the world."

The hard parts are clearer. "I never have enough time. If I want to spend some time with Ling Chen, there is always some deadline to meet, meetings, my own job, my studio work and traveling."

The first few years after Ling Chen came to the United States were especially hard. Hung Liu was working for an artist-in-residency program in east Texas, a four hour drive from their home. She taught art, kindergarten through high school, in small towns all over east Texas.

"My son and my husband had just started their relationship. I remember Jeff made macaroni and cheese for dinner from a box. Ling Chen hated it, but Jeff forced him to eat it because he was worried that the boy didn't have enough food. When I got home after the first

week, Ling Chen held me and cried. I was so sad, but I had to go to support the family and make some money and develop my career. It is part of who I am, I guess. I tried to come home every weekend or every other week and Jeff started to improve his cooking skills. But I was not home for months. It was very painful for me. I still can't imagine how the two of them got through it. I don't know what they ate. And at that time Ling Chen was still in the English as a Second Language class. It was a hard time for everybody in the family."

Throughout her career, teaching art has been Hung Liu's major source of income. "In the artists-in-residence program in Texas I made some money. And now I have a regular job, plus some sales. In China it was a low wage, but I got support from my mom and my aunt. I wouldn't have been able to do it just on my own salary. So it was okay. We survived. Today I have a full-time job with a guaranteed income. I have a studio and this house. Ling Chen is going to a private school, so a lot of expenses. But it is okay, I guess. Like everybody we struggle to make ends meet."

While teaching in a tenure track job at the University of North Texas, Hung was offered a position at Mills College in Oakland, so the family moved. "Everybody in the family, mainly my husband and me, felt we belonged more to the west coast instead of Texas. Plus it's closer to China. It's just across the water from here. Of course I miss China. I will always have a connection and roots there. But I've learned a lot this last decade. I can say that I am a new American."

I respect Hung Liu's ability to balance her life. Her mind is not cluttered by guilt or others' expectations. She tells me about having lunch with a former graduate student of hers from Mills. The woman, who was sitting with her three month old daughter, said to Hung Liu, "I'm always amazed at how you can be both a mother and an artist. It seems like the two terms are contradictory. If you want to be a good artist, especially today, you basically have to abandon all the other duties. You have to concentrate and do one thing."

With focus and intent Hung tells me her response to these ideas. "I don't believe that. When I work I do several paintings all at once. When you do one thing you concentrate on it but it doesn't mean you can only do one thing. And also if you only concentrate on one thing, you can get very tired. You can become a machine instead of a full human being. We can be both mothers and artists. It takes more time, of course, to take care of a child from baby to teenager but that part made me a more three dimensional person."

Similarly, Hung Liu refuses to make concrete priorities. "I cannot choose," she answers unapologetically. "My father is a priority now. We are trying to get him here. So probably family still is a priority. And also, my career is very important. I enjoy it. I get so into it. I don't care if I sell it. But if my son needs my help or my father needs me in China or anybody in my family needs me, I will probably put everything down and go there. For an emergency I can postpone a lecture, exhibition or other important business. I can give up some great opportunities. For awhile. It doesn't mean give up my career, but I don't mind sacrificing some."

But what keeps her going? Again, she credits an inner rather than outer strength. Hung Liu has a very useful attitude, based on her Chinese upbringing, which supplies her with the stamina to see past day to day troubles. "When I get very low, depressed, like today with

this kind of weather, I think, well, I can look either to the future or to the past. Because time is moving. Nothing will stop in this moment. In the past when my son hurt me or was unreasonable or I got mad, I used to think, 'Maybe I shouldn't have had a child. He gives me all the trouble.' But I don't think that way anymore. I know it will be over and if he owes me an apology, he will give it to me. And also, life goes on, you cannot hold on to this. You have to look at the big picture.

"I have pictures of him as a baby in my studio. Once in a while I'll look at them and think, everything is becoming history. The baby grows up and goes away. It helps me to think that time is long. Ancient Chinese poets use water to symbolize time. Water comes from the spring and keeps going to the ocean. You cannot stop it. Any minute it changes. But that's okay. As long as you know it's moving. It's a way to cheer yourself up. The high is in the moment, it won't last forever. My husband says, because I'm Chinese I never get too excited or say I'm the best in the world. Life goes on to the next project or something else. And if it is bad, it will be better, it could not be worse. I feel old enough not to try to kill myself if I face some problem."

Hung Liu is ambitious and always looking for new ways to grow and develop. But in the future she would like to slow down. "The speed is too high all the time. It could be because I'm getting recognized. But also I'm a very nervous person, probably always have been, and cannot relax. I think always about the next meeting. And if I'm not doing any serious thing in the studio I feel guilty. I feel I'm wasting my time. And so I want to shift gears, if possible, in the next ten years and to enjoy life. Maybe take a walk, even see some movies and read more books.

"I want to develop my own work more. I don't have detailed goals but I want to keep changing my work. Each show should be different. I have to keep challenging myself. Also I want to see my son get into a good college, become a serious person, with values, who has a career, not just a job. I want to see him become a very educated and thoughtful human being with a good sense of humanity and heart.

"Time moves on and more things will happen worldwide and nationwide. The gap between countries will be even smaller. It will be easier to travel back and forth from China and the United States and the United States and Europe. But I want to keep the old way of doing things. I'm an old fashioned person. Like the almost primitive way I do my paintings. I want to learn how to use the computer to do more things, too. I'm curious about the next ten years. The big picture, the politics, the economy and the whole world."

Pictured from left:
Cody Hammond, Mare Davis

Mare Davis, *WRITER*

MARE DAVIS IS a poet, an English professor, a lesbian and the mother of Cody, twenty-one, who has cerebral palsy. One of the first things out of her mouth is "I was my father's oldest son and my mother's oldest daughter." In her typically matter of fact manner, Mare has stated one of the basic truths about her life. She has had to do it all. She is the gracious, personable daughter of a Methodist minister, trained to be the perfect child. She is also the daughter of a woman who was depressed and hospitalized during parts of Mare's childhood, but who at the age of sixty, became what she truly was, an artist. While Mare's father encouraged her to be a writer, her mother showed her how *not* to follow her creative dreams. Throughout her life, Mare has fluctuated between these roles, the competent professional and the overwhelmed and isolated mother.

We sit in the miniature kitchen of her fourth floor apartment in downtown Portland that she shares with her girlfriend, Monica Shinn, who is a visual artist. It is quiet, except for the merry comments of her bird in the background. Mare smiles her big-toothed grin frequently during the interview. As we talk I feel her warmth reach out to me. She is pleased to be telling her story and leaves out nothing. I sense that she hopes to learn as much from this process as I do.

Born April 24, 1949 and brought up in a suburb of Cleveland, she is descended from Quakers who arrived in the New World with William Penn. She is the oldest of three children, but her brother died a couple of years ago, leaving just Mare and her sister.

Mare's identity as a writer springs from her relationship with her father. "He took me around with him as he worked and he talked with me about his work," she remembers. "He was very proud of me, liked to show me off. I did tricks. I was expected to be able to talk to adults, speak up, know people's names, all of that kind of thing. He gave me a lot of self-confidence in my ability to meet people, especially adults. By the time I was fourteen, when my father would introduce me to people, he would say, 'This is my daughter, she's going to be a writer.' He always took me very seriously. Probably caused me to take myself too seriously at too young an age."

Mare did become a writer, a poet. Her work echoes the tone of our conversation, an atmosphere of sadness and pathos. She writes about her life, but searches to discover what lies beyond and beneath the initial idea or memory. Her creative life also extends to teaching. She has a PhD in English Literature and at the time of the interview is teaching various literature and writing classes at University of Portland.

I am interested in talking to Mare because she is living a different kind of life. As she admits, she likes being different. "It was something built into my family and one of the things I'm most grateful for in my family. The idea that being different is good because it means that

we're better, more interesting. It was very good for me later on, when my son was born. When I was a kid it meant that I didn't feel that I had very much in common with other kids. I had friends but I didn't have any of those twin kind of friendships girls have. I felt different from other kids. And I liked it. I learned how to play with them, but that's not what I was interested in. I wanted to be grown up. I didn't want to be a child. I was outside a lot. In the first house we lived there was a woods behind the house. The woods were always and probably still are a real refuge for me. The place for me to go, when I needed to be safe."

"It was not safe in the house?" I ask.

"I think it was not. One of my recurring and almost symbolic images of childhood is of myself bursting out of the back door and running for the woods with a real explosive, 'I've gotta escape,' kind of feeling. And then when I got to the woods I was okay again. Most often by myself, by the way."

Her mother was overwhelmed as a mother and wife, Mare explains sadly and a little bit angrily. "She went into retreat a lot. Being a minister's wife is a job. It's like being the president's wife. People vote for the president but they get the wife, too. I think she was struggling with it a lot. She was really an artist but was trained as an occupational therapist. Her parents wanted her to have a way to support herself. She was very depressed and was hospitalized off and on while I was growing up. Her emotional health was always tenuous. We were given the impression that she was too sensitive and that gave her problems. And somehow that was tangled up in being an artist.

"At the age of about sixty she really started to do her art. She's in her seventies now and she lives a total life of an artist. But it took her a long time to get to that. And she's pretty angry about it. Almost feels like it's too late."

Conversely, her father *was* living out his creativity. "My dad is a writer really. He wrote a sermon every week. One of my childhood memories is the sound of the typewriter. Someone actively involved in writing. He consciously taught me how to write by talking to me about his sermons as he was working on them. After we sat in church and listened to the sermon he asked us questions about it, to quiz us on the main points and how they were put together. And then when I began to write in school he helped with that."

Mare started writing as a child because it was comforting for her and something she could do by herself. She "wrote poetry first, but other things, too. Little stories." Quite early, she was also aware of "being able to say things other people feel but can't say." She explains forcefully, "My writing is not at all like my father's. I push further than my father is willing to do."

Yet she confesses, "I don't like to do things if I'm not good at them. In fact, that's a real limitation of mine. It makes it hard for me to do new things. Because if I'm not good at it right away, I don't want to do it. And that's probably why I felt like I could write, because as soon as I started to write, I was good at it. And so it kept encouraging me in that direction."

Despite this early encouragement and support, by college Mare had stopped her personal writing. At nineteen, after one year of college, she dropped out and got married to a boy she had known since they were twelve. "By the time we were in our mid-twenties, I felt like it was time

for me to have a baby. So we tried to get pregnant and did. It was very deliberate. But everything that happened after that was pretty out of control."

In telling the story of this difficult time in her life, Mare doesn't hold back. Her emotions are on the surface, threatening to overflow. In spite of the problems, motherhood was something she had always wanted to experience and is very glad she did.

"In my family history there are a lot of pregnancy problems. I was born very early and so was my sister and my brother. And my sister had a premature baby. But Cody's disabilities are not because he was premature. Probably he has cerebral palsy because of a virus that I had when I was pregnant. I don't know that for sure. I always knew that I would just have one child, so there never was any reason to track down the sources of it. He was born very early and he was very small. We were living in Colorado very far from home and poor, with no car. It was pretty dismal. It was obvious pretty soon that Cody was going to need a lot of extra stuff and that we were going to need extra stuff. So we moved back to Ohio to be closer to our families."

A couple of years later, Mare's marriage to Ken broke up because she came out as a lesbian. Mare explains the situation very carefully. "After the first year, our marriage had always been non-monogamous. It was the late sixties and the early seventies and it was a politically correct marriage in that sense. So it wasn't just that one of us had an affair or something. My relationship with another woman would not have broken us up. It would have been fine with Ken just to go on as we had been. But I didn't want to do that. I wanted a new life. I wanted to really experience being with other women in a place where women lived

and there were no men. And so that was what really broke us up."

After the marriage ended Cody continued to live with Mare, although his father participated in Cody's care, too. Unmarried and on her own, Mare's life swung back in line with her father's creative model. "I hadn't written anything seriously since the kid stuff. But when I came out as a lesbian, I went back to school. I discovered how to write poetry then and turned myself into a poet.

"The woman I was in love with and living with was an English major. She helped me rediscover the part of myself that had always loved to read and talk about books and write. I went back to school as an English major, part-time at first and then full-time. Cody was actually a pretty good source of income then."

The system that surrounds disabilities is huge and convoluted. Parents of disabled children have to learn how to take advantage of all the services available. Mare chuckles ruefully, "Child as source of income. It's too bad I don't have him now. He's still a pretty good source of income. I could have gone on welfare, but because Cody is handicapped, he always got an SSI check. And so I was able to go back to school on grants, some loans, Cody's SSI and food stamps. And I worked part-time. I was able to put together a package that kind of worked."

I wonder how she was able to do all this while Cody was small. She tries to remember. "He was in a day program. But I think there again it was sort of put together. His dad helped out and Amy my lover helped out. I was working nights so the nights I worked he spent at her house, for instance. But by the time he went to school, I went to school when he went to school. I just fixed it so that I could fit my schedule into his

school. It placed certain limitations on me, but that's the way I did it."

Cerebral palsy affects muscle control and can affect intelligence. Cody uses a wheelchair to get around and needs constant help for his basic needs. He is highly verbal and retarded. "When he was young we just carried him or used a stroller. He didn't really have a wheelchair until he was about six. It's hard to understand him at first. But people who are around him all the time understand what he says. He is very sweet and pretty and interesting."

When talking about how she feels about Cody aside from the logistical problems, Mare's tone softens. "I've always appreciated Cody. I really like him. I like his differentness. And because Cody is so different, that's lucky. Other people's children sometimes seem boring to me because they are just going along on the regular way, pretty predictable. Cody was never predictable and that's always been part of our relationship in a really good way. I'm good at talking to him as a person."

Mare put enormous pressure on herself to be a good mother. "And to be a good mother to a child that had a lot of needs, who didn't sleep through the night, who even now doesn't sleep through the night, who needed help with everything, who couldn't do enough physically to amuse himself so he was even dependent on me for even just passing the time unless he was watching television. And of course there's a lot of pressure to not let him watch very much television. And there were times when his health was fragile."

What is a good mother? Mare answers adamantly, "I think a good mother is a mother who likes her kids, who's able to enjoy their company, appreciate and see them for the people they are. A good mother is able to satisfy her own adult needs in her own way with other adults and doesn't depend on her kids for intimacy or support or understanding. In other words, a good mother has her own things going on in her own life."

Mare speaks fondly about those early years just after the divorce, when she was living alone with Cody. "There was a time when I really felt like I was living my life as an artist. Cody was maybe three or four and we lived in a little house. My girlfriend Amy lived up the road and we traveled and visited back and forth daily. She was a writer and her roommate was a musician and a writer and our friends were reading and writing and making music. Things with Cody were very loose. He was sometimes with me and sometimes up the road and sometimes just hanging out with everybody. And sometimes he was with his dad. I liked that kind of patchwork life. That's really the life I continue to envision for myself."

During those years Cody became a source of creativity for Mare. "He gave me something to write about. And there is that funny way in which he provided a kind of freedom and financial support. I had my job as a mother, which freed me from other things. I don't know why I think that because I was also going to school and working part-time. That's probably one of the reasons I wrote poetry. Poetry was something that I would carry around in my head for a long time and work on while I was doing other things. Then when Cody went to bed I could write it. I didn't do prose because I was never able to give it the sustained effort that it takes. The poem seemed manageable in my patchwork lifestyle where I had to jam it in around the edges of other things."

Nurturing herself during those early years was haphazard. She

scoffs at the question. "I smoked pot and drank too much, probably." Mare pauses and says sincerely, "I do think that is probably what I did. I've always had a real need to be by myself and I was able to continue that one way or another. Going for walks helps me out a lot. And that is something I would do with Cody. I could put him in the stroller and just walk and not even necessarily be talking with him or interacting with him but both of us sort of just rolling along.

"I think my school and my work was one of the ways I nurtured myself. It was a way for me to be alone, to have something that was just mine. Especially later on after I broke up with Amy and was living with Karen, who was very abusive. She wanted to control me and my relationship with Cody. I was pulled in different directions, between what I needed to do to be a good mother and her demands for my relationship with her. So that was very hard."

The conflict between motherhood and selfhood is an ongoing theme in Mare's life, compounded by a child who needs more than most children. I ask her to speak more about support. Her anger is apparent as she spits out the answer, "My immediate response is 'nothing.' I know that's not true, but I want to tell you that's my immediate response. Whatever help and support I got with Cody was so small compared with what I needed, it felt like nothing.

"For instance, I spent a year at Yale in graduate school. I got a fellowship that paid for me to go wherever I wanted to go to study. So I decided to go to Yale. It was a disaster. In some ways, the people around me actively worked against my trying to be a mother. To the point where finally I couldn't do it anymore. I have to say that's how I feel it was. My grandparents gave me some money for extra babysitting.

But the help I got was so insignificant compared to what I needed, I don't feel like I got very much.

"My mother is the one who has given me the most consistent help. She has been a good grandmother for him. When we lived in New Haven he spent a couple of hours with her after school every day and they did projects and crafts together. And in the days when I traveled four or five times a year to Boston to visit Cody at school, my mother almost always went along. The trips were often very difficult emotionally and the three of us shared all of it, the fun, the work and the terrible sadness at the end. But I think I didn't have nearly enough support. And at the times when I really needed it bad, I didn't get it."

After leaving Yale, Mare went back to Kent State in Ohio, where she had been living before. "I knew I could do it there because I had already done it there. I got a lot of support there for myself. I might have left Yale anyway. But I would have liked to make the choice."

The support she has gotten as a writer came from individual women, her former lover Amy, her teachers, and the women's and poetry communities in Kent. "There were always places I could go to read and places where I could get things published just by telling somebody I had a piece. It spoiled me to death. I didn't really have to push myself. But it was good support for my work. I got a lot of recognition. I was famous in a small place and that really suited me. Then later on, Monica. From the start, that was definitely an important part of our friendship. We wrote together. We wrote a play that was produced by a women's theater group. That was before she was a visual artist."

When Cody was nine Mare's life changed abruptly. Stretched to

the limit emotionally and physically by the demands of her life, she snapped. When Ken decided to go to China for an extended amount of time, Mare pleaded, "You can't. I'm on the edge. I won't be able to make it. I need somebody around whose job it is to help with this child, not somebody I can call up and ask for a favor." Ken went to China anyway. Mare realized that just saying she couldn't handle Cody anymore didn't mean a thing if she continued to do it. "Finally I was pretty desperate and I stopped doing it. Cody went to visit Ken at Christmas and I said, 'Don't bring him back. I can't do it.' He said, 'Okay I get it. I'll help out, but in order to help out I want you to give me custody. Because if Cody's going to be over here, he's going to have to be in a different school system and in order to do that I have to have custody.' So I gave up custody. It was all pretty horrifying."

Mare further explains the situation. "I was also at a point in my relationship with Karen that was totally out of control. I realize looking back on it, that was one of the reasons I had to get Cody out of there. I had tried to leave, myself, a number of times and hadn't been able to. I feel glad now that I was able to get Cody out of it, even though what it took to do that was so horrible. It was the worst thing I've ever gone through in my life. I'm not over it yet. I will never be over it."

She goes on. "Ken announced that he was going to move to Boston and was taking Cody with him. We had made a verbal agreement that he wouldn't move, but there was nothing I could say. I had given up custody. So Ken moved to Boston and immediately found the perfect living and school arrangement for Cody. Cody lives at school and goes home on the weekends. If I had had that kind of option available to me, I would have been able to keep him. It makes me very angry that the resources were not available to me. The end result was I couldn't do it."

Throughout this narrative, Mare's voice has been strained, angry and outraged. She had wanted to be a good mother for Cody, yet felt thwarted at every turn. She speaks sadly of her regrets. "I have been a terrible mother because I was such a mess, so unhappy, so out of control, in so much pain. And I'm not even talking about after he left. I'm talking about before that. I wasn't centered. I didn't have any control over myself or my life, or anything. He was subjected to all that chaos. I'm sorry about that part." Pause and a smile. "But somehow it all worked out all right."

I ask her about what she hopes Cody will learn from her. She is strong and immediate in her response. "I want him to learn that things can always change. You never know what you may do next year. In fact, that's really important for him right now because he's going into a different, more adult living environment and he's beginning to have to get realistic about what that means. I want to remind him that just because he can't do it right now, doesn't mean that he'll never get to do it. He needs to think that anything could be a possibility."

Mare has learned as much from Cody. "Cody's pleasure and Cody's joy come from the people around him which is good for me to see. In my life, my joy and pleasure has basically come from myself. It's good for me to have the reminder that you can get that from other people. Cody is always reaching out to other people. People that I would not make a part of my life at all have become a part of my life because of Cody. He doesn't read, so he's good at reminding me that not every-

body has to read to survive in this world.

"Some days we take pictures together. He's very interested in that. He wants to take pictures himself and I'm helping him make a book. When we travel we take pictures and then tell the stories. But it's more the lifestyle that affects him than the art itself. I don't know if he thinks I'm different from other people's mothers. That might be sort of sophisticated thinking. I'm just me to him. He doesn't think about much beyond that."

How has her world view been affected by Cody? "It's probably made me more aware of other people's pain. Especially other women's pain. All the possible pain that can be associated with having a child is much more real to me. There have been very real things that have happened that I've had to deal with. They deepened my feeling that the world is a very hard place, a place of separations and sadness."

My question about choosing one's art over one's child has special poignancy here. Mare did choose herself over Cody once. "I did do that," she admits. "That's the decision that I made. I left my role as a mother in order to be myself and part of that was definitely my work, my writing. I'm glad I did it. Having been through the worst part of it I know it was good for everyone in the long run."

She brings it full circle. "I can't help but think how my life would have been different if my mother had made different choices about her art. I wish she had. She left us every day, even if she was just going into her room and shutting the door. And sometimes she left us for more extended periods of time when she went into the hospital. I'm not sure if she was very present for us even when she was around. My mother has what's probably a chemical imbalance which causes her to be manic depressive. So if I had had a choice, I might have said, leave us, do your art. In a sense we were kind of taking care of ourselves anyway. I feel pretty strongly about that. I'm not sure she did us any favors by sacrificing her art."

Mare is proud of where she is now. "I did make it through and changed my life around. I don't even want to say it was that bad. It just wasn't right. And I figured out how to make it right, eventually. I'm forty-four years old now and I can finally say I'm a happy person. But I really had to figure out how to do it. When I was a kid, everybody was saying to me, 'You can be anything. You can do anything, you're talented, you're brilliant, you're successful.' And none of that made as much difference to me as what I saw when I looked at my mother. When it comes right down to it, I would want to be the kind of mother who would show my daughters especially, that you can live a productive and creative and happy life and that that's okay. In fact, that's the goal. I work at it now with the young women I have in my classes. We don't have to be mothers to do that for kids."

Where does she want to be in five or ten years? "I really want to live my life as an artist. Rather than being a teacher who writes on the side, I want to organize my life around my writing. That's very exciting to me. Both in terms of what that means on a day to day basis and what it means in the larger sense.

"In 1980 I published my own book of poems and I enjoyed choosing the paper and the type, overseeing the printing, etc. I also like having control over my own audience, instead of being dependent on a publisher to create an audience. In the next years I'd like to learn more about printing and I'd like to combine words with visual images."

Mare shifts back into the present and briskly explains her plans for the near future. Her relationship with Cody is about to drastically change. Ken recently got a job in New Mexico and asked Mare to take over primary care for Cody. Monica and Mare are planning to move to the East Coast to be near him. Though they have chosen to do that, it is with mixed feelings. "If it were up to us, we would stay here. It's hard to move back there. But we feel like there are also going to be advantages. Right now, it's true we have freedom from the mothering stuff an awful lot of the time. But when Cody is here all summer, it's hard for me to do very much else. If I'm working at my job and I have Cody, that's it."

"I'm looking ahead to take over Cody's primary care again for the first time in over ten years but it scares me to death. I can't imagine how I can do it and still have a creative life. Even though many things are different now, I don't *feel* it differently. I have lots of plans and ideas and yet there's that voice in my head that says, 'get real.'"

Since Mare's life is in transition I arrange for a second meeting in September 1994, almost a year after the first, in Providence, Rhode Island. It will also be an opportunity for Chris Eagon to photograph Mare and Cody together. When they pick us up at the train station, it is only a few days after Mare and Monica have settled into their new apartment. We drive to Cody's school an hour away in Canton, Massachusetts and Chris takes photographs. After dinner back in Providence, Mare and I meet again in the kitchen of their apartment and she tells me what has happened since their move.

Things are not as they had hoped. Mare is clearly frustrated with the system. Not only has Cody's money for personal care attendants been held up, the responsibility for hiring and managing those attendants has fallen on her and Monica's shoulders, a situation they didn't want.

They decided to hire Monica as Cody's attendant. She has fifteen years of experience working for people with developmental disabilities. "You know, they won't pay me to do his personal care," Mare says. "But they will pay Monica. Technically she's not a member of his family. And so we intend to take advantage of that. I do think that we might be able to make it work. Because if we were going to be taking on this responsibility and anxiousness of it . . . the 'Gee, it's five o'clock on Friday, did somebody pick Cody up? Or it's the middle of the afternoon on Saturday, is he okay? Maybe there's a shift change, did the person show up? Was that person who came in drunk last week, are they going to be okay this week?'"

Does she feel like it was her turn after twelve years? "In some ways I don't think it was my turn because that implies that I wasn't doing my part before and that's not true. Cody has always spent a lot of time with me. With Ken's arrangement having Cody at school during the week and at home on the weekends, I don't think there is much difference between what I was doing and what he was doing in terms of time and commitment.

"But on other levels I felt like it *was* my turn. I did not feel like I could say no. There have been other times when I haven't been there for him. And this time I just couldn't say no. I don't know what Ken would have done if I had said, 'I understand that you want to take a job somewhere else, but I just can't leave Portland. I have a job here, I

have a life here.' And he doesn't even need to think about what he would have done, because I said yes."

What would be the ideal scenario? Mare answers quickly. "Monica and I would like to have a studio together. I would have a work space at the studio for my projects. I could take a class if I wanted to. I would have time to write. Monica will be working with Cody on the weekends. I might go up on Saturday afternoons and have dinner with them, stay overnight and come back Sunday. And that would give me time on the weekend to myself and I could work."

Unlike most kids, Cody is not going to grow up and move away. He will need a lot of care the rest of his life. But there is the potential of partial independence and that is what Mare and Monica are working toward. "It's a matter of degree. There are certainly people like Cody who have their own independent lives. They live in group homes or in independent living. And their parents visit and see them and they have basically adult lives. That is a possibility but there just aren't the services, enough places in group homes or enough independent living centers to make that happen."

Housing arrangements aside, she feels good about being here. "I'm getting along great with Cody. We always do." Mare's eyes sparkle as she remembers. "I realized this summer that I was a football mother. You know Cody is a sports person, a jock. And for the last seven or eight years, while we are at my mother's, the high school football camp goes on. So we started going to watch the practices. And then one year the coach took an interest in Cody and gave him a t-shirt. So we wrote a letter to the paper to thank the high school football team for being so nice to Cody. And Cody's picture was in the paper."

This past summer Cody decided he wanted to be assistant coach for the football team. Curious, Mare asked Cody what it meant to be the assistant coach. "It turned out that it basically meant going to the practices, going in the locker room, sitting on the side lines with the team, wearing the uniform shirt and blowing his whistle and just being a part of things. Cody is a total team person. He likes to be a part of a team. Or families, if you want to put it that way. And as he began to talk about it I began to realize, on those terms, maybe he *could* be an assistant. So I helped him write a letter to the coach in which he said what his experience is and listed the kinds of things that he could do for the team. And the next time we went down to the field we gave this letter to the coach.

"And the coach responded completely. He called Cody over, gave him a team shirt, a hat, an official whistle and he said, 'you're my assistant coach.' The next day he announced it to the team. He really did a wonderful job. And he made sure Cody was there at practices. Basically, Cody and the team handled it. If practice shifted from one part of the field to the other, one of the players would be given the job to push Cody over there. Cody was part of the picture taking for the year book. He went to scrimmages. He went down every morning for the practice. And it was hot, so he was really working. He took it seriously." She smiles again, and says in amazement, "I never thought I would be a football mother."

Since the move, Mare hasn't done any writing. But she is inspired by her experience as a football mother. "I would like to write about that, and use it as a way to write about Cody. About how important it is for him to be on the team, even though he's never really going to

play football. I want to figure out for myself what it means."

She is in a new chapter of her life, for which she is thankful. "I am getting a second chance. That's probably the main reason why I couldn't say no. There really wasn't any question about it. Cody still needs my care. And he always will. For somebody else, who has a normal child who moved away for twelve years, it would be too late. But in my case, it's not too late. He doesn't need me in the same way he did when he was nine. But there are certain things that he needs from me still, that are really very basic childcare kinds of things.

"This next stage of my life has to do with figuring out how to have a life with him in it. I wasn't very successful before. I didn't have the support for one thing. Now, in my best moments, I feel like I do have that support around me now. I have Monica now, to help. And she helps in all kinds of ways. There is no doubt in my mind that whatever is going on, I have to figure out a way to have a happy, productive life and have Cody be part of it.

"He loves having me here. He says he doesn't miss his dad. He must. But it obviously means a lot to him for me to be here. He doesn't say, 'Gee mom, I really appreciate the fact that you threw away your entire life to come here and be here for me.' But it sure is obvious to me. One time I was talking with him on the phone soon after his dad had gotten the job in New Mexico. I said, 'Well, how do you feel about this? Your dad is moving.' He said, 'I'm going to miss him , . . but I get you.'" She pauses and in the golden glow of the lamp, we look at each other. "He got me," she continues, her smile deepening. "And that's what he wanted, that's what he's always wanted. And he's doing great. He likes it. And that's what it's about, that's why I'm here."

Chapter Five: Inspired

These women really wanted to become mothers. There are no accidents here. They are very serious about their motherhood, love being mothers and gush when they talk about their children. As a group they are soft but strong. I think of the image of water. It gives, surrounds and slowly wears away the hardest rock.

This is the only group who even entertained the notion of giving up their art. Adriene Cruz gave up her crocheting for a year or so, before deciding that she didn't have to and ventured into quiltmaking. Susan Harlan assumed she would have to stop painting and was pleasantly surprised that she could continue with her work. Chana Bloch's poetry slowed down to almost nothing during the early years of her sons' lives causing her to question her identity as a poet.

Though many other women in this book have used motherhood to expand their art and worlds, this group focuses on it. I am reminded of how motherhood is really a spiritual practice—a daily series of tasks we must do no matter what. Our egos scream to do what *we* want. Our exhausted and angry bodies balk at having to get up at night once more to coax a restless child back to sleep. The urgency of a young child's needs forces our own needs to quiet down, wait and possibly even change. Taking care of a toddler is a matter of life and death. We need to be in the present, awake and full of care, even though we would rather think our own thoughts.

Chana learned to treat *herself* more gently and took the opportunity to heal her own childhood by creating healthy ones for her sons. Adriene sees her children as extensions of her artwork, requiring her to come up with more and more creative solutions. Susan's artwork expanded to include handmade books, that most intimate of art forms, so that her son, Jordan, could read them. Each of these women embrace motherhood fully, learn its lessons gratefully and look forward to the continuing adventure.

Pictured from left: Tasnim Dunham, Adriene Cruz, Ola Dunham

Adriene Cruz, *FIBER ARTIST*

WALKING INTO ADRIENE Cruz's house I feel I have entered a sanctuary. Every surface is covered with richly colored fabrics and enigmatic objects. And overlaying the whole environment is the soft scent of incense. Adriene herself is dressed in layers and layers of brightly colored and lively fabrics that dance gaily when she moves. Her large and magnetic eyes are framed by even more fabric that is wound round and round her head. Her artwork is much the same. Using African fabrics and painted canvas arranged in patterns and shapes she creates vibrant wall hangings that evoke emotions and shake with energy. Where does one part of her life leave off and the other begin? Nowhere. Her art, her spirituality, her home and her family are totally entwined.

But as she leads me up the narrow stairs to the attic it becomes clear that I am getting closer and closer to at least one source of her inspiration: The Studio. It is only a year old so she is still excited about having her own space away from the daily household. "Mine, mine, mine!," she gloats jokingly. "But the children love it and they come up here and perform. I just have a couple of rules, like whatever they bring out, they have to clean up and they are to stay out of my work area. Sometimes the iron is on. I don't want to have to put away my blade. I say to them, 'You are in my area and you are welcome as long as you respect what's going on here. You can play, or whatever, but it all has to be done in a loving manner, because that's what's going on up here.' My daughter Tasnim likes to do her homework up here because the energy is settled. There's no TV up here, only music."

We are sitting on a fabric covered bench in what she calls her "head space" an alcove away from her work table. "It is the area where all the mental activity takes place," she says grinning, "where I can practice yoga and sit, read, be still. I also need a place to have an altar for deceased family members, the ones who went on before me, for the symbols and things that I need to balance and stay focused. Just surrounding myself with the things I needed to nurture myself to create."

Adriene was born December 16, 1953 and spent her early childhood in Harlem. Her parents separated when she was four years old and her mother raised Adriene and her older sister Leslie alone. Her mother worked as a secretary and her father worked in a General Motors parts factory for much of his life. At age eleven, Adriene moved with her sister and mother out of Harlem and the projects to Washington Heights, which she hated. She preferred the cultural richness of Harlem with blacks from all over the world.

When asked how many children she has, Adriene answers, "I gave birth to three, but I have two." Her two daughters are Tasnim, nine and Ola, five. Her son Kumalo, Ola's twin, was still-born and remains a spiritual member of the family. She lives in Portland, Oregon with her husband Larry Dunham and their daughters.

Adriene's parents were born and raised in Harlem, but both of her maternal grandparents came from Jamaica. Her paternal grandfather was Puerto Rican and her paternal grandmother also has Caribbean and South American roots. "As a result," Adriene says, "I grew up with a sense of 'in, but not of' this country."

She draws strongly upon her African heritage for artistic inspiration. I ask if she knows any more about that part of her background. "Oh, how I wish I did!" she exclaims, eyes brightening. "It feels very much like being an orphan. What happens very often with black families is that they will focus on the lineage that does *not* come from Africa. They can tell you about the Indian this or the French that, but when it comes to the African part, either they don't remember, or they don't want to talk about it. So that doesn't get passed on. I do remember hearing stories about my great-grandmother marrying an African prince and I feel a strong connection to the Yoruba of Nigeria."

Adriene's interest in her cultural heritage was encouraged by her mother. "I was rewarded with affection when I expressed myself in ways that related to an African or Caribbean influence. She enjoyed seeing a carry over of the culture." Her mother also helped develop Adriene's visual acuity and sense of color. "If we were outside or even just looking out the window, she would pick out people and what they were wearing or how they put their colors together or certain patterns and say, 'That looks Jamaican.' If we were on the subway or something and she heard someone else speaking and it was clear that they were from 'The Island,' she would nudge us, 'Listen now, LISTEN.' Because that's the environment she grew up in, it was music to her ears. She wanted us to experience it, too. So even now, if I hear someone from any Caribbean island, it doesn't have to be Jamaica, I feel a kinship."

"Is she still alive?" I ask.

Adriene answers emphatically, "Yes, yes, she's alive. She lives in New York still and we are very good friends. I think the love bond between us is so strong that we've been able to get over some major hurdles. She's very strong. Her mother died when she was seventeen. She didn't have the best relationship with her sisters or her mother, so she didn't have a family support system. She didn't know how to lean on anyone or accept support. And with having to raise two children by herself and the job she had and so forth, she was not a fun person. The nickname for her when we were younger was 'The Dragon Lady.' If she was here now, she would laugh at that.

"The worst thing in the world for my mother was to be seen as poor. I remember she would say to us, 'You don't want to wear that, the button is missing. You don't want people to think you're poor.' She's excellent with money. This woman could take next to nothing and go forever with it.

"My mother and my aunts would talk about the difficulty they had when the war was going on. They went to school with holes in their shoes and would change the paper when the old paper wore out. My grandmother made all of their clothes so their clothes were fine. From the few pictures I've seen, they did not look poor."

As a child, Adriene was quiet, almost reclusive. I ask what her favorite thing to do as a child was. "DAYDREAM!" she shouts. "We were inside and alone most of the time because my mother worked. The name for us now is latch key kids. I used to hang out underneath the beds or under the table in the kitchen and in the closets. One of

them had a bamboo shade in front. I liked being inside on the shelf and looking through the spaces of the bamboo. I also liked to draw. My mother would bring home supplies from work. Multicolored telephone wire, red and blue pencils and typing paper. Those were my art supplies for years. I loved to dance and play on the swings, it felt so free. But I didn't really make friends well."

Though very close since their mid-twenties, Adriene and her older sister did not get along as children. "She didn't like me then," Adriene says. "So I thought that nobody else liked me either. I wasn't comfortable around people because I thought I was offensive. As a result I developed ways to make things beautiful."

Both girls went to Catholic school, though not Catholic, because the schools in Harlem were not very good and their father had gone to Catholic school. "I wasn't even baptized until I was five years old so I could go to St. Aloysius school in September. The nuns were black so there was a strong community sense there. After school we would go to the convent. The best part about that was the walk from the school to the convent because we had to go along two main streets of Harlem where everything was happening. It was powerful energy out there.

"There were certain principles and images that stayed with me, even though I'm not a Catholic. Like my fascination with altars and the idea of guardian angels, which I now feel are ancestors. I really do feel we have protectors, those who have gone on before us who watch and open doors for us as long as we stay on the right path. And as long as you do what you're supposed to do, things will open up for you to continue. When you step off, that's when you find problems."

Her eyes flash as she adds, "But there were so many lies. They taught us that Catholicism *was* religion and there was nothing else. I was really surprised to find that there were beliefs and opinions other than those of Catholics."

As children Adriene and her sister made art from whatever was around. "We made wire sculpture and earrings from the telephone wire. And we'd make little clothes for dolls. And when I was eight I remember piecing together a blouse from different fabrics. I was very proud of this thing, you know. I tried to make sure my stitches weren't too far apart and all that. When I put it on to show it to my mother she fell out laughing. I understand now that she was laughing because she was tickled by the whole thing, but I was devastated. I didn't try to do anything with fabric again until my first daughter was a year old."

The art education she received in school was limited. Adriene remembers those years with a mixture of anger and amusement, "I remember a woman coming in. I believe she was French. Art class was passing out little cards of like 'The Blue Boy,' by Gainsborough and other European classical art pieces. I do remember doing some coloring once in class. I remember being concerned about what grade I got for art. And once when I did get a low grade, I was horrified. 'Look at what they gave me for art class. Don't they know who I am?' I was insulted. So my mother spoke to the nuns about it.

"After we moved uptown I went to junior high school where you could major in art. But the way to get into that program was to be tested. Now since I didn't have any formal art training, I didn't know what they were looking for in this test. I followed whatever instructions they gave us, assuming I would get in. I did not get in the first time. The second time around I realized they were looking for something

specific, as opposed to what I was feeling. I did the test according to what I felt they were looking for. And then I got in. I don't know how. It must have been those guardian angels.

"My art teacher there didn't pay much attention to me. In fact I annoyed her because I made my people too pretty. Then I noticed that there were certain white students that she was pulling aside who were working on portfolios. I'd never heard of a portfolio before. And I heard something about testing for Art and Design, one of the specialized high schools in New York. So I told my mother about it and she called the school and got the information about the testing dates. My own art teacher did not give this to me.

"We had to be tested and also bring in a portfolio. I did not have a physical portfolio, much less anything to put in it. So I did just a bunch of drawings and got two pieces of oak tag and taped that up together for the portfolio. I went and tested at Art and Design which I knew I just had to get into because they would see that I was an artist. As it turned out, I was not accepted and I was totally crushed. I stopped going to school. If I wasn't going to this art school I didn't understand why I should go to school at all.

"Then one day I moseyed into school around midday and the students told me one of the deans was looking for me. I was scared to death because I hadn't been coming to class. The dean said Art and Design had called and needed to know if I was going to accept the position that was open in the school. It turned out that there was a standby list and I was on it. I started going to class again.

"Art and Design was a great school. Those teachers were all artists and they loved us. They saw us as their children coming in behind them to continue what they had started. Just a wonderful experience. Nobody wanted to graduate. In fact, I've never loved school like that before or since.

"In my senior year, Mr. Tatti my sculpture teacher was very concerned about what I was going to be doing after graduation. Of course, I had no idea. Next thing I know, he's telling me about some sort of scholarship at the School of Visual Arts in New York and that I should go check it out. I got a full scholarship to this school. Again, I was floating around in there, unfocused. Not sure of who I was or what I was doing. But I did get the degree. Again, it's the guardian angels and the ancestors. I have to believe in them."

She pauses and reflects on her educational experience. "I'm very afraid of this unfocused energy with my children because I don't want them to be like me with school. I didn't remember anything. I was not mentally there. One day in second grade I tuned in and everybody in the class knew how to tell time. I was in another space totally and all of school seems to be that way. I don't know how I got by. My mother didn't check for homework. I don't know if it was because they had so many children in those classrooms or since I didn't cause any trouble they just pushed me through or what."

Adriene laughs ruefully. "I knew how to spell because at St. Aloysius we would get beatings. If you misspelled your word, it was spelled out on your hand three times. I think that happened to me once. I could spell after that. Good thing they didn't beat us for math because I wouldn't have any skin left. I had a series of math tutors and they checked my eyes because I would redesign the numbers. I just saw them as design so I would add on to them and change them around."

Motherhood, on the other hand, was a long time coming for Adriene. "I'd always thought that I did not want children. I thought if a person had a choice who, with any sanity, would choose to have children. All I saw was struggle and hardship and sacrifice. But I did want to be a grandmother—took me the longest time to realize I had to be a mother first!

"Well just last year I had a revelation about that. I remembered in school whenever they would go around the room and ask 'What do you want to be when you grow up?' I would raise my hand and say 'artist,' but in my mind I was thinking. 'When my children are asked what their parents do, I want them to say their mother was an artist.' So somewhere in there I wanted children although I resisted."

In fact, Adriene and her husband were married for fourteen years before their first child was born. "I just didn't see children as part of my life. And so it was such a pleasure to find out all the things I didn't know. Yes there's sacrifice and yes there's all the responsibilities, but I didn't know they could be so much fun. I didn't realize how much love there was, how much growing in all kinds of ways. I wouldn't change it for anything. It's the best thing I could have done."

The decision to have children first grew out of her relationship with her sister's daughter. "She was having some problems so I would keep my niece maybe three or four days at a time. I just loved her. In fact when we first came out here to Portland to visit to see if we would move, Lelani, who was three at the time, came with us. And there was a possibility that she would make the move with us. But we decided against it. So I had that experience of a child being around. And then with the people we made friends with here, I found myself hanging out with the kids. My heart turned over that I wanted children.

"I also realized that I was supposed to have them because I collect a lot of things. I remember one time looking at all the family photographs and things I had and thinking, 'Who are we saving these for?' And then I thought of myself older and I said, 'Adriene, if you don't have children you're going to be sitting in your little rocking chair going over your life and you're going to be real sorry you didn't have any children.' So it was almost like a discipline thing. Then Tasnim came.

"And then I thought, okay, I have the one child, this will be fine. We don't need anymore. But after about a year, I felt like I needed some help. 'I'm not going to be her sole source of entertainment for the rest of my days. I don't think so. We'll have to have at least one more.' It was exactly three and a half years later that Ola was born. We did lose her brother, and that was very difficult. It still is at times, especially around their birthday."

Adriene is a master at blending the different aspects of her life. Her spirituality is deeply connected to her artwork in the same way her mothering is an extension of her art. But the transition from being an artist first to being both an artist and a mother was not quick. The work she had done before children required focused attention. "I was the tapestry crochet queen! I used to do very intricate, detailed, many-colored coats and sweaters, with tremendous speed. I could have a sweater or coat done in a week. I was just pumping it out. Enjoying it. In fact that was my social life. If I went out I had my work with me. I used to think, 'Adriene, when you do have a child, no problem, because you're home. You won't have to find someone to take care of her.'

"I went through major adjustments after my daughter was born. I wasn't really able to work anymore. I could be watching TV, she'd be fine playing. I could read a book, she'd be fine. But let me pick up that crochet hook, she would go into fits. In fact, throughout the last piece I made I was in tears, because I was frustrated. I knew that this was going to be the last thing I was going to make for a really long time. The work that gave me so much pleasure and peace was not there for me anymore. I did write about my work for publication but I wasn't able to do the actual work. It was a very difficult time.

"By the time Ola was born I was hardly doing anything at all. Everything had come to a screeching halt. And it was frustrating because people would call me for work and I wasn't able to deliver. Soon I got sick of hearing myself say, 'Oh yeah, I did that before but I can't now.' I was disgusted I wasn't working, I was disgusted with my whining. Get a life, Adriene. Do something! At the end of 1991, I took the quilting class and things have changed for the better."

For Adriene, the easiest part about being a mother is the loving. "I love holding them and squeezing them up and telling them how much I love them. We do a lot of that. I like making things for them which they read as love. I love sharing family stories with them or just sharing what I've learned about handling emotions and adjusting to situations.

"The only problem is what I call the selfish times when I'm working and I don't want to be bothered. I can never just shut down and peacefully leave the work. I feel like a bad mother. Like I'm not doing what I should. I'm not being nurturing enough. I just pull out the whip and do the Catholic thing. Beat myself up."

Her usually loud voice mellows. "We're so responsible for these little people. Wanting them to come up well adjusted so that there aren't big holes. I would like for them to feel that they could talk to me about anything. If I snap at them because I'm wrapped up in something else, this may carry over to, 'Oh, she's not going to listen, she's wrapped up in whatever.' And there's going to be a time when I really want them to talk to me and they might decide not to based on the times when I wasn't open to them. So I'm real concerned about that."

Adriene has used daycare very little. Her older daughter Tasnim was in Headstart for two years. But when they couldn't get Ola in the program they wanted, Adriene decided to keep her home. "I knew she was going to be the last child so I wanted to spend this time with her even though I still wanted to work. These are special years. It's a real luxury to be home as a child, create your own spaces, be with your mommy. I didn't really want to put my kids away. My mother wasn't around so to me the luxury is to have a mother who is there. Even though you might not be a thousand percent happy about it all the time, I think in the long run there are benefits."

She has also had the support of a community. "When my oldest was five or six months old, a friend let her teenage daughter stay with me for the summer. She knew more about babies than I did. So I was really glad to have her around. We still have a very good relationship with her. I can talk to friends who are mothers and whose children are older. And they let me know that I'm doing okay or what I need to work on. If I say I need help, I will get help."

But she would like more family around. She misses the day to day contact she could have if she lived near her parents. "I'll call up my sister and my father's at her house or my mother's at her house. Her chil-

dren are with cousins, that sort of thing. When my mother's here, we can do the grandmother thing and she does come a lot and stays three weeks at a time."

Support for her as an artist has expanded in the last year and a half. For the first time she feels like she belongs to an art community and she credits her children for that. "I was always a loner. All through school I didn't really connect with anyone else as an artist. When I was out of school and married I was still a loner. Having children was the best thing. They forced me to come out and see what's happening outside of my own little space."

She has connected with an international art community of African American and Brazilian American artists through participating in an artists conference in Brazil called 'Bridge to Bahia.' "They asked me to speak, me!" Adriene squeaks. "It was an exchange between ninety-five African American and African Brazilian artists. There was really a very common heartbeat going on there. An exchange between African descendants brought to the Americas keeping our ancestors alive through our creativity. There is a certain type of art wanting to come out that relates to where we've been, where our ancestors have been and what they've done. That really is the core of my work and this seems to be the core for almost all the other artists that I met. With all the hardships and horrors that our ancestors had to go through, look at what is still surviving. There is definitely a sense of community."

At home in Portland she surrounds herself with strong supportive friends. "Charlotte Lewis is here and we did an exhibit together. We were working on our separate projects while in the same space but you could feel the relatedness between the work. And then my friend

Roslyn Hill has a gallery which is within walking distance. And Valerie Maynard has been a real source of inspiration and strength. We met in 1992 and she's become a very powerful influence in getting me connected to the artists' community I mentioned. And it's great, I never thought I'd like being part of a group. It's nice being a part of something and finding out that things that you thought were unusual or unique or different are part of a community feeling. I feel a strength in my work that I might not have felt if I didn't know about the energy of these other artists."

It is significant that Adriene chose to adapt her work to her new life as a mother rather than the other way around. "The quilting is something that I began after my family was started. I work around the family. Now I'm a mother first and an artist second whereas before I was an artist first. I had to change a real selfish part of myself who was used to just having time and space to do as I pleased for years. I was spoiled rotten."

I'm intrigued. "I want to ask about being a mother first and an artist second and arranging your work around your children. How do you do that? What goes on in your mind?"

"It's the time thing again," Adriene explains. "I can work on something that's already started with them around. But I cannot start a project. So if I'm going to start something I have to think about what time block I'm going to use. Because I'm doing cooking and laundry and all those little things. Before I had the children, I could start working about 10:00 a.m. and stay on it until 3:00 or 4:00 in the morning no problem. And of course you can't do that with a baby. It seemed like no matter when I went to bed I was still tired the next day. I didn't

find out I was severely anemic until the next pregnancy.

"But now if I have a lot of work to do I'm out of the bed at six. I need to get started on something before I have to deal with my family. So my day has been started in my own space in my own way. And then they come into it. I find that I am in a really bad mood if I feel like my day has been taken, if it started before I was ready. I get over-whelmed and wonder, 'When am I going to be able to get upstairs to me?'"

Adriene has used motherhood as a way to grow, become less self-centered and take new risks. And she is amazed. "Because of them I learned how to sew and I learned how to drive a car. I've had to step out of myself and meet people and socialize. I've been very surprised to find that I can do that and have fun. I have friends here in this Portland life who know me fairly well and they cannot imagine me at all the person I said I was as a child and young adult, withdrawn and being afraid to speak. I tell them that's the best compliment that they could give me. And I could say that's the children.

"Children force you to see what it is you are teaching them. And what you teach them is not what you tell them, it's what you show them. I'm learning to act out what I say I want. They push me from thought to action. A thing can't just be said, it must be done. I was afraid to have children because I didn't think I could be a good mother, but they think I'm the best mom a child could have, so that's what I am."

Being a mother has also altered her world view. "Again, I've had to pull out of myself because you have to think of the children and what they're going to have to deal with. I've been forced to think beyond me and my own little world, environmental stuff I might not have thought about as much. What planet are they going to have, what's going to be left? What are we doing to make a difference? I didn't have a world view. Let's put it that way. They gave me one. I wouldn't have felt responsible for making changes before."

Adriene's purpose for making art and her view of it in the world have changed, too. "Before the children my reason was just that I need-ed to create. Art was my voice and personal expression. And now it has to be beyond just art and the pleasure of making it. My children are watching me thinking, 'What is so important about this that you can-not go on a walk with me?' My work has to be a substantial thing so they will see it as worthwhile. I'm aware now that people are affected by the work. I never thought of an 'other' before. It was just getting it out. Now I'm in touch with the work having a life after it's out."

She chuckles as she confesses, "I need to make money from it. I'm working on developing a business sense, so there's a life beyond the cre-ation. Like a paycheck. And again that's so that it has some purpose for them."

Balance is important to Adriene and something she is constantly seeking to achieve. She gestures toward a fabric piece hanging on the wall across from us. "This piece I'm working on now is called 'Balance.' And those scales on my altar are there to remind me," she adds, points to her altar.

I look at the fabric wall-hanging across from me. "I know it's abstract," I say, "but I see eyes and arms and legs and people moving. It seems like it's filled with people."

She looks at me and smiles. "That's very interesting. I *was* thinking

about people. I was working on finding the balance between me, the center and all the directions people can pull you in if you allow it. We have more control over situations than we think and balance is the key to maintaining control.

"This year is the first year that Ola is out of the house so I'm sure that things are going to develop that have not been there before. I'm beginning to balance the scales. I might be able to keep house, which I never did before. And being a little bit older, I think they'll be able to assist me; because I'm very creative, I know how to make things fun. So that they will want to help. They don't want to see The Dragon Lady come out either."

The balance Adriene is seeking means her whole family is working together, including her husband who is an important source of support. "He says someone should be able to feel the freedom of doing what they really need to do. He makes absolutely no demands on me. None. Which means I've been left to either do well or terrible. If I don't do well I have no one to blame but myself. He comes from a family of artists so he's used to being around people who have the 'I must create, I must express obsession.' He's used to that kind of temperamental stuff when things aren't coming out right.

"He's taught me how to love and care and to give. And he's really wonderful with the children. He washes their hair, he irons, he cooks, spends time with them. He's very maternal—very nurturing and he's this way naturally. In fact, he's the other reason for the children. When we got together, it was understood I did not want any children. I said, 'If you want children go with somebody else because I'm not having any.' I also knew in his heart of hearts he wanted children but he was

not going to ask for any. And as time went on I started feeling, 'It would be a shame for somebody not to know this person as a daddy.' I tease him sometimes and tell him, 'These are your children. I had them for you, so you could be their Daddy. Now let me work.' And he has not fallen through on what we knew was there."

Tasnim and Ola are deeply connected to their mother's art and they know it. They love gallery openings and Adriene doesn't like to go without them. "I remember there was a folk arts community meeting, and each of us brought something that we made to show. And Tasnim and Ola were there playing. When I laid my quilt down on the floor, they just came out of nowhere and laid all over it. Like, 'We're part of this. Now you're talking about something that we know about.' I'll always have that picture in my mind. Before that I was thinking that they were in the way, because they were bouncing around and stuff, oblivious to our meeting. But when it was my turn to speak about my work they came right over to it. They were rolling on the quilt as if they were caressing it.

"Tasnim does a little stitching and quilting. They're both very creative in all kinds of ways. They'll do spontaneous call and response songs, make up new languages and they always work out a harmony. And they do little dramas totally in character. They like what I do and they like that I'm home."

What would come up if she had to make a choice between her children and her art? Adriene's answer sums up her attitude toward art and motherhood. "I get a lot out of the work, but there would be a real void without them. These little girls are really special. Even if they weren't my children, I could be creative with them. If I chose them I

would not be giving up art. That's what I'm saying. If I chose the art I would be giving up children and that would be a loss. My children force me to adjust and be even more creative. And see, I've already gone through that struggle and decided that I wasn't going to do that anymore—choose one over the other—it's balance and adjustment. I just had to get the priorities together. They are works of art. I get the best of both if I choose them."

"How do you nurture yourself?" I ask. "Making art?"

She luxuriates in the thought. "Ummmmm without a doubt. I feel best when I'm creating. Or just being able to be alone. I love being still and alone and just looking at all the things that I've put around like the artifacts and pictures from Africa and India. What I draw in then gets pulled into another visual form. When I'm creating and making something, especially if I have a lot of problems at the time, I transform the energy. Like if something is going on and I'm not happy about it, I have a part of me that can create something beautiful and the negative thing is transformed into something beautiful. I could look at almost all of my art pieces and tell what was going on in my life at the time. So creating is definitely therapy and nurturing."

When she *does* get frustrated at not having the time to work, Adriene has some sure fire ways to get herself out of that hole. "Oh, I'm not fun to live with," she howls. "I'm real cranky. What do I do? Play solitaire. I do, really. I have a little beat up deck of cards over there. I play solitaire when there's just too much coming at me at one time and I can't do what I really want. By the time I win a game I should have figured out what I can do.

"Sometimes I write. I write out every little detail that I'm dealing with and then analyze it to see where I can make adjustments. I also try to be physical, whether it's walking, dancing or making love. The purpose is to free my spirit to open the way for creative adjustment.

"If I'm frustrated, it means I'm not working. I don't really get stuck on pieces. They generally move. Because there's a creative way through everything. You just have to figure it out. Figure out how to lay The Dragon Lady to rest, because she *will* come out and she *does* breathe fire."

"She probably has some really important things to say." I suggest.

Adriene frowns. "Yeah, she does. But I see that as going on automatic. When I was a child that was the way my mother dealt with frustration. 'RRAAHHH. My life is not what I want, I'm not happy, I'm not going to be easy to live with and the world is going to know about it.' I'm not saying we shouldn't let it be known when we're not happy because how else will we all know how to work together? But it doesn't have to go to that extreme. I don't like The Dragon Lady to come out, because it means that I'm not being creative and haven't thought of another way to work through the problem."

I ask her to tell me about one brilliant thing she has done as an artist and a mother that has been very effective. She pauses. "Relaxing in situations."

"What?" I lift my head up sharply from my notes, surprised at her answer.

Adriene explains. "There's no telling what will come in to help you when you're relaxed and balanced. Keeping those channels open to figure out what's the most creative way to deal with any situation."

And then she blows my mind. "It could be something as simple as

saying yes instead of no. If children want to do something and you feel like a no, allowing yes to come in. To allow yourself to try something other than what you think you should do. And what would you get if you tried the other way? Just give yourself room to find other ways to work with situations. And again, if you're relaxed and not all worked up about things, it'll come through.

"My children like to go to stores and look at the clothes and try them on. Not my idea of fun. In my mind I'm thinking, 'I'm not buying anything, Why should I go if I'm not going to buy?' Then I think, 'Why not make something of it? Bring your camera, bring your accessories, go to the store, find the most fantastic thing, try it on, do them up, fix their hair, take pictures. Take it off, stick it back on the rack and you go off skipping. You had some fun and have pictures to remember it by.' And we've done that. My children know they can *experience* something they want without possessing the thing."

Adriene is also glad that she figured out who she was as an artist before she had children. "That worked for me but someone else, they might not find out who they are until they have their children. But I needed to develop an Adriene who could then be there for someone else.

"I made a mistake assuming that since I was already at home working as an artist there would be no problem in continuing once I had the children. Hah hah hah. Major mistake. I was trying to do the things I was doing before, with my child literally screaming at my feet wondering how come somebody didn't come. I went from that extreme to, if I can't do this the way I want I'm not going to create at all. I was bitter about that until I accepted the need to adjust. Allow the creative energy to flow through everything and keep your vision. And let it expand.

"I want my work to be closer to the core of life. What I mean by that is being really in touch with the essence of being creative and creating. The finished product is supposed to give passion, love, spirit energy. Because when we feel good then we can be more productive. I see my work as a tool for making people feel good.

"I would like to make some money. That would make *me* feel good. I would love to have money for traveling. But I don't think money would ever be the reason why I would work. It's a nice benefit if I could get it. And recognition, not so much for me as for the ancestors. So that in spite of the struggle, the beauty still remains because of the spirit to create, to survive and do well."

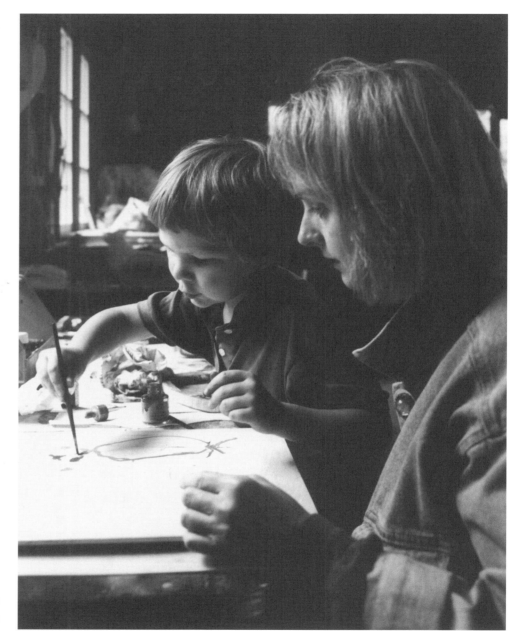

Pictured from left:
Jordan Maughn and Susan Harlan

Susan Harlan, PAINTER & BOOK ARTIST

THE WAY TO Susan Harlan's house in northwest Portland, Oregon takes me over hills and through forests. I park in front of a large blue garage that I later learn is Susan's studio. The house, also large and blue, is up a short staircase. Susan and her husban Richard Maughn chose it because of the garage and also because of the downstairs apartment where Richard's mother Lois lives. Their son, Jordan Maughn, whom they adopted at birth, is five. At my knock Susan opens the door. She is distracted. Richard is about to go food shopping and they are still discussing what to get. Finally he is gone and we settle down at the kitchen table with tea.

Susan is simultaneously exactly what she seems and not at all what I expect. She is a painter, a book artist and since 1992 a professor of painting at Portland State University. Earlier in her career, she taught at Corcoran School of Art in Washington, DC. In her dress and demeanor she could be a suburban matron, but when she talks about the mystery of her artwork, my mind does a double take. Throughout the interview I am awed by a symphony of opposites. She speaks in a soft southern cadence that promises intimacy and confidences. She leans close, her chin length blond hair swinging, mouth curved in a conspiratorial smile. A moment later she whisks herself away and I am left holding a piece of air. The southern lady in her is revealed. Illusive yet deadly honest. Intimate yet remote. Her surface sparkles with hidden meanings and significance but I am not easily admitted into the depths.

Once again I am amazed at how closely the artwork resembles the artist. Susan's paintings and handmade books are abstract, complex, highly symbolic and majestic, with rich surfaces that call out for touch. Her ideas are original and compelling, full of scientific and medical references mingled with the arcane. Using materials such as rabbit's foot glue, wax, gilding, encaustic paint, handmade oil paints and other pure and organic materials, she builds her deep and mysterious worlds, drawing upon images from her life and subconscious. She has a BFA and an MFA from the University of Miami and shows her work regularly at galleries in Portland, Washington, DC and Los Angeles.

Susan Harlan was born in Germany on March 7, 1952 when her father was in the service. She grew up in the little town of Clearwater, Florida. She is the youngest of three children. Her father was a businessman and her mother worked as a medical technologist. The marriage ended when Susan was in high school.

Peals of laughter accompany nearly all her answers. And even behind her more serious answers I detect a slight chuckle. Is she uncomfortable with my questions? Perhaps.

"It was great living in Florida," she begins with a rush. "We lived sort of a simple life on the water. That's what I remember most. I have

an older brother and sister and we raised each other. My dad was never there. My mother was the Rock of Gibraltar, just a sweet, giving individual, very supportive. But neither of them were really artistically inclined."

Susan has just summarized her childhood. Again I am amazed at how early our true selves emerge. Susan remains the person she was as a child, passionately connected to the earth, messing about with pure and earth bound materials. Yet she is also the urbane and glittering socialite.

Susan's mother, who died two years ago, inhabits a tender place within her daughter. "The most important thing about my mother was that she encouraged everyone to do what they had to do. She was really strong, very independent and sensitive. For instance, here's my dad in the service and she's flying all three of us on an airplane at ages one, two and three from Europe to the Philippines. Three kids. I mean, I can hardly fly to Washington, DC with Jordan without having a nervous breakdown. She was really loose.

"I always knew my mother really loved us because I had my father to compare it to. I know he loved us but it was hard for him to touch us and hold us. He was from a very Victorian type family and so it wasn't all his fault. He was an only child and spoiled in some ways. My mother was an only child and spoiled, too. My brother and sister and I always used to laugh and say we raised them because we had to teach them how to share. They wanted separate houses."

Susan discovered art in a fortuitous way. When she was about five or six her family moved to Virginia for a year, her mother's home state. "I met this wonderful woman who lived behind my grandmother,"

Susan says, smiling softly. "Her name was Mary Overstreet and she's the reason I'm an artist. She didn't paint, but she would knit and sew and make things. She taught me how to knit and then how to cut out little things and sew them together. She was the seed. I can remember how it just electrified me, opened me up and I felt at home.

"When we went back to Florida I would go hide out and just make things all day long. I remember my mother saying, 'Where's Susan?' They were worried about me because I was so introverted. I wasn't really, I just spent a lot of time making things." Susan pauses. "I wish Aunt Mary would have saved some of the things I made her because I'm still making them. Like when I collected shells, I never would collect the whole shell, just the fragments and then put them all together. And if you look at my books and my paintings, they are really layered, so that layering began back then."

The seed planted by Susan's Aunt Mary was potent indeed. Susan was able to keep that new found knowledge alive and well once she was back in Florida. She was helped by the natural environment around her. She and her brother and sister didn't have many toys so they utilized what was most available: the beach. "We were really into building these elaborate structures. We got our big brother to drag things and we had all this sand so we could dig. We would build all kinds of trap doors and structures and tents. Recently, I've been doing this series of drawings that are tents. Maybe it's from then. I really always loved materials. By the time I was in high school I made everything by hand. I didn't have a sewing machine so I sewed skirts, jackets, everything by hand. I love little things. My mother says I used to crawl around picking up dust bunnies on the floor, just observing them."

Susan sits back holding her tea cup close to her body. "Aunt Mary truly was the spiritual link to my work and still is in some ways. She supplied a beginning to the structure of making. I never looked at it as being an artist. However I just found a little photo album from first grade and it says, 'What do you want to be when you grow up?' And I said, 'a painter.' So I must have had some sort of idea that it was a profession."

It wasn't until high school that she made the conscious connection between what she loved to do and art. In one art class, the teacher entered Susan's work in a national show and it was published. "It was the first time anyone had called what I was doing 'art.' So I thought, 'Maybe I can make use of what I do.' I was raised in a very practical way. We never went to a museum or anything. There was nothing like that in Florida."

Another important moment in her growth as an artist came during a trip to Europe the summer before college when she was eighteen. "The most incredible experience that summer was in Venice at the contemporary museum," she says, almost bouncing in her seat. "They were having an international exhibit called the Venice Biennial. There was the piece by Robert Rauschenberg with the goat and the tire around its neck. I walked up to this piece and realized right then that I was going to be an artist. I had no idea that this was art. It was so exhilarating. When I talk about it now I feel like I'm still there. It was the most interesting array of work and it changed my life."

When Susan returned to the United States to go to the University of Tennessee she decided to major in art. Subsequently she transferred to the University of Miami where she was awarded a scholarship and finished her education. After graduate school she dutifully got a job teaching art in Pensacola, Florida. But Pensacola proved too remote for her so she soon quit.

It was while she was working on a grant with some filmmakers in Mexico that she came into contact with her next employer, The Franzini Family Circus. She made friends with some of the performers and when they suddenly needed someone to fill in for an absent performer, they asked Susan. "They were doing a benefit for an orphanage and since I was hanging out with them they said, 'Well, why don't you do it?' I said, 'You've got to be kidding, NO!' I thought I was going to throw up. They then said, 'You have to, you have to help these children.' When they put it that way I felt like I couldn't say no. So I said, 'What do I have to do?' They said, 'We'll train you.'

"It was a small vaudeville circus, like the Flying Karamazov Brothers. It was mainly performance and magic and no animals except for a pygmy goat and a snake. One of our acts was a fifteenth century Commedia del Arte piece where I was Colombine. I could handle that one. It was a really funny routine. Then of course, I knew how to juggle and mime because I'm from Florida. Everybody in Florida knows how to do those things because the circuses all stay there. I was also a clown and would wear this elaborate costume. I thought, this is really fun, making people laugh. I was so scared but it was such a wonderful time.

"I came back to the United States with them and auditioned for their world tour. After the audition they said, 'You are really the worst audition we had but since you have performed with these people and know them well and they love you we have to choose you.' The prob-

lem with the circus is not so much who can do what, it's who can live with whom. You're changing costumes with everybody in the same space. You're really on top of each other and it's stressful. So I really lucked out."

The year Susan spent on tour with the circus continues to inform her work. They traveled cross-county to San Francisco and then to Indonesia, Japan, the Philippines, Korea, did some USO tours and ended up in Australia before heading back to the United States. Along the way Susan filled journal after journal of sketches and ideas about cultures and art.

Susan's decision to be a mother was abrupt and came directly from her relationship with her husband. "After knowing each other two days we decided to get married and have children," she says giggling. "I didn't want to get married until much later in life and I couldn't see having a child without being married. That never came into vision, coming from a southern background. My grandparents were Southern Baptist and very strict."

"You had some difficulty conceiving. What happened then?" I ask.

"We went through amazing amounts of surgery." she says, laughing off the memory. "When I was twenty-four I had an ovarian cyst that burst. I was opened up and they took out tubes and ovaries but said to me, 'You can still have children.' But through the years scar tissue built up in the other tube. I tried a lot of things prior to surgery. I did the dye test and trying to blow up the tube. I never did do any drugs. I felt like a machine. Every month for about two and a half years I was doing something related to fertility.

"Right before I was going to have laser surgery to open up the tube I went to a masseuse. She turned out to be a psychic masseuse. She said to me, 'I see a child with you.' So I was sure that this surgery was going to work. But she also pretty much said I didn't need to do the surgery. She said, 'Go off caffeine, don't eat yogurt or milk products and be macrobiotic and see what your body does.' Nine months later we adopted Jordan."

How they came to adopt Jordan borders on the magical. After the laser surgery proved unsuccessful, in vitro was offered as the next step. Instead they looked into adoption, despite it being too expensive for them. When they found out about an organization in DC that offered the possibility of a quick adoption of a mixed race child, they decided to contact it. "Richard and I talked about it one day and I made a phone call to this company but they hadn't gotten back to me yet. That weekend we went to my best friend's wedding. She went to college with a woman whose husband was a gynecologist. At the wedding I was sharing my laser surgery stories with this guy and he said, 'So you want to have children? I thought artists don't want to have children.' I said, 'Yeah, I'd love to have some kids.'

"I guess it was about a month later when the doctor's wife called and said, 'There's a women here who's pregnant and would like to give up a child. She wants to give it to a really good couple. And we would like to recommend you if you are interested. Ricardo and I really liked both of you and thought you'd make good parents.' We were just like amazed. The baby was due in five weeks. We went up to Vermont and met the birth parents and they both decided that we were okay because they loved cats and I was a painter. Good thing we didn't have dogs.

"We came back home and I said, 'Richard, we have to be there for

the birth.' He said, 'Susan, are you crazy? That baby could be born a month late.' I said, 'No, we're going to be up there.' So, close to the fifth week we went up there. It's Vermont so we did some hiking and cross country skiing and waited. About the seventh day we thought, 'Should we go back to our jobs?' I said, 'No, not even if I lose my job.' We arrived on Sunday and the following Sunday at 8:00 in the morning she went into the hospital. The doctor called us and said, 'She wants you to coach her.' So we went in and Richard and I coached her through the birth. The doctor handed us the baby, which is unheard of in Maryland where I was living. In the DC area you're not allowed to touch the child until you're out of the hospital. They gave us the baby, gave us a room in the hospital. I have these pictures of me laying in this bed with Jordan laying on my stomach like I had just given birth. It's so funny. We adopted him in Vermont and went home four days later."

As with many women who have waited a long time for a child, Susan was ready to be a mother. When I ask what is hard for her as a mother, she looks at me with a puzzled expression. "I don't really look at it as easy or hard," she says. "I just look at it as lessons. Like it's really the most wonderful thing that ever happened to me.

"I like the play. What I like to do with him is physical games and building things out of nothing. Once when I was in my studio I let him have some tape and some string and he completely encased the place like a spider web and we got inside of it. I love that. The thing that I care the most about is that he knows that I love him. So I make it known even when he's in a rage."

Susan is also proud of her patience. "I get that from my mother," she says with a grin. "My sister is also extremely patient. If I had eight kids I would be the same. I don't get wired or frustrated. I had all these kids over on Saturday and I let them run through the house and take it apart. It doesn't seem to affect me."

"It's a great gift," I say.

She smiles and nods. "The other day I had three boys in the back seat of the car with me. Richard was in the front seat, we're taking them to the movies. They are all being rowdy and rough-housing and I'm just riding along. Richard says, 'How can you stand it?' I go, 'Stand what?' And it came to me that when my brother and sister and I were all in the back seat making noise and screaming for help, my mother would just turn the music up and keep going." Susan tips her head back and roars.

"What are you terrible at as a mother?" I pry.

She is quiet for some time. "Let me think what the best one is," she says. "The real honest one." Pause. "This is real hard." Another pause. I can feel her inner struggle. She finally answers, "I'm probably the worst at keeping a regular schedule for him, which is not good for him. That would be the safest one to say."

I dig deeper. "Tell me one that's not safe."

She smiles, somehow relieved at my question. "Can I say guilt? I feel guilty. I would like to be more of a normal mother. I envy all these mothers who can go pick their kids up and invite other kids over and they have a life with kids. It's truly not that way for Jordan. It's as though he's part of a different kind of life. I know it's true. So I feel kind of bad about that.

"He gets this real irregular lifestyle. I mean, I feed him and bathe a

him and he goes to sleep . . . But for instance, I can imagine when he's a teenager and he'll be playing strange music and want to really upset us and we'll probably love it. We'll encourage him to go to Europe by himself. Experience life. And he'll be some accountant or something." She chuckles and suddenly asks me, "What about you?"

"What am I terrible at?" I say, surprised to be asked. "I yell. If Rowan doesn't want to do what I want him to do, I yell back at him and we have these yelling fits. He tries to hit me and I have to fend him off. I think it's awful but I do it. I get angry. It doesn't take much for us to feel incompetent, does it?" Susan grins back at me and we sit quietly for a minute. Then I resume, "What is a good mother?"

Susan smiles, and looks out the window at the trees, "I don't know. Mine was so wild and crazy. She was a good mother." Her eyes swing around to meet mine. "A good mother is someone who loves her kids unconditionally and the welfare of the child comes first. That's the bottom line for me. I think that's the hardest thing about being an artist, too. If I had to give the art up, I would. If something happened and Jordan was paralyzed and I had to take care of him I would. Art is not as important."

In fact, Susan was willing to become a mother even though she thought her career as an artist would be over. "I thought I'd have to give it up for maybe five or ten years. I wasn't sure. I'd seen a lot of women just give it up. So I really had some reservations about it. I'd just seen what my friends had gone through and they were perfect mothers."

Susan's eyes snap with amusement. "But it turned out that I wasn't going to be a perfect mother so it didn't matter. I thought that there was just one circle, but when you have children, there's another circle going simultaneously. It feeds the work, it doesn't take away from it. I didn't know that. Being a mother is definitely a powerful food of love and giving that released me. It just opened me up to a whole new thing. I'm so glad for that because again, it's back to ego and the lessons. And I don't have to live that egotistical way anymore. Children are freeing. And you can never tell that to anyone who doesn't have a life with one. Baby sitting seemed to be such a disaster, when I was going out with friends who had kids. They would say, 'I can't go, I can't find a babysitter.' Now I don't want to go so it doesn't matter."

Once Susan became a mother, her work also went through a deep transformation. "Before Jordan," she explains, "I was painting and making art that *implied* books. But after being present as his birth, which was one of the greatest moments in my life, I really wanted to do something just for him. So I made a book for him filled with the story of his life. All my other books have been for him, too.

"Just the other day Jordan and I went to this solstice gathering. We had to throw into the fire all the things we wanted to get rid of. So I wrote down all these things in a little book and started to throw it into the fire. He screamed, 'You can't throw my book into the fire.' He knows that all my books are for him." Susan stops, then adds in an offhanded way, "The paintings fall by the wayside, everyone wants to see the books."

"Why do you think people like your books more?" I ask.

"Well, I think they are more intimate. People desire that sense of physicality that we lack. I noticed when these Russians were here, they were so affectionate, much more affectionate than Americans. [ed. note.

Susan recently participated in an artist residency in Moscow. Soon after, PSU hosted a group of Russian artists.] They were all kissing each other, even the males. Every time you walked into a room, they all stood up and kissed you. So I think the books allow that connection.

"Having Jordan has made me more aware of physical things. It's all related to having this little child in my hands that I thought would just break until I realized how durable he was. The books have grown metaphorically with him. When I had a show at the Woman's Museum in Washington, DC, the curator said, 'You should never sell your books.' It was like a voice from myself because I always said they were for him. Of course my husband says, 'We must sell these books. We need the money.' But I do keep the ones that are close to me."

The content of her work also changed. Susan sits up straighter in the chair, visibly excited. "It was like this BC-AD thing. There is much more of a groundedness about my work. I think we're all in suspended adolescence until we do have children. When he was born the cycle of life became clear. The responsibility of life became very real. We assume that children will take away what little time we already have to make art. It's not true. What it does is make it rise up to a finer level. It's a clearing."

I ask her to speak more specifically about a piece of work that grew out of her motherhood. "Well, I'm not sure," she answers, hesitating. "Maybe the piece I did when Jordan was first born will explain it. I went to the Natural History Museum with Jordan on my back, which I always did. There was a wonderful show based on an Indian myth about the whale hunters who carried ravens on their backs to help with the hunt.

"And there I am looking at this life-sized figure of this guy with a real bird on his back. And Jordan's on *my* back. I'm drawing this in my sketchbook and realizing at the same time, 'I'm carrying this little creature.' That winged figure became a symbol for that period. There was a click connection and it became a breaking point in my work. It was a very strong series of work, perhaps my strongest. It showed me a new direction that I've been going in ever since.

"Since then I've read about Australian Aboriginal women who carry their children on their backs for four thousand miles until the children can walk by themselves. During the four thousand mile trek, the children learn the songs about the land. And the territory marks out their history through songs and stories. So they walk singing the song and they would reach say, the Three Dead Sisters Rocks. And everybody would sit down and tell the story about the three dead sisters. So the myths and the songs and the land all connect. I made a book for the Women's Museum about that called *Songlines.*"

Jordan has been equally affected by Susan and her work. "Jordan paints like I do. Everything is a structure to be built. He puts something down and layers it and puts something down and layers it. There is another little boy who comes over who's very talented and he paints the outline and the tree and then paints the sky blue. Jordan has never painted any sky blue. He is very free with his paint. I don't direct him at all with art. I give him all the supplies and plenty of room to make a mess.

"Yesterday, unfortunately, he saw me working with the encaustic process and he just had to do it. I can't stop him when he wants to do it so badly. So I let him make a little encaustic piece with hot wax and

he burned himself. He just is very inquisitive about it. I think it is great. I always had a studio out of the house until Jordan was born and then I made my studio in my house. It's always been accessible to him."

"What does Jordan think of your work?" I ask.

"He's never really talked about the imagery. But I tend to be an intuitive painter more than an intellectual painter. If I'm working on a painting, I say, 'Look at this painting I did today.' And he says, 'I want to make one, too.' I think he feels the texture and then relates to it. That's why he wanted to do wax yesterday. He loves it when company comes over. He shows them the books. He gets them down and rubs his hands over them. He's not protective of them. He really looks at them."

I ask Susan to name those who have given her support as an artist. Without missing a beat she credits both Aunt Mary and her mother even though neither of them are living. "My mother always was clear that I should do what I had to do and that was the most important thing. Before marriage, before children, before anybody. My mother has died and that was a real hard thing because she gave me so much support. I get none from my dad who still thinks I shouldn't be an artist. My brother and sister give support. Especially my brother. Then I met Richard and he truly supports me like I never would have imagined."

She also received support from teachers along the way. "I had a couple wonderful female teachers who made it clear that women have a different struggle than the men. And that you just have to ignore a lot of what is said and be the observer and understand that it is cultural. In the late sixties and seventies in college things were changing but never fast enough."

Most significantly, Susan has a sense that the world in general *wants* to see her work. "I know they're people out there who care so it gives me energy to produce."

I inquire further about support. How much would she *like* to have?

Susan's eyes twinkle. "I would really like to have more opportunity to discuss art with people. I want to be able to share ideas with other artists and really make some changes. It is the community that does it, not individuals. I would like to be with not just other painters, but people who are interested in cultural development. I want to be more in touch with a culturally stimulating environment and I want to see more caring. Everything is lacking content. Why is that? Am I on my box again here? Sorry, but I want content not just in art, I want it in life."

To my question about what nurtures her, Susan replies. "I paint. Paint nurtures me so much. You never see me happier. If I've been painting all day it makes me . . . just gives me the right thing. I do a lot of reading. I read a book last night, a book the night before. I like to look at art and that feeds me a lot. And I like the ocean."

In recent years, Susan has been traveling more often for her work. She often takes Jordan with her if the trip will take over a week. One exception was her recent two and a half week trip to Moscow, the longest she has ever been away from him. "It was hard. I missed him more than I thought I possibly could. Terrible guilt. But when I go east for five or six days, Lois is here and she loves him dearly and he loves her. I've never left him with a baby sitter for any length of time. But I see that he's getting older and it's easy for him to travel. It's hard to get the money from people to take your child with you on these stints."

"Do you get it?" I ask.

"Well, no," she admits. "When I went to Moscow last summer, I probably could have used some of the money that I got to take him. But it was too dangerous there. I've been asked to go somewhere else this summer and I don't think I'll be able to take him again. But when he gets to be eight or nine, I think it'll be a little easier. I don't think I'll go anywhere without him. It will be fun for us both."

"What happens when you take him?"

"He loves it. He just loves to travel. He seems to fit right in. When I had a show in New York, we stayed with a friend of mine and her mother took care of him. I work it out ahead of time. I don't just go and leave him with strangers."

Susan grimaces when I ask her to describe a typical day. "Well, I don't want to talk about the days when I'm in school. Those are hectic. Crazy. Getting Jordan up, getting him fed, getting him dressed, getting him to school. I like to take him to school. He has to be there at 8:35 a.m. And then I have to rush to my school. And then worry about him riding the bus home.

"But when I'm off, which is most of the week, I like to take him to school leisurely. Walk him through the door. He likes that a lot. Then I rush home, get in my studio and paint until 2:15, 2:20 p.m. and race down and pick him up. So I work in my studio all that time. After that I do whatever I have to do, shopping or other errands.

"In the summer I get up at 5:30 a.m. and work till 9:00, 9:30 and then garden and do errands and stuff with Jordan till about noon. Sometimes in the afternoon I'll go back in the studio. I'm pretty much of a morning person. It's such a beautiful time. Especially with kids around, because they are safe in bed then. And you are not so tired from putting them to sleep the night before. I couldn't go to the studio at night after that."

"Talk about money." I say suddenly.

Susan balks. "Aaakkk," she screams. "We have no money. What do you want me to talk about?"

"Talk about how you live."

"Is it a big issue for everybody?" she asks, backing away from me.

"Well, yeah," I say. "It's the great secret. No one talks about their money. And if they do, it's only about how much they *don't* have. How do you do it?"

"Well," she says quickly, perhaps hoping I won't really hear, "I teach college to keep the bills paid and live in the house that I want to live in." She adds, "Well, actually I was a trial artist for years. I also worked for a newspaper. I've always made a fairly good salary as a professor. We both have to work to keep our lives going. We have both been out of work at different times. And we've been very supportive of each other at that time. Richard is a computer programmer, systems analyst.

"My father was a businessman, but my mother was never materially oriented. My brother is a lawyer and my sister was married to a very wealthy guy. To them, I've always looked so poor. I've never looked at it that way. Richness comes in different ways. Money is just to survive.

"As I get older we would like to have a little security for Jordan. Hopefully, the art will give him that. It's scary what's going on with the economy. I'm up for tenure at Portland State, but there's no such thing as tenure anymore, in the way it has been for the last century. By the

time I get there, there won't be tenure. So there is no security. I don't concern myself with money as much as I should."

She is both anxious and relaxed about money and her job. Guilty and proud of her mothering. What enables her to manage a life so full of opposites?

Susan's eyes narrow as she thinks. "I'd say observation."

"How does that help?"

"Because then I can see what is going on," she explains. "It's like watching a play. If you're on stage, you can't really see it. So when I can get off the stage sometimes I can direct it. Not in the sense that I can have control, but I can at least see what is going on. It helps to be the observer instead of the player all the time. That sense of observation is the gift that having a child gives me. They have a fresh way of observing. It's a goal of mine, to be more observant."

She would like to concentrate on painting in the future. As well as being in a artistically exciting environment. "In ten years I want Portland to be a hot bed of radical content-oriented life. And I want my artwork to get better so that I can show internationally. I want to be traveling, in fact I'm buying a house in Mexico. I want Jordan to be really excited about learning, excited about understanding things. I want to be healthy for him. I really want to do things with him. I want to expose him to a lot of things. And so I really want my work to allow that."

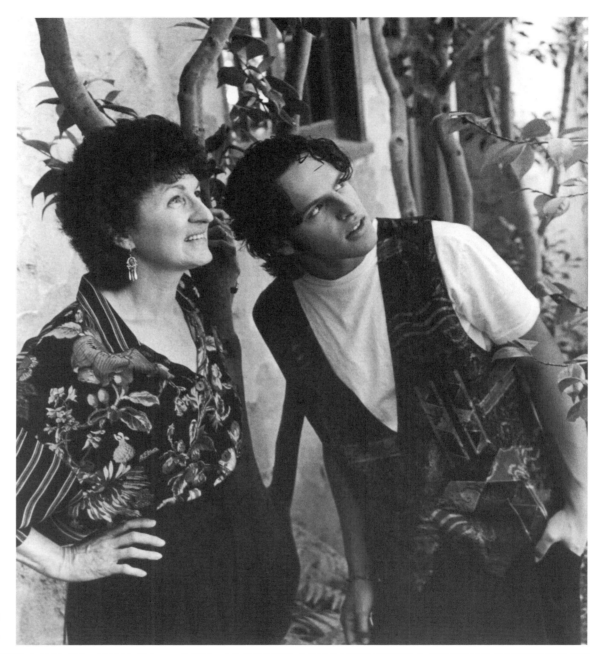

Pictured from left:
Chana Bloch, Jonathan Bloch

Chana Bloch, *WRITER*

CHANA'S HOUSE IN the hills above Berkeley, California, is tucked in snugly amid thick trees and bushes and the odd outcropping of bedrock. It is a cool and tranquil retreat from the city below. Chana answers our knock within seconds, draws us into her well cared for and orderly home and putters around preparing tea. She is pleased to see us and we are warmed by her sincere welcome and openess.

Chana is dressed neatly in blouse and pants. Her short, curly gray and brown hair is carefully controlled. She is small and moves around her house gently like a cat, making no mess. But her appearance hides a strong and passionate vision. She writes poems that explore the gritty realness of family life. Her words conjure up a world built of physical sensations and delight. She is also a scholar and translator of Hebrew. Most recently, Chana and her ex-husband Ariel Bloch, who is Israeli, collaborated on a translation of the "Song of Songs" from the Bible. They raised their two sons Benjamin, twenty and Jonathan, seventeen in a bilingual home and spent some years living in Israel. Chana has a PhD from the University of California at Berkeley and teaches poetry, English literature and writing at Mills College in Oakland.

She was born on March 15, 1940 and grew up in the Bronx, New York, which at the time was largely middle class and Jewish and "hardly the wild place it is now." Chana's parents were Jewish immigrants who came to this country from the Ukraine around 1920. Her father was a dentist and her mother a housewife. She has one younger brother who is now a psychiatrist.

After the interview, Chana's younger son, Jonathan, emerges from somewhere deep in the house. He is newly showered and his hair lies slick and shiny against his head. Chana introduces him proudly and they playfully joke with each other. As he devours a huge sandwich of improbable combinations of food, we discuss the photography session to take place tomorrow. His older brother, Benjamin, is studying in Germany so cannot be in the photo. Jonathan seems pleased to participate in this project with his mother.

Her New York accent, though clear, has softened around the edges. She speaks slowly and carefully, making sure I hear the whole truth. She describes her childhood and family life with a brutal candidness. I am honored by her trust which washes gently over me. I give her mine in response.

Chana has just returned from six weeks at the MacDowell Colony, an artists' colony in New Hampshire and is filled with that experience. "I was one of the few people there who had children," she says with amazement. "Women in their thirties would sit at my table and interview me. They would say—I heard this more than once—'I'm thrity-eight, the clock is running out. Should I have a child? I don't know what to do. It's a major decision. Tell me what you think.'"

"What did you say?" I wonder.

"I said, 'My answer may not hold true for you. But for me it was the right thing. It's especially difficult in the beginning, for physical reasons, because you have a lot to do and you're tired all the time. But the main benefit is that it develops a whole range of feelings inside of you that you won't even begin to imagine until you're there. And if you're an artist it will benefit your art because you become a deeper, more complicated person. Not all the feelings you have are pleasant feelings. But they're feelings nonetheless and it's good to have them. It makes you a richer person.

"At a certain point you're not having to work twenty-four hours a day as a caretaker and then the rewards begin to predominate. At this point in our lives the rewards are incredible. It's just wonderful to talk to our kids. They're beautiful to look at, they're wonderful to listen to. They're hungry for experience. They're what young people are—alive and growing every single minute. In middle age, to talk to someone like that is to touch a source of renewal all the time.

"Somebody once taught me a very useful expression, 'Time not money.' One of the things that a young child does is take up all your time. So it's worth spending money to buy time for yourself.' I told these women at MacDowell, 'If you want to have a child, just be very sensible about providing some help for yourself—household help and childcare—in the beginning. That doesn't mean shunting the child off to somebody else, but you need a certain amount of time to do your own work.'

"There's another benefit that I mentioned. Sometimes people are afraid to have children because their own experiences as children were problematic. In my case, I found that if you don't treat your children in the same way that you were treated you are actually healing yourself. I made a big effort to be encouraging to them, not to be critical all the time. To see that they are human beings with the right to live their own lives. To be available to them when they have some problem. I don't just have to pass down what I got. I'm not saying I've succeeded all the time. That would be too rosy a construction. But it has certainly been an aim of mine, and a lot of the time I've managed to acheive it. And it's made me feel a lot better about the past."

As the child of Jewish immigrants, Chana's childhood was full of hope tempered with fear. The gulf between her parents' lives in Russia and her life in the United States was often confusing. "My father grew up in a mud hut with a mud floor and a straw roof," she says, her voice full of emotion. "He told me that he never went to sleep as a child without being hungry. And freezing cold. He said he would wake up in the morning and there would be ice to the thickness of a couple of inches inside the walls. It's unimaginable. When people talk about poverty, I think about what he came from."

After a pause she goes on. "When he was twelve years old he was farmed out as a servant in somebody else's house. When he was thirteen his father was killed right before his eyes. He and his brother dug a hole in the ground and buried their father. So he saw quite a lot in his life.

"He came to this country when he was fourteen and went to night school, studied English and became a dentist. That was light years away from his beginnings. He made an enormous leap in his life. He did it with the typical immigrant diligence and dedication and belief in

America. He died twenty years ago but for me he was a kind of hero."

Her parents, who both came from tiny villages near Kiev, met in Buffalo, New York where her father went to dental school. Her father settled in New York and her mother's family went to Buffalo. Chana muses, "Sometime I'd like to go back and see where they came from, but of course it's not going to be there."

Chana grew up in an apartment, which also housed her father's dental office. She smiles as she remembers. "His patients would stream in and out of the apartment all day long and my mother would make coffee for them. It was a kind of family business. It had benefits for my father, but there was a lack of privacy as a result.

"When I remember the Bronx, the first thing I think about is the intense city noise day and night. It was a ground floor apartment on the corner of a fairly busy street, across the street from a hospital, so there were ambulances going by all the time. On the other side there was a swimming pool and then the elevated subway about a block away." Chana pauses and looks out the window. "That is why it's really amazing to me to live in a place like this. The silence is blessed around here. There was nothing so quiet in our part of the Bronx.

"My younger brother and I shared a bedroom. Cramped quarters. I had no place to be by myself in that apartment. I would try to do my homework in the bedroom and when my brother went to bed, I would then retreat to the kitchen where my mother and father were talking or arguing or whatever.

"The house was furnished in my mother's style of 'fancy,' an odd combination of Chinese lamps and Italian coffee tables made of pink marble. Everything was intended to be a 'conversation piece.' She had

an extravagant notion of elegance that was the result of her discovering America all at once. As a young girl I must confess I found it attractive, but as I got older I began to see how gaudy it was.

"I don't remember going on trips to museums or concerts or things like that. We didn't do that. My parents really didn't know much about the resources of New York; maybe they were afraid of life in the big city. Also, my father worked very hard and he was exhausted when he got done working. He didn't have much energy for anything. Visiting his family was something he liked to do. We would pile into the car on Sunday and drive down to Brooklyn which took about an hour. Then we would spend the afternoon at Uncle George's. And come home in the evening listening to the radio in the car. Or we would get into the car and go to some shopping mall with my mother. That was when shopping malls were just getting started. My mother loved them. She would lead us around from one store to another."

The respect and tenderness Chana felt for her father is somewhat absent from her relationship with her mother, who is still alive and lives about a mile from her in Berkeley. Despite their proximity their realtionship is not close. "She was a rather difficult and controlling person," Chana says, her voice tightening. "I had a very vexed relationship with her for a long time. My mother was always very quick with criticism and not especially empathetic towards me. So I would say it was a little rough growing up under her tutelage. In a Jewish home the son is always preferred and my brother was the apple of her eye, her prince."

Chana lifts her head up. "I escaped into studies and into poetry," she says fervently. "My mother couldn't understand my poems. If I

gave her something to read she would say, 'Oh, I can't make head or tail of this.' So I knew that was a world where I could have some privacy. Also it enabled me to say the truth about things, because in our home the truth wasn't told. My mother's story was that we were happier than other families. In fact we were quite a dysfunctional family. So poetry was my way of finding a corner for myself where I could say what I really saw."

"Did you think of yourself as a writer; was that your goal?" I ask.

Chana laughs gently. "Nothing so grand as that. I loved to write, but I was very tentative about calling myself a writer. That self-identification has come only gradually."

"So what did you think you were?" I ask.

"A good student. A good girl."

But good girls don't often grow up to be serious writers. Chana must have had some more help along the way. And she did. "I went to a wonderful high school in New York City, for girls only," she explains joyfully. "It was called Hunter College High School and was run by Hunter College. That was where I discovered the world of the mind, that there were endless possibilities of things to be interested in. There were some exceptional teachers at that school. It was very high powered and exciting."

"How did you get to do that?" I ask.

"We took an admissions test. I had a very good teacher in the sixth grade who encouraged a group of us to take this test. All six of us passed the test. But then we said we didn't want to go there because it was in Manhattan, our parents didn't want us to travel on the subways, and besides, there weren't boys. The teacher got very angry at us. She said, 'You've taken the test and you've passed and now you have to go or you'll disappoint me.' So we all ended up going to that school. And for all of us it was a very special kind of experience.

"A lot of the teachers there were role models to me. Some of them were married, and had families and children, and yet they taught. I was always looking around for an older woman to admire because I had such a difficult relationship with my mother."

Those early models were instrumental in Chana's assumption that she could be a scholar and writer as well as a mother, despite later brutal experiences in college. Chana grew up before feminism had taken hold. She describes an incident that happened around 1960. "When I started writing in college, women's subjects were not considered a worthy subject for literature. I took a poetry writing class in college at Cornell and wrote a poem about imagining that I was pregnant. At that time I was a movie reviewer for the *Cornell Daily Sun.* I had seen a movie in which a woman was nine months pregnant and I went home and dreamt about it. I woke up in the morning and wrote a poem about being pregnant. I showed it to a woman friend who had a child and she said, 'Yes, you've captured that experience very well.' Then I submitted it to my poetry teacher, a male, and he handed it back and said, 'You'll have to give me another couple of days with this poem. I can't decide whether it's ultimately beautiful or ultimately ugly.' And I said, 'Okay, take another couple of days.' When he handed it back to me he said, 'It's ultimately ugly.' And I think he gave me an eighty-three. He used to grade the poems. I found it very offensive.

"His whole approach was so patronizing and he was obviously threatened by the subject. He's a paradigm to me of how *not* to be a

teacher. But I also think that his attitude was a reflection of that particular time. I don't think a male professor would ever say something like that in our day."

Despite the mixed messages from the academic world, there was never any question that Chana wanted children. "I used to imagine when I was young that I would have six children," she says smiling. "I don't know where I got that idea but I used to think I would have a large family. When my father died I immediately wanted to have a child and name the child for him. When I had some difficulty getting pregnant I was very distressed. It seemed to me like the worst thing that could happen would be to not have a child. When I became pregnant and Benjamin was born I was actually ecstatic.

"In fact," she says laughing, "the mood lasted a couple of months! Then one day I felt a little blue. And I stood there, changing his diaper thinking, 'Oh my goodness, I hope I'm not going to harm him the poor child because I'm in a bad mood.' The second time around I was much wiser. I realized that children are very resilient creatures and it won't harm them if you have a dark mood occasionally."

Chana was thirty-two when she had Benjamim, and in those days was classified "elderly primipara," which means "old childbearer." "I loved the feeling of being pregnant," she says savoring the memory. "It was wonderful. I loved nursing the child; I think that's one of the most beautiful things a woman can do. I loved the physical sensation and the emotional sensation. I hated when I had to stop. I wish I could do it all over again.

"My ex-husband is a professor at University of California at Berkeley and in those early years we had one car, one child and two schedules. So we would negotiate a very complicated series of arrangements about who was home when, and we got some help. Someone to clean the house and spend a couple of hours per week doing childcare."

But when Jonathan arrived the equation became more complicated. "It gets harder by a geometric progression," she says, chuckling. "Tiredness piled upon tiredness is not two tirednesses, but tiredness squared. It was particularly difficult because Jonathan was rather sickly in the beginning. He was born with jaundice and it didn't go away for awhile. My sense then was that he might be a sickly, scrawny child. As it turns out, he's a great big strapping robust teenager."

She sits back and considers. "At that point I was working, trying to finish my PhD thesis, trying to write and do a lot of things at the same time. I had the sense that most of the time I was trying to juggle a couple of balls in the air, and I was dropping them. It was pretty frustrating."

Bringing the different parts of her life and art together has been an ongoing process for Chana. But combining the different aspects of her scholarly work was also a challenge. Since college, she has been interested in English literature, poetry and translating Hebrew. Planning to live in Israel, she got an MA in Near Eastern and Judaic studies at Brandeis University. But once in Israel she was told, 'What you've just learned is what most eight year olds know. If you want to live here, you probably could support yourself better by teaching English.' So she returned to Brandeis and got another MA in English Literature. Then after getting a job teaching English at the Hebrew University in Jerusalem, they told her, 'If you want to stay, Chana, you have to get a PhD.' So she came

to Berkeley, planning to get a PhD and then go back and teach in Jerusalem. But instead, she met and married an Israeli and stayed in Berkeley.

"For much of my life I felt that I was being pulled in two directions—English literature and Judaic Studies. Whenever I was studying one thing I would always think the other looked like what I really wanted to do. I had to figure out ways of bringing the two together. And whenever I *could* figure out a way to bring the two together, then the different parts of myself are satisfied.

"It worked very well with George Herbert [seventeenth century Anglican poet]. I wrote a book about how he uses the Bible in his poetry and found the subject endlessly fascinating. Herbert was a very wise and beautiful soul. He is a master for me, a guru. For the fifteen years I worked on that material, I sat at his feet and tried to learn from him about life.

"The same thing happened again with the 'Song of Songs.' Before that I had worked with my ex-husband on a number of books of translation of contemporary Israeli poetry. Yehuda Amicha and Dalia Ravikovitch were the two poets that I translated with his help. Then collaborating on the 'Song' was a particularly satisfying project because again it offered a way of combining poetry and the Bible and translation. It's like pulling together the scattered parts of yourself and finding out that they are not moving in different directions. They can really work together."

The idea of choosing between her writing and her children initially stumps Chana. "I don't know what to do with that question," she answers.

"Everybody says that," I say, "but they always end up saying something interesting."

"Maybe life makes those decisions for you," Chana says slowly. "When the children are young, you don't have much choice, because you are required to put the time in, in childcare. My work was on hold during those years. And then you reach the point when they are old enough to take care of themselves and you can begin to devote yourself to your work. So maybe I didn't choose enough. Maybe I could have figured out a way to choose more of the time. But I didn't. I let circumstances choose for me."

"Did you think of yourself as a writer even if you weren't writing as much?" I ask.

"Well, I had my doubts. Adrienne Rich says, in *Of Woman Born*, that in those early years when she had three young children, she would be grateful if she managed to write one or two poems a year—but she says it with an edge of bitterness and frustration. I read that book when I was nursing Jonathan. I remember sitting there nursing and reading about how difficult her experience had been. It was very frustrating not having enough time. When I wrote very little, of course I doubted. I thought to myself, 'If you're a poet, you ought to be writing more than this. Why are you writing so little? What's the matter with you?'"

"So what did you think?" I continue.

"I thought that whatever ability I had was dried up and that felt awful. Because poetry was always a very important part of my life. At the same time I was involved in scholarship work, writing the book about George Herbert. I found that I could do that even when I was

tired, distressed, whatever. I could go on reading the books, making the notes, developing the hypotheses. But the poetry was not always available to me and that was very distressing because poetry was actually more important to me than scholarship.

"Now I understand in retrospect that I wasn't writing because I was trying to do 110 things at the same time. You can't write poetry unless you have a little bit of time to fiddle around, to make rough drafts, to throw things away, to be lavish with what you're doing. And I had so little time. I would look at what I wrote and if it didn't shape up pretty quickly, I would be very critical and that's the first way to stop the whole process. Now I understand that if you take those beginnings, which often look unpromising and work with them, they will continue to grow. You have to trust in the process."

The family has always been an important subject for her, more so since becoming a mother. Chana has let her children fill her poetry. "When I first started writing poems I wrote about the stories in Genesis and how they deal with family experience. How people are deformed by the experience of living in a family. Those elemental tales are very good reflections of what goes on inside a family. And I also wrote about love and relationships. But the children were a new subject."

Chana's face takes on a warm glow. She leans close and the joy in her voice increases. "I've written poems about being pregnant, about nursing. One poem 'Eating Babies' is about the experience of loving an infant which is a hands-on kind of experience. Jonathan was a very edible child with great big fat juicy cheeks. Just hugging and kissing him was a treat. The kind of tenderness you can feel loving a child is different from loving an adult.

"I've written about how children are puzzled or tripped up by what goes on in the adult world. At one point in his life Jonathan stuttered. I wrote a poem called 'The Stutter', about how I believe the stutter arose. We would all sit around the table talking very fast and he wouldn't be able to get a word in edgewise. I'm sure that had something to do with his frustration as a child. I've also written about our oldest son in his teenage mode. I find the two of them fascinating to contemplate.

"It struck me that these poems about the children are really explorations of my own childhood. One thing that having a child does is to give you a free ticket back. You have a chance to revisit the scenes of childhood and to understand them in a way that you might not have otherwise. And so in these poems there's often a reference to some event in my early life that is illuminated by the present."

As a mother she is most proud of her ability to listen well to her children, especially when one of them has a problem. "I try to figure out what's going on and to say something useful. It's very important to me to do that. In fact, it has been helpful to me in my own life. Sometimes when I'm very hard on myself, I can stop myself in the middle of a sentence and say, 'Chana, what would you tell Benjamin and Jonathan if they came to you with that problem? How would you treat them?' Because I can be very rough on myself and I try not to be rough on the children. I think that I do that well."

The hardest part is when she is *not* able help her sons with a problem. "I feel helpless. I would dearly love to be able to make things turn out better and I know I can't. I watch them struggling and give all the good advice in the world and I see that it doesn't touch the source of pain. After all, we are separate people and they have to live through the

ups and downs of their own lives.

"Bedtime was a total failure," she adds with a grin. "One hundred percent. An argument every night. I never figured out how to manage it. I also regret that I didn't figure out a good way of getting the kids to get up at a reasonable time in the morning. Jonathan at one point thought that socks and shoes were unfair to children. So we spent a lot of time on socks and shoes every morning. I see that in other families the kids get up at 7:00, alert and ready for life and I think, 'Why wasn't I able to give this?' It would have been a real gift."

"How much have your sons been around witnessing your artistic process?" I ask.

"They were always involved with my work. To this day, they're involved because I show them things that I write and they give me first-rate criticism. And they are very straight talking. They tell me exactly what they think.

"The first time I went away to MacDowell I called home at one point and I asked Benjamin, 'How are you managing without me?' His answer was, 'You probably want to hear some sentimental bullshit, but the truth is, you run too tight a ship.' I said 'Thanks for telling me. From here on it will be looser.' And it *was* looser. I thought that was a wonderful comment.

"I think it was Hemingway who once said that what a writer needs is a built-in shit detector. When you have a child in the house, you have a built-in shit detector. Children are honest. They tell you the truth about their feelings. If you can bump up against children in your life, you get tested in certain crucial ways. Having children forces you to come to grips with your own limitations, with your failures. And I

think that's all to the good. It forces you to grow up."

"How did *you* grow up?" I ask.

"I figured out that I can't do everything. That I can do some things well, but they may turn out badly even if I work very hard. Also I used to be a much more frenetic person. I was easily disturbed about little things. I have steady nerves now. I can face difficult situations.

"About six years ago I had ovarian cancer. At one point it looked as if it had metastasized to the liver. I had to have an emergency operation. The weekend before that operation I drew up a list of all the groceries we ever buy and put it on the computer so that my family would be able to order the food without me. And I went shopping with the kids and bought them winter jackets. I remember that very clearly. I brought a lot of strength to that situation. I think I got the strength from living in a family with my husband and my two kids in which we were engaged in daily problem solving. That's what a family is about.

"The children taught me a lot about my order of priorities. Years ago, I would have been distressed about a hangnail. Now I can understand more about the dimensions of what a human being has to face in this life. They have also shown me that a lot of things turn out really well. *They've* turned out really well. So there are many times now when I'll be feeling low about something else and I'll take a look at them and think, 'Well, you helped create those two.' It gives me enormous satisfaction."

"What are the things you want them to learn from you as an artist?" I ask.

"The most important thing I would want them to learn is to keep going in the face of disappointment. Life is never simple. There are

always surprises coming from left field. I've had to struggle with all kinds of disappointments. It took me a long time to understand that change is the most central fact of a human life. What I would want for them is to have a steady faith that when life is difficult, if they hang in there, things will eventually change for the better. It's important to live in a way that you yourself can respect, although it's not always possible, because we all do things that we don't like, or say things we wish we hadn't said."

Traveling to retreats such as the MacDowell Colony to write has been a recent activity for Chana. Since 1988 she has spent time at artists' colonies on seven different occasions. "I went for the first time when Jonathan was twelve and Benjamin was fifteen. Recently I met some women who went to colonies like these even when they had young children. The idea never occurred to me. I wish it had. I don't think I would have gone if a friend hadn't really prodded me into it. She said it would change my life. I was very anxious about going away but it turned out much better than I expected.

"The idea is that you have uninterrupted time for your work. You eat your breakfast and dinner with the other colonists and they bring you your lunch in a basket and you spend all day working. One of the things that happens in my normal life is that I get pulled into dealing with a lot of responsibilities. Poetry is usually last on the list and I don't write as much as I would like to. There, poetry was first on the list and I surprised myself by seeing how much I had to say. And that's an encouraging sign for me. When I'm back at home, even if I'm not writing as much, I can remember that other state of mind and not feel so frustrated.

"In the past I blamed myself. That was something I became expert at in childhood, telling myself that I had nothing left to say and there was no point in even trying. Now I understand so well that the whole enterprise is difficult. You have to be kind to yourself. To allow things to develop from very slender beginnings.

"One thing I do as a way of teaching myself this truth is to save rough drafts. I urge my students to do this, too. I keep them, date them, all clipped together, each poem in its own folder. And when something gets published I have a little ritual. I go back and take out that folder and look at what the poem started from.

"Often it will start from just one line or maybe even a single image. And I see how much I had to throw out and how much I had to work on it. Sometimes I'll work on a poem for years until I get it to the point where I think it's finished. A writer needs to have endless amounts of patience. I didn't know that to begin with. Just the way I thought you could get pregnant on the first try. I used to think a poem had to look good very quickly or else it wasn't worth bothering with."

When Benjamin and Jonathan were young, Chana worked on the dining room table. "Every time somebody would come to the house I would have to clear away all my papers and put them on a shelf somewhere, and then spread them out again later. And I felt very provisional about my work. Now I have a study where I work but for many years the television was also in there. In the late afternoon the kids wanted to watch some program on TV and I would have to pick up my books and go somewhere else or negotiate with them. Just the ability to leave things out and not to have to put them away is a major gain. I think people do need that kind of space. Jane Austen could write at the

kitchen table but she was a genius. Virginia Woolf was absolutely right about needing a room of your own. It may not be a whole room, it may be just a corner, but you need a place where you can leave your things open and unfinished and be able to go back to them the next day and pick up where you left off."

Chana is proud of her ability to work despite interruptions. "I don't know how it happened but in the course of being a young mother I did learn it. There would always be noise—sounds of conversation or fighting or whatever—and there would be plenty of interruptions. I learned that you don't have to be there every single minute. You can say, 'I'm working on something now, please don't interrupt me.' Sometimes I would say that and then I would sit listening with one ear to what was happening outside of my room. It was good for the children to learn that I was not there to serve them all the time. I was their mother and I loved them and I wanted to help them, but I also had a life and responsibilities apart from them. Maybe that gave them a sense of the real proportions of their universe."

We sit quietly. I have asked all my questions but I do not feel done. I inquire, "Is there anything you want to add that I haven't asked? Is there an area of your life that we ought to know about?"

Chana smiles and her eyes brighten. I am glad I asked. "I used to have a recurring dream that I loved," she says. "I would go into a house where I happened to be living and there would be a door that I hadn't realized was there. I would open it up and discover a room that I'd never known was in my house. And I would be immensely excited to discover this room. It always left me feeling elated.

"This summer it returned, not as a dream, but as a feeling. I went to MacDowell to write poetry and I started writing prose, to my amazement. I thought, 'This is the dream of the extra room. I've gone into a room that I didn't know was there. And it's been there all along.'

"That's one difference between being middle-aged and being young. When I look at my kids, I can see there's not a day in which they are not discovering a new room that they didn't know was there. That's the quality of being young. When you get to be middle-aged it happens more rarely. And I think that's what keeps people young, to go on discovering rooms in themselves that they didn't know were there. That's something I really hope I will go on doing forever.

"I met a woman this summer at MacDowell who's eighty and very vitally alive. I caught myself studying her, watching her. Then I realized everyone there was studying her and trying to figure out, 'How does she do it?' I would like to go on being that alive for as long as I can. And one way to do that is to go on discovering parts of myself that I don't even know about."

Chapter Six: Revolutionaries

As defined by Webster's Dictionary, the word revolutionary means "having the nature of, characterized by, tending toward or causing a revolution or drastic change, especially in a government or social system." All three women in this chapter fall easily under this definition. They want nothing less than a world where both mothers and artists are free to define themselves. They perceive the institution of motherhood as limiting and oppressive and work daily to challenge it. And they have all chosen art forms that, by their very nature, require us to suspend preconceptions about art and life.

In their lives both as mothers and as artists, Cheri Gaulke, Susan Banyas and Diane Torr seek to create a better world. For video, performance and public artist Cheri Gaulke, becoming a mother was and is a political decision that she faces daily. Being part of a lesbian couple raising twin girls, she answers questions from curious people every time she goes out into public with her daughters. And each time she explains that she and her partner are *both* mothers, she feels she has done a good deed by educating someone. Susan Banyas wants to bring the qualities of mothering into the art world. She started Dreams Well Studio, a space where she and other performers can receive true and loving support. Diane Torr, who leads "drag king" workshops, creates films and performs internationally, has not only consistently educated her daughter to understand and question sexism, she refuses to apologize for not conforming to any mothering role that doesn't ring true for her.

The art forms that Cheri, Susan and Diane have elected to work in contain strong elements of performance. This is not a coincidence, as performance has a long history of use as an agent of change. In her book, *Performance: Live Art 1909 to the Present*, RoseLee Goldberg wrote, "Within the history of the avant garde—meaning those artists who led the field in breaking with each successive tradition—performance has been a way of appealing directly to a large public, as well as shocking audiences into reassessing their own notions of art and its relation to culture." Through her performances and videos, Cheri has looked at issues such as nuclear disarmament, religion and sexism. Susan's work as a director, choreographer and performer reveals and examines the importance of everyday life. Diane walks the streets of New York City "passing" for a man and performs before audiences in various male personas.

In addition to performing, Cheri, Susan and Diane all teach, lecture and speak out regularly for their beliefs. They risk high visibility, acting directly against our training as women. Women are taught to keep quiet, stay home, think small and not expect much. This training serves to keep us safe in a dangerous world, since those of us who do express ourselves openly and loudly are often attacked. The women in this chapter are speaking out anyway.

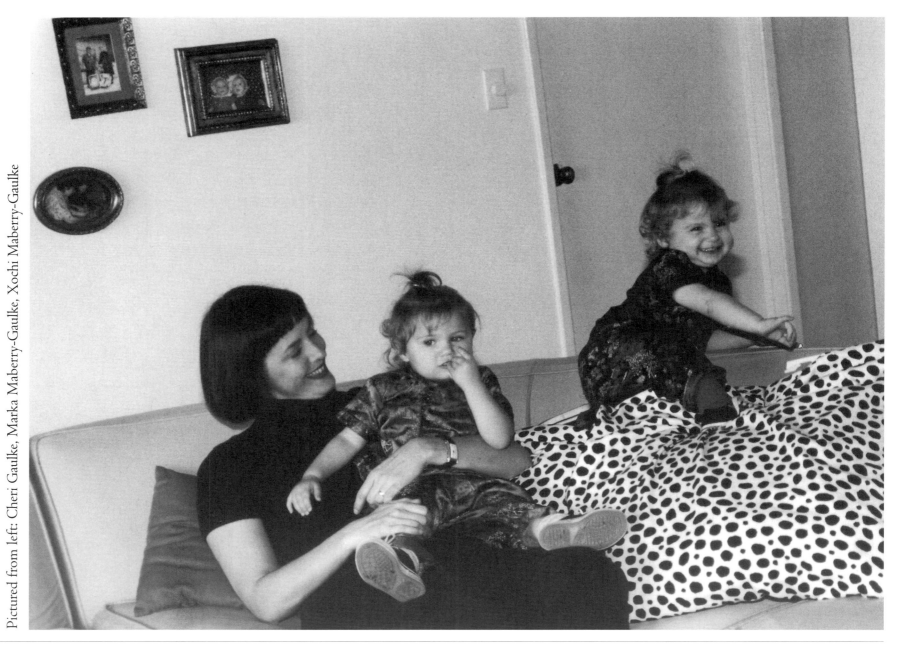

Pictured from left: Cheri Gaulke, Marka Maberry-Gaulke, Xochi Maberry-Gaulke

Cheri Gaulke, PERFORMANCE, VIDEO & PUBLIC ARTIST

IT IS 10:00 A.M. on a smoggy Saturday morning in Silverlake, a section of Los Angeles draped in and around the hills between downtown LA and Hollywood. As we drive up to the tall, modern duplex, Cheri waves at us from the gate, holding one of her twin daughters on her hip. She is dressed in black and her dark red hair is cut in a severe bob, circa 1925. She leads us up the stairs and we enter the house to the sounds of the other twin being changed by Sue Maberry, Cheri's partner of sixteen years. Xochi and Marka Maberry-Gaulke are eighteen months old.

So what are the facts here? Who is the mother? And how did two lesbians come to be mothers anyway? These are the questions Cheri and Sue have to answer every time they go out into the public with the girls. Cheri laughs as she runs through them. "'Oh, are they twins? Identical or fraternal?' We say, 'No, sororal' So right away we are educating people about language. 'Who's the mother?' And we say, 'We both are.' Which usually gets a puzzling look. People go, 'Wait, how could you both be?' Some people actually think we have biologically figured out how to split them and she bore one and I bore the other. Then I go on to explain that I actually had them biologically, but we're both the parents. Still sometimes they don't understand that. And sometimes I just say, 'We're a lesbian couple.'"

Always a public person in her art, Cheri has become even more public as a mother. In fact, she didn't come out as a lesbian at her teaching job until she was pregnant. "You can't be in the closet when you've got kids," she says smiling. "You are a target. You're out there in the public, people see you and sense that you're a family. They get that on some level."

Cheri is at ease with life as performance. Since 1974, when she discovered performance art while in Scotland participating in a program called Edinburgh Arts, Cheri has blended feminism, politics and art. After graduating from Minneapolis College of Art and Design in 1975, she hotfooted it to the mecca of feminist art activity, The Woman's Building in Los Angeles. It was an actual building for women artists (named after The Woman's Building at the 1893 World's Columbian Exposition in Chicago) started by Judy Chicago, Sheila de Bretteville and Arlene Raven. Cheri joined the Feminist Studio Workshop, a program for women artists housed in The Woman's Building. She later received an MA from Goddard College.

The content of her work has ranged from body image and religion, to ending nuclear war. Her art forms include performance, video, installation, books and public art, which she creates both in collaboration and alone. Cheri's strong sense of community is revealed in her art and elemental in her every day life. This sense of being part of a larger group has continued into motherhood. Seventy-five people attended

Xochi's and Marka's first birthday party. "It's really an extension of my years at The Woman's Building and the friendships that I formed there," she explains. "I am a really big networker. Sometimes I'll be in a room and I'll just stop for a moment and look around. And I realize that what all these people have in common is me. They have their own independent relationships, but at some point, I referred this person to that person."

This ability did not arise out of a vacuum. Cheri's parents, living in St. Louis, Missouri, far away from their families in Wisconsin and Minnesota, also had to build their own network. In their case it was centered around the Lutheran Church. "They would say to young seminary students, 'Oh, come over for brunch after church on Sunday.' They'd take the students under their wing. And then it was professional colleagues or other people in the congregation. I loved to just hang out and listen to my parents and their friends. When their friends came over I never wanted to go in my room and play. I wanted to hang out with the adults because I thought they were so interesting. So maybe I learned those skills from my parents."

Cheri sits back against a pillow and chuckles. "But I need a lot of people around me. I need an audience. And it's one thing you learn as a parent, too, is that you are no longer the center of attention. I've learned to take a back seat to my children."

Cheri was born February 28, 1954 in St. Louis, Missouri where she lived from age four through her second year of college. She has a brother four years younger. Both her parents are descended from German immigrants, the Lutheran Church figured strongly in her upbringing. As Cheri explains with amusement, "My family is four

generations Lutheran clergy and it's passed through the female line. My mother's father was a minister and her grandfather and her great-grandfather were ministers. The women either married or gave birth to ministers. In my mother's case, she was born from a minister, married a minister and gave birth to my brother, who's a minister."

Education was an important value in her middle class family. Her father came from a working class background, was the first in his family to get a college degree and has a PhD in Religious Education. Her mother stopped just short of her dissertation. Cheri's father worked for the Lutheran Church, but did not have his own congregation. "He is an editor and a writer, but he would help out churches that didn't have pastors. So a lot of times on Sundays we would drive a hundred miles to some obscure little congregation in 'Podunk, Missouri' and he would do the sermon. And then we would go on an interesting picnic."

Growing up, Cheri considered the Lutheran Church to be liberal. She was surprised when she discovered how conservative it really is. "I grew up in a house where I had a lot of permission to challenge ideas. We ate together every night and talked about ideas and philosophies. So I always had nontraditional ideas about things. I remember in grade school they were saying how awful LSD was and I said, 'Wouldn't it be potentially useful to have a drug to expand your mind?' I also remember imagining when I was young, that if I ever had children, it would not be in the context of the nuclear family. It would be in more of a communal living environment. I wanted there to be many adults and many children taking care of each other. It's kind of funny to me that I ended up being a lesbian."

Cheri has always thought of herself as an artist, for which she

credits her mother. "My mother introduced me to Georgia O'Keeffe, Käthe Kollwitz and the fact that there had been women artists in history. She noticed that I had some visual talent and encouraged it. I would do some illustration and lettering for her that she could use at school. And she would always 'ooh' and 'aah' about how talented I was.

"I really can't remember a time when I didn't know that I was going to be an artist. It's something that I really appreciate about my parents. I grew up in an environment where that was valued. I also think it's an expression of a middle class environment. You have this trust in the power of education and your own dreams. So I feel very lucky. I have friends who were raised working class and were heavily pressured not to be artists because they couldn't make a living that way."

Cheri admired her mother, who was an example of a woman who moved easily and professionally in the world. "She went back to school when my brother and I were in grade school and got her masters degree in education. She became a school counselor who worked with kids identifying learning disabilities and negotiating problems between kids or between teachers and kids. In some ways I always wanted to have a more traditional mom. Like I wished I had a mom that baked cookies and stuff. But at the same time I really admired that she was a woman pursuing her own career."

"I thought she was really cool and smart and confident. She always wore black. I remember in later years she had her 'colors' done and someone told her that she was 'fall.' Apparently she locked herself in her bedroom and wouldn't come out because they told her she had to get rid of all her black clothes. But my mother was very sleek and fashionable, and I would get her hand me down designer black jackets."

Despite being at the tail end of a bad cold, Cheri moves smoothly and articulately through the interview. Her own poise is strongly in evidence. Following her mother's model and both of her parents' ambition, she was raised to stand out. Her family cultivated the knack for being unusual. "We would never have the traditional Thanksgiving turkey dinner. I remember one year we went to Ruggatsi's which was a bar in the Italian part of town. It was a favorite place of my parents. You know, we are living in the midwest. So this is not the normal thing to do. But we went to Ruggatsi's and I had frog legs because it sounded interesting. I remember the next day being both embarrassed and proud when people would ask, 'How was your Thanksgiving?'"

The lack of accessible extended family also made the four of them close. They were a unit, facing the world together. That closeness extended to traveling, which was a way of experiencing other cultures and broadening their education. They got along well enough to travel twice a year on long car trips to places like California, Mexico and New Orleans. "We were always exploring a new place. So when you travel four people in a car, you have to get along really well. We even went to Europe for two months when I was in high school. We bought a VW camper van and picked it up at the factory."

Cheri received support from her parents, not only to be an artist, but to excel. She expected to be the best and was almost affronted when she fell short. "In the eighth grade I did this drawing of a field of daisies and my best friend in school got first prize and I got second prize. I was just so upset not to have won. She did a more formal arrangement of two red tulips and mine was a more wild impressionistic watercolor thing."

She also surpassed her classmates in imagination and sheer industriousness. Cheri's eyes light up as she remembers one particular assignment. "We'd have to do dioramas. Everybody would do this sort of ugly cardboard box that you peeked in and saw a scene. But I was very into Japanese stuff at one point. My bedroom was all Japanese and I collected Japanese stuff. I had this doll, so I made her a house for the diorama assignment. It had a roof that was made out of woven straw dinner mats that curved and came out at the ends. And I made her a little tree with flowers glued on it. And tatami mats on the floors. I made the shogi screens out of that fiberglass that had leaves embedded in it. And I used black electrician's tape to do the black lines. It was really amazing.

"In high school my mother would take me down to the St. Louis Art Museum to take art classes. I really loved being in the museum, but I hated the classes because they had us go around and find a painting we liked and copy it. It seemed stupid to me because it wasn't challenging. So I would go in the vast entry lobby of the museum and do body drawing. I would start to do floral patterns down my leg and on my knees. I would of course be wearing these short shorts. And I would attract a crowd all around me." Cheri grins. "I was doing performance art but it was my own little invention. I was making a spectacle of myself and my body. It foreshadowed everything I came to do later."

Always a maverick, Cheri's career has been marked by diversity and experimentation with new art forms. "I loved to do every kind of art," she says smiling. "In high school I did sculpture, drawing and painting. I did collage. I was very into experimenting with techniques." This refusal to settle for just one medium made things difficult when it came time to go to art school. Her voice rises in intensity. "I tried to get into Kansas City Art Institute after it had closed admissions, because there was a little window of opportunity for some extraordinary student. And I felt I was extraordinary because art was my life. And I really was very prolific. But they didn't like that I did everything. They were looking for people who were really strong in one area. And that really made me mad. I felt it was a strength. And in some ways I still deal with that in today's art world. It's hard to make a career when you do a lot of everything."

She then went to junior college in St. Louis. Fortunately, the school had a good art department and Cheri learned photography, drawing, painting and was particularly attracted to lithography. "I had this teacher who taught us that the litho stones had souls and you had to communicate with them. There was this spiritual dimension the way this guy taught it."

In fact, when she went to Minneapolis College of Art and Design Cheri planned to major in lithography. "But then I was exposed to video," she says laughing. It was the early seventies when artists had just started to use video. Excited by the possibilities, Cheri immediately began experimenting with multiple monitors and interactive installations. She also began collaborating with a friend Barb Boschka. "We set up a monitor that was focused on an image somewhere. You would have to find a partner and one of you would watch the monitor while the other would go find where the camera was, then position themselves in a way and create a composition. So a lot of the collaborative and interactive work that I later developed within feminism came from these early ideas that were more formal."

It was in the summer of 1974, one year before graduating from art school, that the pivotal event occurred which brought the powerful combination of feminism and performance into her work. She went to Scotland and participated in Edinburgh Arts, an art program led by gallery director Richard DeMarco. They visited contemporary art galleries and artists and also prehistoric sites, standing stone circles. "I was very affected by the power of these standing stone circles. They weren't contemporary art but they just resonated with incredible power. I wanted to make art that had that power."

She was also introduced to performance art through two teachers in the program, Jackie Lansley and Sally Potter, who were both well known artists in England. Sally Potter later became a filmmaker and made the film *Orlando*. "It just changed my life. I had been doing video in art school, which, of course, requires thousands and thousands of dollars. I didn't know when I got out of art school, how I was going to be able to continue that. So to suddenly be introduced to an art form that required no baggage, that was literally your body and maybe a few props you picked up at the thrift store and a specific setting that you had chosen . . . I was just so liberated by that. So that's when I decided to be a performance artist." Coincidentally, the group consisted of thirteen women and the content of their work became very feminist. "I went back to my art school where no one had ever heard of performance art. It was such a new art form, and there I was doing it, so I got put in a class for all the kids that didn't fit anywhere else called 'Intermedia.' We had a teacher who was just wonderful who has since died, Barry Kahn, who gave us critical feedback. And I continued to collaborate with Barb Boschka and do performance art."

Cheri then found out about The Woman's Building in Los Angeles. "They were not only doing performance art, they were doing feminist performance art. I was very frustrated in art school. I was trying to organize the women artists and the women art students were very afraid to identify as women artists, because that was seen as a negative and you had to just be one of the boys. And I didn't want to be one of the boys, I wanted to deal with feminist issues. So when I heard about The Woman's Building, there couldn't have been a better place invented for me. To actually have a place where I could do what I wanted to do and get the critical feedback. So I decided to move to L.A., which I did in the summer of '75."

She joined the Feminist Studio Workshop, a program for women artists that grew out of the art program at Fresno State University started by Judy Chicago. Cheri describes her experience. "There were about fifty women from all over the country and I think a couple from Europe. Everybody came with different areas of art expertise. There were writers and visual artists and performance artists and musicians. We had teachers who were all mentors, each in a different area of specialty. Like Sheila de Bretteville in graphic design and Arlene Raven in criticism and history and Suzanne Lacy doing performance. You could work with whoever you wanted but I also felt very influenced by the other ones. Graphic design and the whole realm of public communication that Sheila represented was really great for me to hear about. It was a program where, not only were we developing our own art and learning skills, we were developing the work in a feminist context. Giving each other feedback.

"We were also taking responsibility for running The Woman's

Building. It was a dual commitment to developing yourself and also making sure there was a place where other women could come and develop themselves and the public could come and see women's art. That really worked with my politics and my values because I've never been interested in art for art's sake. To me, art has always been a vehicle for social change. I don't want to just be a social activist, I want to be an artist. But I want to be an artist who has an impact on society."

Working primarily with performance artist Suzanne Lacy, Cheri's work took off. "I was going these places anyway, because of those early art works that involved interaction with the audience. Suzanne's whole notion of performance as a performance structure, that a performance isn't just a theatrical event but it could be a conceptual framework within which different activities happen. Her work 'Three Weeks in May' is a performance and during that three weeks, you gather statistics from the police department about where women have been raped in the city. You also do events and it's all a performance. So that's something that I embraced in my own work with Feminist Artworkers and Sisters of Survival." [ed. note. Collaborative groups of which Cheri has been a member]

Cheri came to The Woman's Building as a collaborator, since she and Barb Boschka moved to LA together, but ironically, it was the support she found there that allowed her to do solo work. "I did a series of sculptures where I dismembered and altered high heels. It was really empowering for me to not collaborate for a change. I continue to do both. I like solo work because I like to work out my own issues there. I spent years working out my religious background in my work. But I also love to collaborate because I think it really strengthens the work when you have another person to dialogue with. And challenge each other. There's the collaboration I'll do with a partner, like Sue or Barb. There's also a collaboration working with teenagers in East LA to do the 'LA River Project,' a video installation about the river, where I am both an artist and a facilitator for their voices. Or the video project called 'Out Loud,' which was working with gay and lesbian teenagers. It was again facilitating their voices, but I framed the artwork and gave it vision and form."

For many years, Cheri considered her art to be her child and legacy in the world since it was such a major part of her life. "How could I be an artist and be a mother? It was just too much," she says laughing. "Becoming a mother really grew out of my relationship with Sue. Sue wanted to raise a child. She didn't particularly want to have a baby. She wanted to adopt an older child, four or five or even eight. But then I thought, 'Well, if we're going to do this, I'd like to do the whole thing.' I had dealt with the body a lot as the content of my work, so I had always been intrigued with the experience of being pregnant and giving birth." She pauses and grins. "It sort of terrified me. But what could be more profound as a woman, to go through that experience? So I wanted to do that. So we worked with a friend who was our sperm donor and for a long time just tried to get pregnant on our own."

They tried unsuccessfully to get pregnant for about a year from 1986 to 1987. During that time Cheri did a performance called 'Virgin' which was all about, not surprisingly, artificial insemination. "I was the virgin, reclaiming the original goddess definition of virgin, which is not a woman who hasn't had sex, but a woman who is one and complete unto herself, which was a more lesbian feminist version of

virgin. It was about that whole experience of Sue inseminating me monthly. It had a lot of humor in it too, since it's a pretty humorous situation. Trying to get pregnant that way is kind of ridiculous. It has nothing to do with sex or romance."

After that year they decided to take some time off, since they "couldn't deal with it." Sue also had decided to go back to school and get a master's degree in library science. Once she was established as a librarian they decided to try again. "Of course, at this point I was thirty-nine. We tried for about six months, didn't get pregnant so we went to a fertility specialist. We found out that the sperm from the sperm donor we had been working with all this time, was not as good as it used to be. We had another friend who had always offered to be the sperm donor, so we took him up on it and got pregnant the first month with him. I was on fertility drugs because I was starting to face infertility. I got pregnant when I was thirty-nine and I gave birth when I was forty. And I guess the fertility drugs were what lead to having twins because I don't have any twins in my family and the sperm donor doesn't have any in his family."

But Cheri, even though she wanted to experience pregnancy and birth, was still concerned about being able to be an artist. So she and Sue worked out an arrangement. "It was always sort of a joke," Cheri grins, "but it was also true. I said, 'Okay, I'm going to have the baby and I'm going to hand it to you, Sue, and you're going to raise it. And I'll kind of help out, but it's your thing.' And she's like, fine. I felt lucky, as a lesbian, to have a woman partner. In a heterosexual coupling, most of the childcare falls on the woman just by default, although there are men who are the exception to this. And Sue was so

into it. She's such an earth mother.

"Then of course, we found out we were having twins. So it's like, shit. It's not going to go as planned. There's no way I'm going to be able to hand her twins!" Cheri leans back and roars. "I knew that I was stuck with having to take full responsibility. And I wasn't happy about it. I'm still not happy about it." Cheri stops, both laughing and crying. "It's hard," she says finally. "It's really hard." Her words come tumbling out fast. "And I absolutely love my girls. I can't imagine life without them. I just could cry at the thought of not having them in my life." She wipes the tears away. "But it's a daily challenge for me. It's really hard."

"What is hard, specifically?" I ask.

Cheri's head snaps up and frustration pours out. "What's hard is I work. I get up at 5:30 in the morning to prepare lunch for everyone. I go and I work all day and then I come home and I pick them up and then I take care of them until they go to sleep. I'm so tired I fall asleep when they fall asleep. So I have no time for myself or my work. People call me for things and they are lucky if they hear back from me. It's painful for me because I feel like a flake. I don't feel as professional as I like to be. I don't feel like I can take advantage of as many opportunities as are out there." Cheri slumps back on the couch and smiles softly. "I have to just know that this is a period we're going through. It will hopefully get better as they get older and become more independent. It was really hard for me the first three months when they were little infants and I stayed home with them. I was with them twenty-four hours a day. That was really, really challenging for me. So I feel lucky to have a partner who's so involved."

She also feels lucky to have a community that is so involved because the biological family support is negligible. "Although Sue's parents are very supportive, they are in Oklahoma so we rarely see them. My parents are missing in action because they disapprove of my lesbianism. They've never met Sue and we've been together sixteen years. They've met the babies once, after they had been alive for a year. Not seeing them was just too much for them to bear. They happened to be in LA on other business so they came and visited them for two hours and then left before Sue got home from work, because they didn't want to see Sue. So that's painful but on the other hand, we have such incredible community support. These girls belong to more than us. They belong to this community."

Cheri qualifies. "There's a smaller circle of friends who see them regularly. We can count on our friend Starr usually two times a week. Just totally loves the girls. There's about three or four people that are just always available. And now we bought this duplex with Elizabeth, so we actually have a person right downstairs. So it's like, 'Help! Come up! Hang out with us and the girls for awhile.'

"The birthday party and the baby naming ceremony and the shower were times where lots of people get to see them. And we also wanted to say thanks for all the help we have gotten. When the girls were born, our friend Jerri Allyn came out from New York and took care of us for two weeks. She got people to bring us dinner for three months. People had weekly commitments so we were really taken care of. We hardly had to do anything for three months. We have the calendar with all the people's appointments on there. And it's really awesome."

Cheri is also proud that, hard as it is for her, she doesn't take out that frustration on her daughters. "I'm not bitchy to them," she says. "They are little babies, so I don't think I've made them feel guilty. I don't say, 'You've ruined my life!' I don't want to paint that kind of a picture. I think I'm fun. I expose them to things. These girls are very cultured. They've been to many museum and art events. They are not little girls that stay home and play with their stuffed animals. They are really out in the world a lot. They have a confidence around being with people. And I like that. It's always bothered me when I'm around people that have children who are freaked out about strangers. I never wanted to have children like that. And I don't have children like that. So I'm glad."

"What's easy?" I ask.

"I think it's really easy to just enjoy being with them," she says after some thought. "You see, I spend a lot of time resisting. I have this fantasy that I can get things done when I'm around them. And I have to keep realizing that that's not the way it is. I really need to give myself to them. That's really all they want. When I try to accomplish something in their presence, or accomplish my own agenda, they get really crabby. It's because they want me. So when I decide that they can have me, it's easy. And it's fun. I can just lay on the floor and they crawl all over me, or whatever. And I love being with them."

"Have they affected your art making?" I ask.

Cheri nods. "They have, because my art usually has some kind of political agenda. So being a member of a lesbian family, I want to create safety and acceptance in the world for who we are as a family. I want to expose people to who we are as a family. In collaboration with Sue, I've done an installation called, 'The Families Next Door.' We net-

worked with other gay and lesbians with children and created an installation out of Sear's portraits. The other thing is when you're a parent, out with your kids, there's no hiding. Especially when you're with twins, boy, are you a spectacle. I've gone through it with each of the checkers at the market. Sometimes it takes repeated times of going through the line. Each time I get a little more specific. And you try to not drop the lesbian, the L word on people, because it usually freaks them out."

"Is it scary to be out like that?" I ask.

"It's a relief really. My sense is that people are much more scared of us than we are of them, because we're maybe challenging or threatening their values. But also the kids are so charming that it breaks down barriers. I'm committed to combating homophobia but sometimes I get tired of it. I just want to be left alone. But most of the time I feel like I've done a good deed for society.

"So it's changed my art in that I've done art about being a lesbian family. And I've just been generally more out. My video tape 'Sea of Time', which was in festivals all around the world, was about trying to get pregnant while our friend Mark was dying of AIDS. And that piece is very successful. It ends on a sad note because by the time Mark died, I wasn't pregnant. But then before I exhibited the piece, I became pregnant, so after the whole credit sequence, the ultra sound image of the girls in my womb comes up. And it says, 'Cheri Gaulke is expecting to give birth to twin girls in May of '94—and the audio is two little girls laughing. So that's really nice.

"For years I was afraid to reveal that I was a lesbian in my art work because I was afraid I would be ostracized professionally. In fact, when I did that piece 'Virgin,' all about trying to get pregnant, I fictionalized myself. There was a character, who I thought was pretty transparent, that was me. Her name was Mary and she was a performance artist living in Los Angeles who was a lesbian trying to get pregnant. Actually, it would have been a better performance if I had just 'fessed up and framed it differently. But I didn't feel safe. So I keep on getting stronger through being a parent." Cheri laughs loudly. "I'm like the fighting mother bear or mother lion and I'm going to make that world safe for my little cubs."

Cheri is still in the process of adjusting to parenthood. Her frustration at not being able to work when she wants to is slowly changing to acceptance. "I've had to realize that the time that I'm with the girls I need to just be with the girls. Since I'm a school teacher, my time is when I have my summer vacation. I get two weeks in the spring and I get two weeks at Christmas. And the girls are in childcare. People always say, 'Are you going to have the girls over the summer?' I'm like, 'Are you crazy?' That is my one opportunity to have my time. The girls still go to childcare and I get to do my artwork. I just don't have the energy any other time. I'm not a person who can stay up till midnight or 1:00 in the morning and work in my studio. I've never been like that. So that's what I do. I still do my work and I have to remind myself I do it in a particular time." She smiles and her face brightens. "I can't wait. I have one more week before winter break and then I'm going to get a whole week to myself.

"Everyone says this, but when you become a mother, you become more efficient. If I have five to fifteen minutes, it's awesome what I can accomplish. I don't fart around and procrastinate and bemoan and

whine or any of that stuff. You don't have time when you are a mother to feel sorry for yourself."

Cheri also sees, for the first time, how badly parents are treated in this country. She is rightly outraged. "It's amazing that our society is built on families and people having children, but I really don't feel like there is much support out there for having children. And that has really been an eye-opener for me. Even just things as simple as accessibility with a stroller. You really become aware of what it must be like to be in a wheelchair when you have a stroller. But I feel kind of bad, in a way, for all those years at The Woman's Building where I was such a committed feminist. I was really very insensitive to the needs of mothers. I remember when Sheila and a few women who were mothers in positions of leadership would say, 'Oh, we should have childcare.' I was always going, 'Oh, we don't really need that.' I thought they were whining or something. How hard could it be? Or, you want children, then you pay the price, kind of thing. I never really got it, until I had my own kids. People want me to go to their performances or go to this or that. You suddenly can't do anything without making elaborate arrangements.

"I think it's an absolute miracle that any woman who has a child who's an artist continues to make art. However she does it, it's an absolute miracle. Either she is lucky to be able to afford help, childcare or if she can't afford it, she does it in the wee hours of the night. Where she gets the energy, I don't know. And I don't think mothers are celebrated. And we really should be. I recently got an award at a conference at UCLA and I got up and I did this big testament to mothers. And not just mothers, parents. It's an incredible accomplishment."

Travel has always been important for Cheri. In fact, during the naming ceremony for the girls, one of the promises Cheri and Sue made to them was to show Xochi and Marka the world. So far, that has only extended to visiting relatives, which has been stressful since the girls don't like being in the car. "But this spring I've got a gig in Nashville and we're all supposed to go down there for like a week and I'm doing a lecture and a workshop. And it will be interesting. So I haven't done that yet. We'll see how that goes. We intend to go to exotic places with them when they are old enough to travel a little better."

Cheri's goals as an artist continue to take her more and more into the public. While pregnant with the girls, she designed a Metro Rail station [LA's recent rail system]. "It was supposed to be completed at the same time that I was giving birth to the girls. I felt this sense of giving birth to this station and giving birth to the girls. But that project has been on hold. They found out it was a toxic dump site and it may never be built. That is really depressing to me, that all the work that I did may never come to fruition."

As a public artist designing site specific pieces that involve communities, Cheri can bring together all her skills. "The way that I like to work in many media, the way that I like to have a community involved in my work, the way I like to respond to a place, be site specific. And it's such a collaboration. It's a collaboration with the community, with an architect, with bureaucrats. It calls upon levels of patience in collaboration that I never experienced before. It's very challenging. So I really hope in the future I will have the opportunity to do more public art. And I'll continue to do work about lesbian issues. And video is definitely something I want to continue doing."

She also plans to continue teaching at her job, which she loves. "Being a school teacher I don't make a lot of money, but I get great vacations. So I've oriented myself to having a life where I work for nine months of the year and then I get three months off where I still get a paycheck, but I can make art full-time. And that's not a bad thing. I've got a retirement. I've got health benefits. I get great faculty development grants to do projects. I can get a few thousand dollars to go off and do a project, as a way of developing my skills as a teacher. I happen to teach at a school that's well-endowed and is very supportive and I can be totally out as a lesbian and do work with gay and lesbian teenagers at my job. I really love it. I'll be there until I retire. It's my plan, unless somebody pays me a lot of money to go live in a foreign country. That's about the only other thing I'd rather do."

When I ask her what advice she would give to young women artists thinking about having children, she quips, "Don't do it." But she doesn't really mean that. She is glad though, that she chose to have her children later, rather than earlier. "I was a fully established person, knowing myself and very visible as an artist, before I had a baby. It would be very hard if you were a young, struggling artist, to not be overwhelmed by being a mother. You get out of art school and you haven't got a career yet and you're trying to build your identity in the world. Those are really fragile times. So I was able to go through that time and develop myself and feel more established and then have children. On the other hand, I'm tired, too. I'm more tired than a twenty year old mother would be. I'm a forty-one year old mother. So that would be my advice, 'Wait. Do the art first.'"

Despite her frustration, Cheri is very happy with her choices.

Motherhood has only expanded her life and given her a way to involve more and more people in her life and work. "In some ways, I see our friends more now that we're parents than before. We always invite people over. We want to be a house that's like Grand Central Station, a place where people just come through and people feel free to stop by spontaneously. And that's much more present in our life than it was before we had babies. Which I love."

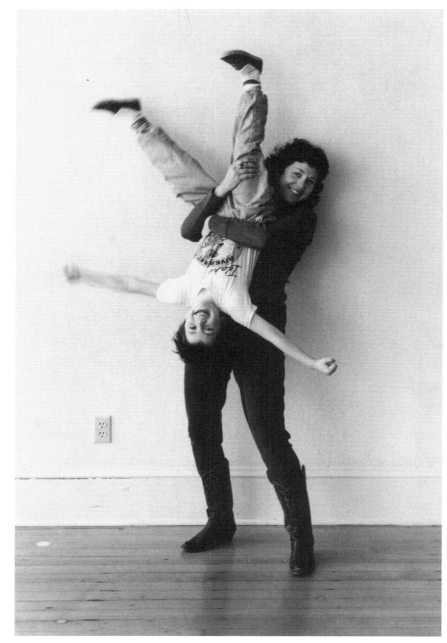

Pictured from left:
Jack Davis, Susan Banyas

Susan Banyas, *PERFORMANCE ARTIST*

THE FIRST TIME I saw Susan Banyas was at Dreams Well Studio, a performance space in Portland, Oregon that Susan founded together with some other women. She was performing a story/dance about her Hungarian background. Susan attacked the space, never still, mesmerizing us with a performance that blended dance, storytelling and acting. Reading her bio in the program, the words, "Honored to have become a mother in 1986" jumped out at me. I immediately tracked her down.

For the interview we sit in the living room of her small white house looking out on a huge rose garden across the street. She is a whirling mass of ideas that draw me in again and again. I want to know more, to be inside that sparkling hub for a little while. Susan's words and ideas experienced together with her physical presence all make perfect sense. But when left with words alone, heard over a tape recorder, something is missing. No wonder she insists on an art form that spans several disciplines. Susan Banyas creates performance pieces about the power of everyday life that integrate dance, language and imagery. She calls herself a composer of images and her work a marriage of feeling, thought and vision. They are as evocative and inspirational as the woman herself.

Susan Banyas was born July 13, 1947 in Millersberg, a small town in southern Ohio. Her father, the son of Hungarian immigrants, was a successful car dealer. Her mother descends from Quaker pioneers who worked as farmers and bankers in rural Ohio. She is a middle child in a family of three daughters and one son.

Susan has an MA in Interdisciplinary Art from San Francisco State University. In 1991 she founded Dreams Well Studio where she produces performance events and teaches classes and workshops. She lives in Portland with her husband Carl Davis who is a freelance cameraman and their son Jack Davis, age seven.

Since childhood, Susan's body has been her primary form of expression and where her power lives. She spent much of her time "adventuring and exploring outside." She and her siblings also had access to a pony which Susan rode regularly. Her face breaks into a smile as she explains, "I was a real physical kid and I liked athletics. I was kind of a tomboy and not much of a doll person. I was much more interested in going to the barn, scrambling up and down ladders." Her model as a child was Liz Taylor, based on the film *National Velvet*. "I wanted to have my own horse," she grins. "I wanted to be an elegant cowgirl. Actually that's still a model of mine; have a horse, dress nice and ride the range."

But she also liked to read and her imagination was fed by the small town surroundings. "When I think back to magical places in my childhood I think of the field, the barn, the outdoor spaces, the pond. My grandmother's house was also a constant source of amazement and

intrigue and imaginative play. And the library in our small town was really magical. It was a big old mansion turned into a library with a ghost in the attic."

Her mother passed away over two years ago, but remains a strong influence in Susan's life and art. As she speaks of her mother, the words come slowly and hesitatingly. "I don't know if she would have been a mom if she were born in a different time. She was an intellectual, not a physical person at all, which is a funny contrast to my dad. My dad's a big physical guy. She had a great sense of humor, but it was based on irony and a very subtle wit.

"She was a wonderful storyteller and good observer. I remember riding in my dad's old Buicks with the big back seats when we went to my grandmother's house on the weekends. It was only fifteen miles away, but for a kid it seemed like a big trip. I have strong memories of my mom telling me stories while we were driving. Usually describing novels that she was reading. She read incessantly. I remember falling asleep hearing her talk about all the characters. I just loved it. It set up a fascination with wondering what happens to people.

"She would also take us once a year to the Cincinnati Art Museum, which was a really big deal. It was a very mysterious place with big halls and things from Egypt and big statues and rooms of paintings. And she had this beautiful book filled with art masterpieces. It was our first introduction to looking at images. So she really was interested in art and it definitely set a tone in our family."

Susan stops and as if explaining it to herself as well as to me says, "There was a little confusion because it was hard for her to understand what I was really doing, why I wasn't famous or something. The

process of being an artist is internal. You can be making great leaps and bounds but nobody notices because it's not visible. Particularly as a performing artist when everything disappears in the moment anyway. However on a deeper level we really resonated in many ways. We shared a love of stories and a love of the observation of life and the translation of that into communication. We had a similar sense of humor and we had a very deep spiritual connection. She was raised as a Christian but she understood it as a form rather than fundamentalist text. She appreciated the beauty and the poetry that came through her religion. In her own way she was a lover of the arts and a supporter of my work.

"The pace was really different at that time. We had big back yards in that small town in Ohio. It was the fifties and people weren't working at night and all this craziness that goes on now. Families could cook out together. We had a lot of time with our grandparents, with my grandmother in particular. There was a lot of connectedness. We hung out at night and the kids played." Susan rouses herself out of the memory and says laughing, "My mom wasn't, you know, trying to be an artist, for God's sake."

"She was escaping into novels instead," I say, only partly joking.

Susan chuckles, continuing the joke, but there is clearly a kernel of truth in her answer. "Yeah, she would run off to the bedroom where the big feather mattress was, after finishing five million chores from raising four kids, and sink herself into a novel.

"I'm working now on a short piece with the working title of 'The Secret Life of My Mother.' It's not a literal probe into my mother's secret life, because who knows what that was. It's more a play with the

idea that everybody has a secret life. It has to do with one's relationship to their passion, separate from their normal domestic life. So it's been really fun to imagine that.

"In one of my favorite snapshots of her and me, we're standing together at the train station in 1975. I'm wearing this big vintage fur coat I found in an estate sale and I look like I'm from the forties. She's sending me off on my first trip to New York. I was going to New York to dance, you know, so this was real exciting. I had my little suitcase and I felt like someone in a novel going to the big city.

"It was just . . . she really wanted me to do it. I felt supported. It was exciting for her. It was something she never got to do. I don't know if she had ever entertained consciously the thought, 'Oh, I wish I could go to New York.' But there was a side of her that had a real passion for art in whatever form it took."

Growing up, Susan was the athlete and tomboy in the family and her older sister Martha was the artist. "It never occured to me that I could be one also, because I thought art was about painting and I was never drawn to that. I did take tap and ballet as a kid and loved them. My mom, bless her heart, told me once, 'You have a gift for music.' I played piano and flute. But I think what she was saying was that I felt the music. It wasn't just a technical thing. So I always felt there was a sensitivity that was recognized. I just don't think she had a name for it.

"There was a program in my family based on what my parents did. You go to college and you get a degree in teaching so if your husband dies you have a job. Maybe you joined a sorority and met a fraternity guy and got married. Then you had babies. I was really programmed to follow this game plan."

And she followed it, up to a point. Susan went to college, got a teaching degree and married a fraternity guy. Susan and her husband were then recruited by the Beaverton, Oregon school district and got jobs at a high school in Aloha, Oregon. Susan taught PE and Gary taught drama. Susan's eyes dance. "The marriage didn't work out but it did get me to the West Coast. I don't know if I would have gotten out here on my own."

The story of how Susan went from teaching PE to performing, directing and teaching performance is the common convoluted journey. While teaching high school in Oregon, Susan met Rosemary, the typing teacher, who was a kindred spirit. "We really connected in a wonderful way. We were wild together. It was during the sixties. Then she decided to join the Peace Corps and go to Africa, although I really wanted her to travel to Europe with me."

That relationship became the catalyst for Susan's own travel. She embarked on a two year journey, traveling through Europe, eventually living in East Africa for about a year and traveling through England on the way home. "It was really the beginning of my art experience. It really opened me up and changed my world. I received a vast pool of incredible images through living them and seeing how people think and express themselves. That trip really physically set in motion my images."

She returned galvanized to either become a lawyer or take dance classes. "I'm not exactly sure how I narrowed it down to those two, but I did. I had run the McGovern campaign in Ross County, Ohio in 1972. And I applied for a job with Ralph Nadar's group, didn't get the job and ended up taking ballet classes. I had taken some dance in col-

lege and loved it, but this really got me. Once I started, I was hooked."

Always hovering in the background was the wish to be a mother. "That was part of the plan that never left," she says giggling. "When I was young I used to imagine myself having many, many children. I had this fantasy of living on a farm and having a big farmhouse with lots of kids. I still can see that fantasy house. I still want to live in the country. Carl's from a farm family so maybe he is the farmer I wanted to marry."

But fulfilling this dream took some concentrated effort. "It was a big time choice. When I hit thirty I was really ready to have a baby, but I wasn't in a primary relationship. I was having serial monogamous relationships. I would meet people and say, 'Hi, how are you, do you want to have a baby? My sun sign's in Cancer.' It was intense.

"Then I moved to San Francisco to go to graduate school and met Carl. I was thirty-three when I met him and when I was about thirty-five I started saying we gotta decide this pretty soon here. Because if we're not gonna get married and do this thing with babies then I have to move on. Meanwhile, I'm in graduate school pursuing my passion. I didn't ever stop that process because it's real core to my being. But I really wanted to do this family thing.

"Anyway, Carl finally went, 'Oh well, okay.' We're still dealing with the repercussions of the process we went through. We got married and waited awhile because he wasn't ready yet. But I finally said now and threw the diaphragm away and got pregnant immediately. It was a very conscious decision and Jack was really ready to come in because he came blasting in."

Susan is happy to be a mother, but she is also ambivalent. That ambivalence lives alongside wonder. "There is a part of it that is very natural to me," she explains. "I like children and I like their reality and living in proximity with a child. I like the nurturing qualities of it. I enjoy Jack a great deal. It's an intense emotional experience. There's all this incredible emotional range that you get from mothering. I found out that there is this whole group of people called mothers that I have a relationship with that I didn't before.

"What I've had a hard time with is the conflict between my first child, art, and my second child, Jack. I can't leave my first baby, I have to keep my first baby going, too."

Even so, she has been able to use her creativity in her mothering. "I'm good at tuning into where he is and responding to him. I think that has encouraged his creativity. It's been real organic. I don't want to push him into anything. I'm fun and I'm good at creating adventure. He and I used to take lots of little adventures. We would pack our little snacks, get on the bus and get off at a certain place, like a fountain and then get on the bus again and go to a different place, ride escalators up and down. The city is such a great playground and we would just go play in it.

"But I catch myself a lot of times not listening. Not being very present. People say kids are easily distracted. I think kids are just fine. I think parents are easily distracted. I often am not paying attention to him, to what's actually happening right then and there, and to the emotional undertone of what he's saying. Basic stuff. I'm like overriding the phone line. Needs, thoughts, phone calls I have to make, just a million and one things."

As we talk, Susan is in motion, jiggling her booted foot, getting tea

and coffee, answering the phone and doorbell. Soaring above our heads are ideas that fly from her to me and back again. I wonder how mothering has affected her artmaking.

"Very deeply," she answers quietly. "He feeds my work a lot. Kids are so creative. They are direct little conduits from the universe. There's no editor. So I just watch him and it's a source of inspiration. He's really a beautiful mover. He started doing this little dance with a large river stone. He stood on top of it and did a balancing dance. I thought God, that's really amazing so I took it over to the studio and created a whole little piece with it and now it's part of my repertoire. Kids are honest. I hope my work reflects that same honesty and that it springs naturally from my core."

"Did your work change?" I ask.

"Yeah," she nods. "But I don't know how much of it's a function of being a mom. It's hard to know. I can't separate those things out because they are so integrated. But now I'm pulling things together that were off in separate territories before. I've always been interested in integrating the storytelling and the movement and the imagery. It's just starting to happen in a deeper and more thorough way. That's part of what mothering has taught me. It's actually been a celebration of the process of improvisation and has strengthened that aspect of my work. It has made it more spontaneous and heartfelt. My work could have definitely gone off on a cooler direction."

I cock my head. "Cooler?"

"Cooler in the sense of being a little more hard edged. I think you always have choices and I still could have been working with personal material but I could have taken it in a different direction, formally structured and so on. I'm interested in directness and Jack models that to me every day. One of the little prayers I say every night when I put him to bed has to do with being grateful for the opportunity to learn from this child. He teaches me incredible stuff every day."

"What do you want him to learn from you?"

"I'd like him to learn more about being kind. But you have to watch what you ask for. When he was in utero I would do this Hottentot prayer, they are a tribe in southern Africa. The prayer was something about 'I want a good strong boy.' It's this prayer about mighty thighs, a good strong penis, a warrior. But I want him to be a peaceful warrior because in some ways I am one. We need good strong spiritual warriors. I don't know how he'll turn out but I'd like him to have strength and lots of courage and continue to evolve as an expressive, dynamic human being.

"It sounds like what you want for yourself," I say.

"Yeah, I think so. I was thinking the other day about my parents saying, 'We just want you to be happy'."

"I got that one, too." I say, howling. "What is happiness? It's a pretty nebulous thing. Give me something more concrete."

"Right. I want you to be rich."

"Yeah, that's more concrete."

"In some ways I understand the sentiment," Susan continues. "I want my child to find a certain contentment with who he is. That's one of the reasons I created Dreams Well. I want to make art just the way I want to. And I want to feel good about it just the way it is."

Starting Dreams Well was a turning point in Susan's career that arose out of her need to find a studio. Interestingly, like the earlier

turning point, it also coincided with a trip outside the United States. "When Jack was three, Carl and Jack and I took a trip to England and Wales. Carl had work over there and I really wanted to go with him. I was at a point in my life where I was either going to ditch this attempt to be an artist and a mother or embrace it.

"Jack and I were standing in front of Dylan Thomas' boat house in Wales where he wrote. Now, Dylan Thomas is one of my all time favorite poets. He is an embodiment of beautiful imagery and voice and passion. Impulsively, I asked Carl to take a picture of me and Jack. I suddenly understood that what I really wanted was to find a place in my heart, and also in a physical sense, that would embrace my child and me, my role as a mother and my role as an artist.

"When we got home I hung that picture up and and started looking for a studio. It took me nine months to do it. I kept that little picture up and cut out another picture from a magazine of a space that I really thought was beautiful and made a little altar. I scheduled time to go look for it, three hours a week and looked and looked.

"One day I decided my muses might be all confused because the two images were opposing each other. The beautiful open room from the magazine had a really different feeling from the Dylan Thomas image that looked out on nature and an estuary. I looked out from my living room window at the beautiful rose garden across the street and decided I had a studio at home that looked out on nature. So I took the Dylan Thomas picture down and within a week I had found Dreams Well Studio. And it looks exactly like the picture from the magazine. So I knew I was on the right track.

"I decided I didn't want to be entirely financially responsible for it.

And I also wanted to put in motion this idea of creating a supportive atmosphere with other women, where we could actually do experiments and feel safe doing them. So I asked a couple of women that I trusted to join me and we began to build a studio together. We work very independently and that was also structured in right from the beginning. I was not interested in a collective. I was interested in having a place where I could do my own experiments with support and also support others. We finally named it Dreams Well, through a process of considering images that suggested nourishment. I love the image of the well. The well is the place we go and the dream is the vision."

I am impressed by the importance Susan gives support in her life and I ask her to describe how that works for her. Susan nods rapidly. "I recently did a solo show called 'Quartet.' I asked a different director to work with me for each of the stories so each one would have a different flavor and approach. There was a movement piece, a piece that had character and voice to it, a piece that was more about images and so on. And I asked not only these directors, but a few of my women friends to come and see the work before I did it, to give me feedback.

"When I was getting ready to go on, which is somewhat terrifying, I looked out at this group of women sitting there in my little space, on their little chairs and I got this great love feeling. I thought, 'This is it. This is what I have been looking for all my life, this kind of support.' I knew those women cared about me, cared about my work, wanted the best for me and were going to put all of their own expertise into watching me, helping me and supporting me in my vision. I thought, this is what being in a tribe is all about. This is the scale and model that I've been trying to create."

Susan is doing more than just creating her own work. She also wants to change how the world sees and understands art. Hence the importance of Dreams Well and what happens there. She goes back to her experience of support. "It was a really different model than what one usually gets in the art world. And it felt really good. I knew it was going to be honest and my work would be formally addressed, but I also knew I would be loved through it. It is a model that is really based on a mothering quality. It's not based on the fatherly concern for justice and a moral superiority. It's based more on an embrace."

Susan is not only revolutionary in her goals for how art is treated in the world, her work itself challenges the current standard. "My work is about finding transcendent moments in the common experience of daily life, the family and the flow of relationships. It's not unlike the Amish way of life where they pray five minutes and the rest of the day is the work. That's not necessarily well received in the art world. I've had a very mixed experience as an artist, from complete rejection to support. When work is done, whether by a man or woman, that has a strong emotional or sensual base to it, it often gets less respect than the more analytical, conceptual or political work. This is also complicated by the confusion about what performance is—theater? dance? The theater of images is not mainstream, though it has ancient roots. People who really see—open up heart and mind—love and support this work."

Susan has also made the choice not to travel for her work right now. "I gave it up because it was too complicated," she says. "I had this fantasy of getting on the performance network. An opportunity came up at one point to do some directing in Baltimore. I started to work out the logistics of it and I thought, I'm not in the position right now to do that, mainly because Carl travels so much in his work. If both of us were traveling, it would be impossible. It would be a lot of stress on Jack and would be asking a lot of our friends. I just thought, I'm going to let go of the travel idea.

"And actually it's been fine. Staying here has helped me focus and root my work a lot more. And the travel thing will happen, if it's going to happen. I have shown my work in Los Angeles, San Francisco and Seattle and it was marginally satisfying. And I'm not sure what the payoff is. I'd like to do some more regional teaching, like take the teaching process I've been developing and share it. That interests me a lot more than performing. Although that may change when Jack's a little older."

In years past, Susan has worked "all kinds of weird jobs, from selling cars to making pizza." She now considers Dreams Well her small business. "Right now, the bulk of my income is from teaching, maybe a fourth or third of it from directing and producing gigs. A tiny bit from performing. I can't sell work, it's not a commodity like painting. I can only sell my services. I don't know anybody in this town who makes a living performing.

"Carl and I have always pooled our money. In his work as a freelance cameraman he's well paid, but we never know when his next job will come. I really need to stabilize it with my contribution. And also, I want to be financially independent. But money is a sensitive issue. I work really hard and make about a third of what he does. He's paid commercial rates. It's not his fault, but it sets up an imbalance. The amount a company like Nike will pay for a little three minute ad would support the arts in this city for about five years."

Susan consciously works to make sure that she is nurtured. This takes the form of commitments to herself. "I have to be Daddy *and* Mommy in a sense. In the class I was teaching this morning we were working on choosing where our focus will be. I can nurture myself just by shifting my focus to another place. For example, I need to look for a studio today or I need to work on that application or I need to make those phone calls or I need to think about this poem I'm writing. Or I can shift it right to the other side and give myself an hour and blast into outer space and not care what I do and say. I have to listen to myself and hear what my little voice is saying."

Balancing the various aspects of her life is illusive. "It's like happiness, very hard to achieve. It's probably like enlightenment, maybe you have a glimpse of it every once in awhile for about three seconds and then it's off. One therapist suggested that I look at my work seasonally. It was actually a helpful suggestion. You will naturally have more action in certain seasons so don't sweat it so much during the off season."

Housework is not a nemesis to her, but an outgrowth of her working process and a tool for centering. "I actually like housework quite a lot. I'm a home person. I like dusting, turning the music on and taking my time touching my things and rearranging the pictures. It's very centering and I often do my best thinking at that time. Again, I'm moving around and doing something, but it's free form. I brought all my props home from the last show and set them up in the living room. All I do really, is create little worlds out of things around me. As far as cooking and laundry and grocery shopping and the maintenance stuff, Carl and I try to split that up."

Another thing she has done to make sure that her life is balanced and supported is set up play groups. "Luckily I've had really wonderful women friends who are my age and in similar situations. There were four of us who would trade and have little play groups. Our kids are still very close. It gave me time to get back to my work, even though it was in small increments at first. I felt really supported by that group of women. I know it doesn't happen for a lot for people. They feel real isolated.

"I still tap into those resources constantly. If I have a day workshop or something, I call Donna and we get it set up and the kids play for a day and I know he's safe and with his best buddy. If you can get with other artists it's great. I never have done daycare very much. Luckily friends have come through.

"Time management is another issue. I have learned an important lesson as a mom. If I don't put it on the calendar it doesn't happen. I say, 'No I'm not available, this is my work time.' As an artist you have your studio time, your creation time and then you have your money making time, plus your mothering time. You just have to make the time available to yourself. If I don't, I go crazy and I'm not a good mommy, I'm a mean mommy. I've set my little stations up around the house so there's a drawing table so I can go over and make a little sketch real quick or I can write down an idea. Things are happening in the kitchen and I can go out to my desk and make a quick phone call. It's all integrated and easy access. I don't feel trapped like I can only be an artist at certain times."

Susan's solution to frustration is innovative and transformative. "About three or four years ago I was really frustrated about not having any time. I didn't have my studio so I decided I would do image cards.

I had used them in a class I taught so I thought, I'm going to do that assignment for myself. It turned into a whole spring of exploring my work through images when I couldn't get out and dance. But it wouldn't have happened if I hadn't had that limitation placed on me.

"The Buddhists say there's a tenth of an inch between heaven and hell. It's an attitude adjustment. When I'm frustrated I have to figure out how to deal with it. It might be a logistical change like I need more time during the week or it might be that I need to change my approach. Or it might mean that if I invite another child over then I have more time because they are engaged. Or it might be a more deeply set pattern that I'm struggling with from my own childhood. My way out of frustration is to explore the frustration and see if I can get to the source of it and see how I might change. Sometimes my frustration comes from fear that life is gonna always be this way and I can't change it. If I can soften the edges and go into the experience, there is often an insight for me."

Like her artwork, which is organic and always growing, Susan's model for her life is still in process and probably always will be. "If anything my advice would be to find a model that works for you. It will be different for different people. I don't think the old model of giving it all to our kids is healthy. We all know we suffered from it."

"What would it be like if you *had* to choose between your child and your artwork?"

Susan shivers. "*Sophie's Choice*. Did you ever see that movie? Heartrending." She looks at me seriously and quietly. "I think you have to make that choice every day. The answer is sometimes you choose your art and sometimes you choose your child. It's tough. It's like ask-ing you to choose between life and death. You choose what will keep you living. Letting go of your creative life in some ways is small death. We all have a creative life, it's just that most people haven't tapped into it.

"In the last few days before my mom died there was a real sadness and melancholy in her. We didn't really talk because she had a stroke and her thought processes were impaired. But I asked her to do some writing in her journal about an early memory. She wrote about sitting in the living room and writing when she was younger. (I can feel the emotion coming up right now.) Writing as a young mom, but how she never felt worthy. I think people should feel worthy of their art. I wish that she had felt her writing was worth something, because it was."

"Would you consider leaving your family if you had to in order to do your art?" I ask, expecting the typical horrified answer. This time I do not get it.

"I would consider it," she says. "I think it's good to consider things like that. The reason is what I spoke of before of finding your own model. It's not just the issue of being a mother, it's also a question of being a woman in this culture. There's a lot of exploration that can be had as a women and as a mother and as a partner. Carl and I are exploring this, too. I think it's fine to entertain lots of different thoughts. I do. Including not being with your family.

"I sometimes think when Jack is older I would like to go off for three or four months and just be alone. I'll see, that's something that will evolve. He's a little young yet and I'm not ready to do it yet. My family provides a certain foundation that's very important right now. My home is one of my great joys. However, I do entertain thoughts of

having my own place sometimes and being free of the family and the domesticity. Carl has these same feelings.

"One of my models that I came up with recently is the circle with the core in the middle and spokes going off. The core is the work, the art, the dance. Sometimes the work is artmaking and sometime it's teaching or whatever. The wheel includes my son Jack and there's Carl and my dad and my friend Louise and the studio, my garden and my cat and my time in the country. There's a channel that gets activated through the work. It can be real strong in a certain direction for awhile. Then another spoke gets activated. You don't have to be deeply involved with your family at all times. I can't work that way, it's too oppressive. I love my family and I love the work."

We are almost done. I ask one last question. "What are your dreams? What do you want to happen in your art and your life?"

Susan leans back in her chair and mulls over the question with delight. "I want to tie back into the idea of mothering as improvisation," she says finally. "I would like to live my life in a very spontaneous way but with enough structure around it so I don't end up in a ditch somewhere starving.

"I want to live life fully. What that means in terms of work, I don't know. The work will take care of itself. I want to connect more with nature and have nature be a part of me. I am pretty urban right now and I feel out of balance that way. I would like to bring the Great Mother into my experience with the natural world. Trees and skies and birds and moon. I like to think of myself as a priestess to the great Aphrodite. I just want to develop a big heart and have lots of love in my life.

"As far as the art world, I would like to see more acknowledgment of women's work. Issues of mothering are underexplored in terms of art. There's a ton of bias about it. I would love to see that just go away. And it's not just issues or content. It's an art process that invites playfulness, sensuality, passion, chaos, synthesis. My own experience as a teacher shows me that people love that side of the work, it nourishes the creative spirit. Institutions and art education in general haven't developed a healthy respect for these qualities yet.

"I'd like to see more acknowledgement for mothering in general and for people to see that mothering is a great quality to develop. It's not just about having kids, it's about a whole way of being. It's nurturing and supporting and embracing others and connecting. It would really balance our world."

Pictured from left:
Diane Torr, Martina Torr

Diane Torr, PERFORMANCE ARTIST

DIANE TORR LIVES on the edge of Harlem, in a fourth floor walk-up, within spitting distance of the northwestern corner of Central Park. We ring the bell at the front door and two minutes later it is flung open. A medium-sized woman with flaming red hair, wearing flowing tie dyed pants greets us and leads us upstairs. Diane and her family which consists of her husband Marcel Myers who is Dutch and their daughter Martina Torr, twelve have just moved into the two bedroom apartment, and it is still raw with boxes and a half-finished loft bed in evidence. After serving us calming tea, Diane notices Chris rubbing her sore feet and swiftly makes up a lavender-laced foot bath. "I do this with everyone," she explains. "It's just part of growing up in Scotland where, to inconvenience somebody is the worst thing you could do." After trudging all over Manhattan being cared for does feel good.

Diane Torr was born November 10, 1948 in Peterborough, Ontario in Canada. But when she was four, the family moved back to Aberdeen, Scotland where they lived until Diane was fourteen. She has two older brothers, one of whom died of AIDS in 1992. Her English father and Scottish mother had emigrated to Canada after World War II but due to her mother's health problems, they returned to the United Kingdom to take advantage of the National Health Care Program. Though definitely working class, Diane's father had hopes of rising up on the socioeconomic scale. In Canada, the family started a

bed and breakfast business but the mixture of health bills and the lack of help from Diane's mother caused it to fail. In Scotland, Diane's father worked as an inspector for an aeronautical tool factory. Her mother, who died when Diane was sixteen, stayed home until Diane was ten and then worked as a secretary.

Diane Torr is a performance artist and dancer whose work deals with cross-dressing and gender issues. She conducts "drag king" workshops all over the United States and in Europe, in which women get a chance to experience the world dressed as men. Diane is a subversive and a visionary. She has seen the underside of society and emerged with a clear vision of how the world works, especially for women, and is outspoken about her perceptions. Refusing to take anything at face value, she uses her considerable intelligence to question and evaluate what she sees happening in the world.

It started early. Growing up with two older brothers framed her relationships, not only with other people, but with the world. "One of my earliest memories is of them cycling off on their bikes and leaving me behind with just a tricycle. I pedaled five times as fast to keep up with them. I guess it prepared me for being a woman in this patriarchal culture. I'm a fighter in the sense that you can't leave me behind. I insist on being included."

Diane also formed an alliance with the younger brother, who was

gay. "We had white mice together," she says smiling. "His was called Joey and mine was called Judy. We also had goldfish together. My elder brother killed our goldfish out of revenge once, because we were ganging up on him."

Diane's connection with her gay brother also set the stage for her later work on gender issues. "I really enjoyed my gay brother. We used to dress up together. And we would exchange toys. I hated playing with dolls, so he would play with my dolls and I would play with his trucks. I remember him racing my doll's pram around the block." Diane and her brother would also exchange the sex-linked chores they were given. "He would do the dusting and I would dig in the garden."

In many ways, Diane's mother personified the limited female role Diane was fighting against. She was a sweet women, who went to the Scottish Presbyterian Church every Sunday. She also had a beautiful soprano voice and sang in a women's choir. But her relationship with Diane's father was unequal. "She wasn't a match for my father at all," Diane explains, her voice becoming rough with anger. "He really dominated the family. I resented that a lot, because when I got to be older my father was quite abusive. I would intervene when he was beating her up. I hated having to do that at the age of thirteen, fourteen.

"My father went away one summer and my mother and my brothers and I had the whole summer vacation together. I think I was about nine or ten. We would help my mother clean the house and wash up. And then we'd all go out and have a picnic in the afternoon. Our lives were so much more pleasant without my father. We begged my mother to divorce him and we even said that we'd stand up in court and testify.

"I remember the day my father came back. I hadn't even seen him yet, but I could feel this oppressive atmosphere in the house. We really felt let down when my mother didn't come through for us and that we were going to have to live with misery guts. But economic dependence is a serious issue. When you are nine or ten years old, you don't realize that. We could go and hang out with her all day long, because she wasn't working and my father was sending money home. All we saw was that it's fun with Mum and it's a bore with Dad. And not just a bore, it's really a horrible life with an alcoholic."

After a moment I ask, "What did you learn from her?"

Diane's face softens and she smiles with the memory. "I learned how to love. She was a very loving, sweet hearted person. Kind. In Scotland at that time there were still a lot of people who were pretty poor. It wasn't uncommon to see people with rickets, for instance. One time she was on her way to work and we were catching a bus together. She saw a boy with rickets and gave him her sandwich from her lunch. But this selflessness and the denial of herself, attributed to her not getting out of the situation."

Diane's voice becomes agitated as she continues. "She believed very strongly until death us do part, because I don't think she would ever leave my father. In the end he really broke her spirit. That's how I see it. My father would say it was something else. But I saw it happen and I lived with it. Her love of God and humanity, and her ability to sing through adversity was how she got through life. She was living with a man who was very abusive and did not appreciate her kindness or lovingness at all. I really resented her for not being strong and more courageous. But what examples did she have? She didn't have any examples."

Throughout her life, Diane has had the ability to separate herself from difficult situations around her. Instead of internalizing them and feeling at fault, she has consistently fought and spoken against what she knows is wrong. This clarity was invaluable during her teenage years, which were, in Diane's words, "troubled." She was fourteen when they moved from Scotland to England—a very bad time to move. "I had already made very strong connections in Aberdeen with other kids. And suddenly I was moving to a place where they just ridiculed me for my Scottish accent saying, 'Sit ya dune' and all this stuff. So I developed an English one as quickly as possible so I would fit in."

After the move, Diane's mother also stopped paying attention to her health. She collapsed on the street a year later with cancer. "So my mother was in the hospital and my father and I were living at home together," Diane explains. "My elder brothers had both left home. I was the one person around that my father could let out his feelings on. He would beat me up and I would be covered in bruises. But when I went to the local doctor and to the head of the school nobody would do anything.

"My father and I were really at loggerheads. I knew he was going to kill me. One night when I came home from the movies, I could hear my father banging around in the house and I knew exactly what kind of a mood he was in. I hadn't actually asked permission to go out and I didn't have my key on me. After fifteen minutes of buzzing the door he finally opened it and there were all these veins sticking out on his forehead. He said, 'Get inside you bitch.' I just turned about and ran. I was sixteen at that time and on probation [for shoplifting]. I never went back to live with my father after that.

"I went to live in Picadilly Circus, which is where all the runaways lived at that time. I was a virgin when I left home but I wasn't a virgin for very long. I ended up being put up by these guys, male prostitutes who fucked me one night and I got gonorrhea. The police were looking for me because I hadn't shown up for probation. My father had also reported that I'd gone missing. I was on the run for seven weeks. Finally my gay brother was tired of the police coming to his door trying to find me. He also felt there was no other recourse but for me to be picked up by the police and deal with the fact that I had broken probation. I met him on the street one day and when two police walked around the corner, he volunteered me to them."

Diane then spent thirteen weeks in a detention center and while there, her mother died. "As a special favor," Diane says with a bitter smirk, "they allowed me to attend the funeral, but I had a guard." She was sentenced to three years in reform school where she rebelled immediately. "I had a choice of being a factory worker, an office assistant, a domestic, a typist or a gardener. I told them I didn't want to do any of those, I wanted to take my O levels, which are sort of like high school equivalency exams. They said it was impossible, because nobody from any reform school had ever done that. But I just held fast to this idea that if I'm going to be locked up, I'm going to advance myself in some way. So one day I woke up, and they gave me these exams to take. I didn't have any preparation, but I passed. And then they allowed me to go to this continuing education college to study for the advance-level general certificate of education, which you need to go to university. It then created a precedent so that after that it was possible for girls to go to continuing education college from school. They still wouldn't let me

leave, because I didn't have a skill. So I studied typing while I was there and became a typist."

She smiles with satisfaction and leans back in the bean bag chair. "I've always been this sort of radical. Always looking for a way to improve and advance the situation." In fact, while in reform school she did a survey of all the girls and found out that ninety-eight percent came from broken homes. Either the father had left or the parents were divorced or they had a second father. Many of them were abused. "I came to the conclusion that we were there not because we'd done anything wrong, but because of the situation in our families. Most of the girls felt they were victims. But I certainly didn't want to be a victim. I wanted to try to understand the situation with another point of view."

"You seemed to have a belief in yourself that the others didn't," I offer.

She nods. "I think my gay brother really helped me with that. He always had an ambition. He wanted to be a millionaire and he succeeded. But he died of AIDS before he could even enjoy it."

It wasn't until she was in her twenties that Diane discovered art. "I tell you, I never really imagined I could be an artist," she says in wonder. A trip out of Britain when she was twenty-two opened her eyes to that possibility. While working for an agency in London which helped people who had landed in jail on drug charges while abroad, she took a three month trip through Turkey, Iran, Afghanistan and Pakistan, visiting people in jail.

Diane remembers it with excitement. "In the process of traveling I would meet musicians and dance with them. I had brought some Scottish country music with me and I did some Scottish dancing and taught it to people in these villages. The whole village would get involved. I found that dancing was giving me so much joy and I thought, 'I don't want to be an administrator for wayward hippies. Perhaps I should pursue dancing.'"

Upon returning to England, she went to Dartington College of Art and began studying dance. Among her teachers were American dancers Steve Paxton and Mary Fullkerson, who were part of Judson Church, a dance company that revolutionized dance in the sixties. They introduced her to the idea of the dancer as artist, rather than technician. In 1976 she came to New York City, planning to continue studying dance and to create a career as a dancer. "I thought this was where the action was. When I got here, the dance community wasn't anything like it had been and pretty much everybody was involved with pedestrian or minimal dance."

Diane started to explore the performance art scene instead. It made sense to her, since she had always been interested in narrative and concepts more than pure movement. "I always think in terms of writing. So even though I was a dancer, I was still dealing with concepts of writing. I would perform at St. Mark's Poetry Project where there was anything goes improvised type of performance. I also had a lot of friends who were visual artists and filmmakers. So my orientation was away from dance and more into the poetry, film, visual art scene. I haven't divorced myself totally from the dance scene. I still teach improvisation and am still involved with the dance world."

The urge to be a mother came upon her suddenly. "What really propelled me into it," she laughs, "was getting pelvic inflammatory disease in my early to mid-thirties. It's this disease where your fallopian

tubes get scarred and you get infections in the ovaries and the uterus. Basically it leaves a lot of women infertile.

"It was the first time I thought about the fact that I wasn't invincible. When I was told, 'It's quite likely you won't be able to reproduce,' it was like, 'What? My birthright? How could this happen?' And that really got me on this serious health path. I started eating nothing but fresh organic live juices, live sprouts, whole grains. I borrowed money from someone and went to Puerto Rico for three weeks and stayed by the ocean and ate very healthfully and healed myself.

"In 1982 I went to Holland to perform and I met Marcel there. I told him I was sterile. That's usually what guys say to women. I don't know whether he believed me or not, but I was kind of haphazard about using my diaphragm."

"Why did you tell him you were sterile?" I ask.

"I sort of believed it. But on the other hand, I didn't want to believe it. And there's only one way to find out, you know. But it wasn't a conscious thing. I wasn't calculatedly putting myself into the position where I was going to get pregnant and have a baby. Although, that's what happened.

"When I found out I was pregnant, I was totally ambivalent. I was confused about being a child or being an adult. If I am an adult and I had these adults as parents and I'm not like either of them, who am I? And the people who I admired who were artists didn't have children. If I became a mother would I lose my identity as an artist?

"Marcel refused to make my decision for me. He obviously felt one way or the other, but he would never let me know what it was. He knew that only one person could decide. He could offer support, but I had to make the decision. I went back to New York because I had performances here and I would call him constantly and say, 'What should we do? Shall we have an abortion or shall we have a baby?' Then, it got too late. You can procrastinate just so long.

"At the time I was making my living as a go-go dancer in New York. And there gets to be a point when you're go-go dancing and pregnant, it begins to show. You can't be a projection for the man's fantasy anymore, because that's what they've left behind at home. They want you to be a virgin looking like a slut. That's their fantasy. So I couldn't work as a go-go dancer anymore.

"Actually, it really pushed me into going for it as a performer. I made a living doing my own work for once. But I didn't have any health insurance so when I was about halfway through the pregnancy I went back to Amsterdam to be taken care of. To be a lady-in-waiting. To be in confinement, in the nineteenth century sense of the word."

In Amsterdam, Diane read books about women and mothers and spent time talking to her daughter, doing "in womb training." Diane grins at the memory. "I talked to her about the history of the suffragette movement. I told her about the world and about this special ability that women have to give life, connecting myself to the centuries of women who have given birth before us and the ones after that. It was a very privileged time, when I think about it."

After Martina was born, Marcel quit his job in Amsterdam and they lived on Social Security for six months. Sharing the responsibilities of those early months was important to them. They have continued to equally share in Martina's care.

Always the rebel, Diane struggled against the limited role of moth-

er that society wanted to pin on her. "It's so pervasive," she says emphatically. "Who do you think you are that you think you can do something else? You think, am I ever going to be able to make work again? You also become kind of bovine, because you're just giving milk. The hormones certainly change you. I'm still pretty aggressive, but I noticed after I became a mother I lost a certain sharp edge to my cynicism. I became softer. I didn't know how I was going to deal with that. Was I ever going to get my hard edge back?"

Motherhood also caused the unfinished business of her parents, particularly her father, to rise to the surface. "I was scared because I knew I had to confront my father," she explains. "I would go into the studio and try to work on something day after day, week after week until finally, I managed to write one paragraph, which was about my father. I then did a performance called 'Girl in Trouble' about the ambivalence of pregnancy. That was the way I got over that stumbling block, in terms of making work."

But to work on her relationship with her father, she went into therapy. Her psychiatrist was a Czechoslovakian Jew who had experienced Auchschwitz. "No story you could tell him could be worse," she smiles. "He was the father I didn't have, so I was able to see my father differently and actually lose a lot of the anger. I don't say it's all gone, but it hasn't immobilized me. I'm able to talk to Martina about her grandfather in a loving way. She's developing a relationship with him and it shouldn't be influenced by my feelings."

"What is it like for you, being a mother?" I ask.

Diane's eyes light up. "Well, I really enjoy it. My daughter is a delight. She's very funny and bright. I get such a kick out of being around her and doing things with her. Every year is different, of course. It's really been a good experience. Perhaps because there are two of us. Obviously it's easier than it would be as a single mother, but I never wanted to be a single mother. I said to Marcel, it's got to be fifty-fifty or not at all. And he's come through one hundred percent and more. He's accommodated me traveling as an artist. There's not many men who would put up with that.

"I'm really good at having fun with her," Diane adds. "I've taken her to so many different performances and theater and museums. She's been in films and performances that friends of mine have made. She's going to be in a Meredith Monk performance that's happening next week. Any interest she has, I will follow up on.

"And I try to contextualize information for her, as a girl. The time I spend doing that is very valuable, because how does a girl have any sense of power in this society when most of the myths and the legends and stories she reads are about women in second place, or being passive? I let her know that she's really bright and wonderful and has incredible capacity.

"For instance, in her school they do a lot of stories from the Old Testament. It's just part of the Waldorf School education. And I'll ask her, 'Who do you think wrote the Bible? Do you think any self-respecting woman is going to write that she was made from the rib of a man? Of course not.' I let her know that it was written by a bunch of old men. It wasn't written by women or in the interests of women. And it serves to keep us confined.

"For a long time, Athena was her goddess of choice. We would go to the Metropolitan Museum and see the model of the Parthenon that

used to be outside the cafeteria. Inside was Athena and we would go to this model and stand in front of it and bow to it and wish for something. Then we would bow to each other. I've been doing this since she was four or five."

Despite her radical bent, Diane is serious about being a mother. During the early years of Martina's life, Diane didn't travel for her work, though she was still performing locally. "The first five years are very important," she says earnestly. "I felt like I had to be with her and pay attention to her.

"But I actually did a performance tour of the United States when she was four," Diane suddenly remembers. "We traveled all over in a station wagon. We built a box on top of the station wagon and we put all our props and stuff for the performances in there. And then every place I performed, Marcel did the tech and the lights and Martina used to give out the programs.

"And then I've had residencies at Covington Community for the Arts about four times. It doesn't exist anymore, unfortunately. They had a children's program and artists could have a studio, so you could bring your kid and other artists brought their kids. It's a great idea, but they went bankrupt."

Nowadays, a typical work day begins at 7:00 a.m., when Marcel gets up to go to work. Martina has to be at school by 8:30 a.m.. After taking her to school on the bus, Diane comes back home. "I do a lot of work in the morning, in terms of the business side of being an artist. Contacting places, sending out tapes and press packages. It does vary, because sometimes I'm also doing Shiatsu for money. And some evenings I rent studio space. A lot of the performances I make involve research and so I'm always reading stuff and writing things, putting things together. I also do lectures and teach workshops, which I see as part of being an artist.

"I've been doing Aikido since 1977. I have a black belt and I also teach Aikido, so I try to do Aikido every day. It's the way I stay in shape. I usually go to the lunch class. I pick Martina up from school at 3:00 and if I haven't been able to go to the Aikido class at lunch time, I go to the afternoon class and she'll come with me.

"Then we have dinner and in the evening we have family time. But a lot of my time is spent on the phone. Marcel and Martina both complain about that all the time. But they are very good natured about it, I must say. And then if I'm coming up to a performance, I'll be working every evening practically."

For the last three years, Diane has traveled regularly to Europe to perform and teach. She is hired as a performer to create work with students based on her own material and interests. Some of these performances tour Europe. In Holland she has worked at European Dance Development Center in Arnhem and the School for New Dance in Amsterdam.

Like many artists and musicians, she takes advantage of the strong public support for the arts available in Europe. "I get a chance to explore ideas that I can't do on my own. In New York, my production costs come out of our bank account which makes it very hard to make work. So I piece it together by getting the ideas formulated in another place and then working with people here who don't get paid, because I don't have the money to pay them. But they work with me because they want to."

Travel brings up the issue of priorities and making choices. "I think we do that all the time," she says adamantly. "We are constantly in the position where we have to make those choices. When I was in Europe I missed all these things my daughter was doing. She had harp recitals, she did a dance performance, she was in two plays. One that was at PS 122 [ed. note. A performance art venue in New York City] for three weeks. I missed it all. And the year before, I missed a harp recital. The school in Holland wanted me to come back and although it's good money and a great opportunity, I said no. I just can't miss all this stuff that my daughter is doing. My husband said, 'Oh, it's okay' and my daughter said, 'I don't mind, Mummy.' But *I* mind! I want to see what she's doing and how she's growing from year to year."

"So you have chosen your art at various times," I say.

"I have, yes. But this year and next year I won't. I'm going to be with my family. But it doesn't mean I'm going to stop working, it just means that there will be other opportunities. I don't see any of this as final. It's a never ending process. As human beings we have such a wide spectrum of possibilities. And for me, performance allows me a way to continue growing, researching and thinking about things in my own way. Cross-fertilization between all the different parts of my life."

But the most important change in her work since becoming a mother has been the way she promotes it. "I had to get real about my situation," she chuckles. "Pursuing gigs and really being a lot more active about that. I'm a bit like a visual artist in that I can do a performance and it's over and I'll go on to the next one. Trying to sell the performance again wouldn't have occurred to me before. Now I'm getting a lot more hip to it. Especially as my work is becoming more com-

plex. I'd like to work with a group of people, but that does entail money."

After doing drag performances and "drag king" workshops for the past twelve years, the concept is finally taking off. "People are really interested in drag and cross dressing and gender," she says excitedly. "I can create a male persona and pass as a man. I can take a group of women out dressed as men and make them feel confident dressed as men.

"Last night I went to a girlfriend's birthday party wearing a Brook Brothers blazer and white pants and a shirt and a tie. I got on the subway alone and I was aware of the fact that people were staring at me." She sits up straighter and says, with not a little bit of outrage, "But who's to define what's normal? Who are these people that might question me about my normality? I could just as easily question them about theirs."

Diane is interested in taking what she has learned in performance into everyday living. Risky, but when has a little risk stopped Diane? She believes in acting out feminist theory in a physical way, not just writing about it. "Like demanding my share of the seat on the subway. Most women would not demand it. They'd just let it be, or whatever. I'm not saying you should always put yourself in danger. I'm just talking about a need to go beyond performance."

Diane is so far away from mainstream perceptions of acceptable art, she cannot relate to my question about how the art world has treated her since she became a mother. True to form, she does not even try to be accepted. "I'm not conscious of that at all," she says puzzled. "I'm the kind of person who would let it just slide off. That's their

opinion and so what. I get a lot of criticism because I dress in drag and I'm not openly gay. I'm bisexual, I've had girlfriends in the past. But I don't feel like the lesbian or transsexual community *owns* drag. I don't ghettoize myself once I discover something. I'm interested in expansion and in the possibilities of many ways of being. So, for me to think about the art world as being down on me as a mother, would be limiting the way I think of myself as a person. I don't think like that.

"It's like when I was in reform school, I didn't want to think of myself as a bad girl. I don't want to see myself as a victim as a mother. I see being a mother as a privilege and a wonderful experience. But I'm not a visual artist, I'm not trying to sell paintings. I'm selling performances. And it's different."

She does have her complaints. Just this morning, Diane had been on the phone to Sussex University in England trying to line up 'drag king' workshops. Her frustration is clear. "I get a man on the phone and I tell him about my 'drag king' workshops, but he doesn't sound too enthusiastic. I get a woman on the phone, she's excited, 'Yes, you have to come, this is great.' So I have to deal with women.

"It's quite apparent to me that unless men get wise to the stuff that women are doing or the ideas that women are expounding they're really going to be left behind in the fifties. This world was constructed *by* men and *for* men. But instead of getting pissed off or whatever, I think, this is the reality. I am not a victim. These guys do not understand my perspective, in fact they feel threatened by it and they should."

Patience is the hardest thing for many of the women I've interviewed. For Diane it is one of the most important things she has learned from being a mother. "When I was single, I would get very irritated if things didn't happen immediately. And when you have a child who's learning to walk, or learning to feed itself and keeps turning the spoon upside down, you've got to be patient. You have to go at their speed. They force you to operate in a different time, on a different level. It brings you out of yourself. I think it's a very good way to learn.

"The other thing is that it's given me an incredible sense of equilibrium. I'm a lot more level headed. I'm able to see the situation and not emotionally react. There are so many crises with kids. Just constant. And you have to deal with it. It's also an acceptance of responsibility. When I was single, I might decide not to accept responsibility for some reason. But now I can't avoid it."

Her response to feeling frustrated or angry at not having time to work has also been transformed. "I've exploded in the past," she admits regretfully. "And felt very lonely as well, in that. But I think that everybody, to some extent, lives a compromised existence. It's just part of living. It might take me longer to get to the ideal, because I have a kid, but I will get there. It's getting an overview, rather than getting obsessed with the short term. Now Martina goes to sleepaway camp. So that gives me another opportunity to just concentrate on my own stuff. So it's like deferred gratification. Knowing that you can't immediately gratify yourself, but you can plan and make it happen. Doing an Aikido class helps. That's like immediate gratification. It helps to balance me out.

"The other thing is never to give up. You have to be so persistent. I've been applying for the New York Foundation for the Arts

Fellowships for ten years. I've gone through all these different emotions of anger, frustration and feeling I'm not good enough. Now I just do it as a matter of course. Maybe it happens and maybe it won't. But the important thing is to just keep working and see it more in the long-term. And I think having a kid really helps you, because you can see that this person has a long life to live and you can see that change does happen."

Her advice for other women stems from believing in oneself. "There's no such thing as bad art," she asserts. "Everybody has a creative capacity. It's how you develop it and whether you develop it. I think of women like my mother, for instance, who go through life denying themselves and living their lives through other people. We're trained that other people are more important than we are and that we should empathize with other people before we think of our own needs. That gives us gallstones and we get sick and frustrated. So it's very important to think about yourself."

Looking to the future, Diane has a stack of ideas brewing. Among other projects, such as a tribute to her brother who died of AIDS, she is working on a series of performances having to do with the senses. The first one focused on the sense of touch and taste. She proudly tells me, "I made a film that went with the performance that was accepted into the Gay and Lesbian Experimental Film Festival happening here in November. It is about a woman's approach to eroticism."

She explains, "When I worked as a go-go dancer, I had a lot of questions, as a feminist working the sex industry. When you are a go-go dancer or when you are stripping, or whatever, the moves are already codified and formulated. I'm very interested in what sexual expression could be if it was defined by women. So I came up with the senses as a place to begin the exploration from. That's a quest for me."

"Do you have anything to add that I haven't asked you?" I ask after a pause.

Diane plunges in. Has she been saving this for last? "People ask my daughter, 'What do you think about your mother dressing as a man?' She'll say she doesn't like it and then people say to me, 'How can you do it when your child doesn't like it?' I think a lot of parents do things their kids don't like. Dressing as a man is pretty minor actually. It's not like I've got a cat o'nine tails in the corner that I'm going to whip her with.

"We have the capacity to be many different things. We've come a long way since the fifties definition of a housewife who's at home with these gadgets and life is so controlled. We don't have to adhere to those stupid ideas and rules about how to behave as a woman. It's true, I do very little in the way of baking. When Martina complains, 'Allison's mother has molds for her chocolate,' I say, 'You'll have to find that experience somewhere else. I'm not going to do that. You can do other things with me.'

"As an artist, you can be as creative as a mother as you can with your art. You know that there aren't any written rules on behavior. You know that you can construct your own reality and be the mistress of that."

Chapter Seven: Transcenders

What makes a person take risks most of us would avoid? Where do they get the energy, the hopefulness, the generosity and the love to take on things that are beyond the call of duty? I suppose being crazy is a possible excuse for this behavior, but not accurate, for the women in this chapter, Suzanne Styrpeiko, Marion Winik and Laura Ross-Paul are all terribly sane.

They have lives marked by extenuating circumstances—tragedy, violence, death and abuse. Not so different from the rest of us, it is just that they have refused to be subdued or to pull back. Instead, they take on more, give out more and make yet another leap into the unknown.

Suzanne Styrpejko endured fourteen years of abuse from her former husband before successfully leaving him. She has three daughters, the youngest with Down's Syndrome. She is now remarried, going to art school full time and, at age forty-four, trying to get pregnent again. After discovering that her boyfriend was HIV positive and she wasn't, Marion Winik promptly decided to marry and have children with him. Simultaneously, her work as a writer blossomed. Laura Ross-Paul's childhood was torn apart after a fatal accident killed one of her sisters. Soon after, her mother died of cancer. In the years since, she has built her own family, achieved success as a painter, and has become a guiding light in her community.

All of them are following their own models of a good life, doing exactly what they want, but also being entirely responsible for those choices. Although they may make mistakes, they accept those mistakes and keep on going. Paradoxically, I felt more hope and inspiration when interviewing these women than any other group. They put me in touch with what lies at the core of both motherhood and art making: love. Love of life, of creativity, of growth and expansion and of other people.

Pictured from left: Ericaa Scheidecker, Johaana Scheidecker, Suzanne Styrpejko, Michaelaa Scheidecker

Suzanne Styrpejko, MIXED MEDIA & INSTALLATION ARTIST

ON THE DAY of our 10:00 a.m. interview, Suzanne Styrpejko has an 8:00 a.m. doctor's appointment in West Los Angeles, an hour away. Chris and I arrive at her house in Laguna Beach on time, but Suzanne is not there. We meet her middle daughter Erikaa, and wander around the narrow streets full of small cottages piled higgley-piggley on the hills. Suzanne roars up in her blue Volkswagen bus, a half-hour late, apologizing. She has driven seventy miles per hour the whole way. In two days she is getting married and the night before she hardly got any sleep. Yet Suzanne plumps down on the couch and enthusiastically answers my questions.

Suzanne's artwork takes the form of mixed media with found objects, cast paper icons and more recently, broken glass and installation. The content is unabashedly personal, direct and powerful, not unlike Suzanne herself. Whether it is a doll embedded in cast paper, broken glass cascading off a chair or hanging petticoats, Suzanne revels in materials.

We have arrived in the midst of a very hectic weekend in Suzanne's life. Another woman might have cancelled the interview and photo session. I am very glad she didn't. Chris and I have a chance to see her operate under high stress. Of course, it quickly becomes apparent that high stress is the norm rather than the exception for her. The interview takes place on Friday morning. She cooks dinner for us Saturday night, even though her wedding is on Sunday afternoon. At 9:00 a.m. Sunday morning Chris photographs Suzanne and her three daughters on the beach. She gets married that afternoon. Her life is like a novel, one of those thick page turners full of dramatic twists and romantic tragedy.

Suzanne Styrpejko was born September 25, 1949 in Santa Ana, California, the second of five children in a working class Catholic family. Suzanne's father, who is Polish American, was a carpenter who later became an inspector for Orange County. Suzanne's mother, who is descended from Spanish Basque and French immigrants, raised the five children.

The first thing Suzanne says when I ask about her childhood is, "Well, I went to Catholic school a lot." She grins and continues. "Like all good little Catholic girls I wanted to be a nun. In school there was a lot of focus on money and procreating. Marry a wealthy doctor, have children, be a Catholic." But despite that, Suzanne glows when she speaks about the freedom she had as a child. "I was raised in Dana Point, California when it was totally undeveloped. There were a lot of hills to play on. I was a really hard player, physically. I really didn't check into creativity at that time. I had so much space to run in and I did that really well. I had a lot of friends. I played like crazy."

We are sitting in the living room on black fabric couches. Suzanne's lanky body is alternately sprawled on the couch or perched on the edge

leaning towards me. The walls and furniture are covered with mementos and artwork. I notice a photograph of a beautiful dark-haired woman who must be Suzanne's mother. Does she think she looks like her mother? Suzanne is taken aback by this question. "I don't know," she says slowly. "Some people say the older I get, the more I look like her." She grins. "I hope I look like her."

Despite the fact that her mother had not been able to follow her dreams of being a dancer, she was still a powerful model of a vibrant, active woman. "I always had a great love for my mother and a lot of respect. In high school they wanted to give her a scholarship to go to dance school, but she was too poor. She had to help support her family. So for reasons of poverty really, she couldn't pursue her dreams.

"She married my father when she was about twenty-one and they were Catholic, so no birth control. And very soon after they started having children and raising a family. She always took classes, had a lot of friends, played pinochle, had parties at her house and was a very gracious hostess. Always was doing a lot for the community. Belonged to the Junior Women's Club and volunteered time at the school. She's still very active, doing things for the poor, through her church and the community. Doing things for her children constantly. She's a great mom. We're very good friends."

Suzanne followed this pattern only up to a point. Unlike her mother, she is realizing her artistic dreams. At the time of the interview, Suzanne lives in Laguna Beach, California, a picturesque seaside artists' colony south of Los Angeles, with her three daughters Johaana, seventeen, Erikaa, nine and Michaelaa, five. She and her daughters are planning to move to Los Angeles next July to live with her husband to

be, Michael Chesler. The interview is littered with references to Michael. This is more than Suzanne's romantic nature. Because of him, Suzanne's whole life is about to change and he is much on her mind. Suzanne is also a full-time BFA student at the Art Institute of Southern California in Laguna Beach. She will be transferring to Otis Art Institute in LA.

Neither Suzanne's art career nor her motherhood was planned. But once she embarked on those roles, she embraced them wholeheartedly. We start with motherhood. Suzanne's voice rings of Southern California, youthful, exuberent and positive. Yet her story is told with a strident tone, as if to say, "This is really what happened, please believe me."

"I never wanted to be a mother," she says firmly. "I was an older daughter and I had a lot of responsibility. I never wanted kids."

I smile and ask, "How long did that last?"

"Till I got pregnant," Suzanne roars. "On accident, every single time."

"Can you tell how it all happened?" I ask.

Suzanne nods and begins briskly. "This marriage to Michael is going to be my third marriage. I was married to a high school sweetheart and became pregnant after we were married for two years. I was twenty-one years old and really had mixed feelings. I wasn't ready to be a mother. But I loved that baby inside. Anyway, I gave birth to her and she died ten days later of a heart defect. We then divorced. We were too young to get married anyway. It was a great relationship, we just needed to do more in our lives.

"I married again in 1974, when I was twenty-three. I had Johaana two years later. Same thing, accident. But I welcomed her. Was really

thrilled to have her, especially since I lost Amanda, the first child. I didn't believe that Johaana was going to live. I thought, 'Oh well, she'll die, too.' But she's seventeen now and big and beautiful, strong and talented. And then another accident, Erikaa. Another accident Michaelaa."

"They were all with the same husband?" I ask.

"Yeah," she says and then adds quickly, "but I'm planning on having another child, that's why I'm having surgery on Monday."

"I was wondering," I say, relieved to have the puzzle solved.

Suzanne goes on to explain why. "It's to have my tubes put back together because Michael wants a child. This will be the only planned child. I'm really looking forward to that. Not that I have any misgivings about any of my other children. I really love them, they are wonderful. But it will just be a new experience, planning one."

"Why are you getting married all of a sudden?" I ask.

"Because I told Michael I wouldn't go through this particular surgery without him marrying me. Whether we end up having a child or not, I need to know that he's not marrying me just for the sake of a child. I needed to know that he would take me as his wife even without being able to give him a child. But it looks like it probably is going to happen."

"Good luck."

Suzanne grins. "Thanks. Almost everybody thinks I'm crazy. I'm the one who is taking the risk though."

"You're getting married on Sunday and having the surgery on Monday?" I ask again to get it straight in my mind. I am still in shock with this story.

"Yes," Suzanne explains. "It's planned like this because I can't drive for three weeks after this particular surgery so it needs to happen on my winter break. I'm a full-time student, I teach, I have the kids and everything. I need to go back to school and teaching in January. Plus I'm getting too old to wait for another semester to go by. We've had genetic counseling, we've had counseling by a doctor, we've had therapy around this issue for a year and a half. We have thought a lot about it, it's time to do it. I feel too old as it is. So it's now or never. Gulp!"

I look at her straight and say, "You know what you are getting into, don't you."

"I totally know what I'm getting into," she answers seriously. "Although things will be different, it won't be like raising three children as a single parent or raising them with a battering husband. I get a nanny. I have an incredible husband to be. Wonderful, supportive in every way."

Suzanne's marriage to the father of her children was abusive. She still refers to him as "the batterer." I ask if she wants to talk about it.

"I don't mind," she says gamely and launches into the story. "I was battered for fourteen years. I bought into religious oppression and the male way of thinking in our country and the world. I stuck it out with this man, hoping for the best. We had three children, and I believed it was the best thing for them if we stayed together. I had a lot of the psychology of a battered woman: hanging in there and hating every minute of it. It was torture."

"How did you leave?" I ask.

"Oh gosh," she answers, remembering her frustration. "I had asked him to leave for five years. I didn't have the resources, the knowledge,

the strength, the courage, the power to just get up and leave myself. But when I got pregnant with Michaelaa, somehow it empowered me. I found out early on that she had Down's Syndrome and chose to keep her. I thought, 'Here I am, pregnant again, third child. She has Down's Syndrome, fine, you can deal with that. But you're not going to make yourself deal with it and him, too. He's a sick, sick human being.' I was determined to do it, so right after I got pregnant I quit having sex with him. I said, 'I don't want you anymore. I don't want this marriage anymore. I don't want any of this anymore.'

"I gave birth to Michaelaa and the first night I brought her home from the hospital he had a fit. He was throwing things and breaking things because I had asked him to fix something minor. I sat on the couch holding the baby, Michaelaa with Erikaa and Johaana beside me. All three of us were crying, just so scared. Brand new baby again." She pauses and looks out the window toward the street. "I can't tell you how many times I've run away from being battered. Or had been battered and was running up the street with a baby in my arms. So I sat there crying.

"A couple of weeks later, after I had just told him again I didn't want the marriage anymore and he had to go, I was in the kitchen and he gave me a knife. He put it into my hand in the position to stab him. Then he started walking towards me saying, 'Stab me stab me.' So Johaana, who was about twelve, ran to friends who lived in the house behind us, told them what was happening and they called some other friends. The batterer went in the back and totaled their house, beat up the friend. Then the friend called the police.

"Someone finally calling the police was the greatest thing that could have happened to me. The next day was Mother's Day, in fact. The police came out three times. Children's Services came out and he was totally seen for what he was. It took two and a half months more to get him out. Never in again. That was in 1988, the year Michaelaa was born."

Becoming an artist was another unplanned turn in the river, but one that she has embraced with zeal. "I always loved it and it was like magic to me, except I 'knew' I didn't have the magic. But I was always into sewing and crafts. In my early twenties I took all sorts of classes on how to tailor and sew and I had a sewing business. I got hooked up with Valerie Bechtol and Julie Keller, who were performance artists, and helped them design and make costumes. I started taking classes from them in 1979 or '80.

"I took it and ran real fast," she says gleefully. "I started creating art, getting it in shows and taking more classes. I also just turned around and started teaching what I knew right away. I taught three-dimensional art, starting with handmade paper."

Though she was in an abusive marriage and had an infant daughter, Suzanne's commitment to her art flourished in those early years. "Johaana was very little, a year old maybe. And she was in on everything I did. She was my constant companion and buddy. She learned to spot out great trash, because I do mixed media. She would say, 'Mommy, there's great trash, turn around.' So we'd turn around and sure enough, she saw some great trash. I love using things that have been used before. I like putting history in to my work.

"It wasn't very hard with one child," Suzanne insists. "It really wasn't. It got harder with two. But that didn't happen till eight years later

when Erikaa was born. I was doing performance as well as my visual art. But I stopped doing performances when Erikaa was born and I haven't done it since. I can't get the guts together to do them again. I've been invited by the battered women's shelter, Human Options, here in town, to do a performance and I just haven't had the courage to get up and do live art again."

I ask why. Suzanne admits, "It may be this particular performance that's holding me back. It's called "Broken Glass" and it's been in the making for three years. I've been doing a whole body of work with broken glass about violence and oppression on every level, not just domestic violence. But this performance would be on domestic violence. Maybe I feel I'm going to have to retreat into those feelings too much to do it."

But I doubt that she will be held back for long. Deep feelings come out generously in Suzanne's work. How has her artwork been affected? She thinks for a moment. "I know how the battering affected it. It made the work very powerful. I've got some pretty incredible pieces." Then she remembers more. "Even before I knew Michaelaa had Down's Syndrome, I knew something was wrong. While I was going through the pregnancy I felt I was dying and by the time I gave birth to her, I weighed less than I do now. I kept losing weight. And I did a piece all around that called "Camille," based on the movie, where she is dying throughout the entire movie."

Suzanne appreciates the feedback she gets from her daughters about her work. "Haana has learned how to be a very good critic for me. I was struggling at the beginning of the semester with a painting class. I did a painting of my bedroom and I asked my kids what they thought. First I showed it to Michaelaa and she said, 'Oh I like your bed.' That was good, my retarded child knew it was a bed. Then I asked Ericaa and she said, 'Well, it wasn't anything like the other work.' Then Haana said, 'Mommy, it's not your thing.'

"They know I'm not a painter right now," she chuckles. "But they are delighted and excited about my other work. And sometimes they are real blown away by it because the subject matter is pretty strong. But they really understand it, because they know me. I'm very candid with them about my life and my feelings and what we are doing and what we've been through and why Mommy did this work."

Then she repeats the mother refrain that I have heard so many times before. "I do my art in stolen moments, because the children are often a priority. I have to really be intent in my art because the time is so limited, so I really make use of my time. So sometimes they do affect my art making. If not for subject matter then for intensity and time."

Suzanne is a firm mother who takes parenting seriously. During dinner the evening after the interview, Suzanne threatens to put her youngest daughter Michaelaa in the bedroom if she doesn't stop pretending to fart. I can tell that Suzanne means business. So can Michaelaa, who stops immediately. "Even though I was a reluctant one," Suzanne says proudly, "I am a wonderful mother. I'm friends with my children. I can play with them. Sometimes to the point where they forget I'm the mom."

Yet she admits to having a hard time listening, too. "When I get into a certain mode, where I am exhausted or frantic or things are really busy, I need to remember to stop and listen. So it's one of the best

things I do and one of the worst things I do, depending on the situation."

The support issue is important to her. It is something that Suzanne has devoted a lot of energy in developing. Most recently, Michael figures prominantly in that area. "He just is a total support for me being a mother. He loves those children like his own. He would like to adopt them. He loves them better than their father ever did. He takes care of them better." Support also comes from her oldest daughter Johaana who has consistently helped with baby sitting and housecleaning. But since she is now in high school and involved in sports and other school activities, Suzanne has lightened her load. She also has support from her neighbor Rosalie across the street, who is a regular baby sitter. Unlike most of the women in this book, Suzanne's mother and sister live near her and help whenever she needs them.

Suzanne is about to embark on a new life. Has she thought about how having another child might affect her artwork? "I have thought about it," she says nodding. "Since Michael's also an artist, he totally empathizes with that. And that's why we have really worked out how it will be, in therapy and everywhere else. Because it won't be like the other times. I have really struggled. When I was with my children's father, I had to fight to do my art in the tiniest moments of time. When he left, believe it or not, even with three kids, I had a lot more free time to do it. I didn't have oppression immediately in my house like that. I had the responsibility of the kids, but I was able to work in the middle of the night. I have done art from 9:00 p.m. to 2:00 in the morning many times.

"But Michael wants to make it totally possible. We're building a large studio in the back of our house in LA for both of us. I will also have a nanny and probably someone to clean my house. I've been cleaning other people's homes for years."

As an artist her support system is equally developed. Michael is important, but she has other resources, too. For the last four years she has been a part of a national support group for women in the arts called No Limits. She says excitedly, "I can't tell you the support I've gotten from No Limits. I would never be as far as I am, doing what I'm doing.

"No Limits is a national support group of women in the arts. It is groups of women who get together to support one another and realize their visions, to think about them clearly and be able to voice them and hear ourselves voice them and have others hear them. You can start really thinking, 'What would it be like to have this incredible vision? Doing my art every day or showing in the Louvre or having a one woman show at MOCA or MOMA.' It's a progressive way of realizing our goals as artists and women.

"I'm a leader of two groups and I also belong to the leaders' group in Southern California. So I have women in Southern California who are connections for me on a lot of levels. We share knowledge about how to get grants, how to be an activist and an advocate for yourself and others. Exchanging knowledge, exchanging ideas, exchanging dreams has really helped me. It just grows. My resume is huge now. I've had the courage to do things that I never would have had the courage to do without the women in No Limits.

"The kids and I do No Limits Wednesday nights. They are learning that they can accomplish things because they have been able to say

what they were. I say, 'Really, that's what you'd like to do?' Or 'Really, that's what is on your mind?' Or 'That's what is bugging you about me?' Well, let's fix it, so that you can grow.' That's how you grow, by fixing your life and getting rid of the stuff you don't need. And then realizing you can do it, just by someone going, 'Yeah, you could do that.'"

Throughout our time together, I am astounded at her continuing optimism. She is admittedly a romantic, but it is grounded in reality. She philosophizes, "Well, your life only becomes richer when you become a mother. It just opens up. Just like my world became richer when I had a special child who was a part of a world that I didn't know. There was a whole group of people that I didn't know anything about. So motherhood is like that. It's a whole world that you never knew before. It's an experience. And the more you learn, the more you have to put in your art."

To my standard question about priorities she laughs. (I am beginning to think that this is a ridiculous question, too, but I still have to ask it.) "You know that's a really hard question," she says. "You mean, husband to be, children, art? All that is one. My grandest vision is to be living with Michael and my children and doing my art every day. That's my world. To prioritize them doesn't work. They switch places. It's almost like watching that game, where they move those shells around. Boomp, there it is. The priorities just keep taking turns. Or like one of those musical instruments that goes boop, boop, boop. Kids two times, Michael once, art three times, Michael four. I can't prioritize. They are my priority."

"Do you ever think about leaving them?" I ask, pressing for more.

"My children?" she asks, shocked and puzzled. "NO, I could never leave my kids. You mean, like giving them to their dad and leaving?"

"I don't know, any way you can think of," I say.

"No, I've never thought of it," she answers confidently.

"Never even . . . " I begin.

At this point Johaana strolls by and interjects loudly, ". . . except she tries every day." Suzanne laughs and then admits, "Okay, in a moment of insanity I feel like running away. I just start crying, 'I hate being a mother! This is so hard!' Freaking out and crying. Yes, I do that. I'm flipping out about being a mother and I'm telling them, 'No, don't bug me, I'm tired, this is my turn, I deserve this.' But it's this total emotional blast and then it's out of me after about a half a day. It's probably when they've been prioritized too much."

Despite her full life, Suzanne has a clear sense of her own needs and she finds ways of getting them met. She is nurtured by doing art and by going to school. And "every other weekend the father takes the two little ones and I nurture myself a lot then. Michael also nurtures me during that time." She then announces excitedly that she is getting a massage on Sunday before the wedding. "That's really a treat."

Spending time alone is nurturing too. "When I have the choice to do my art or clean my house, even. Listening to music. Calling a friend up that I really love and really like to talk to. Reading a book every night before I go to sleep. Just something of choice, whether it's a catalog, anything. The kids are asleep, I've done my work. Even if I only read the first sentence and fall asleep, it's really nurturing because I'm just doing it for me."

At the risk of being exhausted just by hearing about it, I ask her to

give me a run-down of a typical day. "Okay, when I'm in school and I'm just at the end of the semester, I get up probably from 3:30 a.m. to 5:00 a.m. and do my homework, my projects or my art, because that's the quiet time and I'm not exhausted like at the end of the day. I'm alert and the house is quiet and I'm alone. A lot of times I'll stay up in the middle of the night doing my art too. The kids start getting up at 6:00 in the morning or I wake Haana up to run at five. Then I get them off to school and I take Michaelaa to the babysitter close to nine. I have to be at school every morning at nine.

"Then we all come home and do homework. Their homework and some of mine. We try to have as many dinners as we can together. The two little ones and I always have dinner together, but Haana, as you've seen, has her projects. Sports and cheerleading, the sexist role of the high school girl. I was one, too, so I really can't tell her, 'No, this isn't a good thing for you to do as a feminist.' Although she has been a very good advocate for the girls asking, 'Why don't we go cheerlead for the girls' games?' So now they do. So yay Haana! But the boys are the ones, you know. They get out there and jump around for those guys.

"It's crazy though, at the end of the day when we all get home. It's like, I've got to do this, and I've got this project and I've got to make dinner and throw them in the shower. And oohhh, it's hell hour, as my mom always called it, through dinner. When we're eating dinner things calm down. And then we really relax, fold laundry together. Stuff like that. That is a week day."

When she started out as an artist, Suzanne shared a studio with some other artists for five years. But since moving into this house, her studio has been upstairs in a small crawl space up by the rafters. She is especially ecstatic about soon having a bigger studio. She is also very excited about having help to clean her house, as she has worked as a housecleaner for many years to make money. "I chose housecleaning because I could take my kids with me, instead of farming them out to baby sitters. It was important to me to be with them during their developmental years." She smiles. "Yeah, I'm going to do my art and maybe go on to get my degree in art history."

In the past, Suzanne was dependent on her husbands for money and that was difficult. "My ex-husband would not give me money for hardly anything. A little grocery money. I bought our washer and dryer. I bought anything extra for the house. I bought the clothing for the children. Sometimes I even paid the bills. I earned a lot of money housecleaning then. So I worked even harder so I had money for my art and slides and photography and all that stuff. I guess that's why trash became such a great surplus house of art materials for me. But it worked. Found objects are wonderful."

The subject of money increases the tension in her voice. She stresses again how hard it has been. "Since he left, it's been very difficult, too. I have had to go to the DA and fight them to please pressure my ex-husband to pay child support. Then he'd pay it for five months and then stop for five months. We have been poor. Shelter has been an issue. Food has been an issue at times. We're on food stamps and MediCal. Not welfare, though. And I've managed to get grants and student loans to go back to school. And now Michael helps a lot. This is a rented house. My parents have given me cars. Michael bought me the Volkswagen bus.

"I've never been independent with money. That's what is really

important for me about going back to school for my BFA. I want to get into the position where I can not only take care of my kids, but contribute to our relationship too. I would like to not be dependent on him. I'm really tired of that."

She reflects, "I know how to survive. Even if I didn't have the support from my parents and Michael, I would have made it. I really know how to do it. I know how to work the system. And work it honestly and still get what I need. I've learned that I can survive poor and I know I can survive wealthy. I know how to live with both."

As a parent of a child with disabilities, Suzanne has had to work the system even harder. "All the money that I pay out to my baby sitters, which is a lot, is paid by the government. I've become her advocate and in doing so, I've learned how to get SSI for her, which also gives MediCal coverage for her. She has two heart defects. We get almost four hundred dollars a month for her, so that's helped us live.

"Michaelaa was in the hospital a lot when she was young and that was real hard. She has another heart surgery coming up. She sees a doctor more than a normal child does because Down's Syndrome people are very immune deficient. They only absorb thirty percent of the vitamins from their food as compared to us. So she gets sick a lot. So that's juggling a lot. 'Gosh, Mom, Rosalie wasn't counting on baby sitting today, it's not on the schedule, can you come over?' Yes, no, maybe. Sometimes I miss school. That's difficult, but worth it. She's incredible.

"The first three years of her life I went to school with her a lot. Finally, when she was three, the little yellow bus came to pick her up and take her away to school. I was really worried. I thought, 'I'm not sending her to school in the little yellow bus with all the rest of the retarded kids.' But she loved it. She's very social, loves people, doesn't mind leaving me most of the time. Very independent."

As Suzanne moves about in the world, she is open and proud about her motherhood. The normal response, especially in the art world, is a mixture of awe and put-down. "People are in awe of what I do as an artist and a mother. So I get praise for it. I surprise a lot of people. But a lot of people say to me, 'I don't know how you do it.' It started to scare me. It was like, 'I don't know how I do it. How do I do this? Wow, I can't do this. I'm one of those women who do too much.' So I've asked them to quit saying that. I like hearing, 'I'm in awe of you,' or 'It's great.' Because I *do* know how I do it."

Goals? "I'm very proud of LA and being an LA artist. I want to be an important LA artist and have people know my work and know who I am. And then take the next step and have my work shown in New York. And I want to have a degree in art history. I love art history and I would like to teach that."

Advice? "Don't let anyone stop you. Don't ever stop doing your art because you're a mother. Being an artist and doing what you're doing will enhance your motherhood. There are enough places for all of us in the art world and anywhere else we'd like to be. This is important and we have to remember it. Just because you may not have as much time as people who don't have children, when they go ahead and progress and do what they want, you can do that right along with them. I'm proof. All of us are proof."

 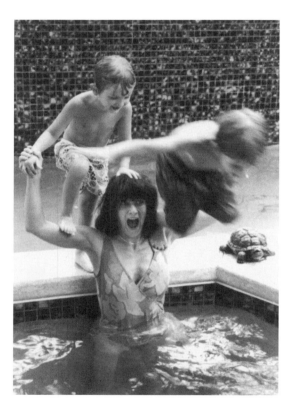

Clockwise from upper left: Vincent Winik, Hayes Winik, Marion Winik

Marion Winik, WRITER

WRITER MARION WINIK says out loud what we are all thinking but are afraid to say. She admits to being bored by children's games, confesses to being selfish and enjoys taking trips away from her children. She knows that it is impossible to be everything to everybody. So she doesn't even try. What a relief!

It is June in Austin, Texas and hot, hot, hot. We arrive at Marion's house on a weekday afternoon in the middle of a pool party she is throwing for her older son's kindergarten class. As the kids splash and scream in the pool and wander dripping wet through the house and yard, Marion plays hostess, answers numerous phone calls and fields my questions.

She has just returned from a national publicity tour for her book *Telling*, a collection of essays about her life. She is also recently separated from her husband Tony, who is in the hospital with AIDS. The interview catches her at a period of transition, on the edge of financial and artistic success and reevaluating her new single parenthood.

Marion Winik was born May 7, 1958 and raised in New Jersey with her younger sister Nancy. Her Jewish ancestors emigrated in the 1880s from Russia and Germany. Marion's father, who died in 1985, was a controller for a textile firm, and operated a chain of racquet ball clubs and a discotheque on the side. Her mother had training as an accountant but chose to stay at home. Marion now lives in Austin,

Texas with her sons Hayes, six and Vincent, four. In addition to her books, her essays can be heard on National Public Radio (NPR).

Marion's loud and insistent voice cuts the air like little knives. She has an opinion for every occasion. A whirling dervish in a blue and purple bathing suit, she is constantly in motion, alternating between drinking coffee, taking cigarette breaks outside the screen door and answering phone calls. She runs through the high points of her childhood with her usual sardonic humor. "Reading was the governing fact of my childhood. I was insanely precocious. I could read when I was two, and I skipped first grade. And my parents were so into it that I really focused on it too. To my detriment actually, because I became very isolated.

"Somewhere in early elementary school, I started being chubby. My mother was on the case about it. We became locked in this thing about my weight. By the time I was eleven, I was on diet pills; amphetamines, we now know. I was a very intense, passionate, unhappy child. I seriously tried to commit suicide when I was twelve. Then I started going to psychiatrists."

After a breath, she continues, "It wasn't just my weight, my parents were fixated on my body. I had braces. I had a lazy eye, so I had an eye operation. I had speech therapy because I had a lisp. I had allergies, so I had to go have eight million shots a week. I was pigeon-toed and flat-

footed and I had to wear all kinds of weird things in my shoes. I was convinced that I was a freak of nature. My mother and I, to this day, disagree on it. She doesn't think that there was anything wrong with anything she did. She was just trying to help. And she *was* just trying to help. But I entered teenagehood with triple the normal bad vibes on my body image."

Since becoming a mother Marion's relationship with her mother has improved. She remarks, "Before my kids were born, it would have been unfathomable to me that she would come and stay here for ten days in a row. But now I love it when she comes. And I'm totally open with her about everything.

"We had a very tough time in my adolescence. I can remember sitting in the car with my mother and saying to her, 'I hate you,' and her saying back, 'Well I hate you, too.' And my sister and I were crazy. We were total druggies and totally rebellious. We were a lot wilder than my parents actually knew or they probably would have cracked down a little more. But they were pretty cool and liberal. They were like, 'We'd rather have you smoke pot in the house than out on the street and get busted.'

"I always thought of myself as the opposite of my mother in every way. She is pessimistic and cautious, while I'm impulsive and over-optimistic about things. She is not very trusting, and I'm, one could say, gullible. She loves to read but I doubt she ever, a day in her life, thought of writing. She doesn't think of herself as creative. She doesn't even like to cook. She's athletic. She has always played golf and tennis and was a big tomboy when she was a kid.

"But in my old age I'm becoming more like my mother, in little ways. Like drinking decaf coffee all day long and gin martinis at night. My mother loves to have a good time and so do I. We still fight occasionally, but even though she holds grudges against other people, she doesn't hold them against me.

"I don't think my mother has any regrets about her life. I know my father always felt and I still feel, that it's unbelievable that someone of her intelligence didn't want to work. But my mother really did not want to work. She wanted to do what she wanted to do. She didn't want to go to a stupid job."

Marion also wanted to do what she wanted to do and that included getting married and having children under the shadow of the AIDS virus. Even though much of this story has been published before, I ask Marion to tell it again. I want to hear it from her lips, unpolished and fresh. It shows her strength, then and now. She tells it with her usual mix of humor and abruptness, despite the intensity of the story. Afterwards she admits sadly, "The strength of my desire to have children really made me blind to the probable outcome of this situation. I don't think I'm going to be having any more babies. Though you never know.

"In 1985, the year before I got married, we found out that my husband Tony was HIVpositive. And I was negative. So here we had been, since 1983, having sex and doing IV drugs together. Also, he was gay before we got together and had had the typical late seventies gay life. Okay, how could I be negative and him be positive? It was certainly a mystery. But it encouraged me, in 1987, to think that we should go ahead and have kids anyway. Now, there were some other factors operating. Even 1987 was early in how devastating this AIDS thing has

turned out to be. At that time I thought there would be a cure soon, and I didn't think everybody that got it would die. And also, I was young and very stubborn and this is what I wanted to do. So even though it seemed kind of a crazy thing, to have a kid, three actually, with someone who's HIV positive, I did it.

"I got pregnant in late summer of 1987. I was ecstatic about it. I was like the happiest most into it pregnant person on earth. I took pre-natal aerobics class. I read books. And I was going to have the baby in an alternative birth center, with a midwife too.

"So three days before my due date, this midwife friend of mine came over for dinner to talk about labor and all. And she asked me if I had been feeling any movement. And I said, 'I haven't been feeling anything the last day or two. But don't the babies stop moving so much right at the end?' And she said, 'Yeah, but maybe I'd better check.' And she couldn't hear anything. So I had to go and deliver that poor little dead baby. That was a nightmarish experience. We named him Peewee. There was an autopsy and it had nothing to do with AIDS. There was nothing wrong with the cord, there was nothing wrong with the placenta, there was nothing wrong with the baby. It just was inexplicable."

But Marion was undaunted and immediately tried again. "I was not into waiting a few months. I had Hayes less than a year after I lost Peewee. Peewee was born and died on May 10 and Hayes was born on April 22 of '88. That was a weird pregnancy. I realized about four or five months into it, that I was completely ignoring it. Especially compared to pregnancy number one, which was like, 'World, sit down, I'm pregnant.' I was obviously kind of afraid to get into it.

"By the end I snapped out of it. Hayes was born at the alternative birth center, just like I wanted and it was great and he was a great baby. The first couple weeks of Hayes' life were really one of the most magical periods. I just think about that bedroom and the light coming in the window and the baby and Tony. I was so into it and then I was so into nursing. I was not a kid person at all. I didn't like to play with kids. I didn't ask to hold them. But I turned out to be a real newborn person. I loved it. And then I decided to have another one. So I had Vincie at home with a midwife in this house, in July 1990. And that went fine, too."

I probe, because I have to be clear, "No HIV anywhere?" Marion answers impatiently, "The only way a kid can get it is from the mother. It's not genetic, it's transmitted by blood and body fluids. Only forty percent of children born to HIV positive mothers are even HIV positive. And even some of those sero convert and turn back negative. So the fact that I was negative at the end of my pregnancy insured that they were going to be negative."

I just sit and listen. I am awed by her fierce desire to have children bar nothing. It appears that she is not afraid of anything which is, of course, not true. "I'm hitting the next part of that disease, the part I didn't really think about, which is now he's going to die. It's going to be very sad for these kids. He was a very, very involved father when they were babies. But AIDS has really broken his spirit and he has sort of drifted away from them. It's certainly not the life story I would pick for my kids."

As a writer, she has been equally persistent. In 1965, when Marion was seven years old, she sent away for a writing test advertised on the back of a matchbook from The Famous Writer's School of Westport,

Connecticut. She filled out the test pretending that she was nineteen and had been writing for fourteen years. When the Famous Writer's School received this suspect test, they called Marion's mother, found out she was really seven and sent her a letter declining her as a student but encouraging her to "wait until she was at least eighteen before enrolling in our teaching program." Their recommendation was that "By the time you reach eighteen, you will know better whether your interest in writing is permanent."

Well, Marion didn't wait until she was eighteen to find out if she was really a writer. She spews out her history at lightening speed. "By the time I was ten, I considered myself a poet. I had a pen name Tracy Beth Richardson. I wrote poems all the time. My father had his secretary type them. I continued writing poetry until I was in my early twenties and I had a book published by a small press here in Texas. It was called *Nonstop* and had drawings by my best friend Sandye. Then I went to an MFA program and wrote some short stories. Another book of poetry and short stories *Boy Crazy* was published in 1985."

At one point, from April 1983 to October 1987, Marion had writer's block. In frustration, she officially gave up writing. It took her first pregnancy to break that block. "I woke up one morning and had this idea to write an essay called, 'How to Get Pregnant in the Modern World.' I wrote it in a very direct and humorous style that was totally different from anything I had ever done. And it was like this new world opened up. So really the birth of my writing career as I now know it all happenend around having kids. Pregnancy and early parenting were really fertile subjects for me." She began to write for magazines and other periodicals and became a contributer to NPR.

Are her children still helping her as a writer? Marion answers loudly, "NO, they're not helping now, they are taking up all my time. I have to figure out what to do about that. I did a reading at a local bookstore when the book came out and I was reading this piece about losing things. I got to the part where Hayes was thirteen months old and he and his friend lost a puzzle piece and it's about going crazy looking for it. When Hayes heard me say his name, he really flipped. So yeah, the main thing that they do to my work is hinder it, because they are such a huge responsibility.

"Vincie doesn't even know what a writer is. If you ask Hayes what his mother does, he says I'm a typewriter. They were pissed that I had to go away so much on the book tour. 'Why do these people have to hear you tell your stories? Why? Why?' Me becoming a quasi-celebrity is happening when they're still young, so they're just going to grow up with it. We go in the bookstore, 'There's Mommy's book.'"

Like most mothers, she "didn't have any idea how much selflessness and sacrifice it takes to be a parent." She announces, "When people tell me they're not going to have kids, I'm like, good, if you have the slightest quiver of thinking you don't want to have them, just don't have them. I guess there are ways that people get out of the hard work, but I've always wanted to be a hands-on parent. Partly in reaction to having had domestic help around when I was a kid. Though now, being a single mom has changed my view on a lot of things."

Since her separation from Tony, she doesn't have the huge amount of support that he once offered. "Tony was great when they were little. He did fifty percent, if not more. And he did a lot of the household stuff because I was working. Right up to when Vincie was almost two

years old, Tony was really good. Until six months ago, he was still doing all the laundry and keeping the house together."

Now much of her support comes from her mother and Tony's parents. "Even though she is so far away, my mother has been great about coming. When I was away for a month on a book tour, my mother-in-law and her husband came for two weeks, then they left and my mother came and stayed for two weeks. I've had great support from their grandparents. I have also always had friends that I trade baby sitting with."

Travel has become a permanent part of her life and she has been able to accommodate this despite being a single mother. "I'm going to this writers' retreat, The Hambridge Center in Georgia, for two weeks this summer. This spring I left to do the book tour. I like being away. Not a lot, but a little is good for me. My first night away from the kids was after Vincie was born and he was maybe six months old. My work is the main reason that I would leave them, but I wouldn't mind going on vacation without them sometimes."

As a mother she is, by turns, passionately involved, frustrated and carefree, but always honest. How does she consider herself a great mother? "I really love my kids physically. I love to hug them and kiss them." She then stops and admits, "I'm bad at a lot." But I urge her to stay with the great stuff and she comes up with quite a lot. "I'm fun. I give good parties. For Hayes' birthday, I took seven little boys camping overnight. How many people would do that?

"I'm good at answering hard questions like, 'Why is Daddy dying?' and other stuff. I feel pretty good about my ability to be honest with them, yet communicate to their level on serious subjects. And I feel pretty good about letting them know what's right and wrong, stuff like racism. And I volunteered at the kindergarten. I didn't love it, but I did it.

"I'm good at financially supporting them. I support my entire family, including my sick husband and his medical bills. I'm good at making money and being a provider. I had all the typical male stuff in my court, even before his illness.

"I'm also very good at letting a lot of people be around. We always have a million kids here and I like that, because then they get more involved with each other and leave me alone. I pick up kids from the extended care all the time and let them come over here for the afternoon because their mothers are working. As long as they don't bug me too much."

Patience is hard for her. "I have something of a self-control problem. I freak out too intensely about stupid things. I think, did I really have to yell at Vincie like that because he wasn't getting out of the car fast enough? I'll be like, 'GET OUT OF THE CAR YE#Q! U#&IO#!! O#ER@ I@W!' Actually cursing at them and stuff.

"I'm not enough of a disciplinarian. I let things go and then freak out because I haven't created a good situation and it's all my fault. They like to sleep in my bed. When I was living with Tony it seemed perfectly fine if they slept in the bed. Now that I'm single, I'm a little more concerned about having my bedroom to myself. So I've been trying to get them to sleep in their own beds."

Marion is not apologetic about the kind of mother she is and states plainly, "I am very self-absorbed. Everybody knows this about me. I want to do what I want to do. I want to talk on the phone to my

friends and I want to read and I want to write. I don't want to do all this shit that I have to do every night. I don't want to make dinner and give them a bath and put them to bed. This whole two hour thing. I'm not into it. So sometimes I pull it off with finesse and I'm just great and sometimes . . . I'm selfish. I don't think it's so great to be selfish, but I am. It's hard for me to give them so much of my time."

She goes on adamantly, "I see these other mothers who are like, 'Come on, honey, let's make macaroni necklaces.' I'm terrible at all that stuff. I don't like to play Uncle Wiggley. I don't like to play Candyland. I always thought I should get a Congressional Medal of Honor if I built a block tower with them. I have better things to do. If they had to make a map of Venezuela out of papier mache or something, I would probably love that. So it will probably get better." We laugh together. It is so true that as mothers we expect ourselves to love every moment of parenting. Though it breaks a taboo, it is a relief to admit the truth.

Talking about money is another taboo that Marion breaks frequently. It is a recurring theme throughout the interview. Marion likes it. "I'm a money machine. I am very, very practical about money. From the minute I met Tony, I was always the one with the money. And I had a lot of relationships like that.

"After I graduated from college, I had some different jobs. I taught in an alternative high school, I did some magazine production work. I worked for quite a while at Stanley Kaplan, the test preparation place, writing reading comprehension courses for the LSAT and the SAT. And then in 1984, when I moved back to Texas, I got this job as a technical writer, writing computer manuals and the job evolved into doing advertising copywriting about the software. I had that job for ten

and a half years until last Tuesday.

"At the peak of this job, I was making $60,000 a year, but I kept going more and more part-time. Until recently, I wasn't making any money from my writing, nothing like 1993. That year I got $20,000 from the National Endowment for the Arts, $20,000 from Random House, and $35,000 from the softcover publisher."

Until a couple of years ago, she never made any money from her writing so she never wrote for income. Writing was separate from making money. "I had a regular job, continuously from the day I got out of college till last Tuesday when I quit my job. Actually, I'm on emergency family leave, because my husband is in the hospital. But I'm probably not going back. I quit my job because I have opportunities right now. Magazines are calling me a lot now. I just have good luck with money. But I would like to be really rich."

"How rich?" I counter.

She rises to the challenge. "I'd like to have so much money that I didn't have to worry about it at all. And I'd like to have all the help that I need to make my life run perfectly smoothly. I'd like to send my children to the best places and I'd like to go on really great trips and I'd like to write all the time."

Marion sums up her philosphy about money. "Money is extremely important and if you don't have it, you can't do anything that's important to you. So I'm into money. The kinds of problems that money can't solve, like love problems and art problems, are much more interesting and worthwhile to devote your time to. When I started figuring out I was going to make money from this, that was a big exciting thing."

However, love is what keeps her going, plus a lot of ambition. "The people who I love and the people who love me. I have a tremendous need to connect with people."

I press for specific things she does that help her. "Reading is very, very nourishing for me. And living my life. I always have tremendous curiosity about what happens next, both in my life and in my work. But there is nothing I actually do." She pauses and says matter of factly, "Coffee, alcohol. I drink a lot." She then goes on laughingly, "We used to say that hangovers were the cause of most good writing. You go out and get totally drunk, make a complete ass of yourself and wake up the next morning feeling like shit. So you write something great because you have so far to go to redeem yourself. That's the hangover theory of artistic production."

She has also made sure she has the support of other writers around her. She recounts the chain of people who led her to where she is now in her career. "The editor of the Austin Chronicle who published all these pieces. The guy at NPR who first read them and the editor who works with me at NPR. Then my literary agent who heard me on the radio and called me up. She's been great. My editor at Random House.

"I'm in a writing group of eight women and we have met every other Tuesday for six years. I have a lot of close friends who are writers. I'm really into other people's work and trying to help other people if I can professionally. It's been amazing to finally have success in the big world of publishing, book tours and Random House and all that stuff. But all along I always had positive feedback and support."

Marion's priorities are merged into one. "The problem with me is that I have four things that are all number one. Number one is my family, number one is my writing, number one is making money and number one is being with my friends. So I'm pretty busy."

She then explains, "I really do not operate at the normal speed. It's not just that I'm fast, I'm hyper and I do seven things at a time. And I'm absolutely committed to all these things." As if she has just discovered something fantastic, she describes a perfect day. "Like yesterday, my kids went and played with people. That was great. I wrote a magazine article, faxed it in, got it accepted. They are sending the check. Then the kids came home and I spent three or four hours with them. Then it was my friend's forty-fifth birthday, so we went out and had this big fancy dinner with no kids. So I got to make money, write, be with my kids and be with my friends. I did all of them."

Marion gestures toward the kitchen and laundry room, which are in varying stages of disarray, and protests, "But I really fall prey to the little things. Laundry and dishes drive me crazy. It's not like I'm an anal retentive clean freak, but just the fact that there is always laundry and it's always dirty. So many things in my life are out of control so when the physical environment feels out of control, I just get like . . . I finally hired a pool service. I realized I cannot do it all by myself."

She is on her way to the kitchen again when I ask her about having to choose between her art or her children. She stops at the counter and turns. "I would refuse to choose. If someone had a gun to my head or something I, of course, would choose my children. You've got to choose people over a thing like a career. I mean really, no matter how lofty this art thing is, it's just a career." She adds, "I think that's a really stupid question."

I am thrilled to be challenged and shoot back, "Why?"

She answers immediately, "I can't imagine any person in their right mind who would not choose their children over anything else. If anyone did not choose their children, and I'm not just talking about over their art, I mean over anything, they are crazy. That person should not be a parent. If you don't have that basic feeling, you are going to be in big trouble when it's time to put down your book and do bedtime."

Being taken seriously as both a mother and a writer has not been a hindrance. "Most people my age do have children. Men, too. Most people I know are between thirty and fifty. It's a normal part of all our lives at this phase. My editor has kids, my agent has kids.

"I've been taken much more seriously since I had kids. But I've also had a tremendous number of lucky breaks lately. I have a lot of respect for anyone who is a parent who also is doing something else in the arts. They are both pretty hard taskmasters. And I feel that kind of respect from other people."

Yet she experiences ignorance as well. She complains, "I got called up the other day to go on some daytime TV show to talk about parenting with other women writers and comediennes. And they wanted me to come tomorrow. And I said, 'You're crazy. You don't call up a mother on Tuesday and ask them to fly to New York on Wednesday. Don't ever call me again if you're just going to call the day before.' I just thought it was ironic that they were trying to get parents to do something that is going to be completely impossible for everyone."

Marion's book *Telling* is doing well. She is in demand as a columnist. What does she see in the future? Where does she want to go with her work? She dives eagerly into the question. "To have the discipline and whatever else it takes to do it, to pursue it with absolute seriousness and concentration. I read an interview with Amos Oz, an Israeli writer, who said that as a writer he feels like a shopkeeper. He just has to go in and open the store everyday and see if anyone shows up. So I have to make sure that I open the store. And then do the absolute best I can." At first I am surprised by the modesty of this goal but then I remember, Marion is very practical and, despite her impulsiveness, is totally realistic. She adds, "I don't think I have the great literary talent of our time, but I think I've got a little something and it deserves to be nurtured."

Her advice for other mothers who are artists is worth gold. "Learn to say no and ask for help when you need it. And believe in yourself. If you don't believe in yourself, no one else will. It's such a waste of time to be negative about your own work. I think it's the belief in yourself that helps you overcome many of the difficulties of trying to be a mother and an artist at the same time. If you really believe the Great Spirit gave you this gift, you'll find a way."

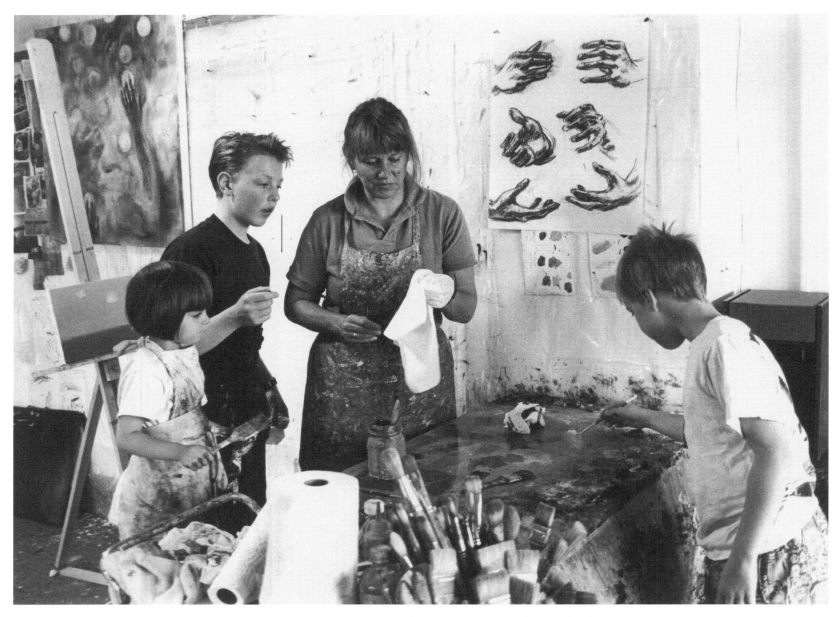

Pictured from left: Emma Paul, Sean Paul, Laura Ross-Paul, Louie Paul

Laura Ross-Paul, PAINTER

I MUST START with the house, because that is the center of Laura Ross-Paul's world and where all her lives truly meet. It is a large wood frame house characteristic of houses built in the 1920s in Portland Oregon, perched on the side of a steep hill overlooking downtown. To get to the front door we have to climb a narrow staircase up from the street. We are met at the door by Emma, age four, who informs us that her mom is taking a shower and will be down soon. As we wait, we look around. The downstairs is taken up by a large kitchen and living room, plastered everywhere with Laura's paintings and prints. I wonder where the family actually lives, since it doesn't look lived in, with the exception of a small room so crammed full of toys that no one could possibly play in there.

When Laura joins us, she promptly leads us upstairs to where the real living clearly takes place. This space consists of a large raw area lit by skylights, filled with dolls, sports equipment, a TV and art supplies. Two bedrooms and a kitchenette come off of this central room. I am struck by how small the bedrooms are, more like sleeping closets. In fact, the three children share one. In this house bedrooms are not for playing in, they are for sleeping. The central space is the main activity room and also serves as Laura's studio. She is the queen bee of this household, the center around which it swirls. She remains stable, seemingly held in place by the motion around her.

Laura Ross-Paul was born in Portland, Oregon on January 30, 1950, the second of four daughters. Her ethnic background is a mix of French, German, English and Swiss. Laura's mother was a homemaker and her father sold industrial equipment, sometimes taking the kids out of school to accompany him on trips around the state. When Laura was seventeen one of her younger sisters was killed in an automobile accident that also seriously injured the rest of the family, except for her. Her mother died of cancer six months later. When her father remarried soon after, she was on her own. He died nine years ago. Laura put herself through college where at age nineteen she met and married her husband.

Laura Ross-Paul is a well known and respected painter in Portland. Her oil paintings and watercolors are lush and emotional landscapes filled with people. She received an MFA from Portland State University. She has three children: Sean, twelve, Louie, nine and Emma, four. Laura lives with her husband Alex Paul.

While we speak, Emma watches *Peter Pan* on the VCR. The phone rings occasionally. Laura sits in a low slung canvas chair, her hair spinning around her head. This is a bighearted woman. I feel enveloped by her embrace and welcomed as a member of her family. She is a warm and enthusiastic person whose thoughts spill out fast and urgently. I want to bottle her essence and hold it in safekeeping for times of need.

Out of the experience of her mother's death and her family's disintegration, Laura has created a life of her own. She married young and has steadily built a family of friends around her. She knows that she does her best work when surrounded by loving support. She has chosen to have her studio in the middle of her home. "I truly work best when they're safe at home," she says.

Even as a child Laura was in charge of her life and creativity. "I was always drawing. My girlfriend and I would play in the morning and then in the afternoons we'd draw pictures about it and put them in books. Also, my father had a shop in the house and he would cut us little chinks of leftover wood and we'd slap them with mud and that was the frosting on our cakes. Then we'd decorate them with rose petals."

Laura grew up with support for her artistic self abound. "There was an assumption I would be an artist. A lot of that came from the support I got in the schools. I had a terrific art teacher Mrs. Shucart in grade school. I was part of her experimental group to find out if you take a group of kids and give them special training, will it help them blossom? I was a success story for her. My paintings were put in a place of honor and I did huge murals for the cafeteria. They gave me a lot of support and told my parents I was real talented. My dad always supplied me with pads of paper and pencils and all that. My mom said when I was a baby I'd startle when she came into the room because I'd been concentrating on the pattern on my crib or something.

"But on the other hand there was this huge expectation that being a wife and mother would come first. When my mom got sick, I was around nurses so much that when I first went to college I took pre-nursing. Earlier, when I got a bunch of scholarships out of high school to finally go to college, the thing my dad said to me was, 'Well, that's fine but when are you going to get down to the serious business of being a wife and mother?' Even though he had money to help me out, he never gave me a penny for college. In my father's mind, being an artist was not like getting more training or more education. My mother would have supported me, I'm sure. She was really the more intellectual one. Her death-bed instruction to my dad was that her insurance money go to pay for my education. I think it was a burden on his heart that he never saw through to do that."

But in spite of her father's lack of financial support, he was an important model of a working person for Laura. "Well, actually, I do credit my father," she says, surprised at her own answer. "We had a very stimulating background to grow up in. He had this terrific stereo system with speakers of the best kind built into the walls. And he'd listen to opera and classical music all the time at top blast. I actually have hearing damage from it because I never could get away from it. We had original art that was handed down from somebody and reproductions of very wonderful, top quality paintings. My mom would read books and my dad would watch Saturday night wrestling, that was how it was, you know.

"But one time he did a very impressive thing. It was when the new airport went in and they had bought a big Louis Bunce painting. [Louis Bunce was a Portland area painter prominent in the 1950s and 1960s.] There was a huge furor in the paper about spending money on an abstract painting that nobody could make anything out of. Well, my dad got us all in the car and drove out to the airport to look at it. We

stood there and took a long time looking at it. Finally my father said, 'Well, look, I think this is like the view you see from an airplane.' He really was an artist at heart. He built our house, he built our furniture. He had a shop, the garage divided in half. Half was my bedroom and half was his shop. He went there every day after work. That's like me going to my studio every day. It was a good role model for being what I identify myself as, a craftsperson. I use my hands to make my living."

Laura was also assisted by a teacher she met at Oregon State University during her undergraduate years. Margaret Meehan was the head of the Honors College and introduced Laura to feminism. "She was really the first one to accept me totally as a person. She knew nothing about me academically but she loved my art work and gave me my first exhibit at OSU. The coolest thing that happened with her was when I was nineteen and first married. She was teaching some courses on feminism. My husband was raised by a European mom who brought him breakfast in bed every day. He never knew about sharing roles. He would expect the house to be clean, the food to be done and everything ready whenever he got home from school. But he'd never really tell me when he was going to come home. And this is with me doing all my own class work, too. One day I broke down and said, 'This is impossible. I just can't do this.' I then asked Mrs. Meehan for some feminist literature. She gave me stacks and stacks of the most current, pertinent writing. I read it all and sat down with my husband and said 'It's not right, we've got to share.' He was a fair guy, it just never occurred to him. He's now such a supporter of domestic work and co-parenting, it's hard to think I'm talking about the same person. That feminist material helped us both."

"What about your mother?" I ask. "I noticed you didn't talk about her much."

Laura hesitates. "Maybe that's such a tender, tender part of my life. I can hardly talk about it. It would probably bring tears even now. I guess my favorite thing with my mother was just to talk. We spent a lot of time together. I'd get home from school and she'd want to know all about it. I was an extremely sensitive person, so if anybody was mean to me and I couldn't figure it out, she'd help me examine it from many different viewpoints. She was interested in my friends. She was the favorite mom. They loved her more than their moms. They'd want to be with me just so they could be with my mom because she was just so interested in everybody. It's like what you do with good friends. We sewed together, cooked together, we did all those women things. We had an inner kind of communication. It's funny because she was the mom and I was the kid, yet I liked to look out for her and be protective of her. Now I see my daughter doing that with me. Emma knew I had a hard day the other day and she wanted to rub my back to get me to sleep. She leaves me little presents when she's going to be in school so I don't miss her. I can see it now from the other side. It's nice being on the receiving end."

Along with her goal of being an artist, motherhood was equally as important to Laura. She started young. "I helped raise my youngest sister and when we were first married we had two foster daughters. After the foster daughters, I knew that I wanted to have my own kids. I could see that starting them out from babies is so much different from getting them as teenagers.

"When we were early married, we wrote a list of our goals and put

it away. Later we looked at it. It said, have two kids but the two was crossed out by my husband and he had written 'three' without telling me. And that's kind of what happened. We had two and then we had a surprise third."

"What was it like having an accidental third child?"

"It was just so wonderful. It got me in touch with how much I wanted another baby. After my second I felt I should only have two. You should only do your replacements on the planet and all that but I think I really wanted a daughter. I love my boys and I'm totally tight with them. The truth of it was that I really wanted a daughter but I wasn't going to do anything about it to get one. She's a real strong-willed pushy girl. She just pushed her way into my life and I like it a lot."

Laura decided to wait until she was finished with graduate school before she had kids. "So practically the week I got out," she says laughing, "my husband said, 'Okay, you made college, so now let's get on with the kids.' But I had just done all this work. I thought it would be nice if I could get established a little bit, get a gallery, get a job. So I did that. I graduated at twenty-seven and had my baby at thirty-one.

"That four year period of getting established was invaluable. If I had had the baby first I'd probably just now be trying to get into galleries. So many of my friends that are in that position say they don't take you seriously, they think you're a housewife. It's really a lot of work. It might be easier to establish who you are before you have kids."

"What were your births like?" I ask, wanting to hear the underside of her life.

"I had the world's most horrible births," she roars. "I had pre-

eclampsia so they were all high risk. The first baby just about died, it got better with the second one. Emma was twenty-one hours. None of them have been wonderful. I went without drugs so that they'd be healthy. I swore that if I had to do it again I would just have them knock me out and wake me up when it was over. They were that bad. I don't think I could go through another one. I'm just very happy they were all healthy."

Laura also has confidence in her ability to be a good mother. "I have the same knack that my mother had with me," she says in her typically quick way. "If there's something troubling my kids, through talking and just being supportive, we work it out. I help give them confidence about facing the world and the complex situations that they go through. I've got a son just starting middle school right now. It's not easy to work through. I think all of my kids are demonstrating that they're very confident. I probably can take credit for that. When we go to bed and I read to them, I have them all in bed with me. Then after we say our prayers there is this time when anybody that has problems can talk about it. They can talk during the day, too, but particularly at night. They know that I'm a person they can trust with the really intimate details of their lives and I'll be respectful of them. I'm a pretty good cook too."

She is equally as honest when it comes to ways she needs to improve as a mother. "The thing I'm working on, momwise, is trying to get a clearer picture of where my flash point is for getting angry. My husband has been helping me work through this. I probably inherited my father's temper. I tend to let it get to the final point before I finally say anything and then it explodes. I don't go hitting them or

anything. I'm trying to watch it and my marks are that I'm improving. I have a family that is confident enough in our relationship that we critique each other all the time. If I'm out of line, I am the most profuse apologizer. In fact, I'll be my kids' slave for days if I feel that I've been out of line with them. We are good for each other."

Laura is also clear about what constitutes a good mother. "A good mother does not sacrifice herself to her family," she says loudly, sitting up in her chair. "But I think you need to be conscious of your needs and make sure you meet them in tandem with your family's needs. It's very important for your kids to know that they can rely on you, that you'll be there for them when they need you. I've seen the most busy people in the world be good parents. I could even say that about our current president and first lady. I think they are probably terrific parents. It's an attitude thing. If your kids have a need and they let you know it, you will drop everything for them. But you will also help them to learn how everybody else can have their own time and their own needs met."

Laura exudes a tremendous amount of competence and confidence in both her mothering and artmaking. But she is not out of touch with the difficult places. "Well, it's just a demanding job," she says, shaking her head as if amazed. "Keeping up on the laundry and just keeping the household and your own life running. And not really getting a break from it. I often feel overwhelmed by just the immensity of the job. You want to do a good job. I think about my single friends and how they can make decisions to do things when they want to and know that they'll be able to do it. They don't have to worry about crises that may come up or conflicts that they haven't checked with. On the other hand, it is such a rewarding thing that it's worth the immensity of that struggle. I keep looking down the road to the time when they've all gone off to their own lives and I feel like I've done a good job and I get my break. I must think it's hard if I keep thinking about that."

I bring up the issue of balance, that tired and impossible concept for which we are always striving. Laura howls. "I don't think I do it very well," she says. "I think I'm always tired. I think every painting I do I'm sleeping through part of it. I'm not an expert at it."

Laura suddenly sits up, brightening. "But a really good asset came from my childhood," she says. "There was a period after the car accident when my family, except for my youngest sister, was in the hospital and we didn't have any money. Somebody saw that the house payments were made but I had to work to get money to feed us and take care of us. I worked at Albertson's scooping ice cream and working the snack bar. And as I was doing that I'd be thinking subconsciously about the report I had to get out for school.

"I've always had, or learned how to develop, subconscious thinking while doing other things. I don't mind doing housework, laundry or dishes or even interacting with the kids because I always have some subconscious thinking going on. I'm really disciplined. My husband used to ask me what I was thinking about when I had a distracted look on my face but now he doesn't ask anymore because he knows I'm thinking of my paintings. I do a lot of mental work so when I get to the physical work of painting I'm really efficient. I probably don't have as much time as a lot of artists do but I can pump it out. I don't explore that much because I've already explored it internally."

I ask her to describe a typical day. She grins happily and begins. "A

perfect day goes like this. Help the kids get off to school first. Alex drives them so I don't have to get cleaned up then. Then do my house routine: make the bed, put the laundry in, pick up, clean the business stuff off my desk which is also my drawing desk. Then I go to the Y for a workout with Alex (always yoga, then weights, bicycle or swimming; I like to vary it.) We eat lunch together, then I go home for a brief nap. It adjusts my brain to begin work. Then I start painting, usually pretty intensely. I try to have flexible time to attend meetings or meet friends or do business with the gallery. Because I paint best when the kids are home, that's usually my inflexible time, which really protects my studio work time. I go to pick up the kids at 3:15 p.m. and continue working. They'll watch TV, do homework or play around me in my studio.

"Alex and I always check in with each other in the morning as to who will be making dinner and if we have supplies. Often dinner is a shared duty. If I cook he shops and does dishes and vice versa. He often coaches sports so I'll cook four nights a week and he'll cook two or three if he's not coaching. We often eat out once a week. I'm relieved of most afternoon kid-sport driving because Alex is usually the team coach for both boys.

"We try to get the dinner cleared off the table as soon as possible and everybody helps, so the kids can start homework. They let us know who needs help. For math, it's Alex and for reports or art projects, it's me. Spelling is either. If he's helping with homework, I'll fold clothes or help with kid baths. The laundry area is upstairs so the kids often visit while I fold. Alex is great with getting a board game going or playing with the kids before bed. I read them bedtime stories while

Alex watches the nightly news. One night a week I watch a favorite TV show and he puts them to bed.

"I try to have flexible time and inflexible time. My flexible times are the times I give to myself, like the exercising or lunch. The inflexible time is when I work in my studio or be with my kids."

Intensely practical, probably fallout from her mixed working class/middle class background, Laura frequently mentions money in tandem with her work. She has also impressed upon her children the connection between her artmaking and money, so that they clearly see the benefit for supporting her in her art. Her voice turns earnest. "The thing that really makes them supportive of me is that they have connected the fact that my selling the painting means that they get what they want for Christmas or they get the trip they want. A lot of times we'll be out and they'll want me to buy them something and I'll say, 'Okay, painting money is buying this.' And they make that connection. They know when I have a show coming up and we will establish what we're going to do if the show does well."

"It sounds similar to what your dad did with you when he took you to work with him," I say.

"Exactly, you just incorporate them. They all go through a period when they want to get into painting. I always let them because I hated it when my dad never let me work with him even when I really wanted to. A lot of times they'll paint on the bottom of my canvas. I don't say 'Don't touch that!' There just comes a time when they know not to touch the work after it gets to a certain stage. Somehow it happens. I can't tell you how.

"Several years ago I had a big painting in an exhibit at the museum

and I made the kids go to the opening with me. They were pointing to the painting and showing people and laughing so I asked 'What is it?' And they showed me where they had had a pillow fight and didn't tell me and the smudge was still there. But it didn't really wreck the painting."

She is also able to look beyond money issues. "I am committed to offering them an example of a balanced lifestyle and my husband is, too. I want them to have the option to do creative work if they want to and have an example of somebody doing that. I have a lot of artist friends who gave up their creativity during their kid's growing up years. I think of my creativity as my first child. I can't just cut it off that way. Kids are adaptable and I can adapt them into it from a really early stage. I can try to balance the home life with participating in their school life, sports and all the things they want to do and really put them first. But I also have my creative life that I try not to compromise. It's hard and I allow them to see the hardness of it."

Laura is deeply fascinated with how motherhood and creativity overlap and connect. When I ask how her work has been affected by her children, she has the answer on the tip of her tongue. "I was doing abstract painting but as soon as I was pregnant I became clear that I wanted to be figurative. You can almost cut out the period when I was pregnant with the boys. The paintings look more psychological. It's was not as different when I was pregnant with my daughter. Pregnancy work has a different look to it. I think you get in touch with a much deeper place. Or maybe you just don't have the time to futz around anymore.

"More and more I have tried to incorporate my whole person into my art. I observe my kids and their play patterns or whatever they are doing and see universal themes. I also use the wealth of feelings that form the experience of being a parent."

"Can you speak more specifically?" I ask.

"Yes," she says and runs to get a photograph of a painting. As we sit close together, looking at the photograph cradled in her hand, I ask her to describe it. "This painting is called 'Buds and Fruit.' It shows a female torso whose arms are crossed in front of her chest. She's holding a sphere about breast size in each hand. In the background there are some plant forms with buds on them. The figure is hiding her breasts, yet she's holding these spheres right in the area where her breasts would be. They are contrasting colors so they're dominant in the painting.

"After I did this painting I realized that it probably had to do with the fact that I was weaning my daughter after four years of nursing. I've been a long-term nurser with all my kids so between the three of them, it adds up to about ten years of nursing. I went through my whole thirties and part of my forties as a cow, basically. I always had lots of milk and they always liked it. This painting has to do with seeing breasts in different ways. You feed your child from your breasts, but breasts are also part of your sexuality. Then the buds on the trees allude to the fact that my childbearing years are over but I've started a daughter who is growing into those years. It's an interesting time. I'm harvesting."

"It's a great image," I say. "Where did you get it?"

"What I first do is get clear on an emotional state. Then it's like a homing device. I'll look everywhere for the right colors or the right

body language, and as soon as I see it, I know it. I have been working with performance artists for models and they have told me that my work is very physical and body oriented. I feel it in my body. In this particular case I actually posed for it myself. I looked in the mirror and that was how I was feeling."

Laura has many feelings about how the art world has reacted to her work since she became a mother. She feels both criticized and supported. It is a subject she has thought about at length and she welcomes the chance to share her thoughts. She sits up straighter in her chair and her voice rises in pitch. "I think women today are totally discouraged from drawing on their kids as a resource for their work. I'm a smart girl, I can look at the art magazines and I can see there is a very dark, pessimistic viewpoint that is being shown. I think being a parent brings out a sense of optimism. Just the fact that you conceive and have a child that is always growing gives you a hopefulness.

"For a long time the main focus of my work was perhaps more aggressive and more like the prevalent work in the painting world. But I was sequestering optimism in my private work, which were watercolors on unsized rice paper. That work was more intimate, psychological and maybe more female. But it was not being exhibited. Then John Weber, a curator who I really respect and a good friend, asked me if we could have a show of that work at the Portland Art Museum. This was in the mid-eighties, right after I started to get critical attention. He thought it was some of my best work and that I was undervaluing it because of the tender and more intimate content. Showing it was a terrific experience and very well received. But I still had a hard time allowing these things into my oil paintings. I remember purposely fighting it

but when I allowed it, the work started getting stronger. But it took a tremendous amount of courage.

"I'll tell you about another painting. I was pregnant when I did it. I wanted the painting to show some kids either playing or being in a life threatening situation. I had the kids get into a tight group and then I said run and they all ran and I took a picture and did the painting from it. It was exhibited at my retrospective and both the male curator and a male art critic didn't like it. A lot of other people really responded to it but these two guys didn't. When I questioned them to find out why, the only reason I could get was that it was about children and that wasn't a serious subject matter. I really think the view of a mother and the experiences of a mother, especially if that's what we put into the art work, is a minority view. There's not a lot of support or people being artists from a maternal point of view. But the only thing I can do is keep offering it up and hope that it will give courage to others to do it, too."

Laura is a long-term person, willing to build her life into a form that works for her. Her artistic support did not just happen, she had to build it, starting with her husband. "He's a terrific supporter. But I had to work at it and convince him that being an artist is important and even if he was able to make more money at whatever he did, my work would pay off. At this day and age I'm making good money with my art so it has paid off and he's totally behind it. For years my husband asked me, 'Why aren't you a nurse? You'd make good money as a nurse. I thought I married a nurse, now I've got to carry these paintings around, they never make any money.'

"My kids are very respectful of the artmaking. They see it as what

I do and who I am. And my gallery dealer is terrifically supportive. It's important for me that she values what I do and that it's not always a money decision. We were friends before she was my dealer and we have a great relationship. I can't tell you the number of business meetings we've had with our kids running around being crazy. She is extremely tolerant and supportive of my position as a mother and artist. I wonder if I would have that with a male gallery dealer.

"I also have a group of women who get together for tea parties. Most of them are in the arts, performance artist, a multi-media artist, a fiber artist and a photographer. I'm the only painter. We get together about every six weeks or so and have a salon-type tea at each other's houses."

After a pause she adds. "I should tell you that I do use childcare. All of my kids have been through preschool. I believe in using those services."

At this point in time, Laura and her husband are financially independent. But that is only recent. Laura laughs loudly at my question about money, but replies honestly. "We've done an interesting dance from the time we met. I got out of school first and started working to help him finish college, then he paid me back and supported me while I was in graduate school. I started teaching and supported him while he got his business going. Then he supported me while I got the babies going. We now have a family business, a housing development for the elderly, that gives us income. He developed many of them, but the last one he and the architect and the builder did on their own. Now he manages it and it produces income for us. It was very scary, knowing we could lose everything and possibly be on the street if it didn't work

out. I was basically a single parent while he was developing it. But the payoff is that now for the first time, and we've been married twenty-three years, we have more free time and we're stable. We think of the business as our patron. It's allowed him to do his writing and me to do my painting. I had one or two exhibits that did real well and they supported our family during the months we had absolutely no money. I was able to save our butts when we really needed it. I think it's important that I'm generating income, that I'm not wasting my time. We had this great talk awhile back about what if we don't make it, what if we don't produce any income? And my husband put it so nicely. He said, 'We'd want to be doing this activity anyway. It's valuable activity. It makes us who we are.'" She laughs and then adds, "My husband and I have this rule that you try to get your art fix everyday."

Her advice for other women comes shooting out. "I have heard so many women complain to me, 'I can't do work, I have the kids.' My personal attitude is that having the kids allows me to do the work. It gets me in touch with things that feed my work. I don't think I could do as good work if I didn't have the kids. If I had to give advice I'd say focus on the positive aspects and allow it to feed your work. Also, kids are so incredibly adaptable. If you allow them to know making art is important to you, part of who you are, they'll respect that and help you to do it. They love you and they want you to love them back.

"Include them, don't separate them. If you separate them you're going to have trouble but if you have a free flowing and integrated way of dealing with it, it works. Look at this room. It was designed for art activity to go on but it free flows. Often basketball games or roller skating are going on and they go round and round in here. I just ask

them not to hit me when I back up from my painting. Don't think of kids as energy drainers. Take the energy from them and allow it to feed the work and drive the work. It's too much work to separate anyway. I wouldn't know how to do it."

We are done, but not quite. I suddenly need to bring it full circle. "Would your mother be proud of you?" I ask.

"Oh, what a nice question!" Laura exclaims, her eyes immediately bright with tears. "Oh, I think she would be very proud. She had her dreams for me. She thought I would be a teacher because I connected well with people. It's hard having all the success of your life done post-parents. I'm not doing it for my parents, because they're not here to appreciate it, but I like to think that part of my success is because of her success with me. That total support and unconditional love in making me feel that what I did was valuable. It gives me some satisfaction that her belief in me wasn't wasted. I wish somebody could let her know."

Epilogue

I interviewed a total of thirty-seven women for this book and chose twenty-one to be in it. What happened to the other sixteen? They are hardly forgotten. Each one had something unique to give me. I can still recall hearing painter and printmaker Monica Marini, who was born in Argentina and now lives in Berkeley, tell of what happened while she was pregnant. Perched on a stool in her studio behind her house, arms dancing in the air, she said, "I enjoyed so much my body being big. It was fantastic. So all my images were of big women. Their arms were beyond the limits of the paper. And sometimes they had many legs and many arms. Or you didn't know where one started and the other stopped." Her face told the rest. Eyes glowing, wide smile of glee and amazement.

I came across cinematographer Nancy Schiesari by accident, while interviewing another woman, and we sat down right then to talk. She was terrifically frank with me and I liked her immensely. I can clearly picture the image of the birth of her second child. Nancy, in a hospital in London, on hands and knees, screaming to the nurse for a bed pan so she could have a bowel movement as the baby was on its way. She was equally honest about her struggles as a single mother trying to work in an industry that demands instant travel and long hours.

Another woman, Mary Jessie Garza, drove all the way from San Antonio to Austin with her two children to meet us for breakfast. All three were neatly dressed in white. Amid the clanging and clinking of the busy Mexican restaurant, she told me, with the strength of her Mexican America culture wrapped around her like a comforter, about her life as a photographer, single mother of a son and daughter and art teacher. I was left with a new way to approach motherhood: with calmness and a firm faith that things will work out.

After all the interviews were finished, I came away with only one concern, but it was a big one. Why are we proud of doing double and triple amounts of work? Why are superwomen our models? The way it seems now, the only women who can balance the two roles of artist and mother are those who don't need much sleep and go top speed all day. Sexism makes us believe that in order to be accepted by society, we need to do twice the work of a man. Overworking is a problem for men, too. They are pressured by jobs and corporations to become workaholics and ignore family life. Though I commend those who have accomplished so much with so little time and on so little sleep, it is not the model I am striving for. I want to challenge the assumption that overworking is something to brag about. Imagine what we could accomplish if we had enough sleep!

The key is getting enough support, a scarce commodity here in the United States. We are hounded by an ideal of total independence. But the truth is that most people who go it alone don't go anywhere. They

stay stuck in isolation. The women in this book who are doing the best are the ones who have support. It is that simple. Hung Liu is an example of someone who has unapologetically utilized her family's help so that she could make the necessary steps to further her career. Cheri Gaulke shows us what it looks like to raise children within an enthusiastic and close community. And Linda Vallejo, who in addition to being willing to pay money for in home help, draws support from everywhere: family, friends and colleagues.

So superwomen aside, what are the tips? They boil down to three. One, believe in yourself and your work. Know that it is crucial work that the world needs. Two, develop lots of support. Ask for more than you need and often. Involve many, many people in your life and work. And three, there are no rules. You are free to create a custom life exactly the way you want it.

My life has changed since I began this project. In our house we are experimenting with cooperative living. Our family of three expanded to include our housemate Rainstar and her four year old son Heron. For one year Dennis was a househusband, so I could work on the book. I have been part of a women artists' support network for over four years, without which this book would never have happened. I feel that I am a good mother and that Rowan is proud of me. "We make books," he tells his friends authoritatively. I truly know that I am not alone. And I have learned that the more I reach out to the world with my ideas and visions, the more I feel its arms return the embrace.

Acknowledgements

This book would not have happened without my artists' support group, No Limits for Women in the Arts. So thank you, all of you. You know who you are. Many thanks goes to Dennis Karas, who put up with only one topic of conversation for four years, took care of our son Rowan and rearranged his life and career for me. Thank you Christina Lowman for your sensitive and thoughtful editing. May this be only the first of many projects. Many appreciations to all those who generously opened their houses and lives to Chris and me wherever we traveled. To all thirty-seven women who let me delve into their lives, I offer my utmost gratitude. And of course, thanks to The John Anson Kittredge Education Fund and Portland Photographers' Forum for financial support.

Book and cover design by Anne Mavor
All photographs by Christine Eagon except where noted otherwise.

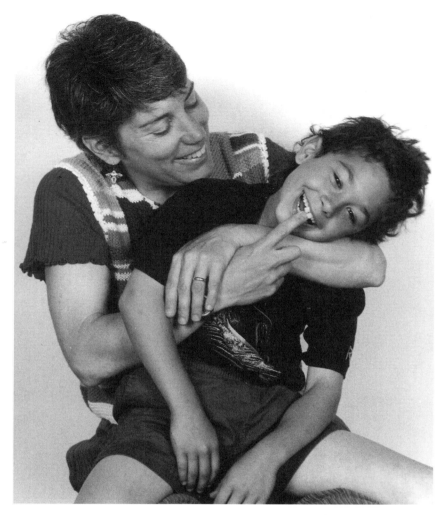

Anne Mavor and son Rowan Karas

Anne Mavor was born April 14, 1952 in Annapolis, Maryland and raised in Massachusetts. She has a BA in art from Kirkland College, an experimental women's college in upstate New York no longer in existence. She spent her junior year at a Folk High School in Sweden studying painting and ceramics.

In 1976, she moved to Los Angeles and joined the Feminist Studio Workshop (founded by Judy Chicago, Arlene Raven and Sheila de Bretteville) at The Woman's Building. While there she became involved in the West Coast performance art movement and did solo and collaborative performances nationwide. From 1980-83 Anne performed nationally with The Waitresses, a Los Angeles based collaborative performance group. In addition to performance, she has exhibited her one-of-a-kind and limited edition artist's books internationally.

Together with her husband Dennis Karas and son Rowan Karas, now seven, Anne moved to Portland, Oregon in 1990. She has continued to create artist's books while also exploring writing and alternative photographic processes. Anne is a workshop and support group leader in "No Limits for Women in the Arts," a nationwide network of women artists' support groups.

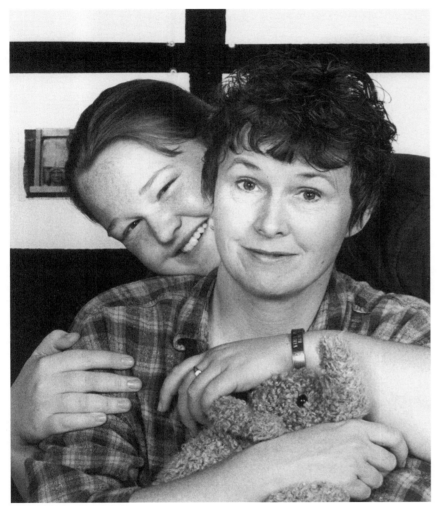

Christine Eagon and daughter Cara Cottingham
Photograph by Cara Cottingham

Christine Eagon is a visual artist who for over a decade has been working primarily as a fine art photographer. She created the photographs for this book hoping to show the relationship between each artist and her children. Photo sessions were on location at the artists' homes, studios and favorite places, working with natural lighting whenever possible.

Chris is a native of the Pacific Northwest, born October 10, 1948 in Hillsboro, Oregon. During the Nixon years she emigrated to Canada where she lived on a small wooded island in British Columbia. When she returned to the United States, she worked as a forest fire lookout in the Kettle Mountains of northeastern Washington. In the peaceful hours between fires, she sat in her lookout tower drawing, weaving and photographing.

Now based in Vancouver, Washington, Chris works full-time as an artist/photographer. She lives with her husband Earle Cottingham and their thirteen year old daughter Cara. In addition to black and white portraiture, she has become enchanted by the alternative Polaroid technique known as image transfer. She also teaches creative workshops for artists and photographers and recently presented two master classes at the World Congress of Professional Photographers in Dublin, Ireland. She is a second degree Reiki initiate and committed to healing circle community.